Royal Academy Symposia Volume

The divided heritage

themes and problems in
German Modernism

The divided heritage

themes and problems
in German
Modernism

Edited by
Irit Rogoff

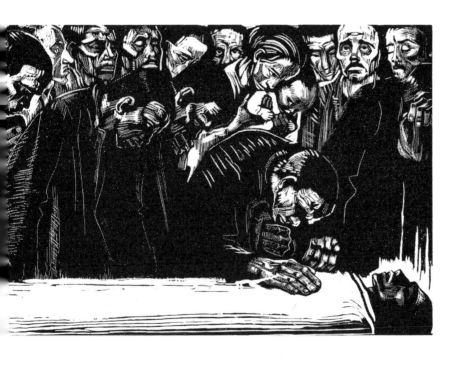

Cambridge University Press

Cambridge
New York Port Chester
Melbourne Sydney

Published by the Press Syndicate at the University of Cambridge
The Pitt Building, Trumpington Street, Cambridge CB2 1RP
40 West 20th Street, New York, NY 10011, USA
10 Stamford Road, Oakleigh, Melbourne 3166, Australia

First published 1991

Printed in Great Britain by the Bath Press, Avon

British Library cataloguing in publication data

The divided heritage: themes and problems in
German modernism. – (Royal Academy symposia).
1. German arts. Modernism
I. Rogoff, Irit II. Series
700′.943

Library of Congress cataloguing in publication data

The divided heritage: themes and problems in
German modernism edited by Irit Rogoff.
 p. cm.
At head of title: Royal Academy Symposia volume.
Includes bibliographical references.
ISBN 0-521-34553-7
1. Modernism (Art) – Germany. 2. Modernism (Art) – Germany (West).
3. Art, Modern – 20th century – Germany.
4. Art, Modern – 20th century – Germany (West).
I. Rogoff, Irit II. Royal Academy of Arts (Great Britain)
N6868.5.M63D58 1990
709.43′09′04 – dc20 89-35777 CIP

ISBN 0 521 34553 7

Contents

Contents

Plates

Plates

Plates

Contributors

IRIT ROGOFF teaches theory and criticism of art in the Department of Art, University of California, Davis, and has written extensively on German and Austrian art and on contemporary European art and cultural theory.

KLAUS HERDING has been a professor at the University of Hamburg since 1975. His publications include *Pierre Puget* (1970), *Realismus als Widerspruch* (1979), *Karikaturen* (1980) and about sixty articles on painting, sculpture and the graphic arts in post-Renaissance European art, including art theory, caricature and revolutionary and industrial imagery.

WALTER GRASSKAMP teaches history and criticism of art at Kunst Hochschule, Münster.

DAVID ELLIOT has been the Director of the Museum of Modern Art in Oxford since 1976. He specialises in twentieth-century and contemporary art, particularly German, Russian and British art, and he regularly publishes and broadcasts on related issues.

FRANZ-JOACHIM VERSPOHL is Professor of Art History at the University of Osnabrück. He is the author of *Stadionbauten von der Antike bis zur Gegenwart* and *Joseph Beuys: Das Kapital Raum 1970–1977*.

MARTIN JAY teaches intellectual history at the University of California, Berkeley.

MAUD LAVIN is rewriting her doctoral dissertation, 'Hannah Höch, Photomantage, and the Representation of the New Woman in Weimar Germany, 1918–33', City University of New York Graduate Center (1989), in book form.

GERLINDE GABRIEL is an art historian and exhibition organiser, currently living in London.

SEBASTIAN MÜLLER is currently working in the Department of Spatial Planning in the University of Dortmund and has carried out research into the history of German architecture and culture around 1900.

Contributors

HANS-ERNST MITTIG lives in West Berlin, studying and publishing work on art under German National Socialism.

CARLA SCHULTZ-HOFFMANN is Curator of Twentieth-century International art at the Bavarian States Collection/Staatsgalerie moderner Kunst, Munich.

IAIN BOYD WHYTE is Lecturer in History and Theory of Architecture at the University of Edinburgh. He has written extensively on German and Austrian architecture and is the author of *Bruno Taut and the Architecture of Activism* (1982) and *The Crystal Chain Letters* (1985).

IRA KATZNELSON is Loeb Professor of Political and Social Science at the New School for Social Research, New York. His published works include *City Trenches – Urban Politics and the Patterning of Class in the United States*, and *Schooling for All – Class, Race and the Decline of the Democratic Ideal*.

JILL LLOYD studied in London and Berlin and worked as a lecturer in twentieth-century art at University College London, 1980–88. She has numerous publications on early twentieth-century and post-war German art, and her book on German expressionism was published by Yale University Press in 1990. She is currently Senior Editor of *Art International* and a recipient of a research grant from the J. Paul Getty Foundation for 1989–90.

VITTORIO MAGNAGO LAMPUGNANI has been working as an architect and architectural historian in Germany, Italy and the United States since 1980, focusing his interest on the history and theory of architecture in the nineteenth and twentieth centuries. Since 1987 he has been deputy editor of the journal *Domus*. His publications include *Architecture and City planning in the 20th Century* (1982) and *Encyclopedia of Architecture of the 20th Century* (1983).

ROSALYN DEUTSCHE teaches art history and theory at the School of Visual Arts and the Cooper Union in New York. She is working on a book about public art and urbanism.

General introduction: The divided heritage – themes and problems in German Modernism

Irit Rogoff

This collection of essays has its genesis in an exhibition entitled *German art in the 20th century*, organised by the Royal Academy of Arts in 1985–86. One of the many events which took place around this exhibition, the first survey of German art of this century to be held in Great Britain, was an international symposium of scholars, critics and exhibition makers. The papers in this collection evolved out of that symposium and the extensive and engaged discussions which continued to reverberate around the issues that were raised on that occasion. For the opportunity of bringing us together and providing both the context and the forum for our discussions, the authors of this volume would like to thank the Royal Academy of Arts and the organisers of this particular exhibition project: Norman Rosenthal, Christos Joachimides, Wieland Schmied and Reinhardt Rudolph.

All of us owe a particular debt of gratitude to Mary Anne Stevens, who, as Head of Education at the Academy, not only initiated this project but also participated in every aspect of its planning, and grappled with the numerous and complex problems it continuously raised. Finally, my personal thanks to Kathleen Sorriano of the Education Department at the Royal Academy, who kept the diffuse strands of this unwieldly tome in her capable hands throughout its long period of gestation.

While both the exhibition and its accompanying catalogue[1] put forward a series of twentieth-century cultural continuities and progressions, this volume, which was conceived to complement them, looks at the tensions between continuity and disjuncture and their cultural manifestations in the twentieth-century tradition in Germany.

Our readers will inevitably be struck by the lack of linguistic and methodological coherence which characterises this collection as a whole. As such it reflects our desire to present a plurality of historical, theoretical and methodological orientations by scholars and critics from different countries, traditions and discursive practices. Such diversity may on occasion make for slightly awkward reading, compounded particularly in those texts which have had to be translated from German into English. However, such awkwardness does serve the purpose of drawing our attention to the problematic relationship of cross-cultural observation

and analysis. It makes tangible the difficulties inherent in the complex process of beholding other cultures from a variety of internal and external vantage points and the implausibility of a unified, international critical discourse converging on one cultural history. Rather than setting out to represent a set of value judgements concerning the achievements and failures of twentieth-century German culture, our choice has been to try and illustrate its far-reaching impact within other people's cultural discourses. Thus the origin of those discourses, be they American, British, Italian or other, are as important as the German tradition they are focusing on. The discussions formulated by these diverse perspectives deploy differing critical orientations from those set up within West German critical culture and in turn serve widely differing strategic interests. Their preoccupation with German material goes beyond a testimony to its enduring interest and cultural centrality, to the ways in which it can serve to illuminate and focus other problematics within other cultures.

'What is German?' In 1969 Theodor Adorno warned that 'the ideal suffers at the expense of the idealisation. The fabrication of national collectives ... is the mark of a reified consciousness hardly capable of experience. Such fabrication remains within precisely those stereotypes which it is the task of thinking to resolve.'[2] Mindful of the pitfalls inherent in the process of working within the framework of national cultural traditions, this collection has attempted to engage with the historiographic traditions which work to construct so-called 'national heritages'. Underlying such cultural and historical pattern making are assumptions about forms of cultural continuity and, more importantly, of certain supposedly clear-cut binary oppositions such as avant-garde and tradition, high culture and mass culture, oppression and resistance. Much of the historiographic tradition we have inherited presents these terms as opposite poles which map out the field of activity and which gain much of their vitality by defining each other through easily determined patterns of opposition. Our own aims, inasmuch as these have existed collectively, have been in the direction of determining the social and political embeddedness of culture viewed through its visual representations. Thus we have, on the whole, chosen to problematise the entire issue of heritage and to pay particular attention to the absences and silences which have traditionally marked its chronicling. By working within a framework of thematic rather than chronological headings, we have attempted to establish a mode of continuous interrogation of our material through a variety of critical perspectives which deal with time, place and historical specificity on the one hand and with different theoretical and methodological questions on the other. One section of the book, for example, focuses on the numerous variants which exist within historical patterns of patronage rather than viewing them as coherent linear traditions. These differentiated forms of patronage are examined from a variety of view-

points whose importance to the modernist project has been somewhat marginalised. Within modern German history one such phenomenon was the challenge of bourgeois patronage to Imperial state culture politics. This challenge is analysed here not simply through models of individual taste and liberal accommodation of artistic freedom and self-expression but also through the entire gamut of economic and industrial interests which enabled patronage activities in the first place but also served to subtly alter the nature and status of the activity being patronised.

Similarly, the case of German fascism and the relations it forged between artistic activity and the state has traditionally been viewed as a clear-cut and unequivocal decimation of the vital and innovative avant-garde through exile, imprisonment, murder and numerous other systematic forms of oppression. The opposite pole to the suppressed artistic activity has been predominantly viewed as the relentlessly intolerant and highly organised state machinery for the production of public art. Between the two extreme poles lies the shadowland of the so-called 'inner immigration': the artists who stayed on in Germany despite the defamation of their work and practised or had forced upon them a form of inactivity or passive resistance. This entire paradigm works through simplified concepts of reviled radicalism, conservative collaboration and muted resistance while ignoring the areas and possibilities for links and negotiations which actually existed between them. The essay on artistic patronage during the period of National Socialist fascism works to enumerate the ways in which artistic production was supported and promoted by a patronage system of great complexity and informed by a far greater degree of variety and co-operation than previous accounts have described.

Another group of papers in this collection attempts to work across the universality of cultural historical continuity by interrogating the social construction and representation of masculinity and femininity. By framing the discussions within the discourse on representation and the inherent links between the establishment of an identity and the ability to represent it, issues of cultural history and gender theory are brought to bear on one another. More specifically, issues of cultural refrentiality, the sexual politics of representation which collude with or work against stereotypical gender images, their relation to artistic production and the relation of both to prevalent contemporary ideologies, are found to evolve into clearly perceived counter-historical traditions.

Other papers look at the centrality of the city in German social and cultural theory and its constant presence in the world of visual representation as a manifestation of every form of change wrought through the processes of modernity. Historically this was a process in which constant demographic change, increasing urbanisation and transitions from capital city to industrial city to world metropolis drew the descriptive, celebratory and critical attention of artists, writers, theorists and critics.

3

The essay in this collection which looks at the emergence of these early images in Expressionist art, does so from the point of view of the construction of a visual idiom for the problems of metropolitanism rather than as a simple reflection of urban realities. Echoes of this same constructed view continue in contemporary artistic discourses known as 'New Vehemence painting' in which one city, Berlin, exists in a highly mythologised form, as a set of stylised signs which signify urban decadence and alienation and which build on the visual codes of previous generations and eras. This essay, which deals with the painterly activity of cross-historical reclamation of visual discourses from the 1920s, problematises their subsequent distance from the social, political and ideological frameworks in which the original artistic activity had been located. It argues that these sign systems operates in an arena which valorises artistic activity as a form of autonomous heroism and which feeds on a romanticised version of metropolitan alienation. However, the ability of these works to instantly signify in turn their cultural and geographic identity is determined through artistic precedents – through the evolution of a discourse of representation we are experiencing a form of urban simulation.

Continuity and disjuncture – the other main argument around which many of the essays revolve focuses on the disparity between historical linear evolution and the thematisation of rupture within cultural history. The tension between these two opposite modes of reading German history is part of the overall shift in paradigms of historical interpretation taking place within all of our respective fields of inquiry.[3] Thus the issue of division is not simply the historical account of disruption, of belated industrialisation and unification, of the legacy of regionalism versus central government, of a sequence of monarchy, republicanism and totalitarianism following one another in quick revolutionary succession within less than half a century or even of two world wars and the geographical and ideological division of one nation. There are other, conceptual modes of division which work across these historical narratives and which several of these essays both characterise and analyse. These include divisions such as those between high culture and mass culture, between the representations of genders, races and classes or between the aspirations of the modernist project and the fragmented condition of postmodernism.

Our collection appears at a time when great attention has been focused on the *Historikerstreit*, the German historical debate which has been raging with ever increasing animosity since 1986.[4] The West German historian Wolfgang Mommsen has characterised the opposing views and attitudes in this debate to processes of relativisation. Instead of bracketing Nazism out of German historical continuity, as does the school of historical thought and method which looks at German history as following in a *Sonderweg*, a unique path, the neo-conservative historians

in Germany have sought to relativise it by stressing in what respects other countries have undergone comparable experience. The opposing argument, which refuses the introduction of such notions of historical relativisation, insists on looking at the Nazi state's activities as institutional continuities sited within a specific development of German history. The contemporary and historical political implications of this debate are immense, and the responses which the West German philosopher Jürgen Habermas has made to neo-conservative historians, charging them with the attempt at the construction of a usable past within present day conservative politics, have illuminated these implications in their full complexity.[5] From the point of view of many of the papers assembled in this collection, the prominence of this methodological and polemical controversy focuses on a tension between revisionism and reconciliation and the need to transcend precisely this paralysis which has been brought about by the inhibitions of the German historical discourse. Thus, for example, within a discussion of cultural legacies, the question is raised here of which of the two Germanies is today the custodian of the national heritage? Are the reinterpretations of the shared tradition so disparate as to be entirely opposed, or are they both partial representations of a continuing tradition?

As our volume goes to press extraordinary events are taking place in Central and Eastern Europe. Tantalising possibilities seem to be indicated regarding one aspect of the division this collection has tried to problematise; namely, the parcelling out of one cultural heritage between East and West Germany. These developments seem to hold out some promise for a reconciliation, if not for actual reunification. Much of the euphoria and optimism evident in the early pronouncements and commentaries immediately following the dismantling of the fortified borders has to do with an aspiration to negate the traumas inherent in the past forty years of division and estrangement between East and West and to subsume ideological differences under a (re)emergent category of national similarities. An alternative development, however, may be that the drawing together, in one form or another, of East and West Germany will in fact reveal unthought-of possibilities for recognising differences which had previously gone unnoticed within the polarised hostilities between divergent political systemns, superpower alliances and the struggle for the possession of German history. Could the cultures resulting from such divergent political and ideological institutions ever co-exist in some complementary mode or are they destined to launch a series of challenges to each other's authenticity? As the tide of dramatic events continues unabated, a set of tendecies is becoming apparent which seek to locate long forgotten or submerged strands of similarity which are in fact brought about in the wake of a recognition of profound difference.

Taking up an attempt at the historical understanding of such differences the essay on art in East Germany looks at the conjunctions of

cultural traditions and official ideology within the framework of state institutional policies. Within the realm of the discourse on representation, however, we are also aware that reconstruction can become its own subject, with refrentiality overwhelming the possibility of linear narrative. This has affected a shift from issues of historical continuity and privileged cultural legacy to those of the contemporary reception and significance of those traditions. But it is not simply a question of who continues which traditions but also of whether those traditions ought really to be continued without having been subject to a process of revision, complete with their exclusions and absences. Many of the contemporary women artists whose work is discussed here in an essay about art forms produced post–1968 are working in defiance of the re-establishment of precisely such a linear narrative. Their work serves not only as a critique of the limitations of high art but also as a set of proposals for the creation of new artistic forms.

One of the hallmarks of Modernism in Germany has been the centrality and urgency of the discursive sphere which surrounded production in the arts and design. Clearly articulated ideological positions and overtly stated links with specific political allegiances worked to create not simply a remarkably broad cultural politics but, more importantly, a real and vital political culture. The great havoc wreaked by NS fascism, by the Second World War and by the Holocaust were not just the loss, exile and decimation of several generations of artists, critics and theorists, much of whose work survived their tragic fate, but also the loss of possibilities for the fertile interactions which made up that discursive sphere. While the National Socialist past has imposed many limitations, silences and taboos on the cultural-historical debate, it has also largely determined the terms of the reinstated culture. What is to be celebrated corresponds in a direct manner to what was reviled, destroyed, denounced and exiled. Great resources of money and effort have thus been spent on the recuperation of lost and dispersed art objects and their reappearance has symbolised the continuity of a cultural tradition beyond its disruption. In the process this German avant-garde culture has also gained a uniformity and a coherence which belies its turbulence, its critical agitation, its internal contradictions and its immense vitality. Fragile and ephemeral though culture's discursive spheres may be when compared with displays of objects which can be marshalled in various historical and aesthetic formations, it is precisely their elusive complexity which many of these essays have tried to reveal, to reconstruct and to review.

The divided heritage

Introduction – against the cliché of constants beyond history

Klaus Herding

One of the merits of the exhibition of twentieth-century German art at the Royal Academy was its attempt to go beyond questions of pure artistic style and to engage with issues of imaginative consciousness in the problematic of German art. Both the arrangement of the works and the essays in the catalogue underline the importance of substantive questions. Almost all of the exhibited works transcended the painted appearance of their surfaces and indicated their semantic context. Even Kandinsky is quoted in the catalogue from this perspective: 'For me, form is only a means to reach a goal' (Joachimides, p. 9). An understanding of this sort is far removed from a disdain of the artistic form – it simply acknowledges a fact that Dieter Honisch recently disregarded completely (with regard to German contemporary art) when he wrote: 'All artists are not looking for the communication value, but rather for the self-value, of what they produce.'[1] The London exhibition exposed the fact that Honisch's *l'art pour l'art* standpoint is especially problematic for German art of the twentieth century.

But is there a common denominator for the undeniable communication value of German art – that was so rightly emphasised in the London catalogue – and what would it be? These are the questions which cause opinions to diverge. The exhibition searched for and found a kind of continuous quality in the expressive value of German art. But whether this expressive statement really existed and still exists to a stronger degree than in other artistic landscapes, whether it covers the whole period of eighty years that was being examined, and whether it stops at the national boundaries – those of 1905, 1920, 1937, 1945 or 1985? – is still an open question. It is, however, of the utmost importance to ascertain if there was any specifically *German* socialisation that was able to create comparable energies of form during such an extended period of time with its many political, economic and cultural differences. To me this does not appear to be the case. And thus as plausible as it might be to query the content of German art and, in so doing, to direct attention to one of the essential factors of its reception – the attempt to subordinate these multiple contents to one single key expression and to define this expression as transcending its own historical epochs – is hardly convincing. Thus, if I

am inclined to accept the basic offer of the exhibitors to couple philosophical and anthropological questions directly to the experience of form of the exhibited works, it seems necessary to me to differentiate their nomenclature.

The peripheral topic of the first section, 'Divided Heritage', is very supportive of this intention. It provides the opportunity to correct the concept of the exhibition: while the romantic tradition is called upon to justify the supposed domination of German expressivity in the twentieth century[2] (obviously the authors think of both as mystical), the key words 'Divided Heritage' also remind us of the classical heritage between Schinkel and Adolph von Hildebrand. And thus the question regarding the prerequisites for the Bauhaus and the New Objectivity as well as for the German neoclassicism of the twentieth century is raised.[3] The only reason the dubious protest against the exclusion of National Socialist art was able to prevail so vociferously as a criticism of the London exhibition was because all of this was suppressed during the exhibition in favour of the fiction of a common basic tendency. In addition, the word 'division' brings to mind the tension between the inner immigration and the manifest resistance and the adaptation of German art to the NS régime. Due to this, the original concept of the exhibition was surreptitiously changed during its second showing in Stuttgart (for example by the increased representation of Schlemmer and the greater attention given to Kiefer). And last but not least, 'Divided Heritage' also directs our attention to the whole problem of a differing understanding of culture and a separated appropriation of the cultural heritage in the two German states of the post-war period – a phenomenon that is also suppressed by the exhibition. In short, it appears to me that 'expressivity' represents nothing other than a word trap that obfuscates the historical reality, its only merit being that it justified the first section of the scholarly colloquium which accompanies the symposium. But at least a one-sided concept has the undeniable advantage of provoking; and so it is certainly productive.

If we now assume that there is and was no one-dimensional, levelling expressive tendency, but rather a multiply differentiating art scene in Germany, we will no longer bother with the mystical question of what is German in German art (unlike Pevsner, who asked about what is English in English art and ran aground doing so);[4] instead we will try to reconstruct the discussion of the historic ruptures and artistic opposites that appears in the form itself. This does not disavow art to *ancilla historiae*; it simply reties the links that the exhibition, contradicting its own concept, tore apart.

Form elaborates on history even when it is not endowing it with a theme. For example, the blue head in Nay's *Tochter der Hekate of 1945* (catalogue 109) shows misperceived particles of the multifocal dissection of human faces that Picasso had been testing since the *Demoiselles d'Avignon*, i.e., a hesitating, artisan-additive gathering of problems that

had long been solved in the European avant-garde. Baumeister's fast descent into decorative patterns around 1950, Hofer's fixation on motive, the evocation of many artists of an antiquity that, even in the judgement of Werner Haftmann,[5] was a flight from the problems of the time into assured values – they are all symptoms of a historically occasioned crisis of form. Thus we are not doing Nay, Baumeister, and Hofer an injustice by saying that the non-recoupable *loss of substance* that German art suffered due to the NS régime manifests itself especially in the first post-war art and in spite of its quality.

If we try to reconstruct these historical dimensions *within* the artistic form, we will have to follow two paths, and indeed the experts of the first section of this volume (as well as those of the other sections) follow two paths: either they attempt to expand the framework of connotation with regard to the concept of the exhibition (it has, for example, proven necessary to introduce Sartre's definition of art to interpret Wols into the future, to show his proximity to Beuys and to rid him of the cliché of being a successor of Expressionism) or they attempt to reach beyond the material presented (Hannah Höch, for example, was only given a subordinate place in the exhibition and its catalogue, since collages were obviously not regarded as a medium equal to that of paintings and sculptures). Something similar applies to the art of the GDR; it was excluded by the exhibition's organisers even though it would have been precisely there that they would have been able to find support for their thesis of continuity, since the artists of the GDR were much more vehement in establishing ties with German Expressionism than were their colleagues in the west.

Thus our section is inclined to think that the exhibition, based on a postulated uniformity, does not adequately represent the discontinuity in German art, its oscillation between preservation of the artisan tradition and adaptation to the international avant-garde of western art, the play between realism and idealism, between smoothed abstraction and image painting (contrasts, by the way, that are reminiscent of the conflicts in French painting of the nineteenth century).[6]

The basis of this discussion, given by the opening essay by Walter Grasskamp in a broadly sketched overview, takes us far back, namely to the so-called *Schwellen-* or *Sattelzeit*, as historians call the century between 1750 and 1850 or 1870. For this is where the terms of the search for a German identity were established, finding its violent manifestation in the proclamation of the German Emperor at Versailles in the wake of the Franco-Prussian war of 1870/71.

It is a useful backdrop to the exhibition and its continuing discursive spheres in this volume, since it is the so-called 'founding period' (*Gründerzeit*) of the German Empire – a period as remote from Modernism as could be – in which Grasskamp locates the roots of the artistic

situation of Germany in the twentieth century and which he characterises as a 'continuity of disjunctions'. Grasskamp sees the German search for an identity as split from the beginning – imprinted by contrasting historical experiences – as in the 1981 Hamburg exhibition, *Dreimal Deutschland* (Three Times Germany), in which Lenbach, Liebermann and Kollwitz were chosen to represent the plurality and disparity of artistic activity.[7] This is even more valid for the period after 1945; paradoxically, though, the idea of a completely new beginning within the realm of the fine arts did not predominate in the east, but in the west. In other words, it occurred in the place where there was an obvious attempt to establish economic and political bonds with conservative, pre-war Germany, while a reversed starting position in the east led to the establishment of the theory of cultural heritage. Both of these, the eastern attempt to found a new German tradition by referring to the enlightened values of bourgeois classicism and the western efforts to make a clean sweep of the past, could, in Adorno's meaning, be considered to be barbaric. Adorno did not say (as the catalogue claims)[8] that it is impossible to write poems after Auschwitz, he simply said that writing poems now is barbaric because it suggests that nothing happened. This kind of prettification could, with exchanged signs, be seen at work in both German states.

Maud Lavin's examination of the interrelation between the mass media and so-called high art in Höch and Schwitters exemplifies that it is hardly possible to limit oneself to the traditional genres when presenting the twentieth century, and in this case specifically the 1920s. To me, it appears that this touches on more than just the question whether it would have been better to include this or that painting in the exhibition. Rather, the problem is whether something conclusive can be said about the high art of the twentieth century if we do not confront the new stratifications, ruptures and cross-connections that the invasion of collages and everyday experiences (including advertising art and photography) into this high sphere made possible. The deconstruction of the old and the utopia of a new world thus probably only become tangible when the visual 'signifiers' of this upheaval are included. Perhaps the 'deconstructive creativity' noted by Lavin is the essential element of German pre-war art, and it is doubtful whether these activities can be included in the thesis of the continuity of the expressive – unless we reduce the anarcho-communist movement of the Berlin Dada or Heartfield's activities for the *Arbeiter Illustrierte Zeitung* (*AIZ – Workers Illustrated Newspaper*) to *Herzensergießungen* (outpourings of the heart),[9] – something that is certainly not permissible.

Franz-Joachim Verspohl's objective is to lead us out of this dilemma by noting a forward-looking treatment of the past in Wols that unites the deconstruction of the old and the construction of a new world. Simultaneously he demonstrates in an exemplary manner that German art could perhaps only escape from 'helpless antifascism'[10] by turning to the

so-called 'hereditary enemy', France, and burying its jealous competition with the latter. (The cliché that the French possessed 'civilization', but that the Germans had 'culture' was common among German teachers even after the war.) Verspohl demonstrates that Wols, in contradiction to the opinion of his promoter Haftmann, is less to be understood from a vantage point of Expressionism, but rather that he constitutes a completely new perception, the result of which can be called 'experimental art'. According to this, not only would the suspension of the detail as a whole (something that objective Expressionism never effected), but above all the negation of the customary concept of a polished, fully painted, completed work of art would be what is new. The very term 'new perception' thus refers to the existentialist attempt to reconstruct the human face in all its subjectivity. The fact that this touches on Sartre's vision of the 'transcendence' of an assumed objective 'propriété' and an 'esprit de se dépasser et de dépasser toute chose'[11] means a more basic renunciation of a fixation on the objective world than is possible even with the collage-like ruptures and the Surrealist alienation (*Verfremdung*) of the object. This phenomenon of experimental art does presage Beuys (according to Verspohl), but it transcends issues of specific German characteristics and qualities and thus also leaves the concept of the exhibition in its wake.

David Elliott's reconstruction of art historiography in the GDR not only relates to the contemporary art of East Germany that was left out of the London exhibition, but also relates to a new evaluation of the realistic-revolutionary art of the 1920s there.[12] At first glance we could expect the thesis of the 'Divided Heritage' to reach its highpoint in this lecture – and Elliott does indeed furnish very convincing proof of the cultural contrast – but we note with amazement that the movement of drifting apart had already passed beyond its climax in the late 1950s and early 1960s (even with regard to the western art of this period that was so neglected in the exhibition). Ever since the GDR introduced the 'expanded realism concept' in the 1970s and immediately enlarged it to include earlier art, there has been an astonishingly large movement in the same direction. That an artist like Volker Stelzmann recently emigrated to the west (something I deem regrettable in view of his merited successes in the east) would, under the influence of the cultural cold war between 'progressive' abstraction here and 'restorative' realism there, have formerly been completely unthinkable. Today it is hard to understand how the art of the GDR can be withheld from the visitors of an exhibition on German art in view of the neo-expressionism of Heisig over there and Baselitz over here and in view of realistic and abstracting currents on both sides. Thus it is all the more important that Elliott has been able to provide some representation of their work within this context. The question remains whether the contrasts within the German art of this century can be read from its form. The section 'Divided Heritage' was only successful if this is achieved.

A historical continuity of disjunctures

Walter Grasskamp

The notion of nation

The exhibition *German art in the 20th century*, that forms the context for the current discussions, presents art in a *national* context, as *German* art. West German reviews of this exhibition have criticised this concentration on the national context as a conservative scheme of presenting modern art, compared with exhibitions like *Paris-Berlin*, where stress was laid on the wide-scale international relations and interactions. This brief discussion will therefore attempt an explication of the specific relation between German art and the concept of a German nation. We will see that the set of specific interrelations between art and nation was subject to substantial changes in the nineteenth and twentieth centuries. I would like to reconstruct these changes in order to prepare (and provoke) the discussion of the question of whether it is possible to speak of a *German* art in the twentieth century.

For many obvious historical reasons the interconnections between the realm of art and the codification of nation have been particularly difficult to clarify within a German context, since the nation assumed the shape of a state only very briefly in the nineteenth and twentieth centuries. From 1871, when the Second Empire of Bismarck's construction ended the long era of particularism, until 1945, when the nation was divided, there were only 75 years of cultural, national and political unity. Furthermore, even during these 75 years, it presented three different blueprints for its national character: the pompous façade of monarchy, the confusing reality of its first democracy and the archaic surface of fascism, under whose cover death was industrialised. From 1871 to 1945 Germany therefore presented three different states of aggregation: expansive, unstable and explosive. Which of these states of aggregation was representative of the real German state?

A state of mind

Perhaps none of these, since for much longer than it had been a state, Germany had been a state of mind. This state of mind was articulated in

literature and art, where patterns of German identity were discussed and represented long before this identity became a political reality again. For nearly a hundred years *before* the political unification of Germany in 1871, the aspiration for a national identity took the form of a utopia, which dominated the arts and was projected retrospectively on to the previous 500 years. In this pattern of development literature took the lead, but the theatre and opera, philosophy and philology and – last but not least – art joined in to create patterns of national identity. A recent book by the German historian Johannes Willms, gave his study of nineteenth-century Germany the title *Nationalism without a Nation*, thereby providing us with a catchphrase which characterises the German state of mind before 1871, the development of which Helmuth Plessner has called *The belated nation*. Because the definition of a national identity was central to the arts before the nation was united, it is possible to speak of *German* art and *German* literature in the eighteenth and nineteenth centuries, even if there was no political reality to match. The end of the eighteenth and most of the nineteenth century were dedicated to this process of filtering and adopting a heritage of different sources for the purpose of forming a national identity. Art served as a simulation of this political utopia and thus played a political role.

AlieNATION

As soon as this anticipated national identity had become a political reality in 1871, most of the living artists lost interest in the historical role that art had played for the generation before them. They did not express opposition to this role – they simply ignored it. Art thereby gradually lost its connection with the specific national context. The indications of the beginning of such a process of alienation were already numerous in the first decades of the Second Empire. Artists lost interest in painting the historical murals with which famous scenes of characters of the nation's history in the previous decades had been celebrated. The gothic revival, which was central to the manifestation of a national identity in the beginning of the nineteenth century, came to an end and was replaced by the eclecticism of the *Gründerzeit*. And if uniforms, heroes or other trappings of the official German tradition still provided models for the painters, then an aspect of irony interrogating the façade or the masquerade occurs as, for example, in the paintings of Corinth or Slevogt. But the most striking symptom of the new alienation between art and nation was the growing influence of French painting, of French *peinture* among German artists. It was the Emperor himself, Kaiser Wilhelm II, who repeatedly blamed contemporary German artists for being 'too French', even when they happened to live in Italy, like Hans von Marées. But not even his Imperial resistance could stop this development. The orientation towards France and Paris gained epidemic proportions around the turn of

the century when Paris replaced Italy as the destination of the pilgrimage of German artists. If we consider the thirty-five artists shown in the present exhibition who were born before World War I, the ratio is significant: twenty-five of them visited or lived in Paris before the advent of fascism actually forced artists to seek asylum. Only fifteen of them visited Italy during the same period and only one of them, Christian Schad, actually lived there for a longer time. Even the artists who did *not* visit Paris (like Kirchner, Heckel, Schmidt-Rottluff, Mueller) adopted and experimented with French forms and patterns of painting, synthesising a wide variety of foreign influences in the process of developing their own individual style.

Segregation

Thus the historical alliance between the configurations of art and the nation received its first (and substantial) fractures during the years before the First World War and was finally to break asunder during this war. In the beginning, however, it seemed as if this war would have quite the opposite result. Enthusiasm for the war united even the modernist avant-garde artists with their nation again. From the nineteen artists in this present exhibition who were involved in the First World War, ten volunteered (Beckmann, Dix, Ernst, Grosz, Heckel, Kirchner, Kokoschka, Macke, Marc, Schlemmer), some of them in order to have their choice of regiment, but others (Franz Marc, Oscar Kokoschka) because they approved of the war. Like the war against Napoleon a hundred years earlier, the First World War seemed to integrate the artists into their nation's destiny, to re-integrate the aesthetic vagabonds into a concrete German identity. Even an artist such as Franz Marc – son of a French mother, to whom he wrote his letters from the front in French, and who was strongly influenced by French culture and French art – volunteered to fight in this war *against* France. The soldier's deaths of Marc and Macke in France are paradoxical for biographical reasons, because both of them admired French culture and both had visited Paris and France repeatedly before the war. But this biographical paradox is only a personal variation of the political paradox that is manifest in the war engagement of German artists. This paradox consists of the fact that these artists, who were already internationalists in art, followed the call for arms in their nation's uniforms.

Despite this phenomenon, the war did not in fact serve to mend the segregation between art and national identity which had become increasingly obvious during the Wilhelmine Empire. On the contrary, the war accelerated the segregation that was finally to establish itself overtly in the first years of the Weimar Republic. This rupture was *not* due to the fact that this war had been lost. The mental crises suffered by Beckmann, Kirchner, Grosz and Lehmbruck had taken place before this outcome was in sight.

The commentary emitted by the artists on the nation's collapse came from a great distance and can easily be misunderstood. One way to misunderstand this segregation of art and nation is to overemphasise its political character in terms of ideologies, doctrines and party affiliations. The other is to *underestimate* its political character by using a merely aesthetic model for this process of separation, the model of avant-garde. The aesthetic distance which had been established in France between the so-called avant-garde and the official salon some decades earlier must not be confused with the political distance which was established between the artists and their nation in Germany after World War I. Politically speaking, these artists were not the avant-garde of art, but the rear-guard of a defeated army. Their odyssey began when they arrived home at the end of the war. A long time after the outcome of the war had been decided on the battlefields, the artists were still preoccupied with the insights it had provided into the corruption of nationalism. When the theme of the nation occurred in their works, it was increasingly in the vein of satire and caricature. Some of these soldiers returning from the war were still dealing with these insights when the ground for the next war was being prepared. If there *is* any specific German art in the twentieth century, it is the art of these inter-war years.

Internationalism and provincialism

If the art of these years is to be regarded as *German* art then another paradox emerges. This is due to the fact that these were also the years when internationalism started to dominate the scene within Germany. Many of the German artists aligned themselves in the years immediately following the war to socialist and communist groups and parties who believed in internationalism – the utopia of a future world in which war between nations would become obsolete. Some of them were founders or members of the Bauhaus in Weimar, a breeding-place of what was later to be called the International Style. In the years of the Weimar Republic, Germany was an international free-trading zone of art and culture, of ideas, ideologies and aesthetics. In contrast to the years before the war, when internationalism was predominantly influencing artistic, but not political, attitudes, it was now influencing *both* as the articulation of an ideologically engaged culture. However disastrous and desperate those Weimar years may have been in economical and political terms, for those fifteen years Germany was the cross-roads of internationalism in both art and politics.

It is important to stress that this internationalism had many centres and sub-centres in Germany. It was therefore not particularly representative to entitle an exhibition which focused mainly on these years *Paris–Berlin*, since its title falsely suggests a predominance of Berlin in Germany that could be compared with the position Paris held in France. If this exhibition had been called *Paris–Germany*, the topographical difference

between these two areas would have been pointed out far more correctly. The task of giving titles to exhibitions of German art in the twentieth century, as all of us here are aware, has proven exceptionally difficult.

During the years of the Weimar Republic, German art became a special case in art history because it was international – directed both to the west and to the east – while at the same time not being dominated by a national capital city but dispersed into many smaller and greater centres. This was a manifestation of a special brand of traditional German provincialism, the heritage of centuries of particularism, and of a political and artistic internationalism – a conjunction which gives additional reason to recognise in the art of this short period a specifically German phenomenon.

Art of the nation

But in the end German art was caught up in its own history; the theme it had neglected, the apotheosis of the nation, was soon to be imposed on it by the forces of fascism. It returned as the focal point of political and artistic activity in a particularly aggravated form. Internationalism was denounced at a variety of levels and the paranoid vision of a world-wide Jewish conspiracy served as a propagandistic tool to banish internationalism in the arts as well. With the persecution, assassination and exile of the Jews, a central part of Germany's historical identity – an internationally linked part – was banished and lost. With the emigration, the division of the nation began and simultaneously became a division of the nation's cultural heritage as well. The Hölderlin or Goethe that fascist teachers read out to classes of future soldiers was totally different from the Hölderlin or Goethe a Jewish or socialist emigrant would read in Paris or Los Angeles. German tradition suddenly had two versions, one at home and one abroad. Different readings of Goethe and Wagner, Nietzsche and Beethoven, Dürer and Caspar David Friedrich were established and were readings that *excluded* and negated one another.

That which was actively dividing the dead also divided the living. And so, for example, of the twenty-nine artists in the Royal Academy exhibition who were born before World War I, fifteen lived outside Germany during the years of fascism, either for some years or for the entire period (Beckmann, Ernst, Feininger, Grosz, Hausmann, Heldt, Kandinsky, Kirchner, Klee, Kokoschka, Meidner, Oelze, Schwitters, Schlemmer, Wols). Their mental distancing from their nation turned into a literal distance, a geographical separation. Now they had become internationalists by virtue of forced emigration. Among the fourteen others who stayed at home in the ambivalent state of 'inner emigration' (Barlach, Baumeister, Dix, Heckel, Höch, Jawlensky, Kollwitz, Nay, Nolde, Rohlfs, Schad, Schlichter, Schmidt-Rottluff, Uhlmann) only two were drafted for active service in the war (Nay, Dix). Only twenty-five

years after the First World War in which half of the artists volunteered, not one of them volunteered for this second War.

These artists definitely did not represent the 'Nation' as conceived and articulated by the fascists. What kind of art *could* be perceived to represent this fascist nation? Two equally inappropriate artistic idioms were considered for this task of the Third Empire. The first and ultimately unacceptable notion was that Expressionism might take this role, because it had 'anticipated' the unique Nordic character of German fascism, as futurism already represented Italian fascism. This proposal that Expressionism should be the art of the 'National Revolution' was discussed seriously (and with the sympathy of at least some of the artists concerned). But the discussion ended abruptly in 1935 when its principle forum, the periodical *Kunst der Nation* (Art of the Nation), was prohibited. This journal published Werner Haftmann, later to be influential in the post-war documenta, as well as Henri Nannen, founder of the post-war magazine *Stern*.

This proposal that Expressionism should and could represent the fascist nation was at best a form of political romanticism. It was confusing artistic avant-gardism with political reaction through a misreading of the emotive quality inherent in both, and it was based on a total misunderstanding of the historical situation. The idea that art should attempt to represent a national identity had lost its historical role of anticipation and turned into a travesty. The fascist state required art mainly to simulate a national consensus on symbolic causes, because fascism itself was the result of a lack of consensus on economic causes – a conflict that was decided by brutal power and hidden behind a façade of national euphoria. For this euphoria Expressionism could possibly have been a partial representation, but fascism did not address its propaganda to the young, the educated and the refined *connoisseurs d'art*, who wrote for *Kunst der Nation*; it addressed its propaganda to the masses and for this purpose a totally different brand of artistic style was required. To this end the idiom of neo-classicism was recruited into service, and this decision was no less tragic than the establishment of Kirchner or Nolde as official Nazi artists would have been; in fact it was a far greater tragedy.

Since the time when romanticism had prepared the artistic road towards a national identity, classicism had served as its very counterpart: the cosmopolitan, the enlightened, the rational, the scientific, the urban, the liberal. Neo-classicism was cosmopolitan not only because it united artists of many nations in Paris or Rome; it was cosmopolitan mainly because it adopted a heritage of Greek and Roman culture that was by no means nationalistic, but rather a common heritage of humanism and democracy. In contrast with German political romanticism, classicism was the internationalism of the nineteenth century.

The fascists adopted the academic remnants of this classicist tradition both as a proof of cultural legitimation and as a legible medium of

indoctrination. Its possible historical evocations were counterbalanced by a racist reading of the romantic tradition. So the worst of both traditions were brought together to create a perverted heritage. Anything left over after this process of reduction was banished and exorcised. The exhibition *Entartete Kunst* (Degenerate Art) gathered together the artists whose work could not conceivably be used as a representation of a coherent national identity. Of those artists gathered together by the fascists as representing everything that was not German, twenty-five are here and now representing German art in this century. Some of them have already represented German art in British forums during the period in which the exhibition *Entartete Kunst* travelled throughout Germany, not only as refugees (like Meidner, Schwitters or Kokoschka) but also as participants in the exhibition *20th century German Art* that took place in the New Burlington Galleries, London in 1938 and which was opened with a speech by Max Beckmann and responded to by Herbert Read. This exhibition was planned to contrast with the *Entartete Kunst* exhibition, not by showing different artists, but by promoting an entirely different estimation of the same work. In both exhibitions it became desperately clear that these artists did *not* represent the nation, fascist as it was at the time. It is hard to tell what precisely they did represent – perhaps once again, only a state of mind.

The divided heritage

Even today these artists do not represent Germany; they represent instead a western view of twentieth-century art. In an eastern European version of an exhibition on German art in the twentieth century, not only would *all* the living artists be an entirely different choice, but so would many of the deceased artists. Some of them who hold a central position in this exhibition – such as Paul Klee – would not appear in an eastern European version. Others who were not included here – such as John Heartfield – would play a central part. In either case the choice is not due to aesthetic value judgements but is the direct result of the differing legacies of a divided heritage.

The difference between the political realities in Western and Eastern Germany could in fact not be illustrated more strikingly than by comparing that which is celebrated as art within their boundaries. Art, which was a utopian representation of German identity in the eighteenth and nineteenth centuries, has entirely lost this function in the twentieth century. It does not represent the nation, but rather its division, and it has done so since 1945, if not since 1933. For this reason it cannot be understood simply as German, but rather as a dialectical construct.

This division of artistic traditions has been intended by both states of the German nation nearly from the beginning. After a very short phase of common exhibition (for instance, the *Allgemeine Deutsche Kunstaus-*

stellung, General Exhibition of German Art, Dresden, 1946) the 'cold war' erected its barricades in the battlefield of art long before other fields were fortified. Both German states joined up together for the Olympic Games until 1960, but were already at war in the fields of art and culture as early as 1946.

They had different arguments and strategies in this war in which culture was apportioned out according to need. For the GDR it was necessary to filter and adopt a socialist heritage out of the legacy of the so-called 'better traditions' of Germany, and for this campaign of historical appropriation *Erbe* (Heritage) was the official catch-word, to stress the legitimate character of this cultural possession. The political programme behind this cultural strategy was to give communism a differentiated German tradition and legitimation, so it would not appear to be only the result of the occupation by the Red Army. There was no disagreement between the heirs on the identity of the authors and painters who were claimed by the GDR in this constucted lineage. The Federal Republic was not interested in the strong socialist traditions of pre-war Germany. In contrary to the East, it attempted to establish a crisis of disjunction of German tradition under the catch-word of *Kahlschlag* (clear felling) that was supposed to signal a new beginning, but which also revealed a particularly short memory. Together with the unwelcome memories of fascism, everything that fascism had touched and used for its cultural legitimation was relegated to cultural oblivion. The Federal Republic instead demonstrated a revival of liberal bourgeois traditions by tolerating the concept of an avant-garde in its midst. This protection of the avant-garde also served to enhance the impression of a totally new and modern Germany that the Federal Republic was eager to give. The founding of the series of international art exhibitions entitled *Documenta* in Kassel in 1955 was one result of this strategy. However, this strategy did not have the same impact nor the same continuity as the strategy of appropriation of previous art in the GDR. After the first years of post-war poverty, the Federal Republic gradually lost interest in legitimating its political system by cultural tolerance, but followed the trend of the western industrial nations to justify itself through economic welfare.

The tolerance it had supposedly propagated in respect to modern art was not really a 'repressive tolerance' (in Herbert Marcuse's words), but, worse still, a tolerance of the deepest possible disinterest. In fact, it could be any form of avant-garde activity which could be tolerated, as long as it was not a *German* avant-garde. In contrast to fascist nationalism, the Federal Republic in its early years was eager to avoid national undertones in art, and so it opened itself defencelessly to any dominant cultural influence that came from the western allies. As a result of this undifferen-tiated support it had not even the intellectual means to understand and describe the fact that *Kahlschlag* (clear felling) had in fact given birth to a form of cultural colonisation. This development of alienation was

21

represented in art, where first French then North-American artistic values swiftly took the lead and were of decisive influence. The former nation's western half gave away nearly all traces of its national identity in reaction to the nationalistic trauma of fascism. This was celebrated officially as a *new internationalism*, but this internationalism was only open to the west, not – as in the earlier Weimar Republic – to the east, too.

No artist has reacted more lucidly to this situation than did Joseph Beuys. It was in the context of the curtailed internationalism of the cold war that he activated his *Eurasienstab* (Eur-Asia-Stick), which cumulated the joint historical and cultural energies that were bound to vanish under the impact of Germany's long-term division. Before fascism had its criminal triumph of nationalistic isolation, Germany (like Austria) had been the clearing area of a historical and cultural landscape since then destroyed and nearly forgotten: namely, Central Europe. Under the actual signatures of regionalism, the gradual disappearance of Central Europe as a recognised entity along the frontier of the two super-powers has again become a prominent topic of discussion in many European countries. As the region in which Asian and European culture interrelated, it has lost its central position and both German halves have been relegated to the periphery of a new set of political and cultural topographies.

For this vanishing of Central Europe along the border of two newly differential political systems, Germany's fate has become the central metaphor. And I regard as a metaphor Jörg Immendorff's pre-occupation, for instance, with the German–German frontier. Crossing this border has forced some of the artists who came over from the East (Baselitz, Graubner, Lüpertz, Palermo, Penck, Polke, Richter, Schöne-beck, Uecker) to look for metaphors capable of giving expression to their experience of being both internally and externally divided. In Baselitz's *Der neue Typ* (The New Model) we have an early proof of this search for a German–German identity. But it is Kiefer who finally completes the circle. In his early paintings, located in his attic studio, he evokes the nineteenth-century motifs which were intended to prepare and anticipate Germany's first process of unification and were compromised by the use that the fascists later made of them. He does not evoke them in sympathy for their fascistic misuse, but in order to find out if they are still at his disposal as functioning signs in a cultural discourse. Kiefer's early paintings were dedicated to the process of sifting the national heritage, a process which up to then had been monopolised exclusively by the GDR, while the Federal Republic was more or less engaged in the construction of a collective loss of memory. But Kiefer dealt with those parts of the common heritage of both German states which neither of them was interested in exploring. He represented the problem of a divided nation by using the motifs of its nineteenth-century anticipation as *metaphors* for a lost identity.

It is in this context that the present exhibition has to be discussed. It has

reacted to the dominant definition of German art under international accents by proposing Expressionism as a long-overlooked (but since re-discovered) subterranean continuity of German art. It is this *continuity of a style* with which this exhibition tries to compensate for the *discontinuity of the nation*. This thesis of a continuity of style is the exhibition's answer to the German dilemma, which consists in the fact that its heritage is not one of solutions, but ultimately one of open questions.

Absent guests – art, truth and paradox in the art of the German Democratic Republic

David Elliott

What is history?

'Wie es eigentlich gewesen.'[1] Such was the deceptively simple answer given in the 1830s by Leopold von Ranke (1795–1886) as part of his criticism of the use of historical example in constructing moral arguments. He set a style and viewpoint which has been followed by generations of European positivist historians who elevated historical, objective, 'scientific' fact to the level of a sacrament; this was to find its ultimate embodiment within a belief in the immutable and inevitable progress of humanity.

Historical positivism, in western Europe at least, has long since been displaced by a relativistic approach which reflects the ever-present realities of world war, genocide and nuclear oblivion. Yet should such a radical change in our perspective on the present now mean that any attempt at a detached view of the past is doomed to failure or even that 'objectivity is obsolete',[2] as one of the organisers at the Royal Academy exhibition has recently asserted? Faced by cosmic uncertainty, are we to founder in a slough of extreme self-regard? May we not view the attempt to resurrect an ideal of history as an essay in truth-telling as rather more than forlorn tilting at windmills?

In art, historical 'truth' is as an elusive an ideal as 'moral' beauty, yet both provide critical standards around which the converted can rally and against which the heathen may rebel. The organisers of the Academy exhibition chose studiously to ignore the confrontation of both, preferring instead the deadening uncontroversy of the view that art refers primarily to itself. As a result the Academy organised a feast at which many of the guests were absent.[3] In the course of this chapter I propose to examine briefly the corpus of one of these guests: visual art made in the German Democratic Republic – paintings, sculptures, murals and performances which represent the cultural life of over seventeen million people. It is a tendentious art rooted in the quest for the positivist ideals of historical 'truth' and 'humanism' which has sought a disturbing and sometimes incoherent resolution within the political system of state socialism. It is not today as it has often been represented – a crude and provincial variant of Stalinist Socialist Realism.

Why were the East Germans not invited to exhibit? On this question the organisers themselves appear to be in some confusion. In his catalogue introduction, Christos Joachimides suggests that artistic developments within the two Germanys 'have little in common as they obey different laws and are embedded in different systems of values.'[4] Yet this in itself would surely be a good reason for including work from the GDR as it would give a further dimension to the history of German art from *Die Brücke* to the present – the intention of the exhibition as stated in its title? The history of Germany before the Second World War is of one single country, and the decision not to include work from the GDR after the war simply because it is governed by 'different laws' must rest on crudely political rather than aesthetic judgement. Subsequently, at a forum held in association with the exhibition, Joachimides shifted his ground by explaining that it was not on political grounds at all but on distinctions of 'quality' that work from the GDR was excluded. This kind of art was simply not 'good' enough to be shown and represented the efforts of essentially 'provincial schools'.[5]

Critics and historians within the GDR err to the opposing extreme in their assessment of their art and at their crudest view it as the inevitable product of the onward march of history. Seminal texts which give the flavour of their argument are gathered together in two important exhibition catalogues in which the case is put that the heritage of art in the GDR extends its roots beyond the Weimar Republic to the fertile seedbed of Dürer, Grünewald, Rubens and Cranach.[6] The exhibition *Revolution und Realismus. Revolutionäre Kunst in Deutschland 1917 bis 1933* was held in 1978 to commemorate the fiftieth anniversary of the founding of *Asso*, the Assoziation Revolutionäre Bildender Künstler Deutschlands, by George Grosz, Otto Dix, Käthe Kollwitz, Karl Hubbuch and others. As the period covered suggests, links with the Soviet Union are stressed in that the exhibition opens not in 1918, the year of the Spartakist Uprising in Germany, but in 1917, the year of the Soviet October Revolution.[7] The exhibition ends in 1933 with Hitler's appointment as Chancellor and the Reichstag fire. The second catalogue *Weggefährten Zeitgenossen*, published in 1979, deals with the more recent past, showing the art made in the first three decades of the new German Democratic Republic.

A confusing but intriguing picture of art in the GDR emerges from these catalogues – an image which, as we will see, is blurred by an increasing divergence between theory and practice. Although art theory in the GDR still finds its forebears in the grisly rhetoric of the Stalinist 1930s and 1940s, artists have, from the mid-1950s, consciously taken a separate path and have vigorously asserted their place within a continuing tradition of European art. In doing this they were working in marked contrast to the recognised avant-garde in the Bundesrepublik who were dominated by the ideals of international Modernism.

Socialist Realism coagulated practice into dogma at the First All-Union Congress of Soviet Writers in 1934. At this gathering the cultural

ideologist Andrei Zhdanov spoke passionately of the ideal of 'revo-
lutionary romanticism' and, directly quoting the words of his father-in-
law Josef Stalin, affirmed that 'artists should be engineers of the human
soul'. To be 'Socialist' art had to satisfy a number of criteria: firstly, it
should express its relationship with the people (*narodnost*) – both to the
masses – the proletariat – and to national or folk traditions; secondly it
should manifest a strong class base (*klassovost*) and an awareness of the
dynamics and progress of the class struggle; thirdly it should be identified
with the aims of the Communist Party (*partiinost*) which would confirm
the artist's awareness of revolutionary politics; and finally it should
contain an expression of the most advanced communist ideas (*ideinost*) in
order to establish an organic link with the life of the proletariat. Within
the discipline of dialectical materialism the artist had an unavoidable duty
to incorporate these concepts within his or her work.[8]

These ideas, which embodied a progressive, optimistic and monolithic
view of society, modelled on the political writings of Marx, Lenin and
Stalin, represented the ultimate in contemporary revolutionary art theory.
In it the avant-garde had become obsolete as it was believed that it could
only have validity as a progressive element under capitalism. After the
Soviet Cultural Revolution of 1928 to 1932, history, and Stalin, had
shown that advancement was synonymous with the dictatorship of the
proletariat – and the proletariat wanted realism.

So much for the tenets of orthodox Stalinism in the Soviet Union, but
when they were exported they were grafted on to local traditions. During
the early 1950s the theories of Socialist Realism were integrated through-
out the eastern bloc and their legacies began to co-exist with the historical
remnants of 'old' avant-gardes, new tendencies and even with 'private' art
markets. This diversity provided a not immediately apparent flexibility
within the cultural system which functioned as an indispensable and easily
controlled safety valve. In the GDR this kind of pluralism is particularly
marked and art which, in theory, should have been heroic, optimistic and
clear-cut seemed from the late 1960s to revel in ambiguity and pessimism.
The inevitable implication of this is that there can be not one but many
concurrent 'truths' within a work of art of a given historical moment.

The origins of this latitude can be traced to the traditions of leftist-
oriented art in Germany, which reached its apotheosis during the pluralist
years of the Weimar Republic and provided models of iconography and
ideology which are still in use. This work focused on the political conflicts
and social inequalities which typified the era and which were shown in the
exhibition *Revolution und Realismus*. The extensive artists' biographies
in the catalogue studiously refer to class origins and Party membership
and, accordingly, a different tradition of art in Weimar is established
which diverges in many emphases from the standard narrative which has
been accepted in the west. The logical conclusion of this political
trajectory is, of course, the foundation of the GDR; history has been

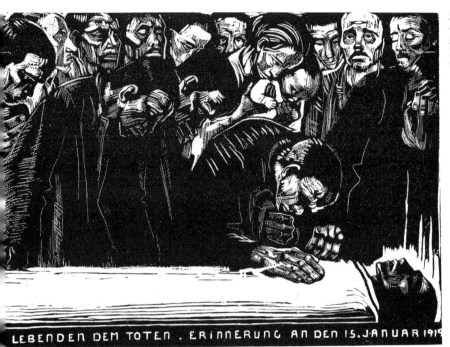

LEBENDEN DEM TOTEN . ERINNERUNG AN DEN 15. JANUAR 1919

3.1 Käthe Kollwitz, *Gedenkblatt für Karl Liebknecht* (In memory of Karl Liebknecht), 1919–20, woodcut

deliberately reconstructed, the perspective being the eventual triumph of socialism over fascism. In this narrative Expressionism, the dominant *leitmotif* of the Academy exhibition, assumes a minor role.

In accordance with this, Käthe Kollwitz emerges in this exhibition as a prominent figure in the reconstructed lineage. Her woodcut *Gedenkblatt für Karl Liebknecht* (In memory of Karl Liebknecht), 1919, based on a deathbed drawing of the Spartakist leader who, with Rosa Luxemburg, had been brutally murdered in the same year by the Government sponsored proto-fascist *Freikorps*, serves to provide both a historical background and a visual codification of these opposing political forces (see plate 3.1). The work of Heinrich Vogeler (1872–1942) is less widely appreciated; a leading member of the Worpswede group at the turn of the century, he followed the Arts and Crafts ideas of William Morris and founded in 1908 a *Werkstätte* with his brother. The First World War transformed his life, although at its inception – like so many of his generation – he had patriotically welcomed the conflict as an opportunity to cleanse a dying and corrupt society in order to build anew. The carnage of the eastern front led to a nervous breakdown; he wrote a letter to the Kaiser criticising the war and urged him to press ahead with peace negotiations with the new Soviet State. He was fortunate to be committed to a lunatic asylum rather than shot; once the war was over he was an active member of the short-lived Bremen Soviet and subsequently founded *Rote Hilfe* (Red Aid), an international organisation committed to helping

27

David Elliott

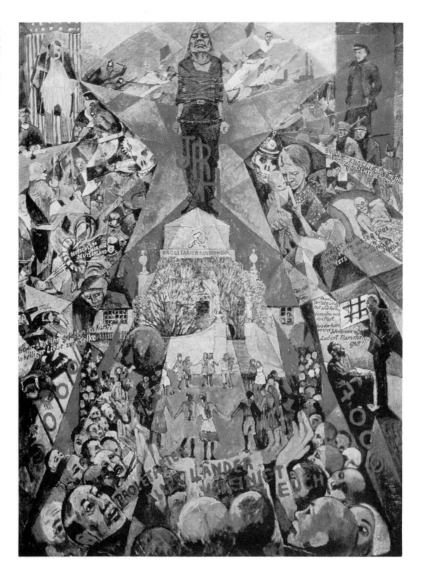

the children and orphans of political prisoners. His oil paintings of the
1920s (*Komplextafeln*) are a striking, if eccentric, essay in the dynamic
montage of social, political and economical visual data on a large scale
(see plate 3.2); the works of the 1930s, made in exile in the USSR, were
divested of all leftist or formalist tendencies in favour of a (by then) safer
and non-controversial realism.

During the 1920s a leftist political orientation was also manifested in
the political posters of Max Herman Pechstein (1881–1955), a leading
Expressionist painter before the war and member of *Die Brücke*. Yet
although many Expressionist artists joined the radical *Novembergruppe*

in 1919 their subjectivism was essentially in conflict with the analytical
tendency which characterised the art of the new Republic. A younger
generation of Dadaists in Berlin had thrown aside Expressionism to
become directly involved in political agitation in work which denounced
equally the old imperial and new capitalist orders. The photomontages
and cartoons of Richard Hülsenbeck, John Heartfield, Hannah Höch and
George Grosz identified a dispassionate 'machine art' upon which a new
society could be built. As the decade grew older such heady ambitions
soon evaporated and both Grosz and Heartfield became increasingly
engaged in social and political satire for the left-wing press.

Many painters of the Neue Sachlichkeit also espoused radical politics;
Heinrich Davringhausen's (1894–1979) *Der Schieber* (The profiteer),
1920, close in spirit to some of Grosz's paintings of the same year, shows
the new man of Weimar – the capitalist, the industrialist, the war
profiteer, comfortably seated within a depersonalised city of faceless
office blocks (see plate 3.3). Beside such men, Grosz and Otto Dix
(1891–1969) drew the old men of the Empire – the decimated but still
powerful militarists – the little Ludendorffs, von Seeckts and Hinden-
burgs who still pulled the strings of the 'democratic' marionette. The

3.4 Otto Dix, *Kartenspielende Kriegsküppel* (Crippled war veterans playing cards), 1920, oil and montage on canvas

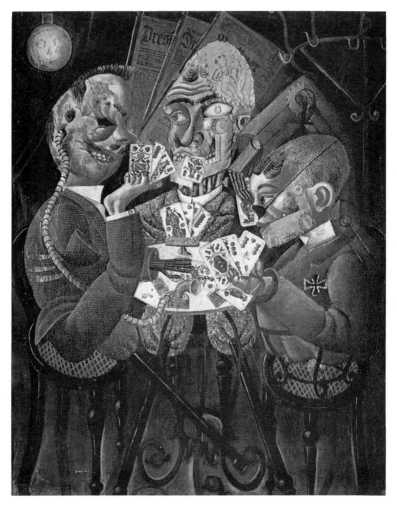

prostitute, the faceless puppet and the crippled war veteran became familiar characters in the iconography of this time and have passed on to the contemporary art of the GDR as representations of the victims and evils of capitalism and social alienation (see plate 3.4).

Within the Neue Sachlichkeit there subsequently developed a school of proletariat painters; nearly all were members of the Communist Party and many of them were based in Dresden – the capital of 'Red Saxony' – where from 1927 to 1933 Otto Dix served as professor at the Kunstakademie. Otto Griebel (1895–1972), a collaborator with Vogeler on 'Rote Hilfe', was one of these; his *Die Internationale*, 1928–30, is a celebration of international communism which, in its intent study of physiognomy, already manifests that clinical grotesquery which is now an outstanding feature of much realist painting in the GDR (see plate 3.5).

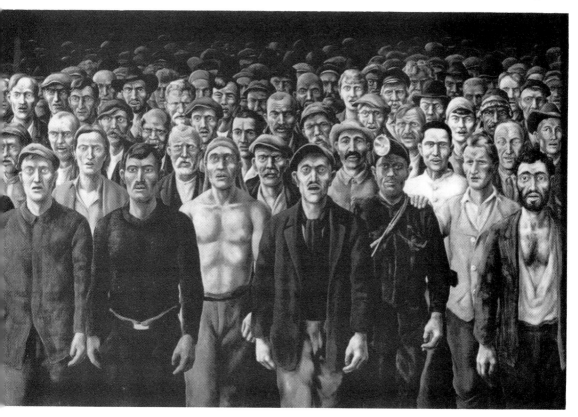

Curt Querner (1904–1976) and Karl Völker (1889–1962) both worked in a similar way and are now highly regarded by East German art historians, although their standing is much lower in the west.

During the 1920s and 1930s Germany boasted the most radical artistic avant-garde within Europe (outside the Soviet Union), yet this did virtually nothing to counteract the popular appeal of National Socialism. One of the greatest tragedies was that the fate of these artists was tied directly to that of the KPD; when in 1933 the Communists failed to gain majority support and the Nazis took power many artists were doomed to artistic silence, to the abrupt ceasing of all political activism, and in many cases either to imprisonment in concentration camps or to emigration from their native country. A few chose to stay and paint in secret: in the west the 'unpainted' pictures of Emil Nolde or Ernst Wilhelm Nay with their cryptic, personal motifs are regarded as examples of 'internal emigration' of the indomitability of the human spirit in the face of fascism. In the east the overtly anti-fascist paintings of Carl Hofer (1878–1955) or Hans Grundig (1901–1958) are viewed and categorised as an art of resistance.

By the end of the war, worm-eaten by the false racial and authoritarian

3.5 Otto Griebel, *Die Internationale*, 1928–30, oil on canvas

31

ideologies of Nazism, the German art world was literally without a centre. It was no longer possible to be proud of being German; both the vocabulary and aesthetic of a great artistic tradition had been completely devalued. Germany under the occupation forces began to try to rebuild its art. Who had not been tainted by the stigma of Nazism? Predictably the organisers of the present Academy exhibition affirmed their faith in an unbroken tradition of Modernism and chose to highlight such artists as Nay, Willi Baumeister and Oskar Schlemmer who, denounced as 'degenerates' and forbidden to paint by the Nazis, had undergone a period of 'inner emigration'; their work only glancingly referred to the terrifying times in which they had lived. But from the very beginning art theorists in the GDR traced a different path and began to identify an art which in its subject matter and political orientation had directly resisted fascism.[9]

It is incredible that work by this latter category of artists is completely excluded from the Academy exhibition on the pretext of 'provincialism'. It seems scarcely believable that the organisers of the first major retrospective of German art to be held in Britain since the war chose to disregard completely those painters and sculptors who, in the 1940s and 50s, had tried to come to terms with the horrors of fascism. Some of these became the first generation of artists to work in the GDR.

In the period of physical reconstruction immediately after the war it had seemed for a short time as though artists of all political persuasions could unite under the common banner of cultural regeneration; on 3 July 1945, under the presidency of the poet Johannes R. Becher, who had just returned from exile in Moscow, the first meeting of the Kulturbund zur demokratischen Erneuerung Deutschlands (Cultural Council for the Democratic renewal of Germany) took place in Berlin. The painters Carl Hofer, Otto Nagel and veteran Expressionist Karl Schmidt-Rottluff took part. In August 1946 the Erste Allgemeine Deutsche Kunstausstellung (First Universal German Art Exhibition) took place in Dresden and included 600 works by 250 artists.[10] It was organised by Hans Grundig, rector of the Dresden Academy, and the art critic Will Grohmann and it included a retrospective section of the artists previously characterised as 'degenerates'. Even when the Cold War broke out the artistic debate did not stop completely; as late as 1948 Carl Hofer was corresponding with Oskar Nerlinger in an open dialogue on art and politics in the magazine *Bildende Kunst*.[11]

Hofer also made an impact on the art of the Bundesrepublik during the 1940s and, with the art theorist Hans Sedlmayr, argued against the avant-garde Modernism so strongly advocated by Willi Baumeister in favour of a figurative humanist tradition. This critical confrontation came to a head in 1950 at the First Darmstadt Dialogue entitled 'The Human Image in our Time'. In West Germany it was abstraction as backed by Baumeister which eventually won the acquiescence if not the hearts of the

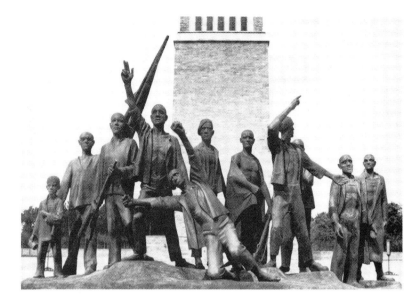

people; it was palpably not 'Germanic' and could be interpreted as expressive of free, democratic and individualistic societies – as such, regardless of its 'revolutionary' aesthetic content, it was profoundly attractive to the political masters. A seminal exhibition of American Abstract Expressionist painting, organised by the USIS and shown in Berlin (West) in 1958, reinforced this tendency and led to the further proliferation of abstract painting within the art schools of the Bundesrepublik. In response to this, realism of any kind came to be considered culturally backward as it was anti-Modernist and tended to become associated with the art of the GDR.[12]

Within the GDR attitudes became similarly polarised so that in 1949 the sculptor Fritz Cremer could write, 'There is no non-objective art. The arrogance of modernism begins here, where the greatness of so-called conventional figurative art refuses to go stale ... Following tradition has within it the consequent responsibility for the development of mankind. This is true in art no less than in other areas of life. Let there be no more non-objective art.'[13] Combining the attenuated line of Wilhelm Lehmbruck with the edgy realism of Gerhard Marcks, Cremer went on to make such large bronzes as *Freiheitskämpfer* (Freedom fighter), 1949, as well as the monumental group in front of the bell tower at the former Buchenwald Concentration Camp (plate 3.6).

Some artists, however, had first-hand knowledge of the camps when they were in operation and it is their experiences which characterise the art of the first five years of the newly formed GDR. There was a desperate need to come to terms with the past. Alexander Dymschitz spoke of this at the Saxonian Artists' Congress in 1946:

33

David Elliott

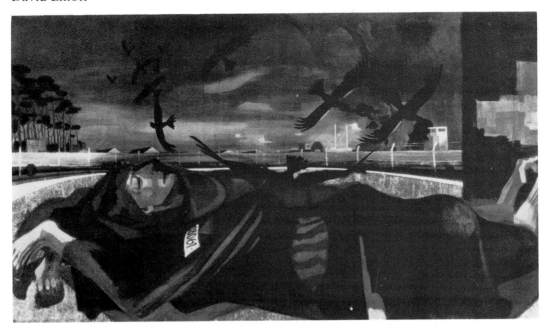

3.7 Hans Grundig, *Den Opfern des Faschismus* (The victims of fascism), 1946, oil on canvas

Es sah so aus, als ob unter den Ruinen der Städte auch die Kunst begraben sei. Es gab keine Theater, keinen Film, keine Ausstellungen, keine Kunstschulen und auch keine Möglichkeit eines intellektuellen Meinungsaustausches. Auch auf dem Kunstgebiet herrschte ein organisatorisches und ein geistiges Chaos.[14]

'It seems as though under the ruins of the city, art lay also buried. There were no theatre, no films, no exhibitions, no art schools, also no possibility of any intellectual discourse. In the domain of art a spiritual and organisational chaos ran rife.'

Hans Grundig's *Den Opfern des Faschismus* (The victims of fascism), 1946, reflects this chaos (plate 3.7). Grundig, himself an inmate of Sachsenhausen, shows a camp inmate in the foreground with Dresden, his native city, burning behind him. Paintings by other artists such as Hermann Bruse's (1904–1953) *Hungermarsch* (Hunger march), 1945, proclaim the same pathetic message.

At first in the immediate aftermath of the war both the Soviet occupying armies in the east and the western allies had the same initial impulse; their task was to expunge Nazism from the face of Germany; both administrations instituted intensive programmes of denazification. At the end of the war the chaos described by Dymschitz was such that a large portion of the population, homeless and hungry, was completely demoralised and demotivated. Bereft of a sense of unity and purpose, they seemed little more than hollow-eyed puppets; pragmatic decisions had to be made as to how to get the country back on its feet. In the east, to put it in the most simple of terms, the answer lay initially in strong, central – Party – control. In the west political differences of the past were set aside to

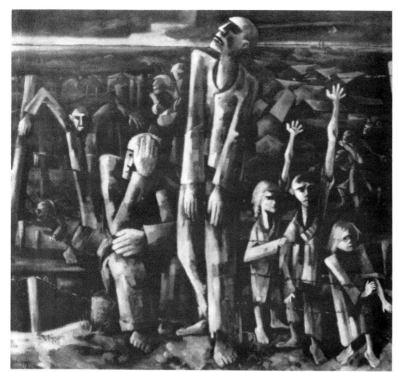

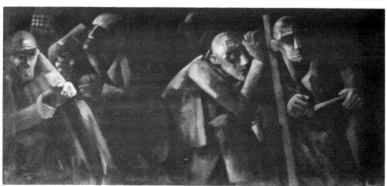

3.8 Horst Strempel, *Nacht über Deutschland* (Night over Germany), 1946, triptych, oil on canvas; centre panel and predella

encourage economic regeneration; the Cold War highlighted a new threat – Communism – against which it was necessary to strengthen the infrastructure of society to provide a buffer. As a result of heightened international tension the programme of denazification now appeared to be an indulgence; the real danger had now to be faced from the east.

In the GDR the programme of denazification was systematically and sometimes brutally pursued throughout the whole of society and artists in turn adopted a gloomy Expressionist realism to drive home their cause and the horrors of the past, as in Horst Strempel's (1904–1975) triptych

35

3.9 Curt Querner,
Selbstbildnis (Self-portrait),
1948, oil

with predella, *Nacht über Deutschland* (Night over Germany), 1946 (plate 3.8). Only those who had openly opposed fascism could provide models for others to follow, yet a sense of individual uncertainty infected all artists at this time as is evident in the expression and stance of the figures in two self-portraits by Hans Grundig and Curt Querner, both made in 1946 (plate 3.9).

Post-war economic reconstruction in the GDR is marked in art at the

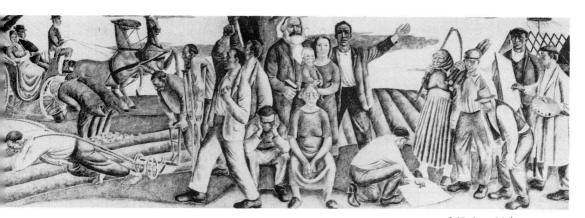

3.10 Arno Mohr,
Deutschlands Wendepunkt
(Germany's turning point),
1956, mural

3.11 Rudolph Bergander,
Hausfriedenskomitee
(House management
committee), 1952, oil

3.12 Otto Nagel, *Junger Maurer von der Stalinallee* (Young construction worker on the Stalinallee), 1953, oil

end of the 1940s and through the 1950s by a materialist didacticism and new heroism based on academic Soviet Socialist Realism. Solidarity with the Soviet Union had to be shown at every opportunity and the whole question of *Kulturpolitik* was carefully regulated by a Government Arts Commission. Mural projects began to be made such as Arno Mohr's (b. 1910) *Deutschlands Wendepunkt* (Germany's turning point), 1956, situated on the first floor of the Kunsthochschule at Berlin-Weissensee (plate 3.10); the subject depicts the historical union of peasant and worker under the benevolent eye of Marx. Rudolph Bergander's *Hausfriedensko-mitee* (House management committee), 1952, is reminiscent in subject

matter of much Soviet painting during the first five-year plan (1928–32) in that it depicts at work the new structures and institutions of proletarian society (plate 3.11). The figure of the industrial worker is eulogised in Conrad Felixmüller's *Der Maschinist* (The machinist), 1950, and, more heroically, in the rather fey stance of Otto Nagel's *Junger Maurer von der Stalinallee* (Young construction worker on the Stalinallee), 1953 – a precursor of the 'Brigade Pictures' of the 1960s and early 1970s[15] (plate 3.12).

The date of this last picture – 1953 – was a fateful year. There were widespread riots throughout Berlin and political demonstrators thronged down the Stalinallee to be forcibly suppressed by the occupying Soviet troops. The artistic old guard, John Heartfield, Bertold Brecht and Paul Dessau, who had returned to the east to live, lost much international credibility through their public support of the policies of Walther Ulbricht and the ruling SED at the time of the riots.[16] Younger artists, however, were determined to establish their aesthetic independence and were helped in this by a loosening of the cultural grip of Socialist Realism throughout the eastern bloc after the death of Stalin in 1953. New stylistic possibilities opened up although the theoretical rhetoric remained the same; in painting at least there was a turning away from the hegemony of Soviet cultural influence towards a consideration of an alternative tradition of radical art based on the work of both Picasso and Léger who, in the mid-1950s, were themselves both Communists. Two early paintings by Willi Sitte (b. 1921), a Communist Party member and since 1974 President of the Verband der Deutschen Künstler, *Hochwasser-katastrophe am Po* (Flood disaster on the Po), 1952/3 (plate 3.13), and *Arbeitspause* (Rest at work), 1959, make clear his debts to these French Masters. Other leading young artists such as Werner Tübke (b. 1929) and Bernhard Heisig (b. 1925) were looking to the grand traditions of German, French and Italian painting through which to develop their work.

An appreciation of the traditions of European Art are still kept alive today in the four main art schools where fine artists and designers are trained.[17] Once graduated, young artists become candidate members of the *Künstlerverband* (Artist's Union) if they wish to continue their career. Membership of the union (which also includes art critics, poster artists and designers) stands at around 5,000. Unlike in Poland where before the declaration of Martial Law there were many such artists' organisations, there is only one artists' union in the GDR and it plays a central role in the administration of the art world on an international, national and local level. In one respect it operates as little more than a craft guild which regulates and oversees professional standards and maintains the livelihood of its members by discouraging outsiders. More significantly, however, it is the body which mediates the necessary consensus between state, Party and artist.

This consensus was recently articulated by Willi Sitte in a speech given

David Elliott

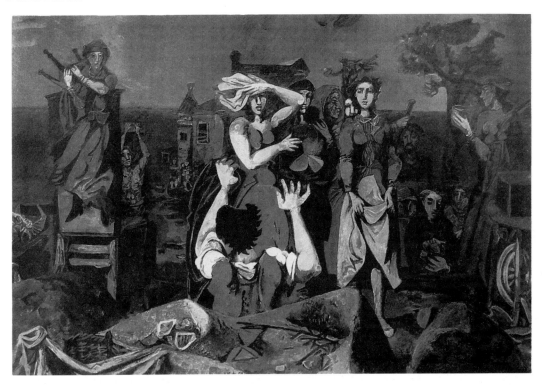

3.13 Willi Sitte,
*Hochwasserkatastrophe am
Po* (Flood disaster on the
Po), 1953

at the beginning of the Congress of the Artists' Union in 1983. Art should first and foremost 'be challenging, it should be capable of shaking up its audience and changing its perceptions [*ideenost*]; secondly it should make the public aware of continuing dangers and enemies [*klassovost*] – racism, fascism and imperialism; lastly it should satisfy the need for harmony and beauty'.[18]

In other words, art should be a function of social struggle and portray a 'realistic' attitude towards history and social development. But is this the whole story? What latitude for artistic creativity can be read between the lines of such official pronouncements? What is the ideological status of 'harmony and beauty'? There is now – unlike Brecht's experiences in the early 1950s – little overt state censorship within the fine arts and most subjects can be depicted except those overtly criticising the government or the Soviet Union. Constraints continue but they are more subtle; no doubt they can be located in the realities that art education and livelihood are all dependent upon one system. In the official search for progress, order and stability there is little encouragement for the anarchistic view – for that compulsion to interrogate the nature and meanings of all relationships which fuels the imagination in the west. This is only partly compensated for by a virtuosity in handling and technique which would be the envy of most western art schools. It is for this reason that ambiguity and paradox

have become distinguishing features of much of the work made in the eastern bloc, where these devices have become a vital source of creative energy. Classical, religious and personal allegories abound which cannot be read at face value and which defy easy categorisation. In some cases the artist is careful to limit the interpretation but for the most part he or she studiously remains silent.

Such tendencies can be clearly seen in Willi Sitte's mature work which can be separated into political, public and personal genres; in his more recent painting he has turned away from overtly social issues to show a preoccupation with sex and the transience of life. The large political triptychs of the early 1970s have a dramatic ambition which is reminiscent of the Mexican muralist Siqueiros and which provide a bombastic yet at times impressive pictorial critique of American Imperialism (see plate 3.14). These can be contrasted with the more recent, personal, smaller-scale paintings such as *Liebespaar zwischen Minotaurus und Tod* (Lovers between Minotaur and Death), 1981 (plate 3.15), and *Liebespiel* (Love play). This view of the evanescence of gratification and pleasure, as well as its considerable grotesquery, suggests the Rabelaisian uncertainties of the Middle Ages rather than the grim optimism of the monolithic state. The style of painting has moved away from Picasso and

3.14 Willi Sitte, *Jeder Mensch hat das Recht auf Leben und Freiheit* (Every person has the right to life and freedom), 1973–74, triptych, oil (detail)

41

David Elliott

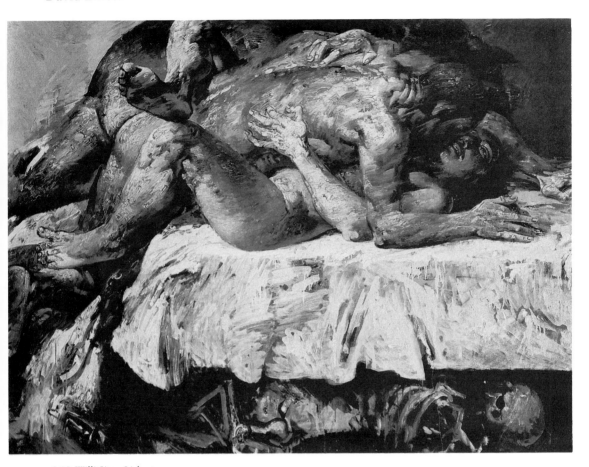

3.15 Willi Sitte, *Liebespaar zwischen Minotaurus und Tod* (Lovers between Minotaur and Death), 1981

Léger towards a homage to the colour range and baroque dynamism of Rubens and Corinth. Yet in spite of their intimate nature these paintings make a backhanded social point – the point of sexual abandon is an iconographical *tabula rasa*; it is a private space where neither conscience not politics can ever impinge.

Werner Tübke differs from Sitte in that he is essentially a history painter, eclectically combining different styles with impunity for both their inscribed references and sense of contemporary dislocation as well as for their strange enigmatic grace. Tübke's view of history is both dynamic and surreal and could never be described as crudely propagandistic; in his paintings struggles are either imminent, in progress or have just taken place. In subject he is preoccupied with the great turning-points of history; the Peasant Wars, the bourgeois revolution of Biedermeier Germany, the Paris Commune (see plate 3.16). These provide a matrix for personal and, one often feels, autobiographical allegories in which the canvas of history is isolated into a series of symbolical incidents (see plate

3.17). The history of the class struggle is invested with a new pictorial mythology. Tübke's masterwork is a 125-metre panorama on the history of the Peasant Wars which has just been completed in Bad Frankenhausen. When asked to give an interpretation of his themes, Tübke, like so many of his fellow artists, chooses to remain silent.

3.16 Werner Tübke, *Bildnis eines sizilianischen Grossgrundbesitzers mit Marionetten* (Portrait of a Sicilian estate owner with Marionettes), 1972, oil

With Tübke and Sitte, Bernhard Heisig is the third member of the triumvirate of artists which has prepared the ground for the present. His main subject is war and struggle, and there is also an overtly autobiographical note – the burning city of Breslau, where he was born, obsessively figures as a warning against the blandishments of fascism (see plate 3.18). In his violently brushed expressionistic paintings Heisig also deals with the present in apocalyptic views of modern – or is it purely capitalist? – society (see plate 3.19). Heisig regards the violence of his imagery and brushwork as a kind of alienation effect in the Brechtian sense. It is a device to distance the viewer from the subject of the painting so that he or she can interpret its meanings. Such an approach has much in common with dialectical method yet the suggestibility of the images is such that, as with Tübke's work, any 'conclusion' cannot be limited to one time or context.

The mood of these paintings is sombre and tortured; there is a feeling of being constantly on the brink. The cautionary tale of Icarus – of man who tried to master the forces of nature – is appropriate for the nuclear age and it is a subject which occurs in the work of Heisig as well as in that of other contemporary artists. Religious symbolism abounds yet the meanings of such works, which are not devotional, are purposely left open. Neither is fantasy proscribed – it appears in the didactic surrealism of such artists as Wolfgang Mattheuer (b. 1927) or Uwe Pfeifer (b. 1947). But to a western

43

3.17 Werner Tübke, *Tod in dem Bergen – mit Selbstbildnis* (Death in the mountains – with self-portrait), 1982

audience such qualities seem both more original and authentic in the intense hallucinatory imagery of the flag paintings and performances of Hartwig Ebersbach (b. 1940), which are based on dreams (plate 3.20), or in the enigmatic and lyrical Expressionism in the oil paintings and wood-cuts of Walter Libuda (b. 1950) (plates 3.21, 3.22, 3.23).

For the most part these artists *are* able to work untrammelled by political directives; they are acutely aware of German history and of the traditions of German painting, and when a reading of their work transcends personal reference it may be interpreted either as striving to show the conditions of life in the GDR or as looking outwards towards a more universal dimension. The robustness of much which is made perhaps reinforces in the western mind the words of the old slogan *Die Kunst als Waffe* (art as a weapon), and it is here that one final paradox may be located. If art is to be seen as a weapon, it is surely too imperfect to enforce the domination of one political system over another. Would it not now be better used to assert 'human' rather than 'political' values by beating down the insidious barriers of ignorance and mistrust which divide east and west?

3.18 Bernhard Heisig, *Festung Breslau* (Fortress Breslau), 1969, oil on canvas

3.19 Bernhard Heisig, *Die Berharrlichkeit des Vergessens* (The persistence of forgetfulness), 1977, oil

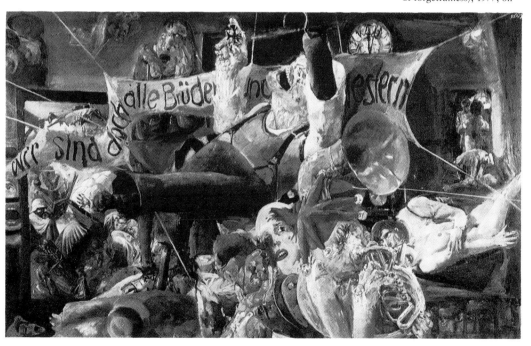

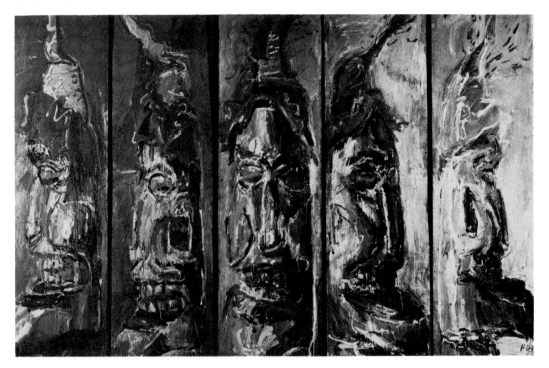

3.20 Hartwig Ebersbach, *Kaspar – die Entwicklung eines Porträt* (Kaspar – the development of a portrait), 1973, oil on board

No such considerations entered the minds of the organizers at the Academy. This exhibition was an opportunity to establish a cultural reunion which has been tragically missed. On an art historical level the inclusion of art from the GDR, where the tradition of teaching technical skills remains unbroken in art schools, could have made a valuable contribution to the debate on the status of tradition and figuration within postmodernist art in western Europe. The bases of postmodernism – syntheticism, revivalism and eclecticism – contemporary and fashionable issues in the west – have also, as we have seen, been the common currency of painting in the GDR since the 1960s; would not the exhibition have benefited from the juxtaposition of one tradition against another? Are there not also lessons to be learnt here about the advantages, and pitfalls, of consciously working towards a radical yet popular form of art? But any critical dialogue about such concerns as these was never on the agenda. The organisers of the Academy exhibition remained wilfully unaware of any perspective, critical or historical, other than that which would validate the work of the group of artists working in the west to whom they wished to give prominence. This was the unstated purpose of the exhibition and the organisers have done us all a disservice by presenting a puzzle of which we all knew the solution long in advance.[19]

History may be put to many uses, and it may also be written in a way which is neither tendentious nor exploitative. This is, perhaps, an

3.21, 3.22 The hallway in
Walter Libuda's tenement;
painted *c.* 1983

47

David Elliott

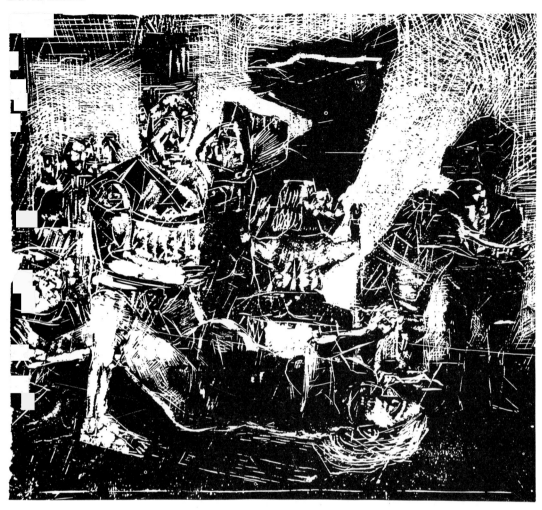

3.23 Walter Libuda, *Die Geburt* (Birth), 1980, woodcut

appropriate point to return to von Ranke's ideal of historical truth with which this chapter began. The exhibition we have seen at the Academy has been a false start in the process of telling the 'truth' about the history of German art. Its view, in its way, is as manipulative, as divisive and as second-hand as the diluted dogmas of Socialist Realism. We have already seen that in the GDR, and one knows that this is also the case in the west, many artists are working in a dimension which lays little value on simplistic historical analysis, even though their work may become absorbed in it. This should, however, not be taken to mean that such work is apolitical – indeed, its intentions and even the fact of its existence may have important political implications; the politics of art in this context is an uneasy bedfellow with propaganda. Both Sigmund Freud and Joseph Beuys wrote at length of the healing or mitigating

powers of art and we may be ill-advised to underestimate their potency. In this respect the international cultural forum, in which such exhibitions as that at the Royal Academy are placed, is of vital importance. An analogy could be drawn between this and the individual psyche in that it is also generally regarded as more 'healthy' to pursue organic and constructive unity rather than destructive division. At our own peril do we screen off the parts of our life – of our history – which we find unpalatable.

At the Academy 1985/86 exhibition of twentieth-century German art the table has been set, but the feast has not been served. If it ever does begin, it will be the duty of the exhibition organisers, whoever they may be, to make sure that not only is there enough good food to eat but also that there are no more absent guests.

Post-war debates: Wols and the German reception of Sartre

Franz-Joachim Verspohl

for Ebtehag Becheir

I

It is nothing new in art history for artists to have found their court-biographers and court-critics. What is new within the discourse on modern art, however, is that these writers can carry out their activities so exclusively that they totally frustrate viewpoints which deviate or even slightly differ from their own. For once such an alliance between the artist and his critic has been created, its effects are lasting because the arguments the critic formulates to support his case are reduced to a few simple formulas through their appearance in the media. The critic is thus never absent when the artist is on show; sometimes he even seems to be more important. Although modernity is subject to rapid changes, once the standards of interpretation have been set, they become generally accepted and are hard to throw overboard in the institutionalised practice of art history in galleries, exhibitions and the media.

There has been a particularly outstanding case of such an association in recent writing on the history of modern art – namely the alliance of Wols and Werner Haftmann, which admittedly was initiated and cultivated solely by the art historian. The latter has defined up to the present the general way of looking at the work of the former, especially as he has been able to insist on an important argument. For Werner Haftmann has always stressed that he recognises his own age and generation in Wols' oeuvre.[1] He makes himself and the artist principal witnesses of the years of fascism and the early post-war period, and it is all the more difficult to make a case against him because, as Uwe M. Schneede once wrote, he 'produced the only history of modern art written by one person which is still studied word for word and assimilated'. For Haftmann's *Malerei im 20. Jahrhundert* (Painting in the twentieth century), which first appeared in 1954, had to defend all the attacks on modern art, especially those of Hans Sedlmayr in *Verlust der Mitte*. If one was irritated by this book, to quote Schneede, 'one went to Haftmann to be reassured'.[2]

With his own self-declared qualification as principal witness and his

acknowledged function as apologist for the moderns, Haftmann's inter-
pretation of Wols had a dual effect. The verdict that Wols was the
'primitive' among the artists of the 'new sensibility'[3] found a welcome
echo among artists since it was an impetus to the feeling of release from
the past and an encouragement to start afresh.[4] At the same time artists
and art historians alike could re-establish with this formula a connection
with the avant-garde which had been disrupted by fascism.[5] This
association with classical modern art was less concerned with the stylistic
characteristics and more with the justification of artistic practices altoge-
ther. By Haftmann's combining a persuasive argument with the equally
striking explanation that 'Painting has now become direct action promp-
ted by existence: the traces or vestiges of its gestures, the choreography of
its rhythms, the heartbeat of the doer',[6] the art production based on this
maxim had *per se* a social consciousness[7] since its source and its place
could be located at the centre of life – the articulation of which had been
so difficult for the artist working before 1933[8] and perpetually pre-
occupied with the representation of modernity and its consequences.

It was possible for Wols to become the connecting link between 'old',
'new' and 'latest' Expressionism. That he could serve such a wide variety
of roles within one culture was in fact due less to the style of his art and
much more to the apparent directness of his painting technique. Thus
even in 1985 Wieland Schmied could still speak of the 'nervous style' of
Wols as 'an elementary form of Expression which does not point beyond
itself'.[9] Ernst Busche affirms: 'Wols . . . locked up the expressive tradition
first of all',[10] while Werner Schmalenbach considered it 'hardly inciden-
tal' that at the beginning of the 'Informel', 'two Germans were consider-
ably involved with their strong expressive impact'[11] – namely Hans
Hartung and Wols – both living in France.

Of course the London exhibition of German art in the twentieth
century contradicted these theories, even if the organisers were not
consciously aware of this fact. At least it was realised in the experience of
the event itself: the very short lateral axis of the exhibition with Joseph
Beuys in the central octagon and Wols on the boundary between
avant-garde before and after 1945 – the works of both artists encountered
simultaneously by the visitor[12] – in reality served to refute the organisers'
hypothesised theory. For, because Beuys had requested that the door to
one of the other rooms be closed and thus had obstructed immediate eye
contact with the work of Lehmbruck (although it became for him the
starting point of his work), and because Wols' paintings were so isolated
by the works which surrounded his, one was forced to relate Wols to
Beuys. His pictures communicated with Beuys' sculptures and let one
speculate on the location of the reference points in post-war art.

However, as early as 1978 Laszlo Glozer had taken issue with labelling
Wols as the embodiment of a new form of Expressionism in his book
Wols the Photographer. In the same year a small volume edited by Peter

51

Inch appeared under the title *Circus Wols. The Life and Work of Wolfgang Schulze*, containing contributions by Dore Ashton, Claire van Damme and Roger Cardinal, who present in outline a completely different picture of Wols – a picture which the painter Öyvind Fahlström began to sketch back in 1960. Werner Hofmann had already presented a different Wols in 1959.[13] In most of these writings another Wols critic – namely Jean-Paul Sartre – occupies a central position. In fact it was he who was prompted by Werner Haftmann in the early 1960s to express an opinion on Wols.

But in spite of these authors art history has continued to portray Wols as a predominantly 'Expressive' artist. The highly respected *Propyläen* series of art history books, in its volume on *Art of the Present Day*, makes no mention of Wols as a photographer. Instead it stresses his uninterrupted work on small scraps of paper and reproduces, of all things, the largest of his oil paintings, which, like many of Wols' pictures, has been assigned a misleading posthumous title: *Composition* (Oil on canvas, 160 x 130.5 cm, Staatsgalerie Stuttgart).[14] The comment on this picture reads:

It is the prototype of 'Informel' painting. The effect of automatic materialisation resulting from running, dripping and spread of the paint, forms the composition as well as the suggested diagonals in the middle which cross. On the beige-bluish underground nervous linear intervals, red patches and spurts of paint appear. These create a vibrant tension on the canvas which is unusually large for Wols.[15]

The 'criss-cross course' of thin colour in the underpainting which is particularly noticeable in this picture is not remarked upon at all, so that the 'contrast between the alchemist's patience which mixes the colour ground and the linear recklessness which is then spread over it'[16] cannot become a problem. Werner Haftmann's 'patterns' and his assumption that the 'moments of human existence' described in the course of 'free improvisation' were inspired solely by the 'signals evoked by the colours and lines'[17] cannot be blindly accepted. The entrenched quality of such positions is more surprising, as Werner Hofmann remarked in 1959:

No method is further removed from automation than this: the first phase of its execution demands a careful saturation, a lifting, turning, sinking of the canvas, so that the colour coagulates into a multi-surfaced texture so the latter presents itself as a conscious act of will.[18]

Glozer has justifiably described Werner Haftmann's interpretation as a 'scarcely tenable purification of Wols' art' which suppresses that which Wols had tackled, not only in photography but also in watercolours, drawings and most especially theory – studies of the 'phenomena of material nature'.[19] It is precisely the 'refusal to do art professionally and produce professional pictures which seems to have been such an essential, controlled impulse for the painter Wols that he thus gets closer to nature'. Roger Cardinal argues similarly:

The logic of Wols' new strategy, however, was not that his pictures should be stripped of all relevance to reality. On the contrary, it may be inferred from what we know of the artist's enthusiasm for the countryside at Cassis, and later at Dieulefit, that his involvement in nature was never so deep as now that his work seemed to be veering towards the 'otherness' of total abstraction. An indication of the way we may resolve this paradox is given in Wols' most successful poem, 'At Cassis', dated Dieulefit 1944 ... it reflects his adulation of the world of matter, as viewed in close-up:

 At Cassis, the pebbles, fish
 rocks under a magnifying glass
 the salt of the sea and the sky ...[20]

Wols' attitude to nature here is like the strategies of Gustave Courbet and Paul Cézanne, who began, in comparable situations, to seek a new pictorial language by studying natural phenomena. With their statements Glozer and Cardinal disqualify Werner Haftmann's theorem of the 'improvised record'[21] on two counts: first by drawing attention to a point of reference for Wols' art which lies outside his own psyche, and secondly by seeing, as Werner Hofmann does, that impulses which keep his action in check are operative in the painting. The Stuttgart painting offers particularly good evidence of this. With admirable precision Wols avoids everything that could create the illusion of a shape's existence or of a colour's ability to indicate a plane, or of a combination of the two constituting an impression of space. On the other hand the elements of the picture which pertain to drawing and painting resist the impression of purely informal signs. They outline forms only to revoke them at almost the same moment. Obviously the pictorial elements oscillate between the functions of the vehicle of meaning and that of pure material substrata. If one uses a linguistic metaphor, Wols seems to be playing a game with graphemes – the smallest semantically differentiating graphic symbols, and phonemes – the smallest semantically differentiating, but not in themselves meaningful, units. Roland Barthes in fact thinks that this structure does not apply to the pictorial arts. It is of course possible to dissect the discourse of the painting into formulas, but they mean nothing, he states, 'until they are seen in context'.[22] Nevertheless he described the colour and brushwork of Cy Twombly (an artistic relative of Wols) as only gestures which captivate through their 'inimitability'[23] and thus are animated and able to inspire. Recognition does not in fact discover realities depicted as such in so far as the corresponding observing perception is appealed to. The perception transforms the apparently meaningless 'object', with its unchangeable gestures, into a pictorial 'object', which is no longer seen as an external representation but as a field of imagination.

Obviously this belongs to the strategy of newer painting, of offering subject matter no longer as a representational picture, but rather as a perceptible fact, of holding the painting in material, hylic ambivalence and in allowing it to oscillate between meaningfulness and meaningless-

ness. It is this manner Sartre finds in Wols: 'Rien n'est sûr, sauf que la précision parfaite mène à plus rigoureuse imprécision.'[24]

It is not coincidental that no authentic title exists for any of Wols' pictures. The artist's intention was to avoid creating analogies at all cost. His pictures are not to be perceived as being divisible into form and content but rather as an undivided whole with multiple facets which offer themselves to the viewer only to be simultaneously destroyed. Wols holds colours and forms in the state between inertia, which allows the creation of meanings in the imagination, and impulsiveness, which once again confuses the traces of this meaning. He creates outlines with the aim of denouncing them, as if it were a question of crossing in one means of expression from volatile mental to fixed external pictures, from 'Image mentale' to 'Image-tableau', from perception to recognition and vice versa.

Doubtless Wols' painting picks out as a central theme its illustrative relationship to the world. As Walter Benjamin had already established, this function was no longer automatically available to the modern artist, due to what he termed the 'crisis in perception'.[25] This served to destroy, as a result of heightening social instability, any possibility of the painting naively being seen as a 'glimpse of life, serving to recreate our daily experience of nature or of man-made nature'.[26] Art had to work against a culture which tried to degrade it to decorative functions, to make the picture a 'thing among things'.[27] Continually in danger of being wrapped up in the strategy of the 'reifying look',[28] it recognised the missing links with any possibility for total autonomy, restricted as it is by its representation-relationship to the world. This is described by Merleau-Ponty:

A Cartesian does not see himself in the mirror; he sees a dummy, an 'outside', which, he has every reason to believe, other people see in the very same way but which, no more for himself than for others, is not a body in the flesh. His 'image' in the mirror is an effect of the mechanics of things. If he recognizes himself in it, if he thinks it 'looks like him', it is his thought that weaves this connection. The mirror image is nothing that belongs to him.[29]

Beyond it, the affirmed and affirming look had disposed of the 'dreaming forlornness in the distance'; the 'creative reference' to the world had become the pure execution of the world.[30] The aura, seen as the ability of pictures to hold and engage the viewer's gaze and thus the viewer's attention,[31] pales into insignificance while the concretisation of art threatened to replace it. Through a radical broadening of Cartesian thinking, art as philosophy succeeded in breaking away from the notion of representational perfectionism: the human organs were no longer understood as 'instruments' but rather as 'detatchable organs'. Space was no longer read as 'a network of relations between objects' but rather was 'reckoned starting from me as the zero point or degree zero of spatiality. I do not see it according to its exterior envelope; I live in it from the inside; I am immersed in it. After all, the world is all around me, not in

front of me.'[32] This realisation had greater consequences for the act of painting than it had for the process of observation: for both are no longer 'a certain mode of thought or presence to self' and both are means 'given me for being absent from myself, for being present at the fission of Being from the inside – the fission at whose termination, and not before, I come back to myself.'[33] But art had to define new basic painting techniques for synthesising this unity, which was a break with illusionism: painting began to replace the representation-relationship to the world by a creative relationship, in that it exploded the form as a spectacle, and space and content unfolded simultaneously. Painting became self-representational in order to establish a new form of aura[34] which could be described as 'movement without displacement'. Its central medium became the 'latent line', whose style no longer imitated but rather set itself into the work without representative demand and offered 'instantaneous glimpses along with, if a living thing is involved, attitudes unstably suspended between a before and an after'.[35] The canvas now became an 'unreal totality of things', which did not exist in the painting but 'manifested themselves through the canvas and seized it by the kind of possession'.[36] The picture is consciously constituted as a 'material analogy' of ideas, 'so that one can comprehend these ideas only when one looks at the analogy'. At the same time this means that the 'idea provided with an external analogy' remains a 'concept'.[37] In this manner the reproduced work overcomes the artistic process as well as its reception: formation and appropriation are consummated within the process of production. Equally so with imagination, whose release is the material analogy, and which itself is destroyed again and again by these processes, since it is not the picture but the concept which is its aim to recreate.[38]

Jean-Paul Sartre not only expanded the perception theory with this phenomenological coupling, which created theoretical possibilities for artistic intentionality but also influenced the creative act, which was now seen as a part of aesthetics. Like almost no other author in the middle part of the twentieth century, he inspired artists, who found his formulations leading towards a pictorial practice which was opposed to principles of imitation. If the picture is a material analogy of concepts, then it can also be understood as a vehicle of creative spontaniety which distances itself from any metaphor.

That Wols was familiar with these thoughts is verified by his illustrations of the work of Sartre, and verified also by the intensive contacts that he fostered within the same circles as the philosopher. After the Second World War he was one of the regulars at Tabou, a restaurant in which jazz was played, and in which he, like Sartre, found pleasure.[39] Here and at other meeting points he met not only fellow artists such as Camille Bryen, but also Sartre, Merleau-Ponty, Simone de Beauvoir, Albert Camus, art critics and gallery owners. In these circles the aesthetical category 'imagination' and the forms of practice derived from it were

discussed – discussions which Wols summed up for himself in concise aphorisms. The short texts contain a theory of art which is related to those of Sartre. That Wols too understood the work of art to be a form of analogy is verified by his sentence: 'A picture can have a relationship to nature, like a Bach fugue to Christ. That is not imitation but an analogous creation.'[40]

For this reason one cannot maintain, as Haftmann does, that the psychic automatism is the most important basis of this painting process, which, according to the art historian,

borders on pure psychography, which today is also acknowledged as artistically valid. The American, Pollock and the German, Wols enjoy great influence in the École de Paris. What we are dealing with here is an unchecked trance-like treatment of the picture surface – a process which takes place without reference to any rule and accepts any chance results – it includes dripping paint and scribbling on the canvas. Formlessness is regarded as the true indication of pure spontaneity ... These procedures are already on the periphery of art and merge into those activities, accessible to every non artist, which today are carried out in every group interested in psychoanalysis.[41]

With these few sentences Haftmann sketched in the first edition of *Malerei im 20. Jahrhundert* (1954) the painters Pollock and Wols, for whom he reserved several pages in later editions and placed in different categories. In fact several central concepts fall within this passage, such as 'spontaneity' and 'releasing activity', concepts which also play an important role in the theoretical formulations of Sartre and Merleau-Ponty, although here they are so misrepresented that almost nothing of their original complexity remains. In particular, the parallel between art and psychoanalysis would have been rejected by Sartre and Wols, because both of them were extremely critical of Surrealism; and Sartre's phrase of the artist's 'double vue' initiates alternative forms of pictorial practice than does the 'unconscious' for surrealistic painting.

Obviously Werner Haftmann was aware of this because he omitted this passage in later editions of his book. Here he charts the progress of the two painters, putting forward a vehement belief in the will for style. The key passage on Wols in the 1965 edition of *Malerei im 20. Jahrhundert* reads as follows:

Wols, a tragic vagrant, wanders along and works ... unceasingly on the breeding of a pictorial calligraphy, which allows him to record whatever inner stirrings were going on inside him. This unerring faith in the higher necessity of one's own creation ... is one of the best proofs of the vitality of the idea which is working itself out in modern art.[42]

The earlier vulgar psychological interpretation of Wols has here been transformed into a form of heroic pathos which itself becomes weakened by an aphorism of Wols: 'Painting or no painting. Wols couldn't care less. But it is strange that he hovers around the central point like a man of the masses in Edgar Allan Poe. Now and again he is allowed to scrounge a

glass, while the guilty ones comfortably enjoy literature instead.'[43] In fact this formula does not exclude the fact that Wols was very well aware of the status of his pictures, but it does make it clear that Wols had constructed another relationship to the post-war period and to the art world altogether. He not only maintained in a highly political mode the continuity of a tradition of activists and victims in the post-war period, but made it quite clear that he wouldn't fulfil the corresponding function of the artist. In this context it is possible to understand the attempt by Wols to prevent his first exhibition in Paris in 1945.[44]

The filiations attempted by Werner Haftmann therefore cannot work: Wols' painting neither goes in psychic automation nor does it obey a single-minded will to style. It belongs much more to the realm of an extraordinary, one-off experiment which has few counterparts and which, in the wake of 'Informel' painting, had neither followers nor valorisation by anyone.

II

It must be realised that Werner Haftmann still upheld his ambivalent Wols-interpretation after Jean-Paul Sartre had offered him, at his invitation, a correction which he included in his Wols-anthology of 1963.[45] Obviously Haftmann didn't understand Sartre's essay 'Fingers and Non-Fingers'[46] in this way because in 1973 he could write: 'Sartre described *at my request* the *impression* Wols made on him in an impassioned essay.'[47] And to make the understatement even clearer, Haftmann maintains in the previous sentence: Wols 'had a personal but infrequent and cautious relationship with Antonin Artaud and Jean-Paul Sartre.'[48] Quite apart from the fact that Wols and his wife lived in the same hotel as Sartre and Simone de Beauvoir from time to time, in the Hotel de la Louisiane, rue de Seiner,[49] and that Sartre often paid for the couple's room, Wols and Sartre also frequented the same cafes and were at home in the same artistic and literary circles in Saint-Germain-des-Prés. Therefore an account that states that the personal contact between Sartre and Wols was infrequent and cautious is astounding in that it shows just how much Haftmann purposely belittled Sartre's analytical interpretation of Wols. Sartre's essay is, without doubt, based on an in-depth knowledge of the works of Wols that his friend Alberto Giacometti and the critic Georges Limbour must have impressed upon him.[50] In addition to this Sartre had personally acquired works by Wols. Finally, he incorporated the essay commissioned by Haftmann in his own collection, *Situations IV*.[51] The essay embraces some of Sartre's most central preoccupations and he writes about the purpose of *Situations* in *L'imaginaire*:

We will call the different immediate types of the records established of reality as world 'situations'. So we will be able to say that the most important requirement, for the representation of consciousness, is that it be 'in the situation in the world',

or briefly, that it is 'in the world'. The 'situation-in-the-world' understood as a concrete and individual reality of awareness is motivation for the constitution of any unreal object, and the nature of this unreal object is adapted through this motivation. So this 'situation' of awareness should not appear as some pure and abstract possible requirement for the imaginary but it is the concrete and exact motivation of the apparition of a particular imaginary.[52]

Sartre laid down this severe guiding principle in this passage from 1940, after he chose the 'cases' he wanted to describe. The essay about Wols thus has a paradigmatic character, underlined by Sartre's inclusion of it with earlier texts about other artists and by his giving it precedence over the central essay in this collection, entitled 'The Artist and his Conscience'. This states succinctly: 'The contradictions and conflicts of the period so overexcite [the senses], that they eventually obtain a second face [*double vue*]. Accordingly it is right that a work of art is at once an individual creation and a social deed'.[53] With *The Imaginary*, Wols becomes for Sartre synonymous with the established standards of the inherent worthiness of the attempt to portray reality, and in 'The Artist and his Conscience', he is representative of selected norms for the embodiment of a contemporary artist's existence.

However, the importance attached to the artist does not confine itself only to the one-sided, masterminding activity of Sartre. Wols was not the passive element in this relationship; he was anything but 'cautious' – as Haftmann intimates – in his contact with Sartre. As early as 1938 he is supposed to have become acquainted with Sartre's well-known novel *La Nausée*, which spurred him on to read other works by Sartre. As early as 1942 Wols recommended that Henri-Pierre Roché, his neighbour and supporter during the difficult years in Dieulefit, should read Sartre.[54] In 1947, during a conversation with Ione Robinson, Wols called Sartre a 'great writer'.[55] What is more telling is that during the post-war period in Paris Wols was not afraid of actively engaging in debate with Sartre. He not only quoted Sartre[56] but criticised the 'frantic industriousness' of the philosopher and author[57] whose commitment to a new left party, 'Rassemblement Démocratique Révolutionnaire', he described as 'excited hustle and bustle'.[58]

Against this background even the illustrations which Wols produced for Sartre's texts can be understood not as random commissions or even the award of a modest contract on the part of the writer to the starving artist, who valued his artistic activity as selectively and discerningly as his capacity for theoretical expression. It can be no coincidence that Wols produced illustrations for all of Sartre's 'Nourritures, suivi d'extraits de La Nausée'[59] and 'Visages, précédé de Portraits officiels'.[60] *La Nausée* was for the artist, as it was for many others as well, a type of Programmschrift which is summed up in the motto chosen by Sartre from Louis-Ferdinand Céline's *L'Eglise*: 'C'est un garçon sans importance collective, c'est tout juste un individu.'[61] In the name of this moral Wols took Jean-Paul Sartre

at his word in 1945 when he criticised his dynamism and wanted to commit him to the 'other side of existence', to that striving for that 'other world which one can see from a distance but without ever getting closer to it'.[62] Sartre was for Wols above all the author of *L'Imagination* (1936) and *L'Imaginaire* (1940), in which the aesthetic theory of the eidetics of the picture was developed and which allowed one to think beyond pictorial theory and metaphor. For Sartre's phenomenological consistency of treatment of different modes of awareness in existence – intelligence, imagination, sensibility and emotion – as the 'experienced' [*le vécu*][63] made it possible to say simply what one saw. That 'direct seeing, not only the sensual experiencing seeing but the concept of seeing can be formulated as original mode of giving consciousness of what ever nature'[64] transformed the picture into a 'certain type of awareness', into an 'Act'.[65]

However, it is exactly these elements of an eidetic ability of the picture which Sartre deals with in both texts illustrated by Wols – *Portraits officiels* and *Visages* (edited in 1948 by Pierre Seghers). Sartre had written *Portraits officiels* as an introduction to a group of texts with the theme 'the human figure' for the magazine *Verve*, to which the essay 'Faces' also belongs.[66] In view of Sartre's degree of fame through *La Nausée*, these essays ought to have caught the interest of a wide public, at least in so far as Sartre for the first time presents himself here as a phenomenologist to a wide reading public. Even Wols appears to have taken note of both these texts at this time, in that the later illustrations which followed in 1947 marked a time span of almost seven years, during which the artist had been involved with Sartre. The sentence uttered in *Visages* – 'I simply express what I see',[67] with which Sartre, as he expressly emphasises, dispenses with 'Metaphors'[68] and aligns himself with Husserl's phenomenology –[69] must have struck a chord with Wols since, in his work as a photographer, he already no longer gave any credence to the perspective of traditional visual theories.

The philosopher, like the artist, had never been able to identify with Surrealism.[70] Their original point of departure was Cubism, which both had learned from immediate sources to be the birth of modern art.[71] In 1932 the young Wols sought specifically those circles in Paris in which representational problems were discussed. In the company of Léger and Ozenfant he heard some of the polemics of artistic autonomy, which stated that in art 'things must come into their own'.[72] Already there is a hint of an answer to the abandonment of the metaphorical. Wols consequently took up this direction in his photography, a development which Glozer explains brilliantly in his book,[73] in that he compares Wols' photographs with those of Kertesz, for example, and emphasises their aesthetic modesty. Wols works against every form of stylisation and does not hide the conditions under which his photos – often in series – were produced. This technique did not mean that the photographer himself as an artistic entity disappeared behind his motivation or his modus

operandi. Much more, he emphasised his position as oppositional factor, as the 'Other'; that is, he did not articulate his motives, but rather made his intentions towards the object visible. In this context the Dutch newspaper *Filmliga* wrote about Wols as early as 1932:

Fernand Léger described the eye as the most important organ; that of one hundred responsibilities. In spite of his youth the wide ranging work of Wolfgang Schulz[e] bears witness to this notion of visual responsibility. This sensibility is founded on a stronger link between the perceiver and the perceived and this feeling for the essence of phenomena in their unity captured through the searching and reflecting eye, pronounces itself in him. The everpresent self finds therein its way back to the diversity of its harmony. The fragmentation, the division and the constraints of the early periods are revoked and destroyed. There remained the beauty of the low, trivial things – a new art of relations, for which there are no set standards.[74]

Similar to Sartre, the young Wols concerned himself with an 'intentional', not a representative, style. The motive was not shaped; much more the development of the motive that surrounded the artist was described, initially neutrally, but to which he now got effectively closer. In the following period, however, under the impact of fascism, internment and life in occupied France being a constant threat to his life, Wols radicalised this treatment. Sartre writes in his retrospective essay that Wols had 'understood' as early as 1932 'that the experimenter is, by necessity, a part of the experiment, the painter a part of the picture'.[75] That comes very close to the image of Wols portrayed in the quotation from *Filmliga*. Now, however, Wols was no longer interested exclusively in finding the way to the object but rather in finding the way away from it as well: he thus entitled his 1939 project *Circus* with the added subtitle *Reception and projection in simultaneity*.[76] That which has been 'absorbed' and 'captured' should be 'rejected' at the same time. His borrowing of this term from Klee is only a superficial connection and serves only to indicate how very much Wols had in fact shed the influence of Klee. His understanding of the duality of 'reception and projection' was a continuance of complete and active realism, which he conveyed between subject and object through the creation of new objects. Instead of the totality of experience and rendition put forward by the 'freedom of awareness' with the imagination: in a watercolour[77] created in about 1939 he still pursues this insight as a form of confusing disorientation. In the harbour scene the house, ship, people, a billboard wall and objects suddenly become the windows of a reflection of the water and a ship or a town with high-rise houses. The house wall stands like a canvas jacked up on a stand; people and monsters are climbing down the billboard wall. Everything appears simultaneously on the stage. The real and the unreal are interchangeable and become reversed. The watercolour does not represent things literally, but plays with them and lets them become a part of an act, a 'consciousness of something'[78] which is always in evidence in the foreground of the representation.[79] Wols no longer looks for a

pictorial form of expression for real entities but rather for the
relationships between them and the gradual differentiation between their
factual, their reproduced as well as their imagined existence. He recog-
nises of course that he cannot depict the abstract in this manner and takes
note, at a slightly later date, of the famous Cassis poem: 'The Abstract
which pervades everything is not tangible'.[80] But he clearly perceives that
this abstraction is conceivable through analogous creations. To this end it
obviously does not need a representable object, but he also cannot
succeed 'without relating back to previous figurative or other formal
representations'.[81] Adapting to the style of King Solomon, Wols says:
'The concrete things take a secondary place',[82] indicating that it is not a
question of figurative or abstract art but of the relationship between
subject and object, of the instability of this relationship and of a technique
or structure of pictorial presentation which does justice to this instability
and which makes the rapid chance of fleeting mental impressions
transformable into material pictures and holds open the latter for ever
new imaginative pictures.

With the aim of bringing 'the infinity of contradictory things'[83]
together under one artistic hat, Wols had every chance of becoming an
early prototype of the Action artist. For when Sartre describes, as Wols
himself did, these main issues of concern of around 1940 as those which
focus on 'Reception and projection in simultaneity', they both mean
that this process should take place spontaneously. In reality the project
entitled *Circus Wols* (1940) points to the fact that Wols was thinking of a
form of Action art. A watercolour which resulted in connection with these
considerations at the time elucidates this.[84] It presents a circus-like arena
with actors, props and an audience; the actors all simultaneously receive,
agitate and project.

On the table of the 'sorcerer' a flea is lit by a spot of light. The interposing
apparatus takes him up and transfers him, grossly enlarged, onto a canvas, which
is drawn around the audience in the auditorium. He [Wols] makes use of the
principle of video film, when he doubles the size of the clown which, thus
enlarged, is placed next to the little agitator, creating a dual form of consumable
optical sensations. The ideas can function together in the series of grotesque
drawings, in which the figure and the apparatus have become one.[85]

As seductive as Glozer's analysis of this scenario is, he obviously does
Wols' original idea very little justice, since he is reflecting the concerns
formulated in a new production of Alexander Calder's *Circus* of which he
had been aware for some time[86] and for which he had great sympathy.
Wols' mechanical deftness would have greatly helped him with the
formulation of a similar undertaking. Already in 1933 he conceived the
idea of opening a travelling cinema with Gréty in the South of France,
another matter for analytical speculation which is thematised in a
biography written in English in 1940 and behind which lie some
speculative thoughts on emigrating to America: 'My chief manuscript on

which I worked since 2 years is intitled [sic]: "Circus Wols". This work is a manual which conceives a new use of technology but also the means of establishing a relationship between art in general and science, philosophy and "human life". This "Circus Wols" is a suggested mode for facilitating in a democratic manner the education of taste and public opinion, popularising spheres that hitherto were reserved for certain classes only.'[87] Instead of thinking of Calder's mechanics in relation to this project, one had sooner think of later programmes such as Joseph Beuys' the 'expanded concept of art' which is similarly concerned with a conjunction of art, science, philosophy and material realities. That Wols still upheld the idea and the feasibility of the Circus Wols after 1945 and continued to sharpen its political orientation signifies his increasing inversion of the concept of 'circus', as can be seen in one of his conversations with Ione Robinson.[88] It made it quite clear, however, that it was superfluous for Wols to stage manage a circus in the contemporary historical situation in which the whole world had become a madhouse. This must have been a growing perception for Wols during the first years of the war because he gave up the illustration of the circus project, changed his style radically, and abdicated the possibility of letting his original ideas take form in 'grotesque drawings'.

Wols, restricted, threatened, an alcoholic, developed a solution which in its forms seems to deviate completely from his original ideas, but in fact embodies in principle the same purpose. He sets himself the paradoxical project of creating pictures which transcend their object status, which push back as far as possible their representational character and instead become new realms of experience, changeable analogues of concepts. In the Sartre texts illustrated by Wols, *Visages* and *Portraits officiels*, the only 'objects' which have the ability to transform or transcend themselves are called 'Faces': the human face. Sartre says of it:

one discovers within objects certain beings that can be called faces. They do not have however the existence of objects. The objects have no future, and the future surrounds the face like a muff. The objects are thrown into the midst of the world, the world surrounds and crushes them, but for the objects the world is by no means the world: it is only the absurd pushing of the adjoining mass. The eye on the other hand, because it perceives distance, causes the universe to appear and for that very reason it escapes the universe. The objects are pressed together in the present, they tremble in their positions without moving: the face projects itself in front of itself into space and time. If one calls this attribute transcendence, which the mind possesses, to transcend itself and to transcend everything; to escape from itself, to lose itself there, outside itself somewhere, but elsewhere then it is the meaning of a face to be visible transcendence.[89]

If a picture therefore wants to win back that strength of aura and that attraction then it must, according to Sartre, take on the attributes of a face. This he claimed unmistakably in his essay on André Masson: 'In order to fill his painting with life the painter has to project the transcendence of human beings into objects, unite them more strongly than just

colour harmonies and form references can do, in that he allows them all to take part in a single human movement; he must allow them to imply the gestures of taking, indicating, fleeing, in short making the human being – either overtly or discreetly – into the magic pole, that which draws the whole painting together.'[90] Evidently Sartre draws a parallel between the structure of a picture and the mimicking of a facial landscape, which for him becomes the epitome of man's capacity for continual transformation. The face is for Sartre simultaneously the instrument for projection and reception. It posits the human imagination as the 'final justification of all reasonable contentions'.[91] It is the absolute means of communication and becomes a guarantee of the human 'being-in-the-world'.

This theory of the face gains clarity and purpose within its specific historical context. Under the threat posed by fascism there were few other methods in the search for truth than the perception of the human face, whose visible expressions constantly refuted its stated verbal expressions. It was under the external pressure of the occupation that it became the epitome of freedom: 'We had lost all our rights and above all the right to speak: they mocked us everyday to our FACES, and we had to remain silent; we were deported in masses as workers, as Jews, as political prisoners; over all the walls, in the newspapers, on the screens we met the abominable, loathsome and insipid FACE, which our oppressors wanted to give us from ourselves: on the grounds of all this we were free . . . since we were persecuted, every one of our gestures had the weight of commitment.'[92]

Simultaneously the face can and does guard against forgetting. Simone de Beauvoir and Claude Lanzmann, both marked by the same experiences as Sartre and his colleagues on *Les Temps Modernes* confirmed this: Lanzmann with the film *Shoa*, in which he, like Simone de Beauvoir, explains, 'the unspeakable is given expression through the face',[93] for 'Faces often say more than words . . . The faces of the Jews fit their statements. The most peculiar of all are the faces of the Germans. Franz Suchomel remains untouched until the moment when he begins to sing a song in honour of Treblinka and his eyes light up. However the claims of the others that they were ignorant of it all, their protestations of innocence are refuted by embarrassed, speechless facial expressions.'[94] Where today only the grass scars mark out the locations of the Holocaust, nothing keeps the memory of the horror alive but the vivid face of a survivor immortalised on film. In contrast Sartre allowed utopia also to shine through the face: in *La Nausée* he lets Roquentin take his leave of the official historical portraits in the museum of Bouville with the words 'farewell you swines'[95] after having thought earlier: 'What these gloomy pictures offered my gaze was the new man conceived by man, with the only decoration being the most wonderful conquest of man: to the bouquet of the rights of man and citizens. I admired unreservedly the human realm.'[96]

The span of plural and contradictory meanings encompassed in the *face* is for Sartre the theme of the *Visages* and *Portraits officiels* texts, first published in 1939 and which Wols was asked to illustrate in 1947. Written in an atmosphere of crisis after the collapse of the Front Populaire and before the unavoidable threat of facism, they aim quite openly at political occurrences. Sartre, in both texts, confronts the official portrait and its political use as a power medium with the face in its genuine human and humane meaning. In fact even the 'normal face' under pressure of psychology and psychiatry can become an 'adjustable butt',[97] but the look of 'the noblest of faces' keeps the world at bay and perceives things 'where they are'.[98] Sight here becomes, as Merleau-Ponty asserted later, a means to witness 'being present at the fission of Being from inside', and thus to a means of recognition.

To what extent these theories provided a challenge for Wols is verified by the change of style, already indicated, which took place in 1940. In his own essay on Wols, Sartre posits the radicalisation of Wols' means of expression at this time: 'Before everyday things served his purposes to lay his traps, to indicate the unobtainable as if they stood on the other side of their contradictions; after 1940, called up in other ways, the being appears first and hints at that only from a distance. Everything is reversed: previously, being could only be divined as the antithesis of man: now man is the antithesis of being'.[99] Obviously, for Sartre, Wols' pictures had succeeded in meeting the demands he levelled at Masson: they have completely cast off their representative character, the transcendence of man is projected into them; they have become like faces because they have conquered pictorial objectivity and have become conscious analogues of a concept of the oneness of the self with the world. This unity is demonstrated by the 'alterity of the being',[100] not through a process of alienation – as he did before 1940 when, for example, he painted a finger as a non-finger, but in reverse, when the presence of the finger clearly allows it to appear as a non-finger. Here Sartre uses a formula by Chuang Tzu, whom Wols considered to be his teacher. A follower of Lao Tzu, Chuang Tzu had formulated his ideas from the principle of the equality of all things[101] – a process somewhat related to that of Sartre, who stressed things' inherent neutrality. 'It is not so good when one proves using the example of fingers that fingers are non-fingers, than when one takes something else to prove that fingers are non-fingers.'[102] Sartre makes the following out of using the same preconditions as Chuang Tzu: 'To take fingers to prove that fingers are non-fingers is less effective than taking non-fingers to prove that fingers are non-fingers.'[103] He emphasises with this that the tautological nucleus of a representational method of proof does not however make Wols an abstract painter; for 'the experience permits him, in that it disclosed to him the being of things, to embody the world in things that do not happen in it'.[104] The picture delivers a 'dubious model'[105] in which a decipherable experience emerges as on a face without having actually been portrayed there.

Sartre then deals with all pictures by Wols after 1940 as faces: they gaze at him,[106] constantly changing. Sartre is drawn to them again and again, building and discarding associations. The same 'voracity', the 'greedy holes', which he describes in *Visages*,[107] confront him now in Wols' later pictures and watercolours again: 'this crack in the stone are eyes, a wooden mouth opens'.[108] It seems to him as if the forms wish to say something that nevertheless remains unarticulated. Therefore it can be assumed that no concrete object has continued existence; the concrete dissolves itself into a general condition; the picture is simply there, an idea of its being and its opposite, nothingness. Quoting Lao Tzu, an author admired by Wols, it is possible to say about Wols' pictures: Their 'greatest fullness seems empty',[109] because 'existence comes from non-existence'.[110]

For this reason Sartre can use Wols' works to demonstrate the principle of 'continuous transformation', which 'is the law of this improvisation',[111] and which has nothing to do with the earlier formula used by Haftmann: 'improvised composition'. This is particularly so since the latter emphasises that Wols transforms the 'flat surface which up to now has been regarded as a field of illusion into a kind of resonance membrane'.[112] Although this formula may have a synaesthetical ring, against which both Sartre and Wols defended themselves, it does however make clear to some extent what Wols had in mind: he marks fixed points on the plane, which, like the organs of the face have immovable positions, and creates between them latent structures with the ability to move without changing position, comparable with facial expressions. That Wols had refined this process extremely rigorously is verified by the fact that there are almost no repeated pictures in his *oeuvre*. Not one oil painting is even remotely similar to another, but this does not make them into a continuous 'Diary of this painter'.[113] For Wols does not speak of 'the other side' of forms or objects but rather 'this side of them' and leaves them in 'the condition of the savagery'. It is not the emotions of the painter which go into his drawing and colour as a priority: emotion becomes synonymous with them, set as strength[114] so that the result is a 'controlled chaos' with few set points and a multitude of variables,[115] thereby fixing intentionality with the discretion of the viewer. The picture forces the observer to function as the gaze of another entity. It is no longer a mirror, a world reduced in scale, but rather the opposite world of the imagined awareness.

Given the undermining and deterioration of language under the impact of fascism, under whose leadership gestures intimated the 'weight of commitment', the notion of a meaningful look was a quasi-concrete utopia, which was a response to the 'dialectic of empty words and silent tongues'.[116] A painting which resembled a face could radiate into 'inarticulate layers' and challenge there the beholder's powers of distinction as well as stimulate reflection and 'penetrate as far as the limits of articulation': 'The picture is capable of wresting an exact sense of a meaning which cannot be articulated, like a visible, optical, sounding

65

equivalent of the word it can relieve the soul. It probably concerns here in reality a broadening of consciousness ... That was never necessary for man except at a time when the unspeakable happens and makes us speechless.'[117] Werner Hofmann, who formulated this idea in a similar manner in 1959, was one of the first to recognise the 'freeing impetus' in Wols, 'which ventured in zones of the ego and world experience, for which up until now there had been no language of communication'.[118] The statement which he makes at the end of his essay obviously contradicts the theory in which he speaks of Wols' paintings as an 'act of defence'.[119] More accurate appears to be the analysis by Wols' friend Camille Bryen, who engaged in vigorous debates with André Breton and who stated that 'form and words are exhausted. Whoever can depict the living catharsis of the void is telling us that life discovers everything anew'.[120] It was soon after this that Wols too must have experienced a feeling of renewed freedom in his work because his painting actively mobilised the eye and gave it back a certain functional simplicity which 'restored it to the creative movement of evolution'.[121] To this end it was not enough to convey the world 'in echoes, connotations, intimations';[122] rather it needed stronger modes of articulation. As Wols described and used words as chameleons – they 'shimmer like chameleons'[123] – so he also handled the linear and painterly repertoire. He employed it in a synthesising manner throughout and abstracted it from his person, his entity as an artist; for, as Sartre had said of Kafka, Wols likewise went beyond the personal 'human situation'[124] of the pursued, interned, addicted man. He was even less involved with the assumption of a psychologising mode which foregrounded the self and viewed the world as its representation, a representation fragmented into a myriad of sensations and putting forward object identities as a sum total of subjective contents and therefore becoming subjective phenomena themselves.[125] He thought of painting as 'anti-object and anti-subject',[126] so that it creates space for a variety of non-determined relationships and connections:[127] 'therefore the represented thing of observation ... eludes: to see it means to produce it and wait for it, swaying back and forth between occurring rejection and fascinated reception; in it fate becomes the otherness of eternity'.[128] In short, the pictures are held in hylic ambivalence and demand no hierarchical positioning for themselves but rather are in the world, simultaneously inert and instantaneous; they are like faces, which constantly transcend their factual reality.

III

Sartre's theory, which is particularly oriented towards visual art and posits the face at the centre of a theory of recognition,[129] makes itself manifest in much of his fundamental writing on the links between creativity and the human face. That Sartre always has the art historical

portrait in mind when thinking of this becomes clear in that, in *Situations IV*, where the central essays about visual art and artists are joined, he gives them the subtitle 'portraits'. The texts *Portraits officiels* and *Visages* appeared in *Verve* in 1939 and initiated an extraordinarily broad discussion concerning visual artists. Here Sartre formulated his theory thus: the eyes 'are created at every moment by that which they see, they have their sense and their fulfilment beyond themselves, behind me, over my head or at my feet'.[130] Many painters must have seen in this observation an indication of some notion of responsibility to be undertaken by the artist, while at the same time perceiving this as a new opportunity for formal engagement with the themes of face and portrait as a radically redefined task.

In this same way Raoul Ubac's deliberations on the 'back side of the face' of 1942 ought to be seen as an echo of Sartre's texts. Ubac stresses that in the Christian era, the head and above all the face had superseded, even consumed, the body. He therefore challenges a representation, in which the 'body takes up the face anew' and 'the face itself reaches out beyond its unavoidable expression': 'These faces are established in the border areas of human portrayal. They reach the point at which the picture only progresses at the price of its transformation.'[131] Ubac is following Sartre here, even to the point of engagement that could have motivated him to turn to painting around 1942. His pictures, whose layers of colour are inspired by the structure of slate stones, represent his ideal picture of the portrait, which he thinks of as a 'stone face': 'A karstic landscape reveals itself there, spreads itself out in the peace which stems from the character of this face, which reflects itself in its features, as these open up in it'.[132] The face constitutes itself not as a closed form, but as an elimination of the space – with which, however, it remains bound. It wavers between existence and non-existence under the indifferent surface of things.

Alberto Giacometti, a close friend of Sartre, addresses the problem of being and nothingness directly as the relationship between death and life: 'The living human differentiates himself from a corpse only in his facial expression. If one wants to "form a living head" so it must have a facial expression, which may not be an imitation of that which is visually perceived but is a reconstruction of the process of perception.'[133] Sartre asks himself the question in a similar manner in his essay on Giacometti's sculptures: 'How can one make a human being out of stone without in so doing turning him to stone?'[134] Here also, as in the case of Ubac, the solution lies in an eidetic reduction Giacometti bestows on his sculptures through a notion of 'absolute distance';[135] then it becomes verified through a process characterised thus: 'that the human being possesses absolute dimensions in the eyes of other human beings: if he distances himself he does not get smaller for me; rather his characteristics compress; his appearance remains; when he comes closer he does not grow bigger:

his characteristics unfold themselves?'[136] The liveliness, the gift of sight of a sculpture was achieved by Giacometti by means of a 'locally defined vision' of the figure – a vision which did not change depending on proximity or distance, but rather on its form of presentation. The sculpture contains an 'immediate transparency'[137] which is the codification of the face.

Les otages by Jean Fautriers also deal with the theme of the body and the face, in that the artist allows the forms of his pictures to 'dissolve' or 'disintegrate' so they can constantly rise anew.[138] These works were created during the occupation of France and Fautrier was first able to exhibit them in 1945, as happened to Jean Dubuffet's *Portraits*[139] for the same reasons. In an informal conversation he voiced the opinion then: 'Human beings look so very alike.' Then what makes them so worthy of portrayal? The answer moves on to the plane of the outlined argument: 'In order for a portrait to function properly for me, it must scarcely be a portrait, on the border of being No-Longer-a-Portrait. Then and only then does it work really well.'[140]

It ought to be plain by now that Wols cannot be disengaged from this picture theory, that his pictures are to be studied as faces and that all the invented titles are misleading and falsifying. All the artists mentioned up to this point had contact with one another either directly or via Sartre as well as through a series of art galleries, through whom they exhibited. Ubac, for example, supposedly got to know Wols through their mutual friend Camille Bryen and both of them showed their activities as photographers. As Ubac articulated his theory of the face during 1942, so we find a conspicuous and consistent preoccupation with the face in the work of Wols of the 1940s.

Already in his photography, portraits are crucial. In numbers the portraits clearly outweigh all other subject matter, since he produced them in series of up to 40 shots per person in different poses.[141] He often photographed the model from above – 'vertically from above'.[142] The picture becomes completely dependent upon the awareness of the observer, who becomes identical with the camera lens; for the usual orientation in picture space, the axis orientation from above and below does not apply. Through this the model delivers him/herself in fact to the photographer, becoming defenceless; for these very same reasons, however, the body is more relaxed, the gaze freer and more intensive at the same time.[143] Later Wols took over this same working and compositional technique of structuring space as a 'vertical below' for his painting. This clearly has less to do with the much valorised and often mentioned influence of aviation on spatial perpectives than with Wols' own evolution within painting.[144] For Wols, 'photography as well as painting cannot be merely a question of an unmysterious interval, as seen from an aeroplane', between the things 'nearby and those further away. Nor is it a matter of the way things are conjured gradually, one by

another, as we see happen so vividly in a perspective drawing. These two views are very explicit and raise no problems. The enigma, though, lies in their bond, in what is between them. The enigma consists in the fact that I see things, each one in its place, precisely because they eclipse one another, and that they are rivals before my sight precisely because each one is in its own place.'[145] What appears to have been more decisive for Wols the photographer than the influence of aviation was the influence of the Taoist 'bird's eye view',[146] which looks out beyond the exterior form of objects in uninterrupted movement, changing angles of vision and tracing their inner connections.[147]

It was actually portrait photography which caused Wols – who could no longer practice photography, owing to external pressures – to concern himself with the painted face at about the same time as he came into contact with Sartre's phenomenology. The four illustrations to Sartre's *Visages* and *Portraits officiels* were the temporary conclusions of a long series of faces (see plates 4.1–4.4). The pen drawing of 1939[148] with the subtitle 'sad clown' represents Wols' period of internment in a still surrealistically alienated scenario. However, it can only have been a little later that the pen drawing of the frontal view of a head was created, since it comes from the collection of Kay Boyle.[149] The solid continuous contour is abated by a fluctuating form of shorthand; the short abbreviated strokes show different pressures. The stronger contours portray the silhouette of the face, mark the eye sockets and mouth, and only the nostrils are marked by thicker black areas. The drawing 'Le solitaire' which Wols made only a little later and which belonged to Henri-Pierre Roché,[150] shows a head and torso in profile. Here Wols again uses the linear methods described earlier as well as continuous lines, in order to allow the body to fray, especially in the torso section. In the face there are even stronger markings around the orifices than before. The head has taken on the shape of a node form from which germs seem to spring up. A drawing obviously to be understood as a self-portrait[151] with a hat (1942) conjures the opposite effect of dots, dashes and continuous lines, so that the freed, strongly outlined features appear all the more empty. The stroke is roughly of the same pressure and works as if towards a goal. However fields of dots eclipse the continuity exactly in the region of the hat like capricious acts. In a pen drawing dating from 1942[152] entitled 'Big head' all the pictorial object elements of a face are deleted. The linear elements order themselves according to place, obeying the rules of the magnetic forces, peeling off from the individual bundle of lines, or seeming to come together as organic forms. The relatively continuous flow of lines of this sheet is eased by a more turbulent linear structure in 'head with helmet' from 1943.[153] In the inner structures which remain free of the thickened shorthand strokes, face and organ profiles are written in a continuous contour of strokes. Here Wols never really uses hatching because it can easily take on a form of illusionary meaning, from which even the

'Passage' technique developed by the cubists could never quite free itself. 'The cross and the eyes' (*c.* 1947)[154] reduces the vertical and horizontally set lines at the same time to notations, in which hole-like dots are written in, and lay increasingly concentrated rings around themselves. The exposed co-ordination system works effectively and is all the more transparent. The same goes for 'The horrific anatomy of the head' (*c.* 1947)[155] which achieves the same effect without the regularity of the previous sheets and allows itself to be changed by proliferating small forms, framed by strong continuous lines. Here one notices the changing posture of the pen, changes of the direction of movement and differing paces of the drawing movement.

Obviously the last-mentioned sheets are already shaped by the aquatints on which Wols was working at that time. However, it can already be seen here that Wols had freed himself from the still representational canon of Klee as described by Sartre. If one can differentiate clearly in the case of Klee – as Andeheinz Mösser has demonstrated – between immediate and indirect formation of movement and creation of movement as growth and if one can speak of the ambivalence between the moving line as a representative means and movement as an artistic gesture,[156] such distinctions cannot be drawn any more in Wols' case, because the drawing repertoire no longer has any descriptive purposes. What is of far greater significance is the effect of inertia and instability of the graphic elements, so that the drawing contains both the ephemeral quality and the constancy of a face. The methods for form are placed – as in Taoism – as 'contrary relations'[157] to show the 'alterity of the being'.[158]

Like Kafka, whom he revered as a poet, Wols approaches an object from all sides, 'always in the flow, in movement, as transformation', approaches it with 'microscope eyes', to reach the 'outside from the inside'.[159] In this respect the four aquatints that Wols prepared for Sartre's *Visages* and *Portraits officiels* (plate 4.1) do not illustrate the text.[160] They confront it as something different as a material analogy; they act as the worm boring the pages of the text whilst creating a coherent text behind the gaping holes. The first etching, used as a frontispiece to the book, becomes a material analogue of an official portrait, which Sartre characterises as possessing the quality of historical court portraiture and its manipulative use of distance–proximity duality, discussed in classical art theory as the relationship between *apparenza* and *sostanza*. The real features of the face mean nothing for a distant viewer because the represented figure has to appear 'disembodied'.[161] The official portrait serves the purpose of 'protecting people from themselves'.[162] The face itself disappears almost completely into official regalia and can – if 'invested' in the picture – relinquish its subjective truth. Wols turns these relationships around in his 'hip-piece of a human being'. The head becomes all the larger when one sees the sheet of paper from the pulled-in waist. On the one hand it becomes a product of transpiring, growing and

4.1 Wols, Four untitled etchings; illustrations to Jean-Paul Sartre, *Visages, precédé de Portraits Officiels*, Paris, 1948

germinating processes and on the other hand a product of an inverting suction effect: naked pulsating materiality behind which the imaginary cowers, the very opposite of an omnipotent and omnipresent clothed sovereign.

The third etching reminds one of a face once again; a face in profile with a cracked structure and spiral-shaped inner movements. As Giacometti creates the face of his sculptures by means of an eidetic reduction through 'absolute distance', so Wols aims at it in the imagination of the observer in that he allows the complete exactness of the face to become overtly inexact and lifts up the representative look. Through its absence and the presence of pure materiality, the observer becomes aware that the eyes are 'constantly being created out of that which they see'.

The oil paintings by Wols from 1946 on can be seen as a sum total of these trials. They have a relationship to the late pictures by Francis Picabia which were exhibited together with those of Wols, Hartung, Mathieu and Bryen in 1948 at Colette Allendy's. In these pictures the dots, like Wols' strokes and the coloration, are 'not the elements of a form'. They stand like speechless 'holes in the plane, glances through on to something else'.[163] Wols blows these holes up, brings – as the painter Antonio Saura aptly noted – 'Malevitsch's "heart of space"' to explosion and destroys the 'traditional composition'.[164] The remaining nothingness is therefore not senseless. Quoting Lao Tzu, Wols could have answered: 'Therefore, on the one hand we have the benefit of existence, and on the other we make use of non-existence.'[165] The transformation of this idea in Wols' eidetic reduction is useful in two ways: in painting the artist practices a 'theory of vision';[166] in observing the picture the recipient learns that painting celebrates no other enigma but that of visibility.[167] This programme is of continuing relevance, both to the fascist era as well as to the contemporary situation, each with its own wide-spread blinding flood of images. Created in the crisis of the idea of the representational function of art, it assures painting without mystifying the legitimation of its place in society and confirms the exceptional quality of iconic symbols in the broadest sense.

Similarly, as Picasso saw the chapter 'Birth of the face' in Brassaï's *Graffiti* book in May 1960, in which the photographer had 'put together faces composed from two or three orifices', he exclaimed:

I have often made similar faces. Whoever carves something like that leads directly towards the sign, towards the symbol. Art is a language of symbols. If I pronounce the words human being I conjure up the image of a human being. The word has become the symbol for the human being. It does not however portray him as a photograph would. Two holes are the symbol for the face, they suffice to call up the impression of a face, without actually depicting it . . . Is it not strange that one can achieve such a thing by such simple means? Two holes – that is very abstract, if one reflects what a very complex being a human is . . . The most complete abstraction is perhaps the highest reality.[168]

The uncrowned monarch of painting in the twentieth century here demonstrates – albeit without specific references – Wols' method: the

eidetic reduction, which he carries out, opens new horizons of the flexibility of the eyes.

IV

Jean-Paul Sartre saw in the behaviour of Wols the opposite standpoint to the 'excited hustle and bustle' of the post-war period. That also includes the painterly and discursive practices of many artists. If one casts a glance over the art scene of the late forties, one can discern everywhere a widely distributed optimism. To give an example of this: the magazine *Das Kunstwerk* introduced a series on 'painters' studios' in 1948. They are tidy, clean and functional. In the accompanying text it reads: 'Epater les bourgeois is no longer fashionable today. The artists dress inconspicuously and avoid every possible picturesque touch and artistic disorder in their studios. They like to emphasise the workshop character of their work rooms: everything ought to be utilitarian, practical.'[169] Wols never worked under such conditions. Since his earliest days as an artist in Paris, he worked with improvised means – a reflection of his actual situation, which became accentuated during the German occupation of France. Wols never recovered from his experience in the prison camps nor from the poverty he suffered during the war years. Meanwhile, however, he had developed a method for himself out of a lack of things. He worked with the simplest means; for example, for his aquatints he used the needle of the record player, which he extended with a handle made of one of his wife's fans.[170] His drawings and watercolours are usually only about the size of the palm of a hand. He dared to try larger pictures only with reluctance.

All this is astonishing when one considers how very much Wols was a child of his time. He loved cars, the modern visual media and jazz. He was classically educated and the possibility of a musical career had been open to him as a youth. He refused that as well. Furthermore the well-read[171] and broadly educated artist conducted himself in a taciturn and withdrawn manner. When after 1945 artists' treatises and declamatory manifestos became an accepted norm, Wols at the most reached back to the fund of his aphorisms. Like almost no other he refused to take part in any rhetoric.

This is one reason why Sartre confronted the 'excited hustle and bustle' of the post-war period with Wols' rejection of the

perception that within the synthetic relationship between detail and entity could be found an active participation in an all-embracing act of creation; for Wols there exists only a fixed system of inter-related co-ordinates: detail is annihilated in favour of entity; in every detail, entity is manifest and contained within itself. Within this double relation the 'being' (existence) is revealed; neither agitated nor immobile an eternity established from the outset, a force that exhausts itself to create and preserve inertia, an inertia, through which the nightmare of action haunts.[172]

Here Lao Tzu's words can be quoted: 'He who pursues learning will increase every day; he who pursues Tao will decrease every day. He will decrease and continue to decrease, till he comes to non-action. By non-action everything can be done.'[173]

But this way was not indicated, nor forced. Wols had consciously chosen it after 1940 and lived out existential philosophy imbued with Taoism, in order to realise this paradox – the non-looking viewed picture. The analysis of Wols by Sartre has a lot in common with what the philosopher wrote about Franz Kafka, who was also an author much quoted by Wols. In *What Is Literature?* (1948) Sartre describes how Kafka's novels ought to be read. These instructions could apply equally as modes of looking at and reading Wols' pictures: they are to be read in motion and with the consciousness of existing 'à l'époque du public introuvable':[174] for 'whether with eyes open or closed – we always find our way. Even in revulsion, in the blackest depths and in excess we find our way.'[175]

Habermas and postmodernism

Martin Jay

In the burgeoning debate over the apparent arrival of the postmodern era (or over the implications of a discourse that claims such an era has arrived), no contributor has been as forthright and unflinching a defender of the still uncompleted project of modernity as Jürgen Habermas. In several recent works, *Der philosophische Diskurs der Moderne, Die Neue Unübersichtlichkeit* and his response to the essays collected by Richard Bernstein in *Habermas and modernity*,[1] he has expanded his critique far beyond the first, tentative essays he published in the early 1980s.[2] These initial efforts, in part because of their imperfect command of the French intellectual scene and in part because of their controversial attribution of a conservative political implication to postmodernism, proved a lightning rod for criticism. In many quarters, Habermas was pilloried as a naively one-dimensional celebrant of an out-dated liberal, enlightenment rationalism. His attempt to formulate a theory of social evolution was damned as a new version of a discredited objectivist philosophy of history.

Although the relation of Habermas' critique to the specific context out of which it emerged – that of the cynically anti-political *Tendezwende* in the West Germany of the late 1970s – was on occasion acknowledged,[3] by and large he was chided with having superficially reversed the profound analysis of the Enlighenment's failure offered by the older generation of the Frankfurt School. Indeed, because he had been understood as a staunch defender of universalist, totalising reason, his work has been accused of being only the most recent and subtle version of an intellectual tradition which inadvertently fostered the authoritarian political uniformity it claimed to resist. Habermas, the passionate defender of democratically achieved consensus and generalised interests, was thus turned into the terrorist of coercive Reason *malgré lui*.

Whether or not his more recent works will dispel this caricature remains to be seen. From all reports of the mixed reception he received in Paris when he gave the lectures that became *Der philosophische Diskurs der Moderne*, the odds are not very high that a more nuanced comprehension of his work will prevail, at least among certain critics. At a time when virtually any defence of rationalism is turned into a brief for the automatic suppression of otherness, heterogeneity and non-identity, it is hard to

predict a widely sympathetic hearing for his complicated argument. Still, if such an outcome is to be made at all possible, the task of unpacking his critique of postmodernism and his nuanced defence of modernity must be forcefully pursued. One way to start this process is to focus on a particularly central theme in his work, which has hitherto been relatively ignored. Because it concerns an issue closely related to his similar critique of post-structuralism it will also illuminate Habermas' no less virulent hostility to the other leading 'post' phenomenon of our no longer modern world.

The theme in question is what might be called the opposition between differentiation and *différance*. The latter term, a neologism coined by Jacques Derrida in a seminal essay now twenty years old, doubtless needs little introduction to contemporary readers of cultural criticism. I would only like to emphasise that Derrida specifically emphasises its distance from differentiation. 'Among other confusions', he notes, 'such a word would suggest some organic unity, some primordial and homogeneous unity, that would eventually come to be divided up and take on difference as an event. Above all, formed on the verb "to differentiate," this word would annul the economic signification of detour, temporalizing delay, "deferring".'[4] Differentiation, in other words, implies for Derrida either nostalgia for a lost unity or, conversely, a utopian hope for a future one. Additionally, the concept is suspect for deconstruction because it implies the crystallisation of hard and fast distinctions between spheres, and thus fails to register the supplementary interpenetrability of all subsystems, the effaced trace of alterity in their apparent homogeneity, and the subversive absence undermining their alleged fullness or presence.

Now, although deconstruction ought not to be uncritically equated with postmodernism, a term Derrida himself has never embraced, one can easily observe that the postmodernist temper finds *différance* more attractive than differentiation as an historical or, better put, post-historical conceptual tool. The meta-narrative of a process of original unity progressively articulating itself into a series of increasingly autonomous and internally homogeneous sub-systems is far less compelling than an anti-narrative of heterogeneous but interpenetrating movements that flow in no discernible historical or evolutionary direction. Even though the prefix 'post' implies temporal irreversibility, it has become a favourite pastime to find the postmodern already evident in such earlier figures as Flaubert.[5] Postmodernists like Jean-François Lyotard explicitly eschew any yearning for the restoration of a pre-differentiated unity or the construction of a de-differentiated totality in a reconciled future. Instead, they valorise a fluid network of proliferating and incommensurable *différances* which escape reduction to a finite number of common denominators. In the neo-Wittgensteinian language that Lyotard adopted in *The postmodern condition* (but later abandoned as too anthropocentric in *Le Différend*), he contends that 'there is no possibility that

language games can be unified or totalized in any meta-discourse'.[6] But if unity or totality is denied, so too is the apparent necessity of those binary oppositions that characterize traditional thought. Thus, the recent post-modernist 'non-exhibition' staged at the Centre Pompidou in Paris by Lyotard was called *Les Immatériaux* to stress the overturning of the rigid separation between mind and matter, subject and object, consciousness and body, even life and death.[7] Furthermore, as Jacques Bouveresse, one of Lyotard's most persistent critics, notes in his recent diatribe, *Rationalité et cynisme*, 'the deliberate effacement of conventional frontiers that exist for the moment among sciences, philosophy, literature and art is the shibboleth *(mot d'ordre) par excellence*, it seems to me, of post-modernity'.[8]

If we also look more closely at the aesthetic dimension of the post-modern condition, we will see the same anti-differentiating impulse at work. Thus, the art critic Suzi Gablik notes in *Has modernism failed?* that a great deal of performance art in particular makes us anxious because 'it violates our sense of boundaries; no distinction is made between public and private events, between real and aesthetic emotions, between art and self'.[9] As such, postmodernism can be seen in part as the non-utopian anti-climax to what Peter Bürger has defined as the avant-garde, as opposed to the modernist, project: the abolition of the separate institution of art and its reabsorption into the life-world out of which it originally came.[10] Typical of this postmodernist penchant for violating boundaries is the breakdown of the differences between high and low art, culture and kitsch, and the sacred space of the museum and the profane world without. In architecture in particular, which has been widely recognised as the cutting edge of the postmodernist offensive, what Charles Jencks called 'radical eclecticism'[11] has meant the disruption of the time-honoured distinctions between different styles in favour of a historical pastiche, as well as the breakdown of the hierarchical superior-ity of 'serious' architecture over a more popular and vulgar vernacular, such as that celebrated by Robert Venturi in his defence of Las Vegas.[12]

What is, however, important to recognise in all of these transgressions of various frontiers is the abandonment of any hope for a new totalisation in the sense of a dialectical *Aufhebung* or sublation. Instead, an untotal-ised network of supplementary *différances* is posited as the superior alternative to the seemingly rigid and unyielding dichotomies of modern-ist differentiation. Georges Bataille's model of a carnivalesque disruption of all hierarchies in the sacred and ecstatic community of expenditure can be found lurking behind much post-structuralist social theorizing. The postmodernist sensibility has also borrowed a great deal from that dimension of feminist thought which rejects the abstract universalism underlying any homogenising humanist discourse, while also remaining suspicious of the essentialising opposition between the sexes that is so much a part of partriarchal culture.[13]

Now, because Habermas has been outspoken in his distrust of both post-structuralist and postmodernist theories, and has heretofore not really absorbed the feminist critique of the western tradition,[14] he has variously been accused of hoping for a utopian totalisation based on the universal power of rationality and rigidly holding on, like a typically German anal-compulsive, to the existent differentiations of a modernisation process still worth salvaging. The first charge is exemplified by Lyotard's complaint that 'what Habermas requires from the arts and the experiences they provide is, in short, to bridge the gap between cognitive, ethical and political discourses, thus opening the way to a unity of experience'.[15] Habermas, he believes, still remains hostage to the fantasy of 'humanity as a collective (universal) subject'[16] seeking a perfect consensus in a meta-language game transcending all others.

The second and in some ways contrary criticism is typified by the Derridean argument of Dominick LaCapra, who concedes Habermas' strong distaste for Hegelian or other meta-subjects, but still questions his alternative:

The problem, however, is whether, in rejecting reductionism and dialectical synthesis, Habermas goes to the extreme of analytic dissociation which is itself constitutive of a logic of domination. Habermas does not directly see how his own analytic distinctions, which are useful within limits, may be rendered problematic, especially when they are taken as categorical definitions of realms of thought or action.[17]

As an antidote, LaCapra urges Habermas to pay more attention to the supplementary and carnivalesque play of language, which would undermine the apparently rigid differentiations posited in various ways during the development of his work. More recent deconstructionist critics of Habermas, such as Michael Ryan and Jonathan Culler, have echoed this advice, in each case defending *différance* as superior to categorical distinctions.[18]

A more patient reading of Habermas' demanding corpus than is evident in these critiques would, I suggest, allow us to appreciate the virtues of defending a certain notion of differentiation against post-modernist *différance*. First, it is clear that although the very early Habermas may have espoused the position attributed to him by Lyotard – that of believing in a meta-subjective species being capable of achieving a universal consensus, at least as early as 1972 and possibly even during the positivist dispute of the 1960s – he had explicitly abandoned this position.[19] Repudiating the idea of a Hegelian-Marxist universal subject as a residue of a discredited consciousness-philosophy, he began to call instead for the nurturing of a plurality of intersubjectively grounded speech communities. In fact, his main complaint against post-structuralism is that it merely inverts consciousness-philosophy by denying the subject, and thus, ironically, is as holistic as the logocentric traditions it opposes. Rather than calling for a unity of experience, as

Lyotard contends, Habermas has scrupulously defended the value of distinctive forms of interaction, not merely among human beings, but also between man and nature. In fact, his scepticism towards the project of reconciling humanity and the natural world has brought him under fire from such advocates of a more Marcusean or Blochian strain in Western Marxism as Thomas McCarthy, Joel Whitebook and Henning Ottman.[20] Instead of holding out hope for a utopian re-enchantment of our disenchanted world, Habermas has resolutely acknowledged man's disembeddedness, that is, differentiation from the natural world.

But secondly, while valorising differentiation, Habermas has fully recognised that the process has been plagued by severe difficulties. Even as he has called modernity an uncompleted project worth carrying forward, he has been very sensitive to the deep discontents it has spawned. Unlike the more sanguine defenders of modernisation who peopled the American and West German academies in the post-war era, he has always been enough of a student of Horkheimer and Adorno's *Dialectic of Enlightenment* to recognize that the mere refinement of analytic categories and the increased complexity of modern society are by no means emancipatory in themselves.

Habermas' attitude towards differentiation is, thus, a highly complicated one. To do justice to it would require tracing its origins in at least two traditions, sociological and philosophical. To make sense of the former would mean beginning with Herbert Spencer and Emile Durkheim in the nineteenth century and passing on to twentieth-century theorists such as Max Weber, Talcott Parsons, Niklas Luhmann and Wolfgang Schlucter, all of whom are critically appropriated in Habermas' massive *Theory of communicative action* and elsewhere.[21] We would then have to reconsider the heated sociological controversies over evolutionism and functionalism and make distinctions among segmental, stratified and functionalist forms of differentiation. And finally, we would have to consider the responses of such contemporary sociologists as Anthony Giddens to Habermas' reading of the tradition.[22]

To probe the second, philosophical, tradition, we would have to go back at least as far as Kant and examine his three critiques, with their separation among forms of judgement. We would then have to trace efforts to undo Kant's differentiations, beginning perhaps with Hegel and continuing up through the Western Marxist struggle to articulate a defensible concept to totality.[23] And we would have to conclude with a consideration of Habermas' recent exchanges with Gadamer and other defenders of a radical hermeneutics, who try to provide a new foundationless foundation for a holistic approach to understanding.

Rather than attempt so ambitious and foolhardy a reconstruction of the roots of Habermas' attitude towards differentiation, let me simply point to the major implications he has drawn from his contact with these disparate sources. Habermas' rational reconstruction of the evolution of

western societies posits a relatively undifferentiated society of hominids who became what can be called human through both the division of labor and the development of kinship structures.[24] At the very beginning of the evolutionary process, as he conceptualises it, there is thus already a form of differentiation between subsystems of the whole. Similarly, the distinction between labour and language means that any universal explanation of human development, say, a vulgar Marxist productivism or a vulgar deconstructionist pantextualism, must be rejected as reductionist. For the process of evolution takes place on several levels, which roughly can be grouped under two rubrics. The first, which Habermas calls system integration, derives from an instrumental relationship between man and his natural environment. Initially generated by the dialectic of labour, system integration spawns steering mechanisms, such as money and bureaucratic power, which achieve a certain autonomy of their own. The second level, which Habermas calls social integration, refers to norms and values. These are derived from a communicative rather than an instrumental relationship among actors, who have the capacity to be active agents rather than mere bearers of structural forces. It is only in the modern period beginning in the eighteenth century, so Habermas contends, that the distance between system and social integration becomes especially evident, with the differentiation of subsystems of economics and administration, the decentering of world views (what Weber calls the 'disenchantment of the world') and the uncoupling of law from morality.

Unlike more complacent functionalist theorists of evolutionary differentiation, Habermas recognises the potential for radical distress in this process. In particular, he is sensitive to the disproportionately advanced development of system as opposed to social integration in modern capitalist and bureaucratic socialist societies. Both types of integration can be understood as emerging against the background of a life-world in which rationalisation takes place when communicative argumentation supplants more authoritarian and coercive forms of social co-ordination. System rationalisation, however, entails means–ends rationalism, whereas social or communicative rationalisation involves other forms of reciprocal inter-subjective interaction. In the modern world, the former has revealed itself as more powerful than the latter, leading to what Habermas calls the 'colonisation' of the life-world by system or instrumental rationality. Hostility to this trend has expressed itself in many ways, including the derogation of all forms of reason as dominating and coercive. It is, however, Habermas' contention that unless we carefully distinguish among types of rationalisation, we risk regressing beyond the genuine achievements of modernisation. Thus, he writes, the deconstructionist critique of logocentrism becomes legitimate when it understands its target 'not as an excess, but as a deficit of reason',[25] because of the partiality of the subject-centred, instrumental rationality it misidentifies with reason *tout court*. It is illegitimate, however, when it

rejects any rational adjudicating of competing truth claims because of the inherent undecidability of all language, a belief whose practical consequence is an irrationalist decisionism.

Following Weber and, before him, Kant, Habermas stipulates a differentiation among three basic types of reason in the sphere of values: cognitive (or scientific), moral and aesthetic. The Enlightenment had hoped that the emancipatory potential of each of these spheres could ultimately be harnessed for practical purposes. 'The 20th century', Habermas admits, 'has shattered this optimism. The differentiation of science, morality and art has come to mean the autonomy of the segments treated by the specialist and at the same time their splitting off is the problem that has given rise to those efforts to "negate" the culture of expertise.'[26] Although understanding the motivation behind these attempts to de-differentiate and thus end the alienation of the separate spheres from each other and from the everyday life-world, Habermas is nonetheless very reluctant to abandon the Enlightenment project entirely. For with it came the refinement of rationalisation itself, which resists the reduction of modern life to any one common denominator, rational or otherwise.

Habermas' argument in this regard is worth following in some detail, because it has so often been misconstrued by those who see him as the advocate of a terroristically universal form of reason. First of all, although Habermas sees each sphere as having undergone a variant of what can be called rationalisation, he nonetheless explicitly rejects the idea that reason means the same thing in each case. In an earlier essay on his attitude towards modernism, I challenged him to clarify in particular what he meant by rationality in the aesthetic sphere.[27] Was he claiming in the manner of, say, Suzi Gablik in her book on *Progress in art*, that Piaget's developmental cognitive categories could be applied to aesthetics, as he argued they could to cognitive and moral development? His reply was that art criticism, which arose with the differentiation of autonomous art from its religious-ceremonial context,

has developed forms of argumentation that specifically differentiate it from the forms of theoretical and moral-practical discourse. As distinct from merely subjective preference, the fact that we link judgments of taste to a criticizable claim presupposes non-arbitrary standards for judgment of art. As the philosophical discussion of 'artistic truth' reveals, works of art raise claims with regard to their unity (harmony: *Stimmigkeit*), their authenticity, and the success of their expressions by which they can be measured and in terms of which they may fail.[28]

Thus, in the discourse about art, there is an argumentative rationality that resists reduction to moral or scientific reason.

Not only does aesthetic discourse reveal such a rationalisation, Habermas continues; so too does art immanently considered. In art itself, there is a type of learning process, which is cumulative. 'What accumulates are not epistemic contents', Habermas contends, 'but rather the effects of the inner logical differentiation of a special sort of experience: precisely those

aesthetic experiences of which only a decentered, unbound subjectivity is capable.'[29] The increasingly decentered and unbounded subjectivity of artistic experience has an ultimately emancipatory potential, for it 'indicates an increased sensitivity to what remains unassimilated in the interpretive achievements of pragmatic, epistemic, and moral mastery of the demands and challenges of everyday situations; it effects an openness to the expurgated elements of the unconscious, the fantastic, and the mad, the material and the bodily.'[30] Thus, 'art becomes a laboratory, the critic an expert, the development of art the medium of a learning process – here, naturally, not in the sense of an accumulation of epistemic *contents*, of an aesthetic "progress" – which is possible only in individual dimensions – but nonetheless in the sense of concentrically expanding, advancing exploration of a realm of possibilities opened up with the autonomozation of art.'[31] In short, instead of providing a straitjacket for transgressive, heterogeneous experiences, as those who formulate a simple opposition between art and reason assume, aesthetic rationalisation, in the dual sense of critical and productive learning processes, allows, indeed encourages, a proliferation of artistic stimuli to a widened consciousness. Only the modernist autonomisation of art, its differentiation as an institution of its own, makes such a rationalisation possible.

The extreme autonomisation of both esoteric art and hermetic aesthetic criticism does, to be sure, create pressures for their reintegration with the life-world out of which they originally emerged. Here Habermas admits to a certain ambivalence. On the one hand, he rejects what he sees, following Adorno, as the premature, forced and impotent *Aufhebung* of art and life in such movements as Surrealism. Yet on the other hand, he recognises that too rigid and inflexible a detachment of art from life courts the danger of forfeiting art's ultimate capacity to reinvigorate the life-world by giving it a high-level access to those expurgated experiences it normally marginalises or suppresses. Too radical a break between art and life also threatens to cause the well-springs of aesthetic expression themselves to run dry. He hesitates to affirm an immediate reintegration, however, because he contends that the utopian de-differentiation of art *by itself* is insufficient to undo the pathologies of modernisation. A new constellation of the separate value spheres with their expert rationalised discourses and the communicative life-world of everyday experience is needed in order to maximise the emancipatory potential in the project of modernity. This necessitates neither the collapse of all of these now distinct realms into one universal language game, as Lyotard accuses him of advocating, nor the rigid maintenance of the boundaries of the differentiated spheres, as his deconstructionist critics aver he upholds. Instead, a more nuanced mediation of relatively but not absolutely commensurable realms is a preferable alternative.[32]

In a recent essay on 'Modern and Postmodern Architecture',[33] Habermas spells out the implications of this argument in the aesthetic field that

is now at the cutting edge of the debate. Modernist architecture, he points out, was at once functional and formalist, following both the socially progressive imperatives of, say, early Bauhaus radicalism and the anti-ornamental purism of constructivist abstraction. In both ways, it sought to break with a sterile traditionalism and to use the methods and materials of the modern world. As such, it was based on a mediated interaction between non-aesthetic needs and the development of immanent aesthetic reflexivity. The postmodernists are right, Habermas admits, in recognising that the utopian social intentions of the early modernists went awry when the international style became the emblem of corporate capitalism and the excuse for alienating and impersonal mass housing. But here the problem was not so much the Enlightenment ambition at the root of the modernist quest as its distorted application in terms more of instrumental, system rationality than communicative, social rationality.

The postmodernists go too far, Habermas suggests, in reaction to this failure by seeking to separate formalist and functional imperatives entirely. Either they retreat into an eclectic celebration of historical styles, which conservatively affirm all of them merely because they once existed, or, 'like surrealist stage designers', they 'utilize modern design methods in order to coax picturesque effects from aggressively mixed styles'.[34] Any attempt, moreover, to generate a vitalist architecture, which would immediately restore all severed ties with the life-world – here perhaps Habermas is thinking of the Heideggerian-inspired call for a 'critical regionalism' by Kenneth Frampton and others[35] – risks turning into an anti-modernist nostalgia for a pre-differentiated form of life. An immanent critique of the limitations of modernist architecture, acknowledging its achievements as well as its failures, is thus preferable to a wholesale turning of the page, which offers only pseudo-solutions to the pathologies of modern life.

Premature de-differentiation is, in fact, one of the most troubling of those false answers, which Habermas sees as legitimated by the postmodernist discourse of *différance*. In his latest book *Der philosophische Diskurs der Moderne*, he criticises Foucault, Derrida and also Adorno for their undifferentiated critique of modernity: 'Enlightenment and manipulation, conscious and unconscious, forces of production and forces of destruction, expressive self-realization and repressive desublimation, freedom-guaranteeing and freedom-eliminating effects, truth and ideology – all of these moments are confused with each other.'[36] The de-differentiation of the value spheres of modernity are, moreover, purchased at the cost of the tacit elevation of one of them, aesthetics – understood in an essentially irrationalist sense. For Habermas, the current fascination with Nietzsche betrays this inclination, for the new Nietzscheanism 'represents the differentiation of science and morality as the developmental process of a reason that at the same time usurps and stifles the poetic, world-disclosing power of art',[37] which it seeks to resurrect.

But in making art somehow prior to differentiation, in assuming that rhetoric is somehow more fundamental than philosophy,[38] it fails to see that the very sphere of art itself is the result of a process of differentiation. In other words, it is mistaken to offer an aesthetic colonization of the life-world as an antidote to its instrumental rational counterpart produced by the hypertrophy of science and system integration in modern capitalism.

Similarly, Foucault's effort to collapse cognition and power is based on a problematic de-differentiation of the will to knowledge and the will to power, which reduces all the human sciences to little more than subtle instruments of discipline and normalising control. Likewise, Derrida's critique of Austin fails to register the linguistic differentiations of the communicative life-world in which fictional discourse has been usefully distinguished from other language games.[39] In short, much postmodernist analysis has been vitiated by a confusingly ahistorical failure to recognise that certain patterns of differentiation have emerged in ways that defy the attempt to say that they are always already undermined. Moreover, it is precisely the separate rationalisations of the distinct spheres that must be defended as a way to avoid a holism of reductive sameness. Albrecht Wellmer puts Habermas' alternative cogently when he writes:

we have to distinguish between those irreversible differentiation processes, which signify the end of traditional society and the emergence of specifically modern, universalist conceptions of rationality, freedom and democracy on the one hand, and the specific form in which these differentiation processes have been articulated and institutionalized in capitalist societies. It is obviously to the *latter* only that the ideas of a sublation of formal law, politics, or art can meaningfully apply. What they can mean is what could be called a new 'permeability' of the relatively autonomous subsystems or cultural spheres for each other.[40]

Such an answer may, to be sure, raise a few questions of its own. How can we tell, for example, when a healthy balance has been struck between permeability and boundary maintenance? If, on the one hand, the boundaries become too fluid, aren't we forced into a postmodernist *différance* in which supplementarity reigns supreme? If, on the other, they have become too rigid, might it no longer be possible to assume even the partial commensurability that is at the root of Habermas' guarded optimism about the modernist project? How can we, moreover, be certain that it is only the specific differentiations of the western modernisation process that possess enough rationality to be worth defending? As Thomas McCarthy points out in questioning Habermas' debt to Luhmann's systems theory, it is important to ensure that 'the possibility of democratization as dedifferentiation of economy and state not be meta-theoretically ruled out of court by systems-theoretic borrowing. Here again, the question arises of whether it should be superseded by some non-regressive form of dedifferentiation.'[41] The same question arises for the other forms of articulation defended by Habermas in his eagerness to

avoid abandoning the modern project before its emancipatory potential is fully tapped. It is perhaps not by chance that *différance* has often come to be the rallying cry for many who feel excluded by the dominant forms of rationality in our culture.

And yet, having acknowledged all of these questions, it still seems justifiable to conclude by stressing the value of Habermas' alternative to postmodernist *différance*. A recent critic of his position, Peter Uwe Hohendahl, complains that

it is not quite evident why Habermas is not willing to use the critical force of deconstruction against the logic of differentiated systems. It seems that Habermas overstates his case when he describes deconstruction as a purely literary approach without concern for problem-solving in the realm of the life-world. Thus my suggestion would be: if we want to free the life-world from the constraints of the overarching system and its institutions, there is room for the project of de-constructive criticism, precisely because it questions the logic of systems.[42]

The answer to this complaint is that for Habermas, the differentiation of systemic institutions cannot be construed *solely* as a constraint on an oppressed life-world, but rather as the source of certain rationalisations that are worthy of continued preservation. It would therefore be danger-ous to turn deconstruction from an essentially literary approach into a more universal solvent of all structures and systems, in the hope of recovering the sacred community of Bataille's ecstatic general economy. For the result would be a night of endless *différance* in which all cows were piebald, which is as deceptive as the old idealist trick of turning them all black. Instead, we should be more sensitive to the enlightening as well as obscuring implications of a much-maligned modernity whose promise is still greater than is assumed by those who counsel a leap into the postmodernist dark.

Images and identities II

Introduction

Maud Lavin and Irit Rogoff

The ideal wife is a beautiful, sex starved, deaf mute who owns a liquor store.
Richard Prince, 'Tell Me Everything', 1986

This recycled joke, quoted from a recent work by the American artist Richard Prince, exemplifies an assertion of masculine identity founded on a caricature of femininity. In its hostile exaggeration of already existing stereotypes, this statement demonstrates the degree to which gendered images and identities are mutually interdependent. Spoken in a male voice in this particular instance, the constitutive components of gendered signification gleaned from this quote could read in the following way. Its cardinal theme is the power of representation and fantasies of dominance, expressed in turn through claims of:

a Aesthetic pleasure
b Sexual desire
c The possession of language
d An illusion of passivity and receptivity
e Gratification in excess

Rather than viewing this extreme statement of a gendered identity purely as an eccentric deviant, it can in fact serve to signal larger issues of power, authority and fantasy. It is these issues of image and identity, both individual and societal, and the materials which form their construction, that frame the concerns of the papers in this chapter. Thus for example one of the questions being asked is: How do male self-representations in high art function in societal terms? Within this context we also consider the ways in which female figures are incorporated into these images and the degree to which they are enlisted as supporting players in the construction of male identities. Furthermore we must address ourselves to the interplay between the two genders in the signification of such identities as forms of cultural authority and domination. Another question being asked in the essay on mass-media representations concerns how various images of femininity operate within fine art and mass culture. For example, is a form of subversiveness possible within the construction and reception of female pleasure in mass media?

The methods of investigation and the theoretical orientations of the different essays that make up this section vary considerably. Rogoff's

89

analysis of self-portraiture centres on conjunctions of cultural ideologies determined by specific historical contexts with theories of sexual politics resulting in the construction of 'author-functions'. The discussion focuses on a tradition of male self-portraiture within the context of a set of specific German cultural ideologies equated, in part, with the emergence of Modernism. It attempts to negate both this genre's traditional categorisation as a pictorial rendition of autobiography as well as its status as the normative form of self-representation regardless of gender. Arguing against this normative tradition, Rogoff attempts to unravel the component parts of this tradition as co-existing sets of binary opposites, as in the case of the marginality of the artist co-existing with the given empowerment of voice and vision. Tracing the different visual codifications of such contradictory and internally embattled dichotomies through Neo-Romanticism, Naturalism, Expressionism and New Vehemence painting, Rogoff uncovers the repeating strategies of quote and reference operating within this tradition. Viewed within the specific social and cultural context of German Modernism, this tradition emerges as constructing radically new significations of cultural authority which are in turn also specifically gendered.

Lavin's essay similarly locates her reading of Hannah Höch's art in a specific historical frame, locating it within a period of transition for Weimar Germany's New Woman and one of tremendous growth for the mass media – two related phenomena within the larger history of industrialisation and modernity. The kernel of Lavin's argument is a consideration of the cultural construct of the feminine as variously represented in certain mass media photographs and in the avant-garde photomontages of Hannah Höch. Höch's representational strategies – on the one hand, deconstructive techniques using photomontage and, on the other, a pleasurable repetition of photographs from the illustrated photoweeklies – allow a reading of the contradictions inherent in the new identities for women after World War I and their imaging. Höch's photomontages are examined as strong re-readings of her mass-media sources as well as historical contributions to certain contemporary debates about media interventionism within feminist criticism. It is acknowledged that the exact interventions of Berlin Dada are not possible today, given the historical development and permeation of the mass-media in industrialised countries. Nevertheless the strategic options of deconstructing hegemonic representations and/or promoting female pleasure are still urgently debated, and Lavin frames her discussion of Weimar history with a presentation of how this analysis is informed by the writer's own historical position.

Gabriel's piece focuses on the incorporative nature of multi-media practices and on explorations of the characteristics of a specifically feminine aesthetic. Historically this analysis is located in the moment of disjuncture launched by the student movement of 1968, with its concomi-

tant critique of culture and its dominant values. These voices lent the important dimension of sexual politics to a previously largely undifferentiated and universalist perception of culture and helped launch the project of experimentation with specifically gendered aesthetics. The discussion picks up on feminist cultural practices of that period and investigates their development over the next two decades. The West German artists whose work serves as primary examples of these practices have foregrounded the body as their arena in which the cultural, the organic and the feminine are most prominently manifested. Gabriel's essay stresses the rich complexity of supposedly contradictory materials, media and the explorations of sensory gratification concurrently at play within these works. This typology of feminine aesthetics also serves to represent a large body of work by female artists working within a West German system in which women artists have still not gained adequate representation.

All of the essays in this section stress readings of art works as one form or another of institutional and ideological output rather than in the exclusive context of an isolated history of the avant-garde. In this expanded context, the role of visual culture in identity formation is a pressing issue for art historians and critics to address. The three essays here point out different areas in which questions are yet to be formulated. Thus, for example, in the case of masculine self-portraiture what remains to be determined is how these representations of self function as constitutive components within the culture as a whole. Whereas the social and cultural construction of individual identity is to some extent historically determined and reflective of the dominant ideologies at play, their eventual reception – contemporary or otherwise – projects them onwards as autonomous signs operating within the field of culture. No longer agents of contemporary cultural ideology they nevertheless continue to perpetuate a series of unchallenged assumptions concerning the authority of the artist. Going beyond principles of inception and reception we need to ask in further detail how the authority of high art gains conviction and authenticity through an emphasis on artistic individuation. Cultural authority and the unique individuality of its author seem to work through mutually supportive dynamics of cultural affirmation and a personalisation of the discourse of artistic production. The location of this process within the realms of Modernism further inscribes it with a dichotomy which comes from the fact that collective aspirations are given expression via individuated, transcendent personas of artists. The specific question which emerges then is whether this individual process of 'naming' via such significations as self-portraits also serves to contribute and enhance the exclusivity and uniqueness with which high art is imbued.

Similarly, mass culture is permeated with modernist reverence for the individual identity and there is a continuing need for criticism to challenge this. Recent studies, however, have raised questions concerning the seeds of pleasure, utopia and other fantasies in popular culture which

can serve to motivate desire for alternative personal and societal identities. These questions consider that the popularity of certain forms of entertainment (film, T.V.) is, in part, due to pleasures not always restricted to individualistic fantasies but equally extending to the mobilisation of desires for more satisfying societal constructions. Further work is needed concerning the reception of both high and mass culture and the assimilation of a complex area of representational interplay within specific areas of reception.

Strategies of pleasure and deconstruction: Hannah Höch's photomontages in the Weimar years

Maud Lavin

I will suggest, then, that the proper political use of pleasure must always be *allegorical* in the sense [that]: the thematizing of a particular 'pleasure' as a political issue ... must always involve a dual focus, in which the local issue is meaningful and desirable in and of itself, but is also at *one and the same time* taken as the *figure* for Utopia in general, and for the systemic revolutionary transformation of society as a whole.

Fredric Jameson, 'PLEASURE: a political issue'

I

Pleasure as a condition has its basis in the body and its drives, but the many levels on which we experience pleasure are not restricted to the physical and personal. Rather, pleasure – or the experience of the pleasurable – also functions ideologically, shifting according to different historical and cultural contexts, but always maintaining an inherent or latent potential for political transformation. In arguing for this conception of pleasure as a radical political force, Fredric Jameson suggests that it occurs in two ways simultaneously: as a motivation for local or individual political involvement and as an allegory for the transformation of societal relations as a whole.[1] In other words, pleasure functions politically when it breaks through the closure of self-satisfaction and links up with the broader pleasure of desiring a utopian social structure. Pleasure, then, always has the potential to serve a specific kind of allegory, one that is a figure for social utopia, and to be experienced dialectically on both local and societal levels.

Today, these issues regarding pleasure and its political functions are central to debates in feminist film theory concerning the nature and function of representation and specifically questioning the ways in which women are identified both as the site of and the principal consumers of pleasure. In terms of processes of reception, a fundamental concern is how women are accustomed to reading visual images and how conventionalised media representations contribute to female identity formation. This contemporary discourse on the relationship between women, mass media and pleasure is critical to my consideration here of Hannah Höch's Weimar era photomontages, since Höch's work provides

93

an important political precedent for the consideration of these issues. As early as the 1920s, Höch, a member of Berlin Dada, had evolved an aesthetic that incorporated the pleasure of viewing the mass media and, while repeating and celebrating these pleasures, also used montage to transform media images into allegorical figures of female liberation and societal revolution. Although Höch's specific techniques or motivations cannot be transposed from her era to the present, her aesthetic *strategies* of pleasure and deconstruction bear directly on contemporary discourse.

Höch's photomontages were created partly in response to contemporary representations of women in the mass media. In the 1920s, an unprecedented proliferation of photography in newspapers and magazines offered new pleasures to female film or theatre fans, who could suddenly see innumerable images of their favourite actresses and dancers. The expanded availability of photographs of these stars contributed toward their idealisation and increased the negative potential to develop closed systems of narcissism and/or masochism in identifying with the ideal. In Höch's work, this closure is disrupted both literally and metaphorically, for the highly controlled or posed photographic portraits are cut up, reassembled and recombined with other photo-fragments to form new, pleasurable yet disturbing representations.

Höch's approach – to aggressively recompose the physical incarnation of the stereotype, to functionally fragment the image and to call into question its founding precepts – is particularly relevant to current discussions regarding the strategic implementation of the feminine masquerade. For some critics maintain that the masquerade provides a device to reveal the cultural construct of femininity, and that the artificiality of the masquerade can be dramatised through exaggeration or other alienation techniques. Mary Ann Doane, in her seminal article on female reception and film, 'Film and the masquerade: theorizing the female spectator', argues that by treating femininity explicitly as a masquerade, the female spectator might gain control over and distance from conventionalised structures of femininity. Doane desires a defamiliarisation of the masquerade, thus invoking a Brechtian alienation effect – that is, one that could forbid empathy and encourage recognition and distance. In this way, Doane attributes to the masquerade a radical transformatory potential: 'By destabilizing the image, the masquerade confounds the masculine structure of the look. It effects a defamiliarization of female iconography.'[2]

However, this claim can be contrasted with the ways in which the masquerade already functions in popular culture. For example, Joan Collins, as Alexis Colby in the television epic *Dynasty*, plays a character developed specifically on the basis of her subtle display and directing of the masquerade. Alexis is shown constantly constructing and reconstructing herself and her appearance in accordance with her current

scheme. Other examples of this type of female pleasure in watching women represent themselves, flaunting and manipulating the masquerade of femininity come to mind easily. The rock star, Madonna, simultaneously wearing the signs of the bride and the whore, or Sheila E., in the 1985 film *Krush Groove*, packaging and re-packaging herself for financial success, both represent impudent and spectacular manipulations of the masks of femininity. Even these brief examples elicit the question: do these stars – experts at manipulations of the masquerade – really produce a defamiliarisation with its Brechtian connotations, an alienation effect that in some ways liberates the female viewer from the constricting range of acceptable female identities?

Rather, what this suggests and what is made clear by *Vogue* and other upscale women's magazines is that western women today are raised with a consciousness of one aspect of femininity as a masquerade already inscribed in their upbringing. And, while a recognition and control of this masquerade might alleviate certain identity traumas and provide limited and closed pleasures, it is not a curative, nor does it ward off the pressure towards homogenisation. To exaggerate (or to apply any other defamiliarisation technique to) conventional feminine identities is one step in recognising femininity as a cultural construct instead of a biological given. However, it is only one step and one that does not provide alternatives to rigid societal definitions of the feminine. With the canonisation and simplification of Brechtian theory in contemporary criticism, it has become common to praise alienation techniques without considering alienation as merely one element in a complex set of a spectator's responses which in turn are a part of a specific socio-economic arena of reception. Certainly, Doane is proposing an alienation more extreme than that usually found in popular culture; however, her contribution is more theoretical than practical and more local than allegorical and refers back to itself only. In general, such defamiliarisation techniques seem largely insufficient unless they are incorporated into an allegorical representation, one that elicits a desire for pleasurable alternatives and political transformation.

So, in relation to these contemporary issues and to Höch's photomontages, we might ask: What would be alternatives to the choice between a restrictive cultural concept of femininity and the exaggeration of its masquerades? Here, I would like to consider as an alternative the representation of oscillation, oscillation being the means for dislocating static definitions of gender and socio-economic hierarchies. What I am calling for is not a different, feminine 'Role model', a humanistic ideal of an individualistic, whole female persona to be projected through the mass media but, rather, an androgynous pleasure in experiencing a range of gender positions. In this model, the ramifications of representing flux in occupying gender roles are linked directly to a utopian socio-economic equity in that gender roles are viewed as characterisations of power

95

relations, not biology. With this concept in mind, my questions centre on how (or if) it is possible to intervene within capitalist mass media's functions in feminine identity formation. How is it possible to go beyond a representation of the masquerade and other defamiliarisation techniques? How can the political pleasures of oscillation between gender positions be represented? And how can pleasure be incorporated with deconstruction and other critical strategies?

These contemporary questions and biases form the basis of my examination of Hannah Höch's photomontages of the Weimar period. Höch's work is presented here not as an ideal, the totalised production of a creative genius à la Picasso to which we turn for autonomous pleasure or mythic answers, but rather as an example, critical for the questions it raises and for the political strategies it employs. Although I am focusing on a tension between deconstruction and pleasure specific to the reception of mass media images in the 1920s, it should be clear that the motivations and context for my investigation are present-day. Indeed, it is this contemporary position from which my writing of history develops that I want to state explicitly. Given the exhibition *German Art in the 20th Century* as the articulating context of this essay, it is necessary to argue for a methodology in opposition to an ordering in which chronology serves as a substitute for history and in which style is invoked as a masking and unifying factor. As an alternative methodology, I want to assert here the idea of writing history and an overtly political representation – a writing of contemporary myth, a rewriting of memory, and a feeding of current ideologies. To do this it is necessary to write into this essay the historicity of my own position. For my position is itself not fixed, but rather exists as part of a contemporary discourse, in which we desire to transform our pleasure as female viewers and producers of mass-media into a revolutionary strategy.

II

During the Weimar Republic, 1918–1933, two developments – both part of a larger history of industry, rationalisation and consumerism – came about simultaneously: a rapid growth in the mass print media and a redefinition in the roles of women. Generally, these social phenomena have been regarded separately, but they are connected in the proliferation of New Women images produced for the mass media's consumer market. Here it is necessary to distinguish between the representation of the New Woman and actual material changes in the lives of Weimar women. New to this era were the numbers of women in assembly line and secretarial jobs, in a rationalised and double-burdened schedule of housework and wage-work, and even participating in a rationalised sexuality propounded by sex reformers of the period. But at the same time – despite these apparently major changes in women's public and private lives – the

socio-economic status of many individual women seems not to have improved. Rather, it was in the mass media that a complex and often contradictory image of modern women was generated. In newspapers, films, magazines and fine art, a radically new societal role for women was projected and distorted, and popular culture became the scene of anxieties and desires about women's transforming identities.

Hannah Höch's photomontages draw on these mass-media for their sources: the cultural myths and mass-media stereotypes of the modern female are ones that Höch, operating within the Berlin Dada aesthetic and from her own socio-economic position as a New Woman, both affirms and negates. Analyzing Höch's representational strategies – on the one hand, deconstructive techniques using montage and, on the other, a pleasurable repetition and restructuring of fan photographs (newly available publicity and news photographs of stars designed for mass consumption) – provides a reading of her individual response to the deeply ambiguous positions of Weimar women.

In terms of Höch's political reading of media images, it is significant that all her Berlin Dada photomontages date from the period just after the so-called socialist revolution of 1918, and after the subsequent disillusionment of many people, including members of the left intelligentsia, with the new Republic. The Berlin Dadaists were especially critical of the Republic's inability to create a viable socialist system and of its bloody suppression of the Spartakist revolt. As a result, the more radical members of Berlin Dada – George Grosz, John Heartfield, and Wieland Herzfelde – joined the newly formed communist party, the KPD, while Höch and Hausmann were affiliated with a more utopian type of anarcho-communism.[3] Despite the Dadaist's attention to other political issues, Höch was the only Berlin Dadaist to centre her montages around the representation of Weimar Germany's New Woman.

As the historian Atina Grossmann explains, the New Woman was 'a much abused and conflated image of the flapper, young stenotypist and working mother', a symbol of actual social and demographic changes in Germany during and after World War I.[4] Intense debate in the media and the legislature of the period centered on two significant trends: a gradual increase in the number of women working (by 1925, 35 per cent of the female population was employed) and a declining birth rate (despite the illegality of publicising contraception and performing abortion).[5] Although these statistical shifts were not limited by class, the popular media sources used by Höch, such as *Berliner Illustrirte Zeitung*, the top-circulation Berlin photoweekly, and *Die Dame*, a German equivalent of *Vogue*, were restricted to candid or idealised photographs of specifically bourgeois women. (Later the *Arbeiter Illustrierte Zeitung* and other communist print media offered a different subject and type of idealisation, heroising the female worker in a photo-reportage style).

Höch herself had been raised in a small-town bourgeois milieu and had

moved to Berlin where she led a non-traditional personal life and supported herself financially. From 1916 to 1926 Höch worked for Ullstein Verlag, the publisher of *BIZ* and *Die Dame* and so was familiar with their New Woman images. Höch was employed in the handiwork department, which produced individual brochures on knitting patterns, crocheting, etc., and which also contributed to a bi-monthly two-page spread in *Die Dame* on women's handicrafts.

The bourgeois media images of New Woman produced by Ullstein Verlag represent a narrow range of stereotypes; in the 1919 *BIZ*, photographs of women are most often either of politicians or performers. For example, the 9 March 1919 cover of *BIZ* portraying two National Assemblywomen is a photograph of contradictory messages: the newly empowered women demonstate authority and timidity, confidence and lack (see plate 7.1). The two wear severe, business-women coats and hats and carry briefcases. They seem insecure in this masculine attire and stand hunched, looking out timidly. As German women had just gained the right to vote in late 1918 and first ran for office in January 1919, in *BIZ* at that time there was a fascination with female politicians, and many portraits were published, documentations of problematic accessions to power within a patriarchy.

By contrast, the 4 May 1919 cover of *BIZ* shows an actress performing the role of the New Woman, outfitted for aeronautics, buoyant and energetic, a photograph functioning as an advertisement for the idealised, bourgeois modern female (see plate 7.2). Framed by the new aviation technology, the actress poses for the camera with a theatre-trained stance. Her smile announces the ease with which she bears both goggles and flowers, helmet and curls, flight wear and femininity. In this photograph, the contradictions of daily life are glossed over; such cosmetic represen-tations could serve to alienate the female spectator from her perception of her own complex identity, material needs and possible effectiveness.

Similarly, in 1918 and 1919, *Die Dame* illustrated photographs of two principal types of women: modern female performers, particularly dancers, and daughters and wives from 'good houses' or well-to-do bourgeoisie. While this visual dualism of 'good daughters' and sensual dancers attests to a traditional good girl/bad girl dichotomy, it also points to a class division between *Die Dame* readers and the photographed dancers. In a general sense, this split can be theorised as a projection of desires about new identities for middle-class women on to the 'other' of what had been, in the pre-war era, a lower-class profession.

Still, these photographs of dancers cannot be judged simplistically, for they also offer historically specific pleasure and utopian moments of identification. We might ask whether such representations could in some way have functioned as allegories for general societal change. Would it have been possible for photographs of bold and sybaritic modern dancers to signify liberation when they were contained within a magazine devoted

Maud Lavin

7.2 Cover, *Berliner Illustrirte Zeitung* 4 May 1919, 'Margarete Christians (vom Deutschen Theater in Berlin) vor Antritt einer Reise im Flugzeug'

to the status quo? This question is problematised by the fact that when *Die Dame* celebrated modernity, it was in the service of selling new consumer products and not as a style connoting alternative ideologies. However, in those early days, the relationship between a female fan and the rapidly transforming mainstream press lacked the narrative and biographical structure of today's fan magazines; instead, in *Die Dame*, dancer photographs were spread on the cover and throughout the magazine with little or no relationship to the articles, creating a counter-text analogous to the advertisements.

If these dancer photographs may have been somewhat circumscribed by the magazines that illustrated them, when Höch removed them from the magazine context, she allowed the reception of these images to change. Moreover, Höch constantly used photographs of admired actresses and dancers in her photomontages specifically as figures of liberation. By combining the pleasures inherent in these images with deconstructive techniques, Höch was able to link female pleasures with calls for systemic transformation and flux in Weimar society, to urge a political use of pleasure.

In general, during the Weimar period, Höch shifted from using mass media photographs of the New Woman as celebratory allegories – as in her well-known Dada photomontage, *Cut with the Kitchen Knife Dada through the last Weimar Beer Belly Cultural Epoch of Germany* (1919–20) – to a multi-layered treatment of such images as in the painting *Roma* (1925), or even the more critical photomontages such as *Deutsches Mädchen* (1930) and the Ethnographic Museum series of mid to late Weimar. Yet, at the same time, Höch never relinquished the pleasure of representing fan photographs of women, as is evident throughout her Weimar work from the 1919–20 *Cut with the Kitchen Knife* to the Dancer series begun in 1926 (see plate 7.3). On multiple levels, Höch both criticised and reproduced the media's representation of women in her day. Therefore it is the interaction between deconstruction and pleasure that merits attention in Höch's aesthetic.

To look closely at specific strategies in a major early work: how does deconstruction operate in *Cut with the Kitchen Knife*? In Derrida's theory of deconstruction, he conceived of it as a process: specifically, the use of components of a system to decentre the supposed truth values, to dissolve the hierarchies of that system, and to activate within it a play of other, alternative ideologies. In employing these terms, my purpose is not simply to map postmodern deconstructive theory on to pre-existing modernist motives, but rather to explore ways in which certain elements of contemporary theory were already nascent in the dismantling strategies at work within certain modernist traditions in the Soviet Union, Germany, the United States and elsewhere. In a general sense, much of Berlin Dada photomontage is deconstructive in that it uses mainstream mass media images – ones that perpetuate the dominant beliefs of Weimar society – to

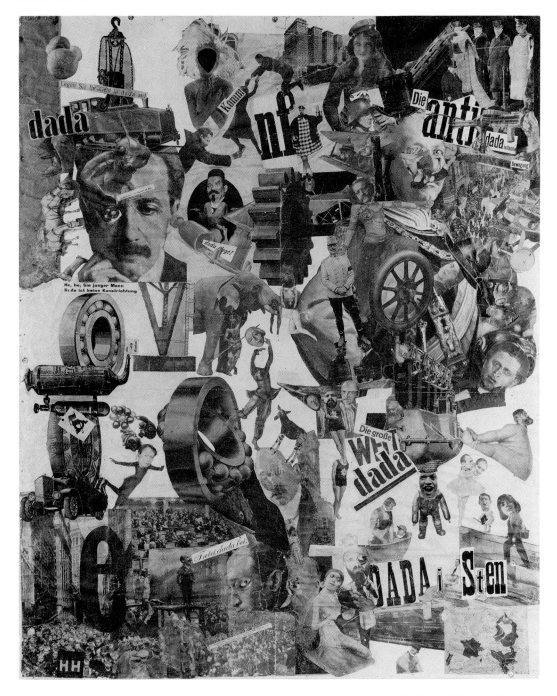

7.3 Hannah Höch, *Schnitt mit dem Küchenmesser Dada durch die letzte Weimarer Bierbauchkulturepoche Deutschlands*, (Cut with the Kitchen Knife Dada through the last Weimar Beer-Belly Cultural Epoch of Germany), 1919–20

create artworks that foreground minority ideologies such as communism and question the very language with which mainstream beliefs are articulated.

In *Cut with the Kitchen Knife*, many of the photographs are of women whom Höch admired. In the opposition Höch creates between the anti-Dada world of the paunchy, compromised President Ebert and other Weimar government leaders (upper right) and images of the Dadaists, aligned with Marx, Lenin and other revolutionary figures (lower right), famous women are used to signify various metaphors of liberation: movement, technology, the female, the new, Dada and revolution. By functioning as operatives in a decentred inversion of Weimar society, the images of women are deconstructive elements in Höch's critique of the Weimar Republic.

However, the various mass media representations of the New Woman are not themselves deconstructed. Instead Höch appears as a fan of these images, and it is significant for the reception of Höch's work that she makes use of easily recognisable photographs celebrating famous contemporary women. In *Cut with the Kitchen Knife*, the centrifugal composition rotates around the body of the popular dancer Nidda Impekoven, who holds aloft a speared and beheaded Käthe Kollwitz. In the Dada circle portraits, these female faces are included: Nidda Impekoven again (here bathing John Heartfield), Hannah Höch, and the actress Asta Nielsen (as an American photojournalist). On the whole, the recognisable women are, by their identities, movements and locations, strongly and positively associated with Dada and the new. (Although there are three women in the anti-Dada section, two are anonymous.)

In this work, the power of Dada is signified on several levels by movement; it is a destabilising force. The dynamic action of the compositional design is paralleled iconographically by images suggesting movement, either by machines, wheels and roller bearings, or female dancers, or revolutionary scenes.[6] Hanne Bergius has suggested that dance could represent the anti-intellectual, action-dedicated beliefs of Dada.[7] In the same way, Impekoven, as a female dancer, can be read in her position here as antithetical to male logocentric culture, with Kollwitz's head in an importantly unresolvable and ambiguous position. As the dancer symbolises power, movement and the female, the key role of Dada dancer is one that Höch assumes for herself. For the title, *Cut with the Kitchen Knife*, implies a female actor; it is the female gaze which cuts through the 'Weimar Beer Belly' and offers this Dadaist cross-section.

Höch's women in *Cut with the Kitchen Knife* have major and revolutionary roles. Within the composition of the photomontage, physical expression, such as dancing and ice skating, are mainly performed by women. Dada, as disseminated by voice and word, is associated with men. (For example, 'dada' emanates from Einstein's brain in the upper left of the montage.) But it is Impekoven's body, small as it is, that literally

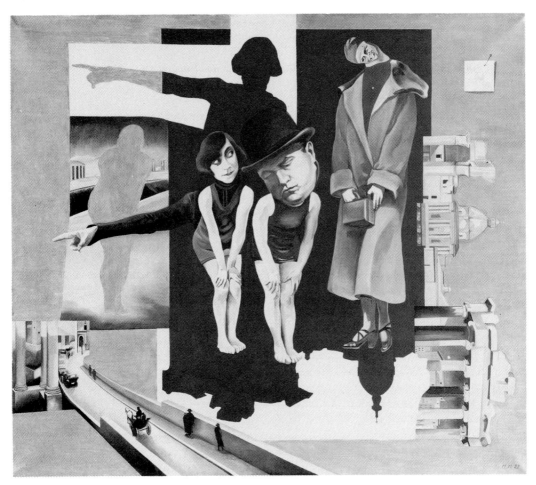

7.4 Hannah Höch, *Roma*, 1925

has the pivotal position in the work. Impekoven's pirouette and the movements of other dancers and ice skaters can be read explicitly in the terms of physical freedom and Dada anti-repression. But, more than this, with Hausmann's theories, the images of women can be confirmed as signifiers of female liberation and anarcho-communist revolution. In *Cut with the Kitchen Knife*, the montages and representations of women function as deconstructive elements within the centrifugal dissolution of Weimar hierarchies.

In a later work, *Roma* (1925), this strategy continues (see plate 7.4). The central woman in this case is the actress Asta Nielsen. In a forceful and provocative way she simultaneously stands for a particular androgynous accession to power in a patriarchy – her fame as a film star was based partly on her playing male roles[8] – and an oppositional, leftist political force countering Mussolini and ordering him out of Rome. What is different here is that, unlike in *Cut with the Kitchen Knife*, Höch is

performing a deconstruction of female coquettishness: in two repeated gestures, Nielsen orders Mussolini out, while also seeming to flirt with him. Nielsen and Mussolini both are dressed as competitive female swimmers, their athletic outfits connoting the 'body-as-machine' cult in post-war Germany.[9] Poised to enter the water, their pressed-together knees and aslant heads also read as gestures of coy flirtation. Contemporary photographs of leotarded or bathing-suited female athletes – common in newspapers like *BIZ* – often possessed sexual overtones such as those emphasised and parodied by Höch in *Roma*. Höch also inverts the meaning of the image of female flirtation, attaching to Nielsen's luring crouch its opposite, Nielsen's pointing hand, ordering Mussolini away. Thus, in *Roma*, the deconstruction of coquettishness is effected by showing opposites but favoring one pole of action, women as commanding instead of coquettish. This dialectical approach is appropriate to montage, where opposites can be juxtaposed on denotative and connotative levels, and Höch created *Roma* as an oil whose composition imitates photomontage.

While in many of Höch's Dada photomontages she employs media photographs of women to symbolise progress, in some Dada images and in many works of the late twenties, Höch uses more disruptive montage techniques to unmask media constructions of the New Woman, her masquerades, roles and sexuality. Particularly discomforting are works such as *Deutsches Mädchen* (1930), where Höch cuts up and reassembles photographs of women's faces (see plate 7.5). Identification with the image of a pretty, young German women is made uncomfortable by this disfiguration, and the subjecthood of the figure is denied by substituting two unmatched eyes for the woman's own. Höch transforms the face and especially the eyes from the home of consciousness and the self into an externally manipulated set of parts; she composes fragments in such a way as to disorient the gaze, multiply perspectives, shift scale and, above all, assault empathy. Again, Höch dismantles conventions of the mass media, such as those that use the eyes to represent an exalted subjecthood. By using fragments of media images, Höch reveals both the conventionalised nature of media representations and their origin as highly manipulated constructions, rather than documentation of natural truths.

To return to Höch's use of allegory in her Berlin Dada period, 1918–1922, the contemporary theories of Raoul Hausmann support the argument that Höch's representations of women in *Cut with the Kitchen Knife* are allegorical and involve the female as a liberating political force. Hausmann's 'feminist' and anti-Freudian theories are elaborated in a series of articles published in 1919, at a time when he and Höch were lovers. Particularly influential for Hausmann's writing was the psychoanalyst Otto Gross, who separated himself from classical Freudianism on the issue of gender differentiation. Not that Freud can be posited simplistically as an essentialist, but Gross saw gender difference as

7.5 Hannah Höch,
Deutsches Mädchen, 1930

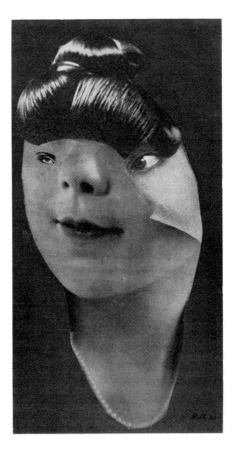

societally conditioned and considered such conditioning as it was prac-
tised in his own culture to be repressive and destructive. Gross's writings,
however inconsistent and utopian, contain arguments for the full expres-
sion of male and female sexuality in communal living. Following Gross'
theories, Hausmann attempted in his 1919 articles to naturalise commu-
nism by locating constructive communal instincts in the unconscious.
According to Gross and Hausmann, these instincts, along with gender
roles, had been repressed and their manifestations malformed by patriar-
chal capitalist society. Therefore they argued for an idealistic repatterning
of sexuality and family structures to liberate communal instincts.[10]

In a series of articles in the post-war periodical *Die Erde*, Hausmann
developed a model of communal living that centered around matriarchy,
in which he combined pre-war anarchist goals with post-war admiration
for communism.[11] For our purposes, what is significant in Hausmann's
theories is how his concept of political revolution is interdependent with a
new, liberated role for women in society. It should be strongly cautioned
that the theories of Gross and Hausmann should be considered as

theoretical texts intertwined with but *not* reflective of their personal relationships; after all, both men participated in the problematic and, by our contemporary standards, sexist bohemian mores of their times.[12]

In his 'Weltrevolution' essay, Hausmann wrote in support of a communist economic revolution, stating that it would not be viable unless accompanied by a sexual revolution:

The communist movement will lead to a fiasco of male spirit if it does not carry out a radical switch-over from only economic justice to a sexual justice that allows women finally to become women.[13]

For Hausmann, the capitalist ideas of ownership were deeply rooted in the patriarchal organisation of the family, a system legalised by marriage which allows the father to possess the wife and children. Hausmann, in theory, opposed marriage, asserting that: 'Marriage is the projection of rape into law.'[14] This oppression of women's sexuality enforced female bondage and the false idea of the male's right to possession. Hausmann, at least in his essays, insisted that each person should have control of his or her own body, and that women should have the right to experience a full range of female sexuality:

The formation of a female society which leads to a new promiscuity and, connected to this, to matriarchy (as opposed to the patriarchal family of masculine shaping) is most profoundly linked to the reorganization of bourgeois society under communism.[15]

Hausmann was a theoretician – his nickname was 'Dadasoph' – and a prolific writer, whereas Höch left few written statements. Unfortunately, she published nothing at the time on feminist issues. Höch and Hausmann were closely associated, but it cannot simply be assumed that she agreed with his writings. In much later interviews, Höch disassociates herself, for the most part, from the women's movement and does not comment on Hausmann's interweaving of feminism and anarcho-communism. There are, though, areas in Hausmann's theory which must have been of interest to Höch and which pertain to Höch's representation of women.

Despite the fact that Hausmann in his relationship with Höch actually contradicted certain tenets of his own 'feminism', he upheld others. Höch recalled the relationship as 'a difficult and sad apprenticeship', and, in contrast, remembered Schwitters as one of the few male artists of the time who could respect a woman as a colleague.[16] Still, Höch might have agreed in general with Hausmann's call for liberation of women. Although a woman from a bourgeois family and the daughter of an authoritarian father, she was leading an unorthodox and independent life. (In 1920, for example, she hiked to Rome across the Alps for travel and in an effort to separate herself from Hausmann.)[17] Also, she was living with Hausmann outside marriage. Like Hausmann, in her Berlin Dada days Höch would most likely have found sexual equality aligned with communism. Her own support of communism is evidenced by her participation in the 1920

107

November Group letter which demanded artists' involvement in politics and advocated communism in particular.[18] This was a time when many Weimar left intellectuals supported the communist ideals associated with the early years of the Bolshevik revolution. And even later, in the Cold War years when it was impolitic, she admitted her earlier interest in communism.[19] The most convincing proof of Höch's associating women's liberation with political revolution is in her art work, where representations of women are central to her ironic, anti-Weimar images depicting and urging political change.

Instead of simply celebrating Höch's deconstructions, however, I would like to raise some problems and questions presented by her work. This is not to suggest that Höch should have existed as some kind of ideal to which we look for model behaviour. Instead, I want to indicate limits in Höch's work and to generalise these for their relevance in our contemporary debates. These limits are ones of class and distribution. For example, Höch's heroines are almost exclusively bourgeois, as are the masquerades addressed. In addition, one might point to Höch's marginalisation, both in relation to other Dadaists and to a larger public. She did not participate in distribution channels which reached a broader audience, as, for example, Grosz and Heartfield did with the Malik Verlag. Höch was the only woman in Berlin Dada, and I suspect that her being female was a factor in her unspoken exclusion from certain distribution systems. So, despite the great power of her images, we are left with questions as to the effectiveness of Höch's aesthetics and deconstructive art in general – doubts that disrupting a sense of unified self or recognising the uses of female masquerades can *in themselves* trigger a shift in political identities, either individual or collective.

III

As I suggested at the outset, Höch's work is not only about deconstruction: it is also about pleasure. Using montage, Höch fragments photographs of female performers and allegorises these images, recomposing them in open-ended narratives, eliciting but confounding a sense of closure and empathy in the viewer. To look at the unintegrated image of Impekoven and Kollwitz in *Cut with the Kitchen Knife* is to respond with feelings of empathy, alienation, exultation and dislocation (see plate 7.6). Ambiguities result from viewing the head separated from the female body and from recognising the dancer's headless body as a signifier of female pleasure, power and movement. As such images become allegories in the deconstructive narrative of the larger composition, this pleasure is linked specifically to revolutionary change.

Here theories of montage reception from the twenties and thirties, particularly those of Ernst Bloch, aid in interpreting the nascent utopianism of Höch's montages. In much of Bloch's theoretical writing, he

7.6 Detail, Hannah Höch, *Schnitt mit dem Küchenmesser* (Cut with the Kitchen Knife, showing the central montage of Nidda Impekoven and Käthe Kollwitz)

stresses the critical value of disjuncture and fragmentation and their relationship to anticipatory consciousness. Bloch does not privilege a single technique such as photomontage. Rather, he celebrates any technique that prompts the viewer to desire a new, Marxist utopian future. This technique would necessarily avoid creating a closed system. Bloch critically examines both fine art and mass culture for utopian traces (these being elements in a representation that elicit a desire for societal utopia). Thus Bloch, unlike Lukács, concentrates on the reception of various styles rather than on prescribing one correct style. Bloch is interested in mass appeal and considers the liberating potential of both the nonsynchronous

109

(*ungleichzeitig*) and the futuristic. This position immediately raises questions about the relationship of mass media to pleasure and the issues of liberation and its link to political change. This whole argument has direct bearing on Hanne Bergius' discussion of the representation of dance in Höch's work as connoting exultation, Dada and the female. For, in terms of Bloch's theory, these dance elements can be read as utopian traces and point to a reading of the more pleasurable, less overtly critical aspects of Höch's work as presenting radical alternatives.[20]

Fredric Jameson's recent theories of utopianism are closely related to Bloch's writings.[21] Both theorists emphasise the need for a radical utopianism and warn of the dangers of a reified utopianism. The difference between these categories of utopianism is in *what* is desired – that which contributes to societal change (such as a Marxist vision) or, in contrast, that which appears to promise newness but actually forecloses change (such as the technological progressivism so prevalent in the twenties).[22] Bloch in particular is concerned with how these different utopian visions combine with other elements in representation (one example is his writing on the mass appeal of Nazi culture).[23] Thus to apply a Blochian critique is not simply a matter of identifying elements as utopian but rather of analysing their function within representation.

In *Cut with the Kitchen Knife*, the historical specificity of Höch's referents to Marx, Lenin, Ebert, Hindenburg and others prevents a timeless idealisation. And, in terms of formal strategies, it is her combination of pleasure with deconstruction that disallows reification. In other words, Höch celebrates female pleasures of liberation along with the dissolution of the Weimar government and suggests an anarcho-communist alternative; none of these is separable from one another; all of these are in flux. This assertion can be explored by focusing on what kind of pleasures are represented in the Impekoven/Kollwitz pairing and how they are depicted formally.

In 1919 Käthe Kollwitz had just been named the first female professor at the Prussian Academy of Arts, and, at the age of 52, held the position of a long-established and highly respected artist/activist. Höch's image of her head was cut from the 30 March 1919 *Berliner Illustrirte Zeitung* which announced Kollwitz's appointment.[24] The oval of the head is left intact and icon-like, but an idealised wholeness is made impossible by the disassociation of head from body and by its diagonal orientation (see plate 7.7). In *Cut with the Kitchen Knife*, the head is speared by an Indian man with an elephant. Yet, whatever connotations of martyrdom might be inferred are made merely ironic by the improbability of the narrative. The spear disturbs neither Kollwitz's head not her contemplative expression. Although formally, there is a great contrast between Kollwitz's integrated stereotypes of working-class women and Höch's ecstatic, fragmented dancers, politically, Kollwitz was aligned often with the Dadaists. In addition, several tributes were later paid Kollwitz in the

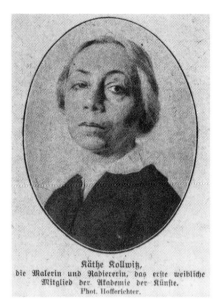

*7.7 Berliner Illustrirte
Zeitung* 30 March 1919,
p. 101, 'Käthe Kollwitz, die
Malerin und Radierin, das
erste weibliche Mitglied der
Akademie der Künste'

communist press. Therefore she could not have simply personified the Expressionist enemy derided in Dada manifestos. Perhaps Höch's mixture of irony and spotlighting here can be interpreted as an inter-generational tribute, a sign of both admiration and difference. In all probability, like most other women in *Cut with the Kitchen Knife*, Kollwitz, as a leftist artist, was someone Höch admired.

Nidda Impekoven was also highly celebrated, but in a different context. Having made the transition from a child star to an adult one, by 1919 'Niddy' Impekoven still conveyed a child-like persona in the popular press and in her dances. The particular image used by Höch was reproduced in both *BIZ* and in *Die Dame* and shows Impekoven in a dance pose dressed in a marionette costume (see plate 7.8). The *BIZ* caption reads: 'Mit 15 Jahren ein Tanzstern erster Grösse! Die Tänzerin Nidda Impekoven, die mit ausserordentlichem Erfolg in Berlin auftrat, als Pritzel-Puppe.' Lotte Pritzel was a well-known contemporary puppet-maker; an exhibition of her work, for example, was advertised in a December 1919 issue of *Die Dame*.[25]

Is the juxtaposition of Impekoven and Kollwitz simply a contrast of ages? This question concerns as well the contradictions between Impekoven's dancer status that could have connoted an active, empowered woman and her child-like identity. However, in discussing the reception of this image, today's viewers must be distinguished from Höch's contemporaries. That this contradiction might have been invisible and only subliminally communicated to Höch's audience can be seen by viewing a February 1922 *Die Dame* brassiere ad, captioned: 'Harmonie der Linien im Tanz mit Büstenhalter *Forma*.'[26] In the accompanying

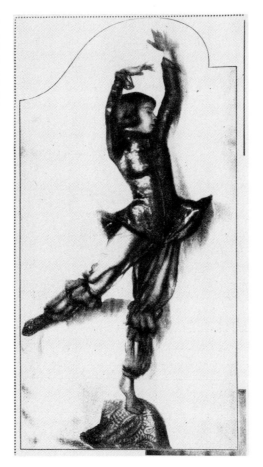

7.8 *Berliner Illustrirte Zeitung* 9 November 1919, p. 460, 'Mit 15 Jahren ein Tanzstern erster Grösse! Die Tänzerin Nidda Impekoven, die mit ausserordentlichem Erfolg in Berlin auftrat, als Pritzel-Puppe'

photograph, Impekoven, slender, virtually without female curves, stretches backwards, further erasing any suggestion of breasts, and yet is presented as an ideal for bra-wearers. Impekoven here embodies a liberation of movement and a freedom from aging, which, however, creates an uncomfortable (and ultimately destructive) equation of female power and childishness. By depicting Impekoven as headless and juxtaposing this photo-fragment with that of Kollwitz's head, Höch further complicates these connotations, perhaps upstaging them with the more obvious contrasts of mind and body, stillness and motion.

Kollwitz's head is pinned in place, but all of Impekoven's body suggests movement. The viewer's focus is on her kick which sets in motion the circular sweep of the montage's composition. Does this mean that female pleasure is located in the body, and that a biologically determinist argument for female power as physical is being presented or can be read? In answer, I would point out that it is a dancer's body *from 1919* that is being thus celebrated, and that female pleasure is not biologically but

rather historically determined in this representation; it is ideological.[27] In this historical framework, the modern dancer can be seen as representing various pleasures associated with new possibilities for Weimar women, particularly in their ideological relationships to their bodies. It can be generalised that these new concepts about the body often concerned issues of sex, class and/or the machine. The image of the modern dancer in Weimar can be read as a pastiche, a sign operating in multiple contexts: partly the lower-class dancer image from the nineteenth century, a woman who could live out fantasies forbidden to bourgeois women; partly a symbol of post-war modernism with its cult of the machine and contemporaneity; partly a myth of a bohemian artist, existing outside class boundaries; and partly a pleasurable representation of an unbounded, fully expressed female body.[28]

On the basis of her montages, Höch herself can be considered a dance fan. In *Cut with the Kitchen Knife*, Höch preserves formal aspects of the fan or publicity photograph of Impekoven. Despite the image's beheading, the graceful silhouette of the pose is retained and highlighted by a surround of white space. (Compare this respect for the outline to the treatment of Hausmann's face – above the diver suit in the lower right – where the scissors have invaded his outline, trimming the face and leaving the open mouth ridiculously large). Impekoven's silhouette is echoed by that of an ice skater, (lower left), and an exotic dancer, (upper right, below Ebert's head). The exotic dancer's body has a dual function: juxtaposed with Ebert's head, it mocks him, and it also functions independently in the composition, echoing Impekoven's movement and adding to the sense of female-propelled motion. Again, it is the representation of ambiguity and the lack of resolution in this montage that is one of its most radical aspects and that responds to the Berlin Dada call to affirm and negate at the same time.[29]

If a recognisable mass-media image is repeated in a celebratory way, even if fragmented, this in and of itself is a method that re-presents the pleasure of viewing media images. And Hannah Höch was a media viewer in the twenties, the era when a proliferation of publicity photographs was new. For example, she could have seen Asta Nielsen on stage and screen, in photographs reporting on or publicising her performances in the newspapers, in 'candid' shots in *Die Dame* and other magazines, and in advertising images. To repeat such images of an admired star in an avant-garde context was to participate in this pleasurable reproduction. However, to deconstruct a Weimar reportage scene using elements of photojournalism was to counter the widespread reverence for the media and its technologies. To combine the two was to turn technological progressivism in on itself and, at the same time, to desire a new order set in motion by the female and the machine – representing an anger, a humour and an optimism specific to the twenties.

IV

How does this analysis of *Cut with the Kitchen Knife* pertain to present-day media interventionism? Unlike John Heartfield, Hannah Höch did not distribute her images through mass circulation channels, a strategy that would become more and more imperative as the mass-media boom continued and has become important today in our media-permeated society. Repetition, defamiliarisation, montage techniques and other strategies that earlier could have been considered critical are not incorporated into the media's sophisticated practices. Like the fore-grounded masquerade, defamiliarisation practices are already so much a part of our mass media that it is possible nightly to see popular American TV talk show hosts (hardly subversive figures) using the techniques of Brecht's epic theatre. For example, it is not unusual to see David Letterman casually bringing the camera behind the scenes to introduce the audience to the man who builds the sets (or, in Brechtian terms, interrupting the narrative flow to display the labour which produces it). Thus specific techniques which were revolutionary in the twenties have a different reception today. This raises the skeptical question of whether deconstruction of the mass media is possible today. I think not. Instead other strategies countering the media's stereotyping must be developed, ones offering alternatives and pleasures. The terms of interventionism have changed; with the increasing centralisation of today's media, there is an increased consensus on what gets covered and how, leaving out wide sections of contemporary society; poverty virtually does not get covered, for example; nor do possibilities for gender identities outside a particular and narrow range. Effective coverage of these excluded areas would mean a distribution on a par with that of existing mainstream media and would be above all an economic challenge.

Within the utopian goals of media interventionism, it is necessary to theorise feminist aesthetics and to address issues of gender identity. For this project, it is helpful to analyse material such as Höch's work which employs a radical montage of strategies of pleasure and criticality. Recently, feminist film theorists have begun to examine the revolutionary potential of female pleasure – earlier considered negatively as a sphere to which women were regulated in ways that shored up a male-dominated hierarchy and now re-thought as a position of difference and a platform for change. This investigation is based on the understanding that women have no position outside (masculine) culture from which to put forward a critique. So the feminine positions within must therefore be examined for their power, ambiguities and contradictions. Thus aesthetics of pleasure are considered for the ways they can motivate change through desire and can represent alternatives in feminine identity formation that allow for an oscillation in gender roles.[30] In this context Höch's *Cut with the Kitchen Knife* serves as a model in which the representation of female pleasure is

read as interdependent with that of a sharp societal critique to create a utopian allegory of revolutionary change.

This article is part of my doctoral dissertation, 'Hannah Höch, photomontage, and the representation of the New Woman in Weimar Germany, 1918–1933', at The Graduate School and University Center of the City University of New York, 1989, and it will appear, in revised form, in my forthcoming book on Höch's photomontages published by Yale University Press. Portions of it were given as a talk at the Frick Symposium, New York City, 1985. I would like to thank Atina Grossmann, Jo Anna Isaak, Rose-Carol Washton Long, Linda Nochlin, Kathy O'Dell, and Sally Stein each for a generous exchange of ideas which contributed to the development of this essay, which was completed in 1986. © Maud Lavin

The anxious artist – ideological mobilisations of the self in German Modernism

Irit Rogoff

One of the characteristics of the author-function is that it does not develop spontaneously as the attribution of a discourse to an individual. It is rather, the result of a complex operation which constructs a certain rational being that we call author.

<div align="right">Michel Foucault[1]</div>

Simultaneously neglected and maltreated, self-portraits have traditionally been viewed as the pictorial renditions of autobiographical experience and the visualisation of so-called 'psychological insight'. The following analysis attempts to deal with a historical genealogy of the self viewed through visual representations. It centres around the construction of an identifiable image of the male artist within the context of a set of specific German cultural ideologies which were articulated during the past century – between the founding of the German Empire in 1871 and the present – and focuses on the work of several artists who are representative of prominent artistic movements that have dominated the historiography of German art.

I have been increasingly struck by the fact that both in historical and in contemporary discussions and inquiries it is woman alone who seems to posess gender.[2] The many research programmes which are at present focusing on issues of gender theory are primarily preoccupied with notions of otherness, of sexual difference or deviation from the one, thereby leaving it – the masculine normative tradition – intact while exploring the many other identities and expressions which operate around it. While masculinity functions as the norm through which every form of otherness is defined, it remains untouched by attempted revisions to define it as another form of subjectivity and one given to innumerable forms of control and authority.

Following along these same lines self-portraits by male artists have been accepted as the standard representation of 'The Artist' regardless of gender or of any other form of differentiation. Whereas self-portraits by women artists – Paula Modersohn-Becker, Käthe Kollwitz, Rene Sintenis, Dora Hitz, Gabriele Münther, Marianna von Werefkin, Hannah Höch, Jeanne Mammen, Hannah Nagel, Ina Barfuss and Elvira Bach – would, among many others, be the historical counterparts of the male painters I am looking at here, they seem to be discussed in terms of their represen-

tation of the 'Feminine'. Patriarchal culture has therefore constructed a role for the male artist and a visual mode for representing that role which in turn have been accepted by cultural descriptive practices as the standard normative representation. Arguing against this normative concept I would suggest that such formulas of self-representation are discursively constructed by both artists and critics and that they form what Michel Foucault has termed an 'author-function':

> Critics doubtless try to give this intelligible being (that we call 'author') a realistic status, by discerning in the individual, a 'deep' motive, a 'creative' power or a 'design', the milieu in which writing originates. Nevertheless these aspects of an individual which we designate as making *him* an author are only a projection in more or less psychologising terms, of the operations that we force text to undergo, the connections that we make, the traits that we establish as pertinent, the continuities that we recognise, or the exclusions that we practice. [my emphasis][3]

In order to make some progress in dismantling this traditional and normative formulation, then, we must engage simultaneously with the discursive construction of 'the author' as well as with its inherent masculine identity and thus attempt to employ theories of sexual politics in an analysis of cultural ideologies. In negotiating such an approach this essay attempts to set up a metonymic relationship among a set of images, a set of historical facts, a set of cultural discourses and an interrogative engagement with the following terms:

the masculine
the public signification of cultural discourses
the construction of an author-function
the authority versus the marginality of the 'Author' within Modernism.

There is a particular importance attached to formulating and engaging in a discussion of the validity of these and other terms as they do not play a linguistic or other role in the traditional cultural discourse; for as Jonathan Rutherford states: 'Our language does not produce us, masculine culture, as sexual subjects or as a category in need of a label'.[4]

Each of these above-mentioned categories may, of course, function as an autonomous discourse within the context of various clearly distinguished sets of ideas, such as public sphere culture or theories of authorship. I would, however, suggest that part of the inherent interest in representations of self is that they assume the status of crossworks constituting a field of possibilities for other discourses in which issues of individual authority and its grounding in collective cultural aspirations, intersect. Thus, for example, we must acknowledge the visually documented co-existence of both cultural authority and signification of voice when analysing the way in which author-functions are constructed. Simultaneously, however, the historical location of the discussion within emergent Modernism inserts a seemingly contradictory dimension, that of the so-called marginality of the artist, which plays a consistently important role in the ethos of the Modernist movement. The intersection of

117

these historical and conceptual terms in which self-portraits are to be located, works to expand their significance beyond that of works of art within a specific genre. Instead they can be perceived as assuming the role of language in the signification of a variety of cultural, ideological and gender discourses. Thus they emerge as more than works of art attributed to a specific artist and forming part of an artistic *oeuvre* and become cultural hallmarks communicating information about culture, cultural allegiances and modes of legitimation, transmitted from artists to audiences.

In acknowledging the construction of author-functions and the discursive quality of authorial signification, this discussion rejects the prevalent notion that self-portraiture can be viewed as an autonomous humanist tradition located outside a specific historical time or a specific national, social or cultural context. In contrast I would propose that elements of pictorial reference to a previous artistic lineage are arrived at through a rigorous process of selection in which previous artists and historical periods are invoked as a form of contemporary reference rather than as a form of traditional continuity or of artistic homage. The reference therefore is made from the point of view of a contemporary discourse and the genealogy of the self is transformed into a history of the present. Rather than the expression of a profound admiration for the individual 'genius' of an earlier artist, what we are in fact seeing is the use of quote and reference to previous self-representations of male artists who have achieved mythical status, as forms of self-legitimation. Capitalising on the discursive practices of cultural history and the artistic lineages which have set up these images as the flag ships of patriarchal culture, younger generations could proceed to invoke these as the significations of cultural authority. At this point an effort must be made to distinguish between the establishment of cultural authority and representations of authoritarianism, two very different phenomena which are all too frequently collapsed into one another. The difference lies in the fact that cultural authority is not necessarily determined by the direct subjugation or the domination of the other, as in the case of authoritarian mastery, but rather by the attainment of privileged insights and the aura of uniqueness supposedly conferred on the male artist by the creative process. This form of cultural authority can therefore encompass cultural personas which we would rarely associate with any form of civil authority – such as that of the 'mad genius', the 'transgressive bohemian' and the marginal 'outcast'.[5] In all of these socially constructed personae, conjunctions occur between 'authority', 'vision' and the masculinity which allows these artists access to a public sphere discourse as agents of mediation between private vision and public experience.

Aside from the establishment of this form of visually coded cultural authority, reference is also a way of establishing a textual familiarity with the culture as a whole, from which specific personal choices and selections

can be made. This form of reference is therefore also akin to the possession of language and the ability to construct a discourse out of the components of the culture, which is in itself another mode for establishing and employing cultural mastery and the authority which it confers.[6] While all of these ultimately result in a form of empowerment, I would however argue that it is overtly aimed at the valorisation of a publicly constituted individual voice – as opposed to the establishment of the forms of subjugation which we normally associate with authoritarianism. It must however be said at the outset that such a culturally constituted voice is obviously also restricted to certain class practices and privileges which embrace the possibilities for both cultural literacy and cultural self-determination. It is precisely for these reasons, allowing us insights into a production of individual, artistic and publicly constituted masculine authority under the aegis of the supposed marginalisation of the artist within Modernism, that this analysis can prove useful.

To begin with, we must locate which public debates on the role of art and artists and which sets of ideological considerations and public expectations have been most instrumental in shaping artists' images of themselves. This course of investigation has revealed that the ideas most germinal in forming male artists' perceptions of their role are by no means confined to aesthetic theories or stylistic affinities. Rather they form the visual codifications of the artists' interventions in a series of social and political transitions and in their cultural manifestations. The argument presented, therefore, is that these works form a pattern of signs and significations of the masculine self and its cultural authority and that they gain their potency and contemporary relevance from their interaction with specific cultural ideologies at given historical moments.

Finally, woven into the fabric of this argument is a consciousness of the degree to which visual representations of the self and their critical reception, of which both are grounded in prevalent cultural ideologies, have resulted in a predominantly public self as well as a predominantly male self. Since women artists of the pre-war era did not, on the whole, take part in the public dimension of such wide cultural aspirations as those delineated by the ideologies discussed here, the consequent public role of the artist and its representations are inscribed with gender differentiations long before they assume the form of portraits of male artists. This is equally interesting when examining the representations of women who have been incorporated into self-portraiture in a variety of ancillary roles such as those of models, family members or colleagues as well as the subjects of works displayed in the background. In many such cases we find carefully structured images of the artists' private lives intended for public display and formulated in response to public expectations rather than as a reflection of private realities. Furthermore, exhibition and sales practices of supposedly 'private' images such as these place them firmly within the realm of the public cultural sphere. It emerges therefore that it

119

is not only the gender of the artist which determines the masculine character of the public self but also the use to which female figures are put within this construct. As Carol Duncan has argued, representations of creativity are clearly linked to virile domination of female figures with modernist practices.[7] Similarly the construction of a culturally authoritative self is equally founded in forms of subjugation, not all of it sexual in nature, in which these various female figures are consciously portrayed as ancillary participants in the artist's project. It is perhaps at this point that the internal shift from cultural authority to authoritarianism can be more clearly discerned.

What, then, are the patterns of intention, the strategies and the inherent discourses which are brought to bear on this body of works by Böcklin, Liebermann, Corinth, Kirchner and Immendorf? Certainly they are statements of artistic credo and must be viewed in relation to the artist's other work, both stylistically and thematically. Equally, they must be seen as the documentation of the shifts in both the status and the position of the self within the Modernist trajectory. Any such discussion must include use of our increasingly detailed understanding of the relationship between the individual and the social organisation of culture which serves to mediate these representations. Historically, it points to the increasing erosion within Modernism of what would previously have been considered the boundaries of private life. The attempt to locate specific constructions of the self and its representations within this shifting arena of differentiation between public and private may be formally articulated as forms of cultural ideology but equally it incorporates a transition from what Richard Sennet has defined as 'terms of eroticism which involve social relationships to terms of sexuality which involve personal identity'.[8] That these transitions have a clear visual dimension becomes apparent when we examine several key works of self-representation from the past century. In these, differing modes of both increasing detachment and proximity to the structuring social order and debates on the supposed autonomy of the artist are visually articulated.

In *Self-Portrait with Violin playing Death*, 1872 (plate 8.1) Arnold Böcklin produced the seminal image of the *socially* autonomous artist. This image, which became the point of reference for several generations' artistic discourse on the autonomy of the creator, the marginality of the artist and on his relationship to the social whole, was essentially a statement of artistic credo. Within it Böcklin combined northern and southern artistic heritages, simultaneously secularising the religious meanings of the *Totentanz* into a form of contemporary egalitarianism and subverting the Romantic concept of privileged artistic vision, using all of these reinterpretations in order to extract the artist from his subservient and confined social position. In this work Böcklin portrays himself as 'close to the edge' in a variety of ways; poised at the very foreground of the work he is listening intently to the figure of death in the

form of a skeleton playing a one-stringed violin behind his shoulder. This figure, which in the traditional form of the *Totentanz* plays the role of making socially polarised figures equal before the power of death, is here used to lend an aura of individual uniqueness to the figure of the artist and remove it from the realm of social differentiation. Rather than having a power of finality over him, the proximity to death seems to serve as a representation of a source of artistic inspiration, while rendering art and its makers exempt from the laws affecting other mortals.

In departing from the conventional formulas of collective identity, Böcklin rejected the dominant German artistic tradition of the 'friendship portrait' in which the interaction between the protagonists and their collective identity takes precedence over the import of the individual.[9] Similarly he rejected participation in the collective enterprise of the official court patronage system, a guild-like existence in which many of his Munich colleagues, such as Wilhelm Kaulbach and Franz Lenbach, took part and prospered in the mid-nineteenth century.[10] Following his

miserable experiences under royal patronage in Munich in the 1850s,[11] under ducal patronage at the Weimar Academy in the 1860s[12] as well as with a few bourgeois patrons who commissioned works and were horrified at the results to the point of refusing payment,[13] Böcklin began consolidating the correlating elements between his subject matter, his painterly modes and his stance as an artist. Even at this early stage every aspect of his project was already inscribed with an understanding of the uneasy relation of the centre to the margins within culture and with his perception of the inherent ambiguity of the marginalisation of the artist. To begin with he left Germany for Italy and began the formulation of an artistic idiom which Kenworth Moffet has described as a 'pagan nature mythology'.[14] In this the Swiss born and educated artist was greatly influenced by the thought of his Basel contemporaries Jacob Burckhardt and Johan Jacob Bachoffen and through them by the early work of Friedrich Nietzsche who from 1868 held the chair in classical philology at the University of Basel. I would like to suggest that Böcklin's systematic search for a visual codification which would break through the stagnation of academic mythology painting had a great deal to do with the particular brand of cultural pessimism which was being developed by his friends and colleagues in Basel.[15] Their deconstructive work regarding the development, construction and representation of western culture provided the basis for one of cultural pessimism's most comprehensive and wide-ranging critiques of modernity in the second half of the nineteenth century. It was in Basel during this same period that Burckhardt was formulating a humanist revision of the genesis of high culture, Bachoffen writing on the evolution of belief systems and the substitution of the original earth mothers with male sky divinities in classical religions and Nietzsche launching his vehement rhetoric of the negation of scientific, rational epistemic systems as governing principles of life. Moreover, Germany, with its far greater and more rapid drive towards industrialisation and urbanisation than their native Switzerland, became the symbolic sphere for this destructive process in the eyes of the cultural pessimists.

The articulating historical context – that of the founding of the German empire to its demise in 1918 – is one which embraces the German nation's struggle to come to terms with the imposed forces of Modernism. The transition from 152 small and autonomous dukedoms, principalities and electorates into one nation had been a long-standing aspiration which can be traced back to the forces of the Lutheran Reformation. When it finally and tortuously came about in the wake of the Franco-Prussian war of 1870 it did not provide the longed-for social or cultural cohesion and unity which had been articulated by political and critical polemics as its utopian goal. The political, military and economic machinations of Bismarck had created an infrastructure which could be viewed and presented as the public façade of a nation. They also generated a belated

and therefore particularly extreme and abrupt rise in industrialisation and urbanisation with their ensuant demographic changes and breakdown of traditional patterns of kinship and social institutions. Within this framework, the processes of modernisation, which did not satisfy either the longed-for unity nor bring about a wider scale of participation or representation in political life, came increasingly to be perceived by social and cultural critics as a severe form of crisis: the crisis of Modernism. The missing dimensions of this so-called unity were judged to be those of cultural cohesion, authenticity (as opposed to commodification) and wider cultural as well as political representation. Such representation would extend beyond the centre to the peripheries and beyond the court and aristocracy to other classes and would provide a more accurate reflection of social realities.[16] These critical views of emergent modernity became the focal point for several generations' cultural pessimism.[17] Amongst the many critiques launched within this critical climate there also occurred a revision of the role of the artist as well as a process of his elevation to the rank of moral guardian and spiritual leader. To some extent the works of several of the artists I am discussing here were a part of a series of cultural projects at whose centre lay a critique of the contemporary practices formed by social and political realities and their cultural manifestations. These critiques embody an uneasy tension between a critical engagement with the centre and an insistence on a form of marginality which in turn guarantees autonomy. Not surprisingly, the issue of critical distance is first perceived as geographical, and only late in the nineteenth century do the possibilities for an overtly critical form of cultural production, which functions from the inside, become consciously apparent. Thus for example in a letter of 1861 to Burckhardt, who was both a close friend and an important patron, Böcklin wrote:

Since I have learned to know Germany, the German disposition, German education, art poetry etc., as I have gradually gotten to know these, so have I wished that I could immediately take the first Express train to the uncivilised South ... If only the Gods would give me a still place where I could live my life unwarped, I would like to observe and create and keep myself distant from all the art rabble.[18]

Aside from geographical distance there was the social distancing, which would enable him to avoid the class stratification of his native world and the cultural patronage constrictions which these in turn dictated. Above all he hoped to effect a distancing from numerous layers of conventional cultural reception of both mythology and Christianity. Together these two spheres provided the iconographic artistic formulas for the representation of the combined forces of order, reason and the European spirit.

Böcklin's choice of subjects are particularly interesting since he eschews all the familiar heroes and heroines of mythology in favour of marginal and more obscure figures who possess little in terms of received characteristics. The familiar figures of antiquity had become in the mid-nineteenth

123

century the signifiers of narratives appropriated by contemporary European culture for its own use. In Böcklin's mature style the heroes of classical antiquity have been banished and not an Apollo, Zeus or Mercury is evident in any of the works. The figures which Böcklin chose instead provide an alternative construct of the senses as opposed to cultural values, namely a representation of sense gratification, be it of pleasure, aggression or eroticism. The figures which he chose as these representations, those of Pan, nymphs, fauns, satyrs and centaurs, may have had accepted physiognomic properties and behavioural characteristics but very little structured narrative to contain them. By privileging an alternative and marginal set of visual representations over the accepted heroes and heroines of classical mythology, Böcklin also dispensed with the entire gamut of contemporary cultural value constructions inherent in the mythological narrative as formulated by Winckelmann and his followers as the representation of the highest aspirations of the western spirit.[19] This process of negating concepts of permanent harmonies and eternal truths, which had been claimed on behalf of the so-called western spirit or of its construction within German nineteenth-century culture, led Böcklin to the replacement of pictorial discourses of order with discourses of disorder. Böcklin did not perceive cultural formulations and cultural activity as a continuous celebration of the achievements of one informing spirit but rather as a series of ruptures and confrontations in which the artist is linked to a collective unconscious that by-passes the prevalent cultural hierarchies. His practice of drawing on a wide range of diverse cultural sources was deemed barely acceptable by his critics, precisely because he had extracted his images from their traditional readings and therefore was seen as subverting traditional cultural narratives. In the 1872 self-portrait, therefore, we find him drawing simultaneously on the northern tradition of *vanitas*, with its iconographic components of skull and mirror reflection, as well as on the pagan-inspired tradition of the *Bacchanalia*, with its engagement of subliminal and unacknowledged energies which are culturally coded as in visual representations of music.

The project which Böcklin embarked upon as a painter was imbued with a sense of mission to reclaim both nature and culture via a revision of the cultural origins of their representations. In this he enlisted the image of self constructed by the earlier romantic artists in which an emphasis is put on distancing the self from everyday realities through the visual invocation of concepts of 'vision'. In *Self-Portrait with Wife* (plate 8.2), Böcklin, supported by his visibly awed and devoted wife, rejects both culture and nature (in the form of the Roman Campanga and the ancient houses on the outskirts of the city) and gazes into the far off distance from whence apparently comes inspiration. Woman here is posited as both nature and as a representation of certain acculturated behavioral norms such as marriage, support and companionship. The gestural code through which the two engage, however, depicts the actual relationship as one

which may be recognised by the artist as necessary but does not consti-
tute the spiritual reality in which he is truly anchored. The inherently
masculine nature of the creative spirit is here visually codified, as is the
rejection of the concrete spirit of nature which he perceives woman as
embodying. The autonomous artist, according to these works, is there-
fore founded on cultural ideology; his creativity and masculinity are

8.3 Hans Thoma,
Self-Portrait with Cupid,
1875

intertwined and his authority derives both from the subjugation of his context and from his heroic ability to transform nature into culture.

The links between creativity and death which Böcklin established in these works are at once more egalitarian than that put forward in the romantic tradition (i.e., the overt link with the tradition of the *Totentanz*) and at the same time codify a heroic, almost militant stance. According to Foucault, 'The work [of art], which once had the duty of providing immortality (as in the Greek epic tradition, or at least of warding off death as in the Arabian narratives) now (with the advent of modernity) poses the right to kill, to be its author's murderer as in the cases of Flaubert, Proust, Kafka etc.'[20] The heroic stance is therefore linked to a defiance of this deathly potential. Böcklin posits the artist in the context of a dare-devil, death-defying stunt in which he confronts the deadly powers of art and emerges the victor. So successful was Böcklin at constructing this unique representation of cultural heroism, that towards the end of his life Stephan George celebrated it in a poem –

Only You have continually stoked,
we thank you oh Guardian,
the fire which we in a colder time, extinguished.[21]

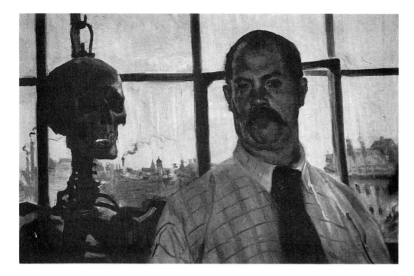

8.4 Lovis Corinth,
*Self-Portrait with Studio
Skeleton*, 1886

Throughout the entire period being discussed, the centrality of the particular image of the artist and death described above highlights one of the main themes within self-portraiture: that of the tension between the marginality and centrality of the artist as defined from within the culture. Again and again this theme was interpreted by artists of consecutive generations as visual explorations which located their artistic activity as alternatively constituting a process of inclusion in or exclusion from the general cultural enterprise. In each case we find that the discussion of artistic marginality provides a critical position from which to view the activity at the centre and the artist's relation to it, occasionally coded in terms of the dominant artistic and stylistic school. Iconographically this theme is taken up, for example, by Hans Thoma (plate 8.3, *Self-Portrait with Cupid*, 1875) who places himself within a far more organic context than Böcklin had: a framework of nature and of mythology represented by the Putti in the tree, thereby subduing the dance of death by transforming it into a cultural realm. Lovis Corinth for his part (*Self-Portrait with Studio Skeleton*, 1886) submits this theme to a Naturalist reading in which the studio setting, the closely observed Munich background and the robust and defiantly live figure of the artist with checked shirt and ruddy cheeks all serve to update the romantic pose struck by Böcklin and transpose it into the realm of contemporary preoccupations (see plate 8.4). Nevertheless, without that previous reference as a point of departure, the image loses much of its potency as a contemporary, secular updating of a traditional sanctified theme and as a means of locating Corinth as either rebel, innovator or traditionalist. In the generations of artists which follow Corinth we find that it is marginality as both an identity and a narrative form which becomes an increasingly prominent preoccupation in self-portraiture, while an orthodox narrative framework is dispensed with to a great extent.

127

8.5 Max Liebermann,
Self-Portrait as Cook, 1873

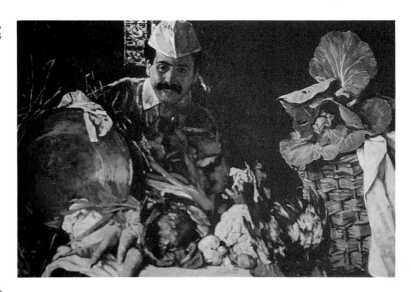

8.6 Max Liebermann,
Self-Portrait in Studio,
1902

Marginality within Modernism as charted through these representations of self was consistently a form of cultural criticism as well as a trope which could articulate specific social and political forms of exclusion. The self-portraits of Max Liebermann, in particular, lend themselves to a critical analysis since the traditional literature has often depicted them as an artistic achievement of a particularly normative nature.[22] It seems that within such readings these works are celebrated for giving visual expression to the increasing professionalisation of the artist and to the location of that process within bourgeois social stratas. As such they are perceived to uphold a safe, aloof and undisturbing code of adult professional behaviour which provides reassuring alternatives to images of dangerous artistic marginals and deviants who inhibit the *sub-judice* sphere of bohemia. His *Self-Portrait as Cook* (plate 8.5), completed in 1873 upon his graduation from the Weimar Academy, takes the issue of professionalisation to slightly comic extremes but nevertheless serves to stress the point of the presentation of self as skilled, competent and rooted in the supposedly real world of work and achievement. Again this emphasis on a normative standard of behaviour valorises masculine professionalism and relegates the feminine to a position of passive consumption of culture. Thus when Liebermann includes his wife and daughter into his portraiture, as in the *Self Portrait in Studio*, 1902 (plate 8.6), they are always the passive consumers of books and other cultural entities, providing the mainstay of a domestic economy of culture. He, on the other hand, is the fully professionalised mediator between the external social order in which he is a full participant and the internal domestic order which they inhabit in a state of preoccupied, unfocused abstraction.

Liebermann the Naturalist (photo, plate 8.7) depicts himself as committed to truth without ornament and to the visual codification of a reality experienced by those who had previously not figured as a represented part of the official culture. During the period between 1873 and the early 1890s he painted a large number of compositions depicting autonomous and inward-looking peasant communities. In these he provided a visual code of identity for a sector of society which had previously reflected only the folkloristic reveries of the bourgeoisie, whose preferred view of the peasantry was one of a quasi-mystical and extremely sentimental union between the people and the land. Moreover, he also depicted them primarily as engaged in work and therefore as taking part in the activity in which both their economic and social realities were defined, as well as their concrete relation to an urban, industrial bourgeoisie. However, it was the pictorial mode through which he did this (*Workers in a Turnip Field*, 1876, plate 8.8), in which the working groups are formulated as rejecting any visual engagement with the bourgeois viewer and therefore insisting on a form of autonomy, which proved most shocking to the critics and audiences of his early work.[23] With these representations the artist and his discourse became class specific and consciously differen-

Irit Rogoff

8.7 Photo of 1894, Liebermann, local model and painting of 'Striding Peasant'

8.8 Max Liebermann, *Workers in a Turnip Field*, 1876

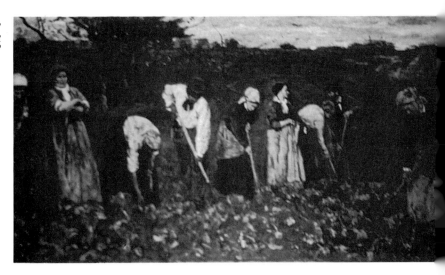

130

tiated and his role assumed a socially mediative aspect, negating the inherited values of culture as the forum in which only one dominant class's values could be reflected. Liebermann's early work served to combine these contemporary socio-political preoccupations with his personal heritage of the values of Prussian sobriety, bourgeois work ethic and the Judaic legacy of communitarianism and internal social responsibility. Through these images the artist posited himself as a committed observer as well as a mediator between the divergent cultural and economic strata of the Wilhelmine society he was part of. These representations of working peasants, combined with his later cultural/ political activities as president of the Berlin Secession and attempts to transform the Berlin art scene into one of greater internationalism, served to bring about another, extreme form of marginalisation. His energetic efforts of behalf of public sphere culture funded by the rising bourgeoisie of Berlin made him the focal point of numerous attacks by both conservative and anti-Semitic elements. While the Kaiser pronounced him to be a dangerous anarchist, hundreds of caricatures depicted him as either part of an exclusive Jewish conspiracy or as a sinister conspirator on behalf of foreign, un-German culture[24] (see plate 8.9). The case of Liebermann can be used to illustrate the complex dialectic between centrality and marginality as reflected in the social positioning of 'the artist'. Thus, in the emergent modern language of cultural criticism, the margins themselves serve as a referent to the centre without which they could not exist. Furthermore, any articulation of marginality is by definition part of a critique since it is inscribed with the issue of exclusion. Thus for example the classic literary texts of marginality, such as *Daniel Deronda*, *Middlemarch* or Proust's *Swann's Way*, bring forth greater insight into the centre's practices of exclusion and to the cultural workings of power than to a body of knowledge concerning the specifically excluded. Indeed, this is by definition a shifting body of knowledge, dependent on specific excluding factors which vary in each historical and social case and which are therefore difficult to subject to a form of general thematisation. (The one exception to this would be that of gendered marginality, which encompasses certain constant power relations which are reformulated rather than redefined within different historical frameworks.) Functioning as constitutive elements within a given culture, the works discussed here serve as markers of the constant absences and exclusions which any supposedly monolithic culture practices as part of its process of self-definition.

Liebermann's self-portraits, which seem to uphold all the basic values of the turn of the century enlightened Prussian bourgeoisie, are in fact an attempt to bridge the gap between his own position of critical marginality and the power base of the centre. This position is further complicated by the fact that the centre is both the articulating context of his work and its potential audience, the source of another internal Modernist contra-

8.9 'Liebermann, the Waiter
of the Secession', *Jugend* 8,
6, (1903)

diction for progressive and avant-garde artists. At this point, however, we could characterise Liebermann's work as founded on the perceptions of one class's and one ethnic group's relation to another, and stemming from a critical analysis of social/cultural placement articulated as the relation of the marginalised to the cultural power workings of the centre. Viewed as either a critical member of the upper middle class or alternatively as a discoursing constituent of emergent public sphere culture, Liebermann nevertheless formulated his critique from within the existing social order. I would like to suggest that Liebermann's dozens of sober, enigmatic self-portraits (see plate 8.10, *Self Portrait*, 1916) formed a strategic response to the public fear and anti-semitic defamation of his

activities as both painter and cultural activist. This policy of reassurance becomes all the more clear in view of the pattern of exhibition and sales policy established and shows that they were logistically placed in important private and public collections in order to promote a safe and solid bourgeois public image of the artist. In a memoir of his Frankfurt youth, Elias Canetti documents the cultural status of works by Liebermann to bourgeois patrons via the story of a visit to the home of the Wertheim family, owners of one of Germany's main chain stores:

8.11 Max Liebermann,
Self-Portrait with Family,
early 1920s

Wertheim's father owned a big clothing store. We were invited to their home on New Year's Eve, and we found ourselves in a house full of Liebermanns. Five or six Liebermanns hung in every room; I don't believe there were any other paintings. The highlight of the collection was a portrait of the host. We were charmingly regaled; it was nice and swanky. The host had no qualms about showing his portrait. He spoke – audible to everyone – about his friendship with Liebermann. I said, no less loudly, to Baum: 'He sat for a portrait, that doesn't make him his friend by any stretch of the imagination.'[25]

The degree to which this type of author-function is discursively rather than stylistically (as a function of so-called artistic intentionality) constructed can be illustrated through a comparison of two representations of self by Liebermann and Corinth. Both these artists are traditionally affiliated with Naturalism; they were the two leading members of the Berlin Secession in its founding years and they have often been presented as participants in a similar artistic project. The complete contrast between these two representations of self can be seen in a comparison between Böcklin's self-portrait with his wife and those of Lovis Corinth and Max Liebermann with their families (plates 8.11 and 8.12). Corinth uses this image primarily to document the achievements of status and social position. Having moved from Munich to Berlin in 1901 and joined the circle of the Secession, he established himself as a major artist in the capital. He had also, as he states in his diaries and in this image, 'acquired' a young wife and a family, thereby grounding himself both personally and professionally in his new life.[26] The artist portrays himself in the act of painting; he waves his brush and palette excitedly above the head of his family in an act of transfixing them through his gaze. They are both the subject of his painting and the subjects in his domain whose purpose is to somehow document his achievement. The painter's wife, Charlotte

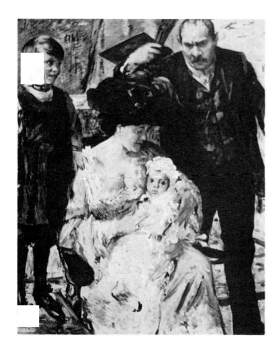

Behrend, herself a promising professional artist and here described in a
highly theatrical stereotype of wife and mother, is attired in layers and
layers of frothy frills and laces, her huge brown picture hat serving as a
form of protective covering over her young family. By contrast to this
form of artistic authority through the domination of the private domain,
Max Liebermann, in a portrait of himself and his family (early 1920s),
documents the comforts and cultural plurality of the bourgeois environ-
ment in which painting, reading and conversation can be pursued
autonomously as the natural activity of everyday life. In the Liebermann
family portrait, which is founded on the sober Prussian tradition of the
portrayal of *Abendgesellschaft* (evening company) gatherings, the family
comprises individual members pursuing his or her own interest rather
than functioning as one overall performing unit. He, in his previously
discussed 'professionalised' mode, sits aside from them, clad in a white
coat and observing the dynamics of this domestic economy of culture.
The comparison between the two serves to focus our understanding of the
different ways in which the cultural enterprise is perceived by these two
Naturalist painters; for Corinth it is a theatrical realm to be conquered
and dominated through the striking of heroic artistic poses of a specific-
ally masculine nature, while for Liebermann it is a public sphere of
activity which functions through a mutuality of differing modes of
expression and which can be inhabited through the various activities that
make up an existence. This too is a gendered division in which, as

135

discussed earlier, separation between professionalised, active masculinity and dilettante, domesticated femininity serve as a main axis of the cultural trajectory in its domestic manifestations.

The roles both of these artists assume are discrepant if not actually contradictory and yet their overall artistic enterprise is usually described as common. In actual fact what does emerge as common is the role that these visual representations of self played within their wider cultural discourse, attempting to mediate between the public and the private realms through the construction of one coherent role which would encompass their cultural, political and masculine perceptions of themselves.

In contrast to such authorial positions of critical participation in the cultural enterprise as put forward by Liebermann, we can posit the increasingly radical construction of the exclusive, unmediating marginality of the avant-garde artist as articulated by Ernst Ludwig Kirchner. The difference between these two positions could be described as that between criticism and critique. While the former is evaluative and corrective in nature the latter interrogates the paradigms within which the culture is produced and experienced. The earlier critical speculation, described above in relation to Böcklin and Liebermann, focused on the inter-relations between the existing social order's constituent components while the later critical transition to avant-garde art lay predominantly in that the avant-garde artist challenges the terms of reference which structure the social order. With this form of bohemian marginality, the avant-garde artist questions and erodes all the traditional cultural constructs in which the artist could be sited, resulting in a distinctly modern, autonomous identity into which gender, sexuality and voice – rather than a set of social relationships – are inscribed.

In Kirchner's *Self-Portrait as Soldier*, 1915 (plate 8.13), which derives from the artist's experience and perception of war as total breakdown, he arrives at a visual formulation of its devastating effect. It is the interior-isation of the war's impact on himself which does away with any remaining possibility of separation between the artist and the man, between the social, the sexual and the artistic. The process by which Kirchner arrives at this pictorial formula also encodes a set of critical social perceptions which had previously not been incorporated into a discussion of the self. The previously discussed image of death, for example, has been interior-ised into the body of the artist and takes on a form of auto-destruction. This fictive destruction, the amputation of the artist's right hand in this instance, becomes a manifestation of the marginality of selfhood under circumstances of a dehumanising collective regimentation of men by society – that is, war. The painting, which depicts the fictively crippled painter dressed in military uniform and flanked on either side by a nude model and a painted canvas, puts forward a range of consequences of the facts, formulated as a series of binary opposition. Thus the physical

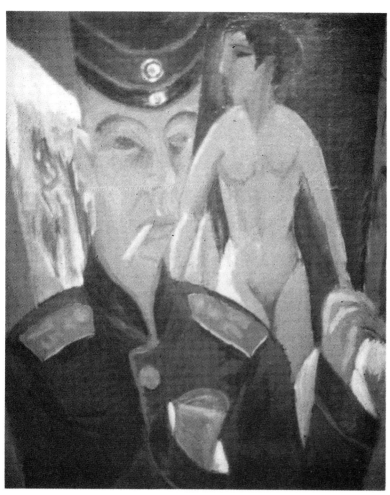

maiming of the artist, itself a fiction, is related simultaneously to the enforced subduing of both artistic drive and sexual drive. Such binary configuring of voice and virility or creativity and castration are further linked to issues of domination and subjugation. The domination of the much smaller naked figure of the model on the right is directly connected to her construction/production as the artwork on the left. Simultaneously he himself is dominated, subdued and constructed by the external social order which has attempted to transform his identity from artist to soldier. The impotence which the painter invokes through this analogy is depicted as a form of passivity and victimisation and yet this is belied by the active belligerence evoked by the uniform he wears as well as by the subjugation of the female model who is reduced to the size of a studio artifact. The result of this set of binary modes at work within the painting is that the collective maleness evoked by the uniform and its social/historical

137

signification negates and cancels individual masculine virility and creativity. To my mind, there is within this attempt to give visual form to a set of internal conflicts, the beginnings of recognition of the way in which representation constructs meaning. In each of the dualities discussed above we are presented with a semblance of 'the real' which is immediately juxtaposed with its own representation, as in the case of the model and the art work. The constructed representation of the artist, whose 'reality' is art, is the socially constructed soldier. The visual signification of this internal and heroic conflict between content as 'real' and signification as constructed by external reality is one of the mainstays of the masculine cultural heroics which dominate Modernism as a movement and avant-gardism as a form of marginalising/marginalised artistic struggle. In many other works of the period we find a process of destructive interiorisation, a depiction of a self-contained outsider who turns in on himself with the energy that is born out of the conflict between a position of marginal individualisation and the desire to play a substantive, often critical, social function. Finally this image reaches its apotheosis in the most extreme gesture of marginality; the killing of the self. (For example, Arnulf Reiner, *Self-Portrait Dead* and Rudolph Schwarzkogler, *Self, Action 1965* – an action in which the artist castrated himself on stage and caused his own eventual death.) In the work of both of these 'Extreme' Austrian artists, death enacted upon the self is formulated as the last line of social and cultural opposition and resistance, a visualisation of what Foucault termed as the 'ultimate act of marginality – the killing of the self'.

Throughout this entire series of images we can trace a continuing dialogue with the terms set out by Böcklin which locate the unique and individual entity of the artist as existing marginally and unprotected on the edge of being, simultaneously inspired and endangered by his vision. The representation of so called 'artistic vision', then, both contributes to a marginalisation of the artist within the social order while simultaneously providing a heroic dimension to his project. It is, however, the specific issues of differing cultural ideologies which serve as the mediating agencies between social specificity and representation.

As in the seminal image formulated by Böcklin, so the somewhat later images which emerged from painting influenced by *Völkish* ideologies at the turn of the century are founded on such contradictory opposites. Culturally pessimistic and fearing industrialisation and urbanisation as the destruction of traditional values, *Völkish* ideology's rejection of rational, scientific and pragmatic thought was invested with a search for a new form of primitivism. One which, as Fritz Stern has analysed as arguing, would follow up the destruction of existing society with the creation of a new society based on art, genius and power and which would serve to give expression to some form of elemental, rather than constructed, passion.[27] Such configurations of art, genius and power with the redemptive attributes of culture as those voiced in the early writings of

Nietzsche and in the ranting, incoherent polemics of such *Völkish* ideologists as de Lagarde and Langbehn created new possibilities for the role to be taken up by the artist (see plate 8.14, Corinth, *Self-Portrait – The Victor*, 1910). However, it is important to assess the degree to which this role served as an *illusionary* negation of artistic marginality. In the combative stance assumed by Corinth, here clad in a suit of armour, the conflict is located outside of the artist. The enemy without is identified as being the entire upsurge of contemporary culture and the tools with which it can be defied and vanquished are the nostalgic trappings of medieval

139

myth and the opulent evocations of the baroque. These then are indicators of power as well as of cultural rootedness which fully justify Fritz Stern's description of this set of cultural ideologies as yearning for a secret emperor, a great artist-hero who would provide the long-awaited internal and cultural unity which had not been achieved through Chancellor Bismarck's provision of the external trappings of national unification. At another level this visual codification of power is enhanced by the blatant sexual aggression and domination depicted in this and other works. Under the guise of quote and reference from the baroque pictorial convention of juxtaposing glinting metallic surfaces with creamy flesh textures, the painter in armour asserts his dominance over the vulnerable nudity of his wife. Sexual aggression therefore aids cultural combativeness in reassuring the artist of the power and potency of his artistic vision. I would argue that in fact what is reaffirmed is the inherent marginality of the artist, since the entire enterprise, which is so succinctly codified in Corinth's blustering posings, is robbed of contemporary relevance precisely through its frame of historical reference. By formulating the imagery through a set of backward projections the artist has in fact abdicated the possibility of playing a substantive social role within a contemporary set of developments. Also evident is an increasing awareness by artists that modernity perpetuated the traditional, romantic marginality of the artist into new realms of social and sexual specificity and that this could be counteracted in part by regressive and conservative nostalgia. The other mode for counterbalancing the continuing erosion of a culturally legitimated public self is through a pictorial assertion of aggression and domination, and it is at this point that the inevitable slippage between the authority of the author and forms of cultural authoritarianism occur. For an artist such as Corinth this constitutes a form of vision – aggressive, backward and nostalgic – which he can nevertheless posit as a form of artistic empowerment.

The early Expressionist project equally attributed potential power to art and to a revolution of consciousness that was forward looking and time specific. 'As Youth', said Kirchner in 1906, 'we carry the future and wish to create for ourselves a freedom of both life and movement against the long established older forces. Everyone who directly and authentically conveys that which drives him to creation, belongs with us.'[28] The confrontation here outlined by Kirchner and the Brücke artists is both social and cultural, since it makes a stand against the academic conventions of both over-refined and overly objective art which does not serve as a vehicle for spontaneous expression. Since art was perceived as a reflection of the artist's entire being, the confrontation was extended to every realm of social existence. This form of confrontation took on the strictures of bourgeois codes of behaviour, of conventions prohibiting both sexual freedom and sexual self-expression as well as a refutation of the unassailable limitations and barriers of class identity. The self-

portraits which emerge are both confrontational and speculative, since they seem to attempt a formulaic accommodation of such supposed internal contradictions as power versus marginality, traditional concepts of artistic vision versus modernity which nevertheless work to construct one another. Furthermore they cut across social contextualisation and arrive at further levels of duality that deal with the gendering of subjects and the possession of voice. Returning to Kirchner's *Self Portrait as Soldier*, we can begin speculation on the consciousness of constructed author-functions. Thus we can interrogate the awareness of identity as a confrontational artist as being inscribed with gender (and as masculine by definition) and its representation as gaining a dimension of its power by contrasting itself with the feminine. However it is also apparent that the artist portrayed is aware that being constructed as an artistic text with a gendered voice has not resulted in total empowerment nor safeguarded him from forms of victimisation which are rooted in the social construction of masculinity. Marginality therefore has here been explored as far more than a social or artistic dynamic within Modernism which provided an alternative, bohemian sphere for avant-garde activity. Instead we find a series of speculations regarding the conjunctions of the possession of voice, the empowerment of artistic vision, and the establishment of sexual difference as elements which work to establish marginality *vis-à-vis* the social order. Creativity and self-expression, however, are romantically perceived within the early Expressionist project as able to accommodate some of these contradictions in working towards a coherent vision. It is interesting to compare this work with Gert Wollheim's 1921 *Female Self Portrait – The Golem*, in which the artist portrays himself as having interiorised a female dimension into his own entity as an artist (plate 8.15). Although he depicts the feminine part of himself as inevitable, as inevitable as the daily newspaper's incursion of reality into his artistic sphere, he nevertheless does so in the most standardised of sexual stereotypes. The female part is depicted through bare buttocks clad in transparent, frilly underwear, red stockings and elegant high-heeled black shoes. The resulting composite image seems to state a comprehension of the interiorisation of sexual and political incoherencies into the artistic self but it continues to represent these almost as forms of creative fodder to be subsumed and transformed into artistic activity.

Across the great divide of postmodernism, similarly codified preoccupations have emerged, together with pictorial references to early Modernism in the recent figurative painterly practices known in Germany as 'New Vehemence' painting (see plate 8.16, Immendorf, *Café Deutschland* 1983). The pictorial space depicted in these works is a reference to the traditional alternative sphere of earlier avant-garde culture within the space of café/cabaret/circus environments. However, these supposedly modest and peripheral sites then get invaded by the spectre of national histories and myths. In the anti-cohesive vein of postmodernism, Immen-

8.15 Gert Wollheim,
Female Self-Portrait – The Golem, 1921

dorf conflates these two opposites by locating central activity in the margins and thereby devalidating it. In what was originally a modest and peripheral cultural forum, Immendorf and his colleague Penck attempt to traverse the barriers of the Berlin wall by thrusting their (working) hands through it. Simultaneously, in another corner of the proscenium space, Immendorf dances convulsively while split in half, part fascist officer in black leather and part sixties radical in jeans and a T-shirt. The full forces of history have converged together in what had previously been a refuge which served to redefine external realities rather than to reconcile them. Their representatives are the figures of these two artists; visceral and boldly gesturing, they depict themselves as actually trying to physically grapple with and capture history. While these works are obviously related to a complex discourse on the recuperation of history through representation which has been taking place in West Germany since the late 1960s, I would like to relate them in part to the specific issue of self-representation and its links with prevalent cultural ideologies.

In 1972 Immendorf painted a self-portrait entitled '*I Wanted to be an Artist . . .*', 1972 (plate 8.17). Beneath a somewhat younger version of the artist dreaming of newspapers is scrawled the caption, 'I dreamed of

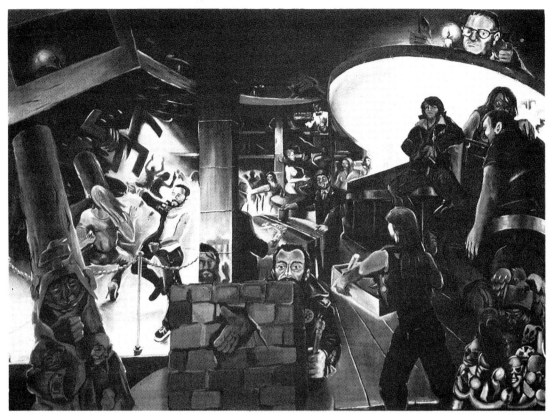

8.16 Jorg Immendorf, *Café Deutschland*, 1983

appearing in the papers, of having many exhibitions, and naturally I wanted to do something "new" in art. My guide [motivation] was egoism.'[29]

While the transcendent idealism and romanticism of the earlier Expressionist painters (whose work these paintings superficially resemble) has been replaced with cynicism, their status as reference points marking a journey towards false consciousness remains central. In his recent exposition of cynicism Peter Sloterdijk puts forward the following analysis: 'The formal sequence of false consciousness up to now – lies, errors, ideology – is incomplete; the current mentality requires the addition of a fourth structure: the phenomenon of cynicism . . . It violates normal usage to describe cynicism as a universal and diffuse phenomenon; as it is commonly conceived, cynicism is not diffuse but striking, not universal but peripheral and highly individual.'[30] Although the categories may be ones of disillusionment and futility, they are nevertheless used in order to depict yet another version of the socially constructed self grounded in historical specificity and endlessly preoccupied with representation's ability to construct cultural narratives.

8.17 Jorg Immendorf, *I Wanted to be an Artist*, 1972

The artistic modes which Immendorf practices in the making of these works also reflect attempts to integrate opposites into a working relationship. The size of the paintings, for example, all of them between 2 and 3 metres square, contain an emphatic reference to traditional history painting while at the same time referring to the particular brand of Socialist Realism which was being evolved in East Germany after the post-war division of the nation. On the other hand the simplified forms of the actual painting incorporate the lessons of clarity, legibility and accessibility gleaned from advertising and the media, and consequently confirm a commitment to the Modernist project and its aspirations. Furthermore, sexuality is not depicted in terms of identity but rather as forms of commodification and advertising stereotypes.

The space depicted – or rather delineated – tends to include certain round, proscenium-like circles, focusing the multitude of activities around a stage of a dance floor which emphasises the sheer artifice of the base on which he is constructing his visual discourse. Nor does Immendorf attempt to represent his efforts to accommodate several different histories within one frantic space as in any way successful. In another version of *Café Deutschland*, 1980 (plate 8.18), he and Penck inhabit the foreground of the painting, sprawled on the floor – felled by art. For all of their painterly and narrative bravura these paintings maintain a speculative quality since they do not make claims on behalf of preferred

8.18 Jorg Immendorf, *Café Deutschland*, 1980

accounts or the feasibility of historical coherence. In fact one senses that Immendorf is inscribing a similar dichotomy into the actual representational idiom he is employing, since both the supposedly regressive act of reference to the past in which he indulges himself and the operatic quality with which he does so are negated by the fact that he has no theory of history to present through this construct. Similarly there is a deeply ironic subtext to the overtly political/historical text in which he speculates on the holy status of culture and the importance attributed to its desecration. The jiving, writhing, assaulting and assaulted figures he portrays are placed in the opulent splendour of a theatrical set, thereby rendering the act of cultural presentation an empty gesture. This is accentuated by Immendorf's later self-representation as an artist whose vision is obscured (plate 8.19); the blurred double vision of the artist who has no social or cultural vision. And yet, do not all these bravura gestures of despair and blinded vision, all these claims to egoism and cynicism, finally claim to inhabit the arena of false consciousness in as heroic, masculine and authoritative a manner as did the earlier inhabitants of Modernism? A recent photo of Immendorf, Baselitz and Schnabel which illustrated a

145

8.19 Jorg Immendorf,
Self-Portrait, 1980

dossier on art put together by the prestigious weekly *Die Zeit* (plate 8.20)
shows the three artists stripped to the waist, sporting shaved heads and
adorned with punk-style jewellery (the two Germans) and a larger cigar
(the American). The picture is entitled 'The strong men of the art
market'.[31] Once again configurations of strength, virility, inspiration and
commercial muscle stride forward to conquer the arena of culture,
valorising the artist and pre-empting critical practice in their attempt to
produce an artistic subject for works of art and to market that subject
through a discourse that connects power, male sexuality and artistic
creativity.

This brief discussion of activity in the arena of visual self-represen-
tation within German Modernism has focused primarily on the conjunc-
tions between dominant cultural ideologies, the empowerment of artistic
vision and the perception of sexual difference. It has located these within
the growing internal contradiction of marginality and empowerment
experienced by the artist within Modernism. These have resulted in an
artistic discourse which has extended far beyond the chronicling of
personal circumstances or individually motivated artistic interventions. It
must be read as a form of interaction between the individual and the
culture as a whole in which self-portraits produce a constitutive, as

8.20 Photo, 'Schnabel, Baselitz, Immendorf – The strong men of the art market', *Die Zeit*, March 1987

opposed to reflective, cultural discourse. However, it is not the visual text as object or the artist as subject of that text, that form the main crux of this discussion, but rather the process of production of a dominant masculine cultural discourse within Modernism.

The female artist: attitudes and positions in West German feminist art after 1968

Gerlinde Gabriel

The exhibition *German Art in the 20th Century* at the Royal Academy of Arts was essentially about painting – expressive, figurative painting whose roots are primarily in Berlin. So far, so good. But this is only one aspect of German art. West Germany as a federal country does not have – and never really has had – a specific cultural centre. Instead, different sensibilities and consequently different concepts of art have tended to be formulated and concentrated in a specific city at a given time. What emerged from Berlin in the first two decades of this century was not the same as what came out of Munich. In the same way, art in Berlin is just one aspect of what is actually happening in Germany as a whole. Cologne, Düsseldorf or Hamburg all posit different alternatives.

Perhaps the most interesting areas artists worked in during the 1960s and 1970s were the less orthodox media of time-based work such as photography or video. Interestingly, cities like Düsseldorf or Cologne still have very strong traditions in these areas. But what is perhaps more significant is that women artists were drawn to these experimental media during this period and are still very active in them.

Much of the literature of recent years on women artists, particularly feminist literature, has been concerned with the polarisation between men and women, stressing the fact that in the search for new visual forms, for a new feminist consciousness, women artists have rejected traditional techniques such as painting and sculpture in favour of so-called 'anti-classical' modes. These are said to be not so culturally loaded. Until recently the history of art has been made exclusively by men and thus has also been defined and evaluated by male criteria. The new media, however, can be considered to be purer and more overt as they are not yet part of a clearly defined aesthetic. There are fewer preconceived expectations concerning the manifestation of the final work. They provide the artist with a wider field in which to manoeuvre.

In positing these claims one perhaps needs to tread cautiously, for such polarised positions tend to dismiss the broader context of art from which women artists gain their momentum, and the historical connection between trends in art and society. In the 1960s and 1970s Minimal Art and Conceptualism left little room for painting. During this period both men

and women were predominantly working with experimental media. It was a time of active engagement with the implications of alternatives. However, what is important to consider from the female artist's point of view is that this period also paralleled the enormous upsurge of the women's liberation movement. These two developments in synthesis are critical to our understanding of why so many women artists have chosen the alternative media as opposed to the orthodox disciplines of art. However, one must be careful not to depart from the main issue in presuming that they exist only outside the orthodox. In fact their work has been nurtured by the orthodox in art and has more recently fostered a relationship in the form of ideas and content which has flowed back into orthodox painting and sculpture.

Perhaps this is a good point at which to ask why such media as performance, video, etc. were so pertinent to women artists in the 1970s and why these media have continued to be so central to women as a means of expressing ideas when in many cases they have been abandoned by their male colleagues: painters like Salomé, Fetting, Middendorf, for example, or even the older generation of artists like Piene, Rückriem or Ruthenbeck. For these new media offered new possibilities of vision, helped new sensibilities to emerge and, more importantly, addressed themselves to the possibility of a new aesthetic.

What is it about a video-tape, for instance, that makes this possible? A video-tape can be orchestrated very slowly. For example, the origin of a movement of a body may lie exclusively in the movement of the body breathing rather than in the manipulation of the camera. Equally, in making a video-tape – as opposed to a film – the artist can do everything him or herself. The artist is producer, director, actor, lighting technician, editor, and so on. He or she is no longer dependent upon a team or on the specific view of a second person (traditionally a man). He or she conceives and models simultaneously. Therefore a new way of imaging emerges that can be critically scrutinised at the same time as it is conceived. The artist can literally see herself as image and can begin to reflect upon the implications of the self as artist, as woman or based on a false promise.

Friederike Pezold's work must be viewed in the context of the centuries-long subjugation of women to men, and the evidence provided by the history of figurative painting in which the constructive images of women were the manifestation of masculine fictions or masculine desire. Between 1973 and 1975 Pezold produced two video-tapes entitled *Die neue leibhaftige Zeichensprache* ('The reincarnated language of signs') and '3 Pieces of a Woman's Movement'. In both tapes the artist creates herself anew. Just as in the story of the Creation, God creates man in his own image, so Pezold creates woman in her own image, out of a notional consciousness of woman. Shortly afterwards she extended the same idea into a video-sculpture consisting of five monitors standing on top of each other. Pezold's black and white video-tapes are without either music or

149

Schlachtfeld Deutschland

9.1 Katharina Sieverding, *Schlachtfeld Deutschland XI/1977*, Installation, Rheinisches Landesmuseum, Bonn, 1978

dialogue: All she uses in filming is the language and sounds of her own body. The images are static for long periods of time, allowing herself as well as the spectator time to see, to think, to feel and to absorb or to experience as creator instead of as consumer or viewer. In reducing the speed of the movement of the images to a minimum at times, these videos give the impression that they are stills, a sequence of photographs encapsulating specific moments in a broader scenario.

Interestingly, Katharina Sieverding who was similarly working in the field of video at the beginning of her career, increasingly abandoned it in favour of photo-narrative work. Her photosequences of the early 1970s dealt primarily with problems of identity, of knowing and finding the self through its reflection in the other. In her work photographic self-portraits are frequently juxtaposed and placed in dialogue with a male portrait. Sieverding is interested in the interaction with the partner, in role definition, role play and role reversal. Her early photo-pieces were characterised by the sexual distinction between male and female and by its ambiguity or lack of concrete definition beyond stereotypes.

'The feeling of the identity of the self,' the artist stated, 'is based on a reciprocal support. It is important to realize the creative potential in oneself and in others as a relationship in which each refers to the creative enzyme of the other. One realizes oneself in picking up and promoting the enzyme of the other.'[1]

Es war eine merkwürdige Freund-
schaft. Es war die Freundschaft zwi-
schen einer Rechenmaschine und ei-
nem Vulkan,

9.2 Katharina Sieverding,
*Rechenmaschine und
Vulkan I* (1974),
Installation, Rheinisches
Landesmuseum, Bonn, 1978

Having dealt with concerns to do with self-definition in examining the microstructure of the relations between two partners, Sieverding shifted into a more intercultural dimension. From about 1975 the central concerns of her work were macrostructures of models of behaviour which tend to have cultural and ethnic causes. It was during this period that she executed her first monumental photographs. The work 'It was a Strange Friendship. It was the Friendship Between an Adding Machine and a Vulcano' is the precursor of these photo-pieces. It shows the artist's own face half-covered by a red field; this portrait is juxtaposed with a blown-up cut-out from a newspaper, an image of an Asiatic woman. Both portraits look unexpectedly similar considering the difference of photographic source material and the ethno-cultural background. Since about the mid 1970s Sieverding has travelled extensively between the Far East and America in order to arrive at a clearer understanding of cultural and ethnical identities and their interrelationships. In all her subsequent works the artist maintains the duality between two figures in order to create a tension which is comparable with the conditions of conduct between two people. The materials used are self-portraits, newspaper cut-outs and sometimes stills from films. However, since the late 1970s Sieverding has increasingly withdrawn from the presentation of the self within a cultural dialectric. She no longer represents the finding of the self through the perception of the other, the alien. Instead what is presented are images which threaten, which ask of the spectator what is his or her relationship to the other, to that presented within the image –

151

Gerlinde Gabriel

where does one stand, for instance, in relationship to a man awaiting execution and death?

The identity of the self or, more generally, the image of the woman is also one of the main issues of the work of Ulrike Rosenbach. But while Pezold's work is concerned with the finding of a new self-identity by gaining a new consciousness through the reflection of her own body, and while Sieverding arrives at an understanding and definition of the self through the understanding of the other, Rosenbach concentrates more on the image of the woman in its cultural-historical context. She is more interested in the many clichés and stereotypes of the woman in our society. Let us take, for example, the image of the Madonna which embodies youth, innocence, purity and sweetness. What provoked Rosenbach most in this cliché was the cruel limitations to which women have been exposed through their Christian education, a cliché which presented an image of the woman as a desirable model. Woman is expected to stay as young, beautiful and innocent as the holy Madonna. This image deprived woman of everything, even of her possible negative aspects, which might have allowed her to develop fully as a human being.

In 1975 Rosenbach executed the video-tapes *Madonnas of the Flowers* and *Don't You Believe I am an Amazon!* In the latter the artist used the haloed head of the virgin from Stefan Lochner's painting *The Madonna of Rosenhag*. Superimposed on the Madonna's face is Rosenbach's own portrait as she shoots an arrow. So one can see at one glance the sweet, long-suffering image of the Virgin and the modern woman fixing an arrow and firing. One feels the shock of each arrow as she strikes target

152

and archer simultaneously. Victim and aggressor become one – or the feminist shoots down the old image of the masochistic woman.

In identifying herself as both Madonna and Amazon, Rosenbach is dealing with two stereotypes. On the one hand, the negatively seen Amazon, aggressive, severe, man-hating; and on the other, the Madonna, beautiful, asexual and devout. However, both images have misogynous implications. Through increasing consciousness of sexual difference, woman is expected to be able to overcome all the traditional stereotypes and conventions she is confronted with in the outside world and which she has internalised as a result of her education; this enables her to relearn and revise her perception of herself and her position in society.

Rosenbach considers herself to be primarily a feminist artist in the sense that her work is intentionally critical of society. However, for her, social critical art has nothing to do with pure realism, illustration or open agitation. Liberation is less a question of pedagogy than an act of active artistic practice. Freedom is experienced through the breaking of redundant conventions, the questioning of old clichés and the positing of alternative sensibilities.

The visualisation of sensibility as such is certainly one of the dominant issues in the work of the video-artist and film-maker Rebecca Horn. Around 1970 Horn began working with constructed body instruments which were extensions of the senses and which enabled her to experience her own body and its sensations in a new way. The antenna-like instrument *Unicorn* (1971), for instance, which was tied on her head, or *Finger Gloves* (1972) were both artificial elongations of the artist's sensory apparatus out of which the sense of touch could be seen as central. Horn has said in this context:

I can feel, grasp, touch anything with them, but keep a certain distance from the objects. I feel me touching, I see me grasping, I control the distance between me and the objects.[2]

As this statement reveals, touching for the artist is closely connected with withdrawal, as this sensation does not carry exclusively positive implications; rather, its ambivalence also implies the possibility of wounding and being wounded oneself. Having initially constructed objects out of cloth, hair or light wood, Horn was subsequently looking for a more 'vulnerable' material. She eventually turned to feathers: as a material these can be considered to be like the second skin of a bird; and are ambiguous in that they are simultaneously shell and cage, a covering that facilitates tactile extension and protective withdrawal.

In 1973–4 Horn used her first feather masks *Cockatoo Mask* and *Cockfeather Mask*, objects with the help of which she referred directly to rituals of zoological origin as well as to tribal rites. Animal incarnations, particularly animal masks, have always been included in rituals of tribal societies in order to visualise and experience fear and its purging. In this

9.4 Rebecca Horn, *Finger Gloves* (1972), Installation, John Hansard Gallery, Southampton

context birds and bird feathers played an important role as they were thought of as metaphors for the self, the duality of vulnerability and strength. 'The bird dies, the feathers live on,' the artist has said in an interview. This sense of 'movement', or rather the ever-present tension between opening and closing, contact and isolation, ties in directly with Horn's use of discreet kinetic machines which allow highly controlled yet often brutal movements to occur, as for instance in the *Paradise Widow* (1975) or the *Chinese Fiancée* (1976). The *Paradise Widow* is a black, shiny feather column concealing a naked woman within it. During the performance the movement of the feather garment changed from gently quivering to spreading out like wings, revealing the female body.

Having extensively explored the anatomy of her own sensibility and observed the reactions of birds in sensory context, Horn arrived at a highly refined understanding of the erotic relationship between two creatures. For her, eroticism is based on tension and the resulting energies which extend from destructive aggression to fruitful pleasure. In order to

9.5 Rebecca Horn, *Paradise Widow* (1975), Installation, John Hansard Gallery, Southampton

co-ordinate these extremes, both rooted in man's as yet not fully explored subconscious, the artist uses machines. As metaphors for the controlling intellect, these echo the precarious conditions that separate conscious manipulation and subconscious reaction.

The duality between intellect and soul or intellect and body is equally an important issue in Isolde Wawrin's work. With the intention of regaining an intellectual, emotional and physical unity within herself, Wawrin dabbed her body and the surrounding floor around her with coloured fingerprints as far as her hands could reach. In this performance, executed in 1976 and called 'Red-Blue Body Circle', painting is nothing more than a manifestation of a touching and touched body, a sign that the body touches itself and becomes one with itself. Wawrin has extended this physical relationship between her body and the surrounding environment by touching it in the same way with her fingers: initially only the floor, but in later works also the walls, objects and canvases. All this seemed to her worth touching in the same way: body and surrounding are all one, the body is what is touched. The body and the surroundings belong to the same world. This kind of painting, touching things with fingers full of

155

paint is an attempt to find unity in the world. Perhaps in this way there exists a close connection between the work of Wawrin and Horn. Both sense a strong need to touch things in order to communicate, to open a dialogue with both themselves and the surrounding world. For neither of them is it enough to name things in order to make contact with them; both of them have to touch and feel. But while Horn feels a need to control her act of communication with the outside world, to keep a distance between skin and skin, to know about the vulnerability of feelings and the fragility of things, Wawrin tries to come as close as possible to her object, to literally dive in and become immersed.

In more recent years she has increasingly painted *in situ*, preferably directly onto the wall. The paint, however, is not applied with brushes or knives, but only with her fingers. The works are schematic presentations of lines and graphic formations in the form of hieroglyphics and fictional scripts which have a similarity to prehistoric drawings or the 'writings' of American Indians. It seems as if her fingers, loaded with paint, have glided over the head, the back, the tail and the limbs of a wolf, or as if they have caressed the beak of a bird. The signs on the wall feel like the leftover traces of such a bodily contact. The work becomes the mediator between presenting and feeling, a dialogue that deals almost exclusively with wild, primeval animals as Wawrin considers them to unite in an ideal way nature and the secrets of being.

It may sound paradoxical, but Wawrin's work seems less concerned with the direct visible world than with expressing the experience of touching it. For her, painting means action:

Painting is the moment of the act of painting. What one can see later has been painting once. After the act of painting is finished it is just a picture or something like this.[3]

In her attitide towards painting Wawrin is very close to the ceremonies of days gone by, to ritual and mythical conjurations. It is in these activities that people discovered resistance to the harshness and anxiety of daily life. Knowing that people have increasingly lost their natural instincts, and with often a certain strength, Wawrin is trying to find a new relationship with nature – not in the simplistic sense of a 'back to nature' strategy, however, but in an attempt to regain new energy from natural forces.

For months the artist observed the process of growing and withering of plants, their germination, fruition and dependency on the earth as a nurturing force, earth as a symbol for nature, in particular for birth, creation and finally creativity. God created man out of a lump of clay. Wawrin touches paint in the same way as she touches the earth, recalling with her fingers the sensation of holding earth in her hands. The act of painting consists of an accumulation of physiological and psychological process, of transmission of energy, rhythm and excitement, born out of a condition of highest intellectual and physical concentration.

While Wawrin tries to regain in and through the act of painting a new unity with nature and its hidden or secret forces, the painter Christa Näher puts into her work an emphasis on the indissoluble closeness between human being and animal.

The bonds between humans and animals have always been located between two poles: the conjuration of animal forces in order to tame them and their conjuration in order to release them. It has been the on-going struggle between intellect and desire, between spiritual order and emotional chaos. The secularisation of human understanding of the world, however, has extinguished the mythical dimension in dealing with animal forces. Today we are aware of the problematic nature of a predominant ratio, and the longing for an irrational and transcendant dimension for the understanding of the world is pushing to the fore.

157

In the work of Näher this longing seems in particular to be a desire for dark nordic and mythical forces and energies. Her paintings reflect an almost manic preoccupation with the horse, again and again conjured up out of frenzied configurations. For Näher the horse is a metaphor for nature. But for her nature never seems to be exclusively a cosmos of protecting and releasing forces; it is also a world full of terrifying and destructive powers. Consequently her pictures can be seen as the visualisation of untamed feelings in conflict with themselves. In all her paintings one can perceive a marked tendency to link human traits with those of animals and the desire to regain their energies and natural instincts which have been increasingly repressed in human beings.

The roots of the imagery of Näher's work reach back to long-forgotten periods, to a world of myths, witches and werewolves – to stories and fables of free-roaming animals and untamed humans. They express an irrational experience of reality. In an interview the artist has stated:

Sometimes I feel like an animal, like a horse, a witch . . . sometimes I think I smell the medieval age – and I sense the contact with primeval times – caused by a sound, a smell, a gesture or a particular landscape – situations which make one understand that everything in the world is born, ages, dies and is reborn.[4]

In Näher's paintings the motifs are reduced to a minimum: the strained waiting animal, alone, or in a terrifying group, the animal lurking behind the human figure or bonded with a woman's body. There is no doubt that in the erotically loaded fight between animal and human being it is the artist herself who is concealed behind the naked, at times impish figure depicted. Usually in Näher's work two figures play the main roles in a tremendous epic whose concern is lust for life with all its untamed ghosts and fantasies and its love and passion until death. In her more recent work the colours of the paintings are obscured and drawing becomes more important. Water and desolation seem to inundate the earth. Somewhere far in the background of this traumatic landscape a horse is still standing or rotting cadavers are left to the night. The lustful and irreconciled struggle between human being and animal has ceased. Only faint traces of life are discernible against the backdrop of death.

Christa Näher's interpretation of the world clearly mirrors the *Zeitgeist* of the 1980s. It is closely related to the feeling of threat and anxiety and the knowledge of a possible final destruction of the world which is also so dominant in the more recent photographs of Katharina Sieverding and in the work of Astrid Klein.

Klein's monumental photo-piece, *Feelings of the Last Few Days*, gives the impression of an inhuman invasion erupting from a void. It reminds one of the Greek mythological raving furies or the apocalyptic hunters. But these inconographic references should not be mistaken for any notion of transcendentalism. After the catastrophe there will be no life at all. The bricked-up doorway, a sign that perspective is necessarily connected with

illusion, does not allow the eye of the spectator to enter the depths of the picture. The closed door cuts off the line of vision and deprives the eye of the power of its glance finally leaving the observer unconsciously staring. The photograph becomes a picture of an inner hallucinatory vision.

Klein works with the aesthetic fascination of terror, which she isolates from the context of our conventions of perception and which she compresses with unexpected effects. In referring to the inconographic tradition of anxiety and threat, her imagery often takes on the character of archetypes as for instance in a recent photo-piece with the ambiguous title *Nature Morte*, meaning both 'still life' and 'dead nature'. It shows a head, chopped off and isolated from its body perhaps from a sculpture, perhaps from an actual human body. Bone seems to have been converted into stone.

Klein primarily uses existing photographic source material from news-papers and magazines. The choice of images used is governed by their immediate appeal as being sensational, by that vicarious appeal that draws one to look with curiosity upon the distress of others when accidents befall them. From her painterly approach towards photo-graphy, a process of building different layers of images one on top of the other, complex pictorial structures result. By extensive manipulation of the negatives it is possible for Klein to condense simple and superficial depictions of reality and to connect and to combine them into new structures allowing new meanings to be established and contextualized. What was objective documentary material becomes a highly manipulated subjective imagery, an imagery that transforms the known world outside into a blurred interior code of signs and shadows. Interestingly, the photo-pieces of Klein quite often have the quality of x-ray prints.

Born in 1951, Klein belongs to a younger generation than, say, that of Sieverding, one in which direct connection between social-political activities and the making of art is no longer deemed viable. Rather, reaction to and anxieties caused by a hostile environment are visualized into codes which are more intimate, personal and oblique.

In this chapter I have tried to outline some of the areas of concern that female artists in West Germany are dealing with – concerns that mirror and inform positions which identify a particular sense of what it might mean to be an artist working in Germany today. However, to see these artists as primarily female artists is to deny them and all artists the right to transcend what they might be as individuals to what they present as artists. All of these artists would declare that their deepest roots lie within their own tradition, irrespective of whatever social-political references they may allude to. Beckmann's position as the artist reflecting upon himself as artist, all artists, is not so different from Rosenbach's position of critical self-awareness, except that now one must add to the problem-atic – what does it mean to be a woman? Equally, Pezold's body politics

can be seen as further thinking within the space of Schlemmer's body investigations. Nolde's visions of ghosts, demons and phantoms and Näher's unfettered beasts are the products of the same earthly spirit, just as Meidner's apocalyptic cityscapes can be seen echoed in the urban fragments of Klein's reflections of the last few days.

Note: This is a transcript of my talk delivered at the Royal Academy symposium.

Artist/patron/state III

Official support and bourgeois opposition in Wilhelminian culture

Sebastian Müller

The observation that out of the bowels of the old something new really does develop is not particularly profound, even when it does apply. It is not even appropriate for the socially and politically reactionary final phase of the German Empire before the First World War, in which, however, Modernism in art had quite clearly established itself as a movement on a rather broad front. In view of the contradictions and the cultural tensions of the time the historical-philosophical self-assurance that resonates in this observation cannot be sustained. It is unsettling to note, with respect to a discussion of reception and promotion of art, that just at the time when the director of the Berlin National Gallery was forbidden by a decree of the Emperor to exhibit works by van Gogh, prominent and publically known collections of Expressionist artists were to be found. Surprisingly enough these collections were those of men who both, without a doubt, were clearly aligned with nationalistic and conservative thought. In all probability they could have been supporters of the Emperor's jingoistic cultural climate rather than champions of Modernism in art. I am referring here to the bankers, Karl Ernst Osthaus from Hagen and Baron August von der Heydt from Wuppertal.

Historians are already inclined, in view of the public debates on cultural matters and in view of the variety of art to be found in the period between 1900 and 1914, to speak of the 'golden age' under Wilhelm II. They systematically 'forget', however, that the hegemonic political and cultural climate since the rearmament of the German fleet in 1897 was characterised by a Cold War attitude in foreign policy. Statements on foreign policy, even by people who were committed supporters, culturally, of Modernism, therefore usually had the following tone as, for example, the words of Emil Rathenau: 'As a result of Germany's development of its socio-cultural mechanisms, learning, technology and art, German industry has grown to such a high level that an even greater expansion in the world market is conceivable and in line with this very substantial increase a stronger fleet could become necessary.'[1] Such foreign policy was the other side of the coin of a domestic policy stance which did not intend to solve the internal disintegration of the nation into a class society. Nor did domestic policy reduce the tensions between an

163

authoritarian state comprised of Junkers, military leaders and the feudal-istic middle classes on the one hand, and the forces for democratisation, mainly among the social democrats and the workers, on the other hand. Instead the policy was to systematically punish the latter by using the police to curtail their democratic freedoms. An attempt was also made to bridge the turmoil with an imperialistic 'global policy'. One has to remember that in this case a racialist-nationalistic socio-cultural complex gave ideological backing to all this. To be German was equated with 'having character' in order to fight for a philosophical view of the world or to raise oneself up to being the intellectual and spiritual leader of all nations.[2]

Books such as *Der deutsche Gedanke in der Welt* (German thought in the world), 1912, by Paul Rohrbach, *Deutschlands europäische Sendung* (Germany's European mission), 1914, by Rudolf Eucken, *Vom Weltreich des deutschen Geistes* (The secular empire of the German spirit), 1913, by Eugen Kühnemann, *Deutschland als Welterzieher* (Germany as educator of the world), 1915, by Joseph August Lux or *Deutscher Weltberuf* (The German global calling), 1918, by Paul Natrop support this point of view. Kühnemann wanted to restructure the whole world into 'a global empire of German culture'. Rohrbach characterises the 'idealistic substance of Germanism' as the most important 'force in the present as well as in future world events'. And Eugen Diederichs expected Germany's 'victory over the world' through the overwhelming force of its idealistic 'humanness'. Joseph August Lux was of the same opinion when he said: 'Nothing is more appropriate to the German, nothing makes him so unconquerable, than this idealism which predestines him to be the moral preceptor in the world, to be the leader among the peoples of the earth, to be the cultural educator.'

The furtherance of art by the state

In such times the support given to art by public institutions and public opinion can not have been exactly favourable to Modernism. On the contrary, a reactionary climate was the determining factor of the situation. Especially embarrassing was the fact that the large support given by the state was usually available only to the elite. This aristocracy, together with the art societies that were dependent on it and the state museums, had control over the academies and over the granting of art prizes, particularly since the right of final decision was a prerogative either of the sovereign or of the Emperor. The Prussian king indirectly exerted his influence over the main annual art exhibition, the Berliner Salon, because he appointed the Minister of Culture and financially supported the art societies. He directly influenced the Berliner Salon in that the prizes to be granted were donated by him personally. Generally, he followed the recommendations of the jury, on whom he could rely. Wilhelm II,

10.1 Wilhelm II, draft for
*Völker Europas, wahret
eure heiligsten Güter*, 1895

however, who had a genuine if partisan interest in art, refused to allow prizes to be granted to the artists recommended by the jury, if, as in the case of the Kollwitz's cycle for Hauptmann's weavers, the views inherent in the works of art were not acceptable to the Minister of Culture or to the Emperor. According to Wilhelm II the political orientation of art should, as far as the state is concerned, be absolutely clear:

Now if art, as is nowadays common, does nothing else than to present misery as more horrible than it already is, then it does an injustice to the German people. Seeing that ideals are maintained is the greatest cultural work one can do, and if we want to be and to remain a model for other peoples in this respect, then the whole nation must contribute to this effort. And if culture is to fully achieve its goal, then it must penetrate into the lowest levels of a nation. That is something it can do only if it elevates rather than descends into the gutter.[3]

Wilhelm II was able to put these theories of art into practice in the Prussian Academy of Arts and in the *Allgemeine Deutsche Kunstgenossenschaft* (General German Art Association), the official organisation of artists, through the intermediary of Anton von Werner, a true court artist. He was an uncritical but technically excellent realist painter. Thus he was liked by the court and by large segments of the German hegemonic circles because of his depictions of events from recent German and Prussian history. Since he was a painter with the best connections to the Emperor personally (this being the reason why he had this excellent official position), he was able to assert his idealistic-patriotic view of art and to discriminate against the Modernist avant-garde, such as the Impressionists, and to exclude them. In the State Art Commission and in the group that prepared the annual art exhibition in Berlin,

10.2 Hermann Knackfuß, *Völker Europas, wahret eure heiligsten Güter*, Heliogravüre in *Leipziger Illustrierte*, 16 Nov. 1895

Werner's Prussian Academy dominated the selection committees and the juries. In view of the enormous publicity effect and the economic importance of the Salons, at which turnovers in the millions were obtained (in 1888 at the Munich International Art Exhibition the sum was 1,070,000 marks),[4] the modern movement had to create its own platform for exhibiting its works. It did this everywhere in Germany by way of 'Secessions'.

The financial means the state had at its disposal to directly affect the art world by way of subsidies were much less than those of institutions, especially when we look at matters on the national level, that is, on the level of the German Empire. At that time, as is also the situation today, support for art and culture was a matter, in individual cases, for the individual federal states. The different German Emperors were able to augment the funds available from the state by way of personal grants mainly for monumental art. In 1868 Wilhelm I made available money for the reparation of the Marienburg from his own private fortune. In 1878 he covered the costs for the German art section at the Paris Art Exhibition. For the building of the Niederwald Monument the Emperor gave 10,000 marks and 550 hundredweights of bronze for casting the figures. Other national projects, such as the completion of the Cologne Cathedral, also had to be supported with large sums from the Imperial treasury.[5]

However, even for this project the combined financial might of the states and the Empire was not sufficient to realise it. Bourgeois pillars of the state were called in to help finance the project. During the expansion of the collections in the state museums in Berlin, the Krupp family, for example, was involved again and again as donor. Already in

10.3 Anton v. Werner,
Self-portrait, 1886

1896/97 30,000 marks were given by Friedrich Alfred Krupp as a 'contribution to the Berlin Museum Society'. There is even proof of 30,000 marks being given in 1912 for the acquisition of a piece of jewellery belonging to the medieval count. And during the First World War the Krupp family contributed around 150,000 marks for the acquisition of a statue for the *Altes Museum*.[6]

Compared to this, the money spent by the state on subsidising art was comparatively small. We know this from a study of the Prussian budgets for the support of art and learning. In the year 1855 the amount spent on furthering art and learning was altogether only 549,240 marks. The expenditures rose to 957,483 marks by the year 1870, and in 1913 the amount was 1,832,408 marks. Since 1897 the amount spent directly on art can be clearly differentiated from the other expenditures; on the average this amounted to 65.45 per cent of all the expenditures. The largest part of the funds for art and learning: on the average 21.6 per cent went to the state museums in Berlin.

Although the increase in the amount of money spent by the state on furthering art over the whole period may appear at first glance to be high, and although a calculation of the average rate of increase within a five-year period may seem to indicate that the expenditures for art and learning were continually being increased in about the same degree as the rate of increase in the state budget, the reality is quite different. In most of these periods the median annual rate of increase in the money spent on art

167

10.4 Anton v. Werner,
*Proclamation of the new
German Emperor in
Versailles 1871*, 1885

and learning was much lower than the rate of increase in the size of the whole budget. The only exceptions were the years 1870 to 1875 and 1900 to 1905. After a rapid climb to 0.4 per cent at the end of the 1870s, the part of the Prussian state budget allocated for art and learning sank again and in the last decade before the war was about as high as it was in 1870, that is, 0.17 per cent.[7]

Even more niggardly were the funds available to the Prussian *Museum für zeitgenössische Kunst* (Museum of Contemporary Art). The *National-Galerie* (National Gallery) which opened in 1876, had, to be sure, a relatively large sum available for new acquisitions. The State Art Commission (*Landeskunstkommission*) made the decisions regarding the appropriation of the funds. The funds set aside in the budget for acquisitions at the National Gallery amounted to 86.1 per cent in 1876 and 68.8 per cent in 1913, the money being increased from 300,000 marks to 392,900 marks.[8] The amount contributed by the German Empire for the support of art was infinitely small. In 1913 it was a mere 173,714 marks.

Institutions exerted their influence on behalf of patriotic idealism and at the expense of Impressionist Modernism. And the intervention by Willhelm II in the selection of the paintings that were to be shown at the World's Fair in St. Louis in 1904 was especially typical as well as especially scandalous. Peter Paret is of the opinion that German participation in the

World's Fair in St. Louis was 'a typical example of the contradictory nature of economic and cultural imperialism in practice'. It consisted of an extensive exhibition of cultural productions and a few technical products from Germany, having a budget at the final count of 5 million marks, and was housed in a reproduction of the Charlottenburg Palace, overladen with decorative elements.[9]

Wilhelm II became involved very early in the matter. He had word sent, by way of the Prussian Minister of Culture, Konrad Studt, to the official in the Foreign Ministry in charge of administering the exhibition that he thought that a larger exhibition of art would be appropriate in St. Louis in order to 'strengthen the interest in German art'.[10] The officials in the Imperial government tried to secure the participation of German Impressionists and avant-garde artists in the show. This they did by bypassing the Emperor, after considerable internal arguments about who had the right to put together a German contribution to the art show. A large committee was to co-ordinate the German contribution to the exhibition. This committee contained representatives of almost the whole spectrum of German art but, above all, the Berlin and Munich Secessions and, further, Leistikow and Klimsch, as well as the more progressive museum directors, Tschudi, Lichtwark and Pauli.[11] When the Emperor got wind of this, he immediately instituted a revision of the plan and, making use of the right of final decision, he ordered that the agreements made by this committee should be cancelled and that the reactionary *Kunstgenossenschaft*, with von Werner as its head, should be responsible for putting the art exhibition together. Thus, the *völkisch* (racialist) nationalistic and idealistic selection of works for the German art contribution to the exhibition in St. Louis was assured.

But – and that is the interesting thing for the politico-cultural climate at the time – Wilhelm II had in this instance stepped over a moral threshold in politico-cultural consensus that was shared by aristocrats and bourgeoisie alike. The bourgeoisie apparently wanted to preserve freedoms unconditionally. This intervention by the Emperor Wilhelm unexpectedly led to a parliamentary debate on art and Wilhelm's art policies that lasted more than six hours.[12] The statements by the speakers of the political parties were, without exception, sharply critical. A speaker for the Centre Party expressed his misgivings over the *de facto* exclusion of the modern artists by an administrative stroke, even though most of the members of his party were not supporters of the Secession. He noted 'that at the exhibition in St. Louis the Secession should have been represented'.[13]

The speaker for the Free Conservatives, von Kardoff, attacked Wilhelm II directly:

The most honourable State Secretary for the Internal Affairs explained further, that one could not forbid the Highest Office in the land to give its opinion on art matters. Who will want to forbid it to do this? However, we are not here in an

10.5 Wilhelm Schultz, caricature in *Simplizissimus* 17 May 1904: '(von Werner:) Die Ausstellung wird an hoher Stelle Beifall finden, die Bilder sind tadellos gerichtet'

absolute monarchy and we are not in Prussia (hear! hear!), but in a federal state in the German Empire, and the will of one individual person can not play such a decisive role here.[14]

The leader of the Social Democratic Party criticised the fact that it was specifically a 'court artist' like Werner who made the decision on whether something was or was not art:

Well, Gentlemen, if court artists are called upon to select those works of art that have been listed for the exhibition in St. Louis, then in the light of our present circumstances it is quite understandable that the choice will favour works of art that correspond to the views of the ruling personalities. But it is precisely this system which is basically wrong. In matters of art one can neither regiment nor drill the artists.[15]

Müller-Meiningen (Liberals) attacked the 'Byzantine nature' of William's policies on art, the 'dictatorship in the area of art' and 'court art':

what does this court art produce? – everywhere failures, wherever we look! . . . Millions of educated people in Germany are still convinced even today that the great, modern, international movement . . . that is searching for nature, i.e. truth, even in art, does not allow itself to be ordered about, and must not allow itself to be ordered about, like a regiment of grenadier guards . . . The history of art, the history of civilization, has shown this; it gets on with its own business, bypassing even kings and emperors who want to hold it in their grip (lively applause from the left).[16]

Count Harry Kessler summarised the position of the liberal, educated classes towards state support for art perhaps in the most radical, succinct manner when he said in this and subsequent debates on the self-organising efforts of the artists:

10.6 Caricature of *Lustige Blätter* 1904: At Gustav Kühn in Neu Ruppin (Brandenburg) or German Art at St. Louis, 'Vortreffliche Idee das auszustellen ... Det können die Amerikaner nich!'.

The modern state is concerning itself with art. It has art galleries, organizes exhibitions, commissions works of art, builds, rewards. And here it is not a question of 'trivial' matters, as politicians too lightly assume, that should not disturb 'the course of major political issues'. Here we have, in reality, those things for which politics exists at all. When it all comes down to its basic principles, politics fulfils, in various guises, only one task. This task is to pave the way for a nation, i.e. for the idealistic intellectual and artistic talents of a people, to develop to the highest, most manifold and broadest level, and to safeguard this development. It is for this purpose that parliaments, ironclad ships and chambers of commerce are there ... And since the state is drawing art into its own domain, then one must demand that within politics art should be appreciated as to its real significance and be treated according to a correct principle, namely that of freedom.[17]

Bourgeois cultural opposition and its alternative institutions

After the turn of the century art and culture and the demand for artistic freedom developed into a central political concept, next to the class struggle probably the most important one. Cultural issues dominated the political-literary journals in the last decade of peace. A journal called *Deutsche Kultur* (German culture) had been published by Heinrich Driesmann since 1905. A journal with the same name, published by the German *Kulturbund* (German Cultural Union), followed in 1909. Ferdinand Avenarius' *Kunstwart* (Art guardian) now called itself the *Kulturwart* (Culture guardian). A Culture Party formed around the independent

171

10.7 Th. Th. Heine,
caricature in
Simplizissimus 43, 1902:
German Art, 'Aujust
quetsch den Deckel zu, se
lebt noch'

scholar, Ernst Horneffer, in the period from 1908 to 1911; this party organised culture conferences that were widely acclaimed. Essays on cultural patriotism, on the 'struggle for civilization' and on 'the necessity of a large culture cartel', demands for a new 'cultural politics' and for a cultural renewal simply mushroomed in monarchical, pacifist, left-liberal, liberal-conservative and culturally conservative/spiritually aristocratic journals.[18] In this area, then, the German bourgeoisie defended (in as much as it did not directly take over feudalistic concepts) its political principle of freedom and thus kept open, in spite of being in agreement with the aristocracy with respect to a fundamental, nationalistic mood, an escape path for the development of Modernism.

The notion that philosophical thinking is free is a concept formulated by the Enlightenment. Ever since the classicist phase in music and the romantic phase in painting, a belief has persisted that the bourgeoisie had taken over the ideological and thematic hegemony from feudalism. Such a premise belongs to the inventory of cultural self-awareness developed by the German bourgeoisie. If, on the basis of the Enlightenment, a social entity has inscribed on its banner the motto of freedom of production of goods and freedom in the exchange of goods, then it is a matter of legitimating logic, even in the cultural area, that the new art should be characterised as free and autonomous and not as bourgeois. With respect to this extension of the concept of art it is not simply a trick that enables one to avoid feudalistic coercive measures, bureaucratic patronising and police persecution. As an area of legitimation and metaphysical meaning

that was very early, and decisively conquered, art is for the bourgeoisie of especial value. For this reason various aesthetic theories appear, the most enduring one being that of Hegel. He formulated the basic principle in this way: 'The productions of art, very far from being mere appearance, can be considered as having within them the higher reality and the truer essence when compared with the usual reality.'[19]

The defenders of the freedom of art entered into the public political discussions about the social function of art and culture in the last ten years before the First World War in various politico-cultural areas. Orientated towards the present and towards industry, but with a feeling for the problems and the sufferings of the subject in this present time, they tried to win over the workers for this culture and thereby to create a cultural revolutionary or cultural reformist 'alliance' in favour of the modern movement. This 'alliance' felt itself committed to only too few social and political concessions with respect to the proletariat.

In this connection art was supposed to serve the raising of the level of the working classes. Essentially this was to be done in three ways. Next to an increase in the artistic quality of mass products and the artistic structuring of the immediate environment 'the common people' live in, we may also mention the efforts at improving training, especially within the framework of a resurgence of handicrafts, and the efforts at 'enriching the recreational opportunities of the common people'.

With respect to the first point, one can assume that a highpoint of these efforts was reached in the activities of the German *Werkbund* (Works Union). This organisation of artists, craftsmen and industrialists consistently promoted an industrial functionalism from 1907, the 'spiritualisation of German labour' and 'quality work', in order to develop an authentic and aesthetically pleasing environment for the industrial system.[20] In this connection we also have the designs for garden-city-like workers' estates or a congress, such as that organised in Hagen by Karl Ernst Osthaus and the *Zentralstelle für Arbeiterwohlfahrtseinrichtungen* (Central Facilities Office of the Industrial Welfare Organisation) in 1905. The theme of this congress was the 'artistic design of working-class homes'.[21]

The second aim began to be realised with the development of school training in addition to commercial training, e.g., within the framework of the *Deutsches Gewerbemuseum* (German Industrial Museum) in Berlin that was founded in 1867. This aim culminated in the debates and in the attempts at reform within the larger circle of the German *Werkbund*. The underlying idea for all of the following – Kerschensteiner's *Arbeitsschule* (Work school), Rudolf Bosselt's reformed art academy for handicrafts with Hermann Muthesius basically in control, and Karl Schmidt's commercial-educational training workshop – was to combine training segments that were closely bound to a specific handicraft yet were artistically free. This was to enable the students to proceed to a realistic

yet speculative confrontation with the training objects. In terms of art history the prominent final destination of this development is reached, of course, between the First World War and the Third Reich, with the State Bauhaus at Weimar.[22]

Another topic for a conference of the aforementioned *Zentralstelle für Arbeiter-Wohlfahrtseinrichtungen* in 1891 was the 'appropriate use of Sundays and one's days off'. The goal here was to dampen the 'spread of dissatisfaction and of revolutionary thinking among the working classes' by offering a culturally attractive plan for 'recreation' and 'socialising'. The result was supposed to be that – as was expressed by the main speaker, Victor Böhmert, at the above-mentioned conference – 'the members of the various social classes should associate with each other personally as real brothers and sisters and mutually support each other in spreading everywhere an unadulterated joy of living and a deep interest in practical work and dexterity, as well as in the treasures of learning and art'.[23] For these reasons, then, we find the various *Volksbildungsvereine* (People's Education Clubs). This development exerted its influence even into the Social Democratic Party. In this connection one thinks here of the *Volksbühnen* (People's Theatre) movement that comes from this direction.

However, one must surely not forget that these cultural efforts did not merely represent harmless bourgeois contemplations, but were connected in a very realistic and cosmopolitan way with the interests of the German bourgeoisie. The atmosphere of fundamental change that was swelling up in the press of the educated bourgeoisie revolved just as much around the concept of imperialism as around the areas of cultural problems and the concept of a national state. A strong sense of mission connected economic expansionist propaganda with the simultaneous discussion surrounding the possibilities of political and civic education. From the *cornucopia* of similar tendencies we may here pick out the publishing programme of the Eugen Diederichs Publishing House. As the years went on, this publishing house increasingly stood politically for what was almost a theology of nationalism within its publications: *Tat* (The Deed), a *politische Biblio-thek* (political library) and *staatsbürgerliche Flugschriften* (civic pamphlets).[24] However, as a member of the German *Werkbund* it also published annuals and publications dealing with the modern movement, but even in these publications 'art and commerce' and 'art and the world market' were discussed.

Let us recall here the foreign societies that were founded at this time, with the participation of bourgeois educated circles, bankers and members of the government and military leadership. Among others, Ernst Jäckh, at that time an official in the Foreign Ministry and, on the eve of the Third Reich, Secretary of the *Werkbund*, and the Berlin banker, Hellferich, were members of the governing board of the German-Turkish Association that was founded at the behest of the Foreign Office. The

shipper, Ballin, General Field Marshal von d. Goltz and other bankers and shippers, the vice-chairman of the Leipzig Chamber of Commerce and the political scientist, Wiedenfeld, among others, were members of the Near East Committee. The president of the Near East Committee, Hugo Grothe, had proclaimed in an article written in 1913 and entitled 'Asiatic Turkey and German interests' the goal of German foreign policy in cultural matters in the Near East:

There are fundamental relationships between the spiritual and the economic influence exerted on a foreign country. The carriers of the spiritual side of culture: language, books, schools, scholarship and art, could be in a position to prepare a broad domain for the manifold material means a country, that is at once a super power and a world trading power, uses in expanding its interests to areas of the world where cultures are awakening and reforming themselves in line with European concepts. Trade, capital, industry and technology of a nation are able to stride easily into a country whose moral and intellectual education has already been strongly influenced from the outside. And as a consequence of the spiritual and economic elbow-room that has been created politics can delineate its most effective spheres of action and make its most effective calculations.[25]

Since the state and official organisations for promoting art were systematically and practically dominated by patriotic historicism and the German Imperial tastes, the development of the modern movement could rely only on the tendencies among the educated, bourgeois classes and on bourgeois support for art that had grown up within the private and semi-official or communal sectors.

Many people were collectors, as soon as they became somewhat rich. They did this not only so that they could have, within their private circle, an esoteric communication that went beyond one's own aim in life, but also so that they could represent a type of prosperity that, being based on money, was more abstract than that prosperity which feudal territorial rule had conferred.[26]

The collectors supported themselves mainly by dealing in art, which at the turn of this century had almost completely replaced the patronage system with its direct artist-client relationship. Among the art dealers the cousins Bruno and Paul Cassirer were the most important for the modern movement. They were the ones who first acquainted the German art scene with the French Impressionists and Neo-Impressionists. They then bought and sold the works of the German Impressionists and Expressionists that were discriminated against. Paul Cassirer, in particular, was closely connected with the Berlin Secession, first as its secretary (together with Bruno) and later in 1912 as its chairman of the governing board. Cassirer understood himself as the executor of a universal 'spiritual movement', namely, Modernism. This he made clear when he responded to the well-known, militant, German nationalistic polemics of Carl Vinnen and his 'protest of German artists' against any endorsement of the French Impressionists:

Why did I have to speculate specifically with French paintings? Answer me that, Mr. Vinnen. Why could I not have done as well with the Germans? It would certainly have been more pleasant for me. The answer is: because I considered the introduction of French art into Germany to be a cultural act. And yet that is also not the real reason. But simply, because I – loved – Manet, because I saw powerful artists in Monet, Sisley and Pissarro, because I recognized in Daumier and Renoir geniuses, in Degas a great master and in Cezanne the bearer of a specific view of the world.[27]

Cassirer was connected with the most important younger German artists, including Corinth, Slevogt, Macke and Barlach, through contractual agreements that offered the artists a set income in different amounts and over differing lengths of time. These contracts required, however, that the artists should deliver a certain number of their works to the art gallery. In this respect Barlach once noted: 'Cassirer clearly wishes to support me as much as possible ... Up to now he has paid out 5,000 marks for me, without, at the moment, having sold the slightest thing. Thus, I personally feel a strong inner moral pressure to observe strictly the terms of our contract.'[28] Art dealers like Cassirer took on the role of patron by making such contracts with the artists. However, the main purpose was not, as was the case with the classical patronage system, to require that the artists contribute to the aesthetic ennoblement of one's own sense of the interdependence of life.

By opening up the princely museums in the middle of the nineteenth century, the German bourgeoisie had initiated a competitive force to the offerings of the aristocracy, even in the public sector and thus contributed to aesthetic culture and education. Also, since the middle of the nineteenth century museum societies and art societies, stemming from the private salons and circles, became established as bourgeois alternative institutions in the matter of art policies. These organisations became effective because of the combined financial might of their members. In general, these organisations consisted of about equal numbers of government officials, bankers, businessmen and bourgeois intellectuals. The financially powerful metropolitan upper classes set the tone. Therefore the anti-feudal feeling lost more and more ground, so that the Cologne Art Society, for example, in the end even accepted Emperor Wilhelm II as one of its members. In these societies the aims were equally divided among acquisition, selection, art appreciation and public showings of contemporary art.[29]

In the by-laws of the Cologne Art Society from 1887 one finds this programmatic formulation:

The Cologne Art Society has as its aim the furthering of the plastic arts and the reawakening of a feeling for art in every manner that is available to it, specifically, however, a. by exhibiting modern works of art of all nations, b. by raffling off works of art among its members, c. by distributing, from time to time, donations the society has received, and d. by grants and subsidies for public works of art.[30]

10.8 Kees van Dongen,
*Picture of August von der
Heydt*, 1911/12

With respect to aesthetics, at first a popular, apolitical and cautious, conservative course – to put it mildly – was taken. This changed from case to case between 1903 and 1909 with the increasing cultural and political fractionalisation of the German bourgeoisie. This development can be traced by looking at the area on the outskirts of the West German Ruhr industrial area. It was from this region that, at that time, one of the impulses in the development of Modernism in art proceeded. Also, it was here that both collections mentioned at the beginning of this paper, those of von der Heydt and of Osthaus, came into being.

The development of the collector, Baron August von der Heydt, apparently takes place almost entirely through his relationship with the Barmen Art Society and the Elberfeld Museum Society; von der Heydt was president of the latter society from 1903 up into the time of the First World War. An introspective person, as the portrait by Kees van Dongen shows him to be, he found here a framework, ideas and people to communicate with, that went far enough for his ambitions with respect to promoting art.

August von der Heydt, born 1851 in Elberfeld, was the grandson of the Prussian Minister for Trade, Industry and Public Works and later Minister for Finance, Baron August von der Heydt (1801–1874). After receiving his leaving certificate and doing his military service, he completed his training as a bank apprentice in Berlin and in the banking house of his father, the firm of von der Heydt, Kersten and Sons in Elberfeld. In

177

Sebastian Müller

1878 he became a partner in this firm. He was a city representative and
later honorary citizen of Elberfeld, Privy Councillor of Commerce and
Royal Greek Consul: without a doubt a solid bourgeois background; nor
is there any question about the nationalist sentiments of the von der
Heydt family. Close connections existed with the Imperial House; just
shortly before the outbreak of the First World War, August von der Heydt
was able to have the Elberfeld Museum renamed the Kaiser Wilhelm
Museum and he donated to the city an equestrian statue of Wilhelm II in
high relief, sculptured by Louis Tuaillon. This statue was exhibited in a
room of the museum from 1914 until at least 1918. In his own collections
and in his donations to the Elberfeld Museum German art that is
expressly nationalistic has no place. Even in Wuppertal there was
considerable pressure to fill the collection with works of art which
expressed this tendency. In Wuppertal the patriotic-idealistic painter,
Ludwig Fahrenkrog, was employed as a teacher at the local Arts and
Crafts Vocational School. Fahrenkrog founded a 'Germanic society of
believers' in 1908, one of those typical contemporary sects of a political
and theological character with a reactionary *völkisch* (racialist) touch. In
this grouping Fahrenkrog was connected with Hugo Höpfner, called
Fidus, who, as a painter, illustrator and poet, was the most popular
representative of the nationalist version of the *Lebensreformbewegung*
(life reform movement) in Germany. A large one-man show was organised
for Fidus at the *Ruhmeshalle* (Hall of Fame) in Barmen in 1910. This had
as little impact on the makeup of the von der Heydt collection as it did on
other so-called 'German' collections.

Often there were conservative attacks against the exhibition pro-

10.10 Living room of the family G. F. Rebber in Wuppertal-Barmen with their Cézanne Collection, during World War I

grammes of both art societies, not only from the members but also in the press. Ludwig Fahrenkrog distinguished himself here in a particularly mean open letter, in which he polemically criticised the 'one-sided preferential treatment given to a rather dubious art genre' by the Barmen Art Society and in which he complained about the inadequate showing of 'German art'. According to his opinion the paintings by the 'Polacks', Bechtejeff and Jawlensky, should be removed from the *Ruhmeshalle*.[31] We are indebted to this controversy for providing the only known programmatic statement by von der Heydt from which we can get a clear idea of his understanding of that which constitutes artistic quality.

In June 1911, the Barmen Art Society exhibited Franz Marc and Maria Caspar-Filser; in August it exhibited the *Sonderbund* (Special Union) of West German art lovers and artists; in September it exhibited Alexey von Jawlenski, Wladimir Bechtejeff and Eugen Spiro; in October it showed paintings by Emil Nolde and Hans Pellar; and in November it presented the works of the Berlin New Secession.[32] At least five of its seven exhibitions in 1911 were dedicated to modern artists. There had been attacks and public declarations by the governing board in this matter. The general meeting of the Barmen Art Society in the following February, in 1912, seemed to have been (even for von der Heydt) of special importance for the defence of the modern movement. As was noted in a newspaper report, he too appeared in order to congratulate Dr Reiche for his efforts and his success.

In Elberfeld we have the same oppositional currents, but one must not let oneself be led astray by this. It is not a matter of the verdict handed down by the respective audience that counts; the Art Society has to present all tendencies in art, otherwise

179

10.11 Music room in the
Folkwang House of
Karl-Ernst Osthaus designed
by Henry van de Velde,
1900

it would serve reactionary ideas. And the town of Barmen should not expose itself
to this accusation, a town that otherwise espouses progress in all fields. The main
thing is to represent the inner life of nature, and how this is reflected in the inner
life of the artist. The eye of the layman has first to be accustomed to this, and it
does accustom itself to this, as the history of art of all periods has shown.[33]

August von der Heydt thus intervened in the debates, his viewpoint being
specifically based on the concept of progress. He objected to a trivial,
naked realism and championed art that interpreted reality through the
declared subjectivity of the artist. Modernism was for him a value in itself,
and Modernism and Expressionism for him were indelibly linked
together. The defence of the modern movement by the governing boards
of the art societies, however, was concerned even less with content and
was more defensive. They emphasised how well-balanced the programme
was.

The tenor of a declaration by the curator is that the main task is to be
seen in the showing 'of all artistic directions and currents' of the present
time. He ends his declaration in this way:

We do not want to drag behind, our reporting should be quick and accurate, and,
therefore, it is a duty of progress to always inform people about the latest
productions in the area of the plastic arts ... At the same time we never forget to
give old established forces an equal chance to express themselves, forces that have
the struggle behind them and have achieved a perfection that is more satisfying to
those who savour art. This is something that a survey of our individual
exhibitions will convince one of.[34]

A similar position was taken by the governing board of the Art Society.

10.12 Stadtbauamt
Elberfield, Enlarged business
house Wallstr./
Schwanenstr. for Museum
Wuppertal-Elberfield,
1911/12

At the basis of the doubts raised about these exhibitions lay mainly the opinion that the paintings of the artists and artists associations mentioned represented works of an 'extreme' tendency that have nothing to do with 'art' and consequently have no place in our halls. The question as to what is 'art' is something the governing board does not feel it is in a position to decide upon, in contrast to this verdict . . . We can counter the reproach that we had one-sidedly favoured the 'modern painters', that is to say, the most recent trend in painting, in our exhibitions, by statistical proof. In 1910 the total number of all the paintings that were exhibited was 1,606; whereas the number of paintings from the *Neue Künstlervereinigung* (New Artists Association) in Munich was 128 or 8 per cent of the total. In 1911 the total number of paintings exhibited was 1,582, whereas the number of paintings of the artists of the 'extreme' works mentioned above was 213 or 12.5 per cent of the total.[35]

The fact that the organisation of the German art societies printed this statement in the first volume of its reports at the beginning of 1912 and that it expressly welcomed this statement shows the existence of an ideological front within the support given to art by the bourgeoisie. The result of the voting in the Barmen Art Society clearly delineates the front line of the diverging opinions. The group of the art society's members that was against the society giving support to the modern movement was defeated.

Thus, in the course of time, the art societies took on an important function in supporting the young, modern artists, while simultaneously preserving a precarious balance of opinions that were pulling it into nationalistic currents. For these societies were expressly committed to contemporary art and they gathered together those people interested in art who had money and were sensitive to art. However, these societies also created a culturally aware public through their exhibition pro-

gramme and were thus, at least at the local and regional level, also public institutions. One more or less explicit goal of these societies had always been to erect city museums so that they could achieve an extensive institutionalisation of and official support for their activities. In this way it was possible for the bourgeoisie to demonstrate, in an autonomous and representative way, their artistic tastes and cultural output. Thus, in Wuppertal-Elberfeld in 1892, a relatively late point in time, the Art Society was organised from the start as a Museum Society.[36]

The town of Elberfeld gave the society a yearly subsidy of 3,000 marks from 1896 and from 1899 it gave 5,000 marks, with the proviso that half of this amount was to be used to buy works of art that were then to become property of the town and be handed over to the society for the purposes of being exhibited. The acquisitions commission was chosen by the town and the town retained for itself a deciding vote in this commission. In 1901 the old town hall was made available as a museum. After 1903 the head of the museum was paid a salary as a city civil servant. Also, after 1903 Baron August von der Heydt was chairman of the governing board of the Museum Society. At the same time he was, through his gifts, the most active patron of the museum.

The building up of the collection did not, of course, get going with the little money coming from public funds. Right from the beginning these public art museums were dependent upon financially powerful private persons – a dependency that was certainly deliberate. The opening exhibition clearly documents the close relationship between the museum and the bourgeois upper class: 165 paintings from private collections in Elberfeld were exhibited. However, gifts from the populace also indicate that the museum project was understood as an institution that corresponded to their cultural intentions. In 1900 the heirs of de Weerth gave 10,000 marks, Mr and Mrs Johann Friedrich Wolff gave 30,000 marks, Mr and Mrs Julius Schmidt also gave 30,000 marks; and in 1901 Heinrich Schniewind donated 15,000 marks.

There was, in general, a tendency to make generous gifts and donations. In the period from 1900 to 1910 the citizens of Elberfeld – and again and again it is the same names that appear on the list – donated about 880,000 marks for art and learning, about 680,000 marks for charitable works, about 310,000 marks for education and 260,000 marks for beautifying the town.[37]

It was only after 1908/9 that changes came about in the policies regarding exhibiting and collecting that were important in furthering Modernism. While up to this time German idealism of the nineteenth century dominated the scene, now the French and German avant-garde began to play an important role in the art world. In 1907 Julius Schmidt donated a painting by Sisley and in 1918, together with Johann Friedrich Wolff, he donated a painting by Courbet; in 1910 one by Monet, and in 1912 a Cézanne. Robert Winkelhaus donated a sculpture by Rodin in

10.13 Berhard Hoetger,
Gerechtigkeitsbrunnen

1910. In 1909 Baron August von der Heydt donated a still life by Paula Modersohn-Becker, a picture by Henri Manguin in 1910, paintings by Hodler and Vlaminck in 1911, and in 1912 (as one of a group of donators) a Jawlensky, and in 1913 a von Dongen and a bronze by Lembruck.[38]

The development was, by and large, similar in Wuppertal-Barmen. The Art Society that had existed in Barmen since 1866 was the agency responsible for all activities relating to the support and preservation of the plastic arts in that town. Its by-laws contained a passage recommending 'the promotion of art and the stimulation and spread of a taste for art'. This was to be accomplished by way of an annual exhibition, the purchase and raffling off of works of art, and by playing the intermediary in sales of works of art to private persons and building up a collection of paintings.[39]

Public exhibition rooms had been available since 1900 in the *Ruhmes-halle*; the Art Society had a 184,000 mark share in this *Ruhmeshalle*. Yet even here the expansion of the collection was able to proceed only by way of gifts and special donations from the members of the society. As far as the works of the modern artists were concerned, Jawlensky's *Mädchen mit Pfingstrose* (Girl with a peony) was donated in 1910, followed in 1911 by paintings by Marc Sinac, Bechtejeff and Erbslöh, and in 1914 by works of Kandinsky and Marianne von Weefkin and another Erbslöh. With respect to Kandinsky this was the first time that a museum had bought one of his paintings. In comparison with Elberfeld it is clear that the emphasis in Barmen was on the works of artists from the *Neue Künstlervereinigung* (New Artists Association) in Munich.

In these same years Baron August von der Heydt and his wife, Selma,

183

10.14 Paula
Modersohn-Becker,
Mädchenbildnis, 1905

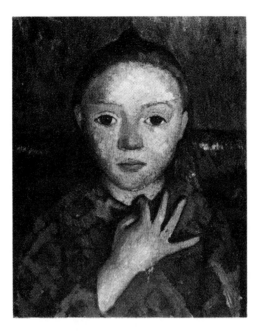

increased their private collection, placing emphasis on the works of the Expressionists and the Fauves. In 1908 or 1909 von der Heydt made available to the sculptor, Bernhard Hoetger, a house on the banks of the Wupper River to be used as an atelier. He donated a fountain designed by Hoetger to the town and arranged for him to get contracts to do portraits of Elberfeld families. Through Hoetger August von der Heydt was able to obtain access to the works in the estate of Paula Modersohn-Becker. Beside the painting for the museum's collection he also bought 27 other paintings.[40]

In the neighbouring town of Hagen the museum projects of Karl Ernst Osthaus were being developed at the same time as the collection of August von der Heydt. Obviously there were connections between the two men. In Hagen parts of a correspondence have been preserved that have to do with projects in the area of modern art: founding of an art magazine in the west of Germany, support for the artist, Bick, and participation in an exhibition in Paris on modern German art.[41] Osthaus' relationship to art was, however, certainly of another type than that of von der Heydt. On the one hand it was more professional and yet, on the other hand, more clearly enthused by a sense of mission and with cultural-pedagogical goals.[42]

Osthaus was born in 1874. His father was owner of a bank bearing his name. Through marriage his father became connected with one of the wealthiest families in metal manufacturing, a family by the name of Funcke. Early signs that nothing worthwhile would come of Karl Ernst Osthaus as far as the family tradition was concerned were his own literary

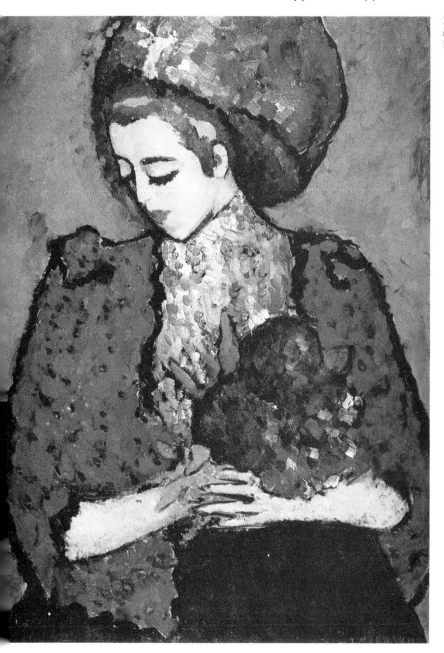

10.15 Alexej von Jawlensky,
Mädchen mit Pfingstrose,
1909

10.16 Entrance hall of the
Folkwang House of
Karl-Ernst Osthaus,
designed by Henry van de
Velde, 1900

production during his school years and his breaking off of an apprentice-ship and turning to the study of philosophy and art history. In 1896 he inherited his grandparents' millions. In 1900 there began a close relation-ship to Henry van de Velde and thus a decisive connection to Modernism in the *Lebensreformbewegung* (life reform movement) and in the history of art.

Osthaus became one of the most outstanding collectors of and propa-gandists for modern art in Germany. He bought and exhibited to the public the French Impressionists, Pointalists and Fauves. Even earlier and in a more comprehensive way than von der Heydt, he opened up his collection to the Expressionist works of Munch, Hodler, Nolde, Rohlfs (in particular), Heckel, Schmidt-Rottluff, Kokoschka, Kandinsky, Macke, Marc and so forth. He was also understood by the artists of the time as belonging to the avant-garde. Thus, Heckel wrote: 'The modern and for us model design of the Folkwang Museum [this was the name of Osthaus' collection] and its truly artistic director have raised in us the desire to put on an exhibition of our works in these beautiful rooms of the first and, for the time being, only modern museum under the direction of its highly esteemed head.'[43]

Osthaus employed some of the most important pioneers of the modern movement in architecture on his building projects. The younger ones, such as Gropius and Taut, developed their first projects for Osthaus. The

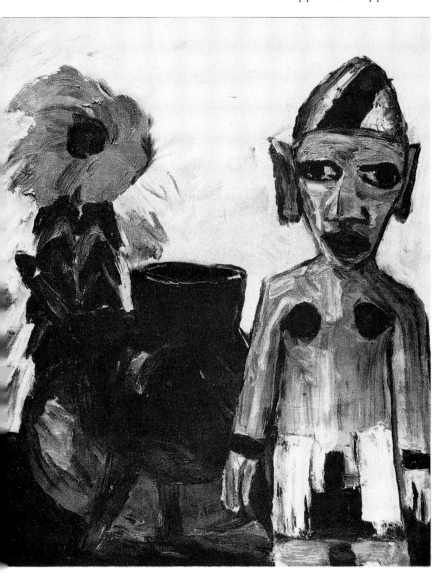

10.17 Emil Nolde, *Nature morte with fetish*, 1911

avant-garde in design is represented in his collections, gathered together in a *Deutsches Museum für Kunst in Handel und Gewerbe* (German Museum for Art in Commerce and Industry). Osthaus was an active member of the German *Werkbund*. His opening up of his private collections to the outside world, thus changing them into public museums, was of major historical-cultural importance. As Osthaus wrote in a letter to van de Velde, this 'is to have the aim of winning over our industrial area on the Ruhr, an area that has been forsaken by art, to modern artistic creativity'.[44]

187

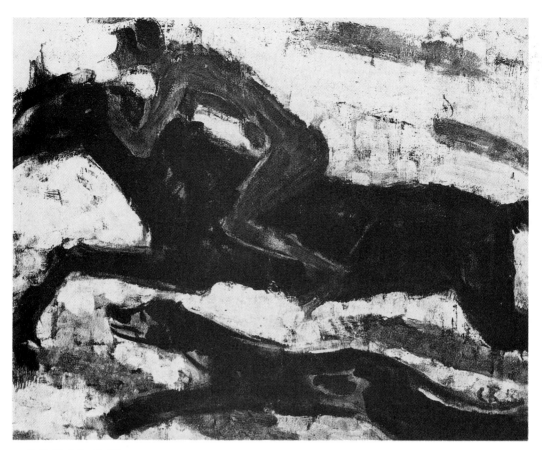

10.18 Christian Rohlfs, *Amazone*, 1912

On the opening of the Folkwang Museum Osthaus himself put his cultural mission into a wider perspective:

the nineteenth century is the century of specialisation. Through specialisation a gap has come about in the world. Each person sits on his own branch and has no idea of the whole tree. Here is where art must come in and act as an intermediary, uniting and unleashing productive forces, and it must saturate every aspect of work. It appears as if one could no longer put any hope that such an effect will be achieved in people who primarily have been called upon to do this, that is, ruling sovereigns. And so industry must step into their place. Art must come out of the palaces and into the industrial towns, and industry, which is already accustomed to working according to the laws of functionality, must be imbued with art.[45]

I feel that in this speech three things become clear: 1. a historical consciousness that is very clear about the fact that the promotion of art must be taken away from the aristocracy; 2. putting hope in industry, with the intention, however, of adding aesthetic qualities and values to it; and 3. the desire and the hope to revive a lost unity of human existence by way of great aesthetic efforts and to regain the meaning, morality and integrity of life and of social production. This is a metaphysical, redemptive programme for industrialism and the class society.

As a student Osthaus thought in philosophical categories: 'What else could be the main principle of my life other than – beauty? What else could be my life's profession other than – professor of aesthetics? But the beautiful must be combined with the true and the good in order to be ideal. Therefore, I must direct my studies to philosophy and history, in addition to aesthetics.'[46] His experiences in the world war and in the days of revolution made him formulate matters in a more political way. Art is for him still a 'rejection of the spurious, of the senseless, of the pedestrian' and 'a devotion to the meaningful, the important, and what one feels'. 'Thus', according to Osthaus,

we did not lay the foundation for revolution, we reached out beyond it. For socialism talks only in terms of work and property; it wants to reduce the one and to more justly distribute the other. Work, however, remains always in its eyes a scourge, and property remains a possession to be envied. It adheres to material things just like capitalism, which it fights against. For this reason it will not save our age. For us, however, we who see creativity in work, it is for us what the beat of a wing is for the bird; it bears us closer to light and beauty, and we do not count its hours. For us property is not the end but the means, the means to raise up the treasures of our phantasy and to form them into a picture. Thus, we have given a new interpretation to the meaning of things, have given them a life so that even for us life would take on a special meaning. And we believe that this understanding of being will bring salvation to pilloried humanity so that this humanity can unite in one happy community to achieve new goals.[47]

Just as both publicly and socially art and production, aesthetic interpretation and general living practices should all flow together, so Osthaus understands the connected unity of his life as a total work of art and as being private and public at the same time. The first house that Osthaus built for himself is, at the same time, both living quarters and museum. In the building in the Hohe Strasse that was completed by van de Velde, living quarters were erected on two floors. The impression of it being personal and intimate was preserved in the whole house, so that the young Osthaus couple could perhaps one day use the whole building as living quarters – something which, however, they did not do. The main living areas were arranged around the central exhibition hall of the upper floor. Both public demonstration and an environment for one's private life make up the impression one gets from the second house, the *Hohenhof*, which was to be connected with the artists and friends of the art association of the *Stirnband* (Browband) and, finally, from the *Stadtkrone* (City crown) projects that Taut, commissioned by Osthaus, designed for the town of Hagen during the First World War. All of Osthaus' collections were to have a place here, next to an art school project and the private flats. They were to be related to each other, yet also to have an effect on the public, like the 'Crown' for the city of Hagen.[48] Osthaus' requirements of art were of a highly metaphysical and moral nature. His projects were on a grand and heroic scale and he constantly attempted to take on tasks which could only conceivably be carried out by state and social institutions: the realisation of freedom in art, together with a comprehensive

promotion of art and its integration into the realistic interconnectedness of life. His projects and ideas were, of course, related to the bourgeois cultural opposition described above. They belong to the most important projects of this opposition in the area of the plastic arts between 1900 and 1914. But just as life at that total work of art, the *Hohenhof*, revives pre-bourgeois behaviour patterns, so do the grandness of the individual cultural gesture and the material expenditures needed to realise these goals, betray fundamental feudal characteristics.

In general, then, there would appear to have been two antipathetical forces that characterise the periods before and at around the time of the First World War. First there was the antipathy between the cultural policy of the state and the policies of the bourgeois opposition that supported Modernism. Secondly there was the antagonism between the social (in foreign affairs) political reactionary forces and the politico-cultural progressive forces. While efforts by the German educated classes to form a morally and metaphysically united cultural policy become reality only in certain rare situations, the modern movement in art was able to establish itself on a broad front. While the formation of internal political blocks keep the social reality with respect to the class situation in check, polarised into those below and those above, a splitting up of the cultural scene into a diversity of forms evidences itself in a way that is worthy of a developed, bourgeois society. This profound segmentation of the cultural sphere, which could no longer be illuminated by state controls, plus the backing given by the educated bourgeoisie, are the pre-conditions for the development of Modernism before the First World War.

A postscript, however: Without increasing its expenditures for promoting art, the Weimar state in the end gave the modern movement a certain legitimation in specific areas. This manifests itself not only in the projects of the *Neues Frankfurt* (New Frankfurt), *Gross Berlin* (Greater Berlin) and the large-scale blocks of flats for housing the masses, but also in the changes at the Prussian Academy of Arts, for example. An important changing of the guard with respect to the members of the Imperial Academy was when the leading figure of the Secession, Liebermann, became their president. He continued the policies of the Secession of 1913, the furthering of Impressionism and Expressionism. However, he now had the backing of the authority and the financial might of a state organisation. With architecture it was similar. That which the Grand Duke of Saxony-Weimar had begun became the first state-supported academy for modern art: the Bauhaus. This all lasted so long until the brown tide of Nazism again washed away all traces of these promising beginnings.

Art and oppression in fascist Germany

Hans-Ernst Mittig

The regime of German fascism,[1] which called itself 'National Socialist', made claims to a renewal of art and the expansion of its role. According to Hitler in 1935, the 'foundations for the new temple of the goddess of art'[2] were being laid. The symbol of this initiative was the 'House of German Art' erected by the regime in Munich.[3] The leaflet of an 1938 exhibition (plate 11.1) emphasises the intention of making art forms other than architecture, sculpture and painting media of Nazism, too. It includes objects of familiar domestic culture seemingly far from political indoctrination.

Today, half a century after these endeavours, the theme 'Art and oppression in fascist Germany' designates a former omission still perceptible in the history of art insofar as it refers to the art of the oppressors; a gap or an absence left by art historians themselves until the late 1960s. A reason often given for this is that from 1933 to 1945 official German art put itself in vassalage and thus relinquished quality, originality and subjective expression.[4] Precisely because this reasoning seems to make sense, it is necessary to examine the reactions of the artists to their patrons and arbiters more rigorously, beyond co-operation and inner emigration than has been done up to now, if we are to say something definitive about fascist art, as well as about its continuing neglect.

Considering the standard practices of the discipline of art history, the products of Nazism should have been included in any appraisal of the twentieth century, if only for the sake of historical coherence. However, only in 1978 was a form of responsibility to such completeness affirmed in the foreword to a West Berlin catalogue of an exhibition entitled *Between Resistance and Conformism*. In it Rolf Szymanski wrote: 'the [two previous] exhibitions *After the war was over* and *Tendencies of the 1920s* left no recourse, no way of avoiding a portrayal of this period in between, the burden of which bears heavily upon us'. The exhibitions, whose theme was 'this intermediate period', that of 1933 to 1945, were mainly concerned with art suppressed by the Nazis, labelled by them 'Degenerate Art' (this was the title of a memorial exhibition in Munich, 1962) and in which 'Resistance *not* conformism' (the title of a touring exhibition of 1980) was represented.[5]

2. DEUTSCHE ARCHITEKTUR- UND
KUNSTHANDWERKAUSSTELLUNG

im Haus der Deutschen Kunst
zu München

vom 10. Dezember 1938 bis 10. April 1939

A) ABTEILUNG ARCHITEKTUR
Fassaden- und Übersichtsmodelle, be-
leuchtete Innenmodelle, Großfotos,
Pläne und Zeichnungen der bedeu-
tendsten Bauvorhaben unserer Zeit.

B) ABTEILUNG KUNSTHANDWERK
Querschnitt durch die Spitzenleistungen
des gesamten deutschen Kunsthandwerks.

BESUCHSZEIT (AUCH AN SONN- UND FEIERTAGEN) TÄGLICH VON 9 BIS 18 UHR.
EINTRITTSPREIS 50 PFG. REICHILLUSTRIERTER AUSSTELLUNGSKATALOG RM 1.-.
ANSCHRIFT: HAUS DER DEUTSCHEN KUNST · PRINZREGENTENSTRASSE 1.
FERNRUF 20214 UND 20215.

Denkmal der Arbeit

Kanzleibau des Braunen Hauses

Neue Oper in München

Erweiterungsbau der Reichskan.

Hohe Schule am Chiemsee

Pfeiler der Großen Striegisbrücke

11.1 Leaflet of the second *German Exhibition of Architecture and Arts and Crafts* in the House of German Art, Munich, 1938

A reason sometimes cited for studying *official* German art of the years 1933 to 1945 is the relationship of this art to other styles and genres which are now undergoing detailed scholarly examination, such as 'New Objectivity'[6] (to which such works as Adolf Wissel's *Locksmith*[7] is close, for example) and 'popular wall decorations' such as landscape and genre scenes of the most trivial type[8] (similar to Oskar Graf's *Mountains*).[9] How far the genres found in the nineteenth century were extended or misused under nazism[10] then becomes an important issue if the study of art is not limited to its identification with upper-class tastes but also seeks

192

11.2 Fragment of an eagle from the former Central Airfield Berlin-Tempelhof, iron, W. Lemke, 1940, re-erected 1985

to examine the actual use of art by a wider public where art repro-ductions have long played a considerable role.[11] In the cases of sculpture[12] and design,[13] the adaptation of traditional art forms is particularly conspicuous.

Even leaving aside the very significant question of continuity[14] which connects fascist art with preceding and later works, critical reflection is necessary because of the continuing, everyday usage of Nazi works, particularly buildings and public sculpture. Around Tempelhof Airfield in Berlin, a series of well-preserved eagles are part of some Nazi architecture still in use today. The central emblem on the top of the building was removed and taken to the United States in 1962 as a kind of trophy but a fragment was brought back recently and presented (plate 11.2) to a visibly grateful Berlin district mayor.[15] This is just one of many instances[16] which illustrate how deeply lacking a critical appraisal of Nazi art has been, even amongst those who have maintained constant contact with its remnants.

However, this lack is explicable via a whole host of causes whose genesis lies outside the history of art. The catastrophic consequences of the fascist régime, whose intimations were already perceptible before the outbreak of war, became virulently clear for *all* to perceive at its end. That the details of this disaster, of the war and of the collapse of the Nazi régime were repressed – and how it was done – has undergone consider-able investigation particularly by Alexander and Margarete Mitscher-lich.[17] A long post-war process of closing one's eyes to mass murder, deportations and war crimes was equally bound up with fending off

193

visual remembrances of the fascist régime. Thus the usual basis of interest, with its fixation on pleasurable art consumption, was not available for the purpose of a critical reappraisal of art under fascism.

These practices, founded in an affirming aesthetic orientation, continue to dominate, particularly in the sphere of exhibitions. Exhibitions have to make a good impression, a visual impact, and usually they have to provide an aura of good will[18] – at least for *art*. In the main, visitors are offered a refuge far removed from the political arena. When the Hamburg exhibition *Art in Germany 1889–1973* was still at the conceptual stage, the authors distanced themselves from the practices which had dominated in recent years, that is, 'a review of illustrious names, embodied in masterpieces which are distributed among collections around half the globe'.[19]

The type of exhibition characterised ironically here is linked to the principle of quality which conventionally governs the selection of exhibits. Within such practices the integration of failed, misconceived or outrageous works is not possible. Although – or because – this type of exhibition does not promote critical reflection, as the Hamburg authors around Werner Hofmann stated, it is frequently accompanied by aesthetic justifications, which in turn propagate the continuing privileging of qualitative values.[20] But it is doubtful whether the art of the Nazi régime possessed the kind of quality which would lend itself to a show of brilliance. However, as Anna Teut[21] stated in 1967, Nazi architecture cannot be dismissed out of hand as entirely lacking in any value. However, in 1974, Hinz stated that the prevalent view of Nazi painting is that it does not merit discussion;[22] sculpture more so, according to Wolbert in 1982.[23] Certainty over quality in connection with genres of movable art works suitable for exhibitions is inconsistent and virtually impossible to establish.

However, it was not only aversion to the art of the Nazi régime which debarred it from art exhibitions. There was also anxiety that sections of the public would be only too keen to see these works again or would succumb to the lasting potency of their propaganda effect. This concern determined the preparation, arrangement and in part the critique of the Frankfurt exhibition *Art in the Third Reich: Documents of Subjection* in 1974. This exhibition had come to terms with the real dangers of showing Fascist art by using the possibilities of an 'argumentative exhibition',[24] an exhibition which uses extensive documentation to further its arguments, which is still not part of exhibitions' practices in which representation and good will are the primary aims.[25]

Nevertheless, the practices – and dangers – attendant upon the organisation of exhibitions in general do not explain why specialist literature has thus avoided Nazi art. Here issues of methods have continuously played a role in hindering investigation and discussion. The special features of Nazi art could be designated using methods of formal analysis but they could not be evaluated.[26] The application

of an iconological approach could investigate content but again could not evaluate it. At first, art history in Germany lacked both an appropriate method and the courage to attempt to formulate any methods equal to this task.

But these were not the reasons given for this form of abstinence. The central argument was that the products of Nazi art should not be regarded as art proper because of their lack of form of quality or their connection with a totalitarian régime.[27] Thus, according to this logic, there are artists who during the Nazi régime were established and productive but whose output is no longer recognised as art: an absurd state of affairs which continues to exist since the term 'artist' is used both to signify the professional occupation as well as the worth of an individual's work. Obviously, we are dealing here with an ideological argument of a defensive nature, according to which all artists are not equally artists, but are assessed in terms of a later period. However, neither the supposed distance created by time nor the present claims to an interpretative authority and the definition of quality can provide criteria for analysing processes specific to certain professions. Moreover, it is possible that in years to come standards of assessment other than today's, in which avant-gardism and quality are seen as inseparable, may prevail.[28]

During the immediate post-war years concepts such as 'Geist' and 'Ungeist', 'Art' and 'Non art', served as a vocabulary affecting a kind of excommunication which brought short-term relief from the obligation to examine NS art but established no actual knowledge. In fact, the German fascists *had* ascribed a servicing role to art.[29] This denial of art's autonomy was considered to be of such importance[30] that the actual extent of outside interference in its production became of secondary importance. Within the discussions which were to follow later, the ideal of autonomy could be defended against a particularly evil adversary – the Nazis and their art – and this simultaneously served as a warning to sceptics who held autonomy to be an illusion for very different reasons.[31]

With the debate on the question of autonomy began the development of a so-called 'alternative' history of art which since 1972 has also focused on the art of German fascism as its measure.[32] The above mentioned Frankfurt exhibition of 1974, which took Nazi art as its sole subject, intended to examine the art works precisely because of their heteronomy. The catalogue foreword contained a programmatic statement: 'If this exhibition is to make a contribution to the process of coming to terms with National Socialism, this can only be achieved if it can be made abundantly clear how deeply intertwined art was with the political and economic realities of the Third Reich.'[33]

For the work on this project, a far more historical discussion – and one that focused on social history – would have to be included than had been

the custom in art history up till then. The concern of several other authors[34] was an analysis of the socio-psychological factors involved in the way Nazi art worked to extend its influence. The attempt was made to include formal analysis and iconographic approaches[35] in the examination of objects in order to elucidate the relations between the sensory perception of nazism and its politico-economic foundations. This work was partly based on that of Walter Benjamin and the Frankfurt School and partly on an approach which was named 'Capital exegesis' after Marx's principal work. 'Traditional' art historians invested considerable energy in fending off this left-wing initiative —[36] far more than they were actually devoting to an analysis of fascism, even, were this possible, via the application of art historical modes.

However, the new approaches based as they were on predominantly socialist analyses of fascism, were opposed not merely by some art historians. It was against such arguments that foregrounded the relevance of social conditions that Joachim Fest's statement of 1974 was directed 'As a rule, the individual work of art does not reflect social reality.'[37] Why then were attempts such as Fest's and others made to ascribe pseudo-autonomous qualities to the aesthetic estate of the Nazis? In my view, it was to protect the commercial marketing of films, books and so forth of this inheritance (which had just begun) from the charge of socially rehabilitating Nazism. Focusing on the person of Hitler instead of on-going social reality, the visual estate of the Nazi era was being prepared for commercial exploitation as a somewhat peculiar side of a nostalgia vogue. In 1977, Joachim Fest himself contributed a well-known film to the so-called 'Hitler vogue', in which he dispensed entirely with his own earlier published rational attempts to explain Nazism.[38] This same trend also proved to be of equal commercial profit in the field of art history. To name but one example, a lavish and widely publicised publication on Albert Speer's architecture appeared in the same year, 1977.[39] Again, there were marked tendencies to lay great emphasis on the figure of Hitler and others such as Speer, as a way of focusing responsibility away from other persons[40] and entire social groups.[41]

During the past ten years, the study of Nazi art has produced two new significant lines of argument. A conference in Frankfurt in 1977 and the collection of essays resulting from it entitled *The decorations of violence*[42] emphasised the co-operation between fascist art and the mass media of the time. The investigation of Nazi art on an interdisciplinary basis – together with neighbouring disciplines such as media, communications and film studies – represented considerable progress in extending the framework in which this art was discussed.

The second trend links art history with a broad historical approach not confined to issues of quality. In many research projects of uncovering local history, issues of causality have been extensively documented. Important results so far are, for example,[43] several exhibitions of 1983

which were not limited to art alone such as *Heil Hitler, Mr Teacher Sir!* held in West Berlin and *Lippe under the Swastika*, in Detmold; similarly the history of institutions currently being researched by Christine Fischer-Defoy[44] at the Hochschule der Künste in West Berlin and which follows after Hildegard Brenner, who has already produced an analysis of the political alignment of the Prussian Academy of Art.[45]

Documents such as letters, directives and curricula vitae can all supply new impetuses for a fundamental revision of the current view of the relationship between politics and art under Nazism. I shall attempt to substantiate this in the following discussion, also referring to the works themselves. The testimonial character of these works is still controversial. Recently, one reads that there really is no such thing as fascist art, only the utilisation of art by fascists.[46] It is obvious that the message of a work of art becomes reality only through its relation to users and spectators within a framework of specific conditions. However, this does not mean that the art work's internal structure may be replaced by this, the recognition, relation, which is both desired and attained. In actual fact much Nazi art *does* exhibit specific visual characteristics;[47] exceptions should be analysed with reference to the scope and contradictions of the Nazi system,[48] instead of ignoring it or homogenising it.

The sweeping statement that there is no such thing as fascist art revives the idea of artistic autonomy and could prove very dangerous. For example, in a recent Hamburg publication, this view permitted the Italian architecture of the fascist period to be proudly extolled.[49] A book by Leon Krier and others interprets Speer's work as 'architecture of desire' rather than as a result and a coercive instrument of real history. The usefulness of this as later apologies for contemporary artists is apparent.[50] However, the direct intention is to salvage the visual vocabulary of fascism and to make it available for the use of some of today's postmodern architectural practices. For this intention, though, it is not even necessary to evoke an autonomism intent on suppressing history, a trend which is currently rife: the architectural motifs employed by fascism were for the most part merely usurped by the Nazis from earlier traditions and could be rendered reusable by developing them further on the basis of knowledge of their pre-Nazi meanings and their further implementation in a free and imaginative context, as has been done, for example, with the Neue Staatsgalerie (New State Gallery) in Stuttgart.[51]

Instead, the utilisation of fascist motifs as a 'spectacle' is in full swing.[52] In the process, these motifs are withheld from the necessary critical reflection rather than submitted to it. One example is Andy Warhol's paraphrase (plate 11.3) from Nazi instruction material (plate 11.4). It is the depiction of a so-called 'lightdome' on the Berlin Olympic Stadium. Apart from other considerations, Warhol does away with the contradiction between the backward-looking, supposedly peaceful, architectural language and the very modern technology – as in the case of

197

Hans-Ernst Mittig

11.3 *Stadium*, Andy
Warhol, 1982, Exhibition
Zeitgeist, Berlin, 1982

searchlights – which is aestheticised here and which rightly belongs to the
technology of warfare.[53]

The authors who tend to treat Nazi art as an autonomous phenom-
enon[54] either fail to examine the dependence of politics on the economic
sphere or dispute in principle the existence of such a dependence at all.
There is a total evasion in facing such allusions as Max Horkheimer's to
the relationship between fascism and capitalism: ('Whoever talks about
Fascism cannot remain silent about Capitalism') which was a motto of the
previously discussed 1974 Frankfurt exhibition. The separation of fascism
from its origins in the undeniably capitalist mode of production of the
period becomes the more credible the less that works of art are permitted
to betray of the politico-economic situation of their genesis. I shall not
pursue this problem further here, but refer readers to the publication *Die*

198

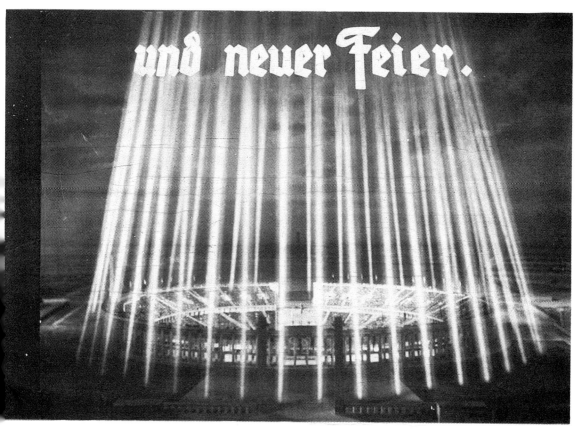

11.4 Light-dome around the Olympic Stadium in the Reichssportfeld, Berlin. Slide from *Gesundes Leben*, picture strip for instruction of the Hitlerjugend, around 1939

Dekoration der Gewalt, where phenomena of Nazi art are analysed as reflections of the 'aesthetics of economics'.[55] The fallacy, that there is no such thing as fascist art, and the consequences thereof, converge with the opposite assumption that Nazi art was so totally determined by politics that it cannot be studied as art using the tools of art history.

The fact that these opposing generalisations continue to exist in specialist literature is explicable when concrete internal polarities within the art of German fascism are considered. I shall illustrate this with two examples and trace the contradictions implied by their contrast. In 1936 Adolf Wamper's sculptures were installed at the entrance to the Wald-buhne in Berlin (plates 11.5, 11.6). Formerly known as the 'Dietrich-Eckart-Bühne', this open air theatre belonged to the *Reichssportfeld* (Reich sports field) complex and was built in the early years of the Nazi régime for so-called *Thingspiele* which were patrial and cultic presen-tations. The name refers back to the ancient Germanic world but the shape of the theatre – as in West Berlin – is modelled on the arenas of Ancient Greece. The walls carrying the reliefs flank the entrance which is of dimensions calculated to admit large crowds of people.[56]

199

[handwritten annotations in top margin: sense of batyhere / still, in..rible, sealem / power pain – stability of power]

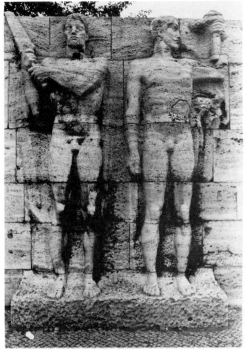
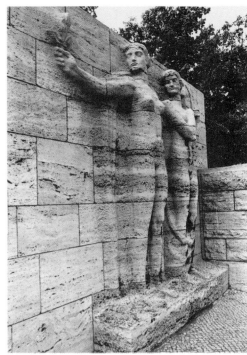

11.5, 11.6 Reliefs at the entrance of the Waldbühne, Berlin, muschelkalk, Adolf Wamper, 1935–36

[handwritten annotations in left margin: Doric Greek + Germanic / men women Greek / Germ / no individual rights (Volk is all)]

Neither knowledge of this spatial and functional context nor that of the special iconography[57] used is necessary here to recognise many of the ideological motifs that so-called National Socialism used: for example, the basic idea of a northern race which would unite both Doric-Greek[58] and Germanic elements.[59] Ancient Greek and 'Germanic' motifs are divided among the sexes: the heads of the women on the right-hand pillar are stylised Greek, whereas the two men on the other side have narrow skulls attributed to the Germanic type.[60]

In accordance with a basic idea which denies the individual all rights (often expressed by 'You mean nothing but your Volk is all'), the figures display nothing analogous to individual feelings. Their attitudes are monotonous (the women's even more so than the men's); their ponderousness and the seams of the wall running through them emphasise that these figures are in no way independent of the wall. Only the man on the extreme left betrays a sign of activity: not resulting from voluntary movement, but rather due to the positioning and symbolic value of the raised sword. Although all the figures exhibit restrained attitudes, the basic idea of the different roles of man and woman, diametrically opposite and with woman subordinate, is nevertheless apparent. The female figures on the relief are presented attractively enough in somewhat revealing garments, as if to encourage what was then called 'the preservation of the species',[61] but the stylisation of the figures imposes a limit on this appeal – at the

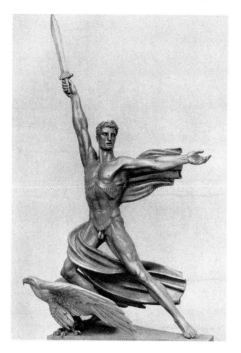

11.7 Genius of Victory, plaster model, Adolf Wamper, 1940

point where fascination and power over the male might begin; an art historian described it thus in 1941 in another connection: 'one does not begrudge oneself the pleasure of natural (female) charms but one resists all overheated allurements'.[62]

These and other patterns utilise motifs which are all traditional.[63] Some of the essential ideological traits only become clear when one realises how they were developed in later works: the aggressivity, which is subdued in this early relief dating from 1934–36, appears with utmost vehemence in the same sculptor's colossal *Genius of Victory* of 1940 and in other works[64] (see plate 11.7).

The oppressive effect often referred to in connection with these sculptures is not simply identical with this visually aggressive quality, for superficially it does not threaten the spectator, the 'National Comrade' or the 'Volksgenosse'. In fact, the sculpture suggests an exhortation to follow, to identify and join forces with the power symbolised. Gestures, which make an appeal to the spectator, are as frequent as the corresponding titles of the works. However, since the foe is neither named nor depicted, such sculptures do hold a threat of a kind for those who are 'not behind them'. Above all, the muscular body – often colossal as here – and the one-dimensional expression of determination construct a basic image which is beyond the reach of the average spectator's physique[65] and psyche. He is denied any feeling of elation when contemplating such a work. Only the role of a vassal, devoid of self, is left to him. The feeling of

201

11.8 Westward Entrance
and Bell Tower of the
Reichssportfeld, Berlin, by
Werner March, 1933–1936,
re-erected 1962

inadequacy in the face of demands made upon one has here been upgraded from a banal means of repression used in military and in Nazi Youth training to an effect of large works of art.

I am attempting to take stock of many references, not always explicit, to the effects produced by Nazi sculptures.[66] Hitherto, the alternative between size that suggests encouragement, and size that is oppressive, has been discussed more extensively with reference to architecture: architecture of proportions which reject the scale of the individual human being was deliberately employed at an early stage by German Fascism.[67] An example is the entrance side of the bell tower (see plate 11.8) in the Olympic complex, facing Wamper's reliefs which I have mentioned above.

At first sight, some landscapes by Hermann Gradl (see plates 11.9, 11.10) seem to be examples demonstrating the opposite of art which conforms ideologically. When the context is not known, their effect is neutral. Their representational context was that six of these paintings, a series, decorated the dining room[68] of the new *Reichskanzlei* (Chancellery of the Third Reich), and as 'symbols of German lands', represented the governed territories in an agrarian[69] interpretation. Instead of depicting particular landscapes, the paintings were to remain typical and in this way could span the territorial expansion that the new building of the Chancellery was to symbolise (according to Angela Schönberger).[70]

The objection that this functionalisation remains external to the pictures themselves for they appear as unpolitical and private, actually leads to a possibly even more important connection with the Nazi system. For this system intervened in and harried people's everyday lives and

11.9, 11.10 Landscapes in the dining room of the Reichskanzlei, Berlin, oil on canvas, by Hermann Gradl, 1939

11.11 Advertisement for cigarettes, 1939

private domain.[71] In part, it occupied it: with compulsory participation in marches, collections, instruction evenings, and meetings – for example, of the *Amt Feierabend* (The Office for After Working Hours). The time that remained of the private sphere to working people and even schoolchildren took on the nature of a refuge, where everything was of interest with the exception of politics, and thus was of no danger to the régime. There was no need – and probably no possibility either – to transform this sphere shaped by private economics: it was World War II which altered it.[72] Within this hard-pressed private sphere, the desire for free personal movement, for example, was addressed by frequently recurring motifs in advertising. The advertisement in plate 11.11 appeared in the issue of the magazine *Die Kunst im Dritten Reich*, which introduced the landscapes from the *Reichskanzlei* to the public. It is significant that they were placed in the dining room:[73] in that location they represented what much of the art on offer at official Nazi exhibitions represented: painting that supposedly catered for the private needs of the 'National comrades'.[74]

Two sides of Nazi art, the 'imperious' (plate 11.12) and 'convivial' (*gemütlich*) (plate 11.13) demonstrate the actual contradiction between modes of domination and personal needs[75] but the system managed this contradiction in a way which stabilised the workings of the system rather than threatened it.

The underlying method can be exposed only if the disquieting fact is

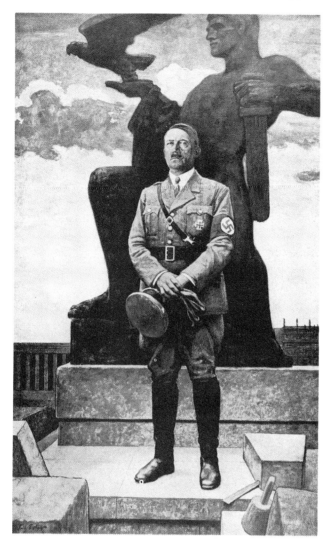

11.12 Portrait of the
Führer, Fritz Erler

recognised that the Nazi system accommodated real needs to a very large extent and genuinely fulfilled them. The 'distraction of the masses' awareness from their objective interests'[76] was not only a coercive act but a process of clever manipulation by the régime of the myriad of conflicting needs which always exist concurrently. The Nazi régime satisfied certain needs to the detriment of others; for example, it clearly addressed the visual curiosity of its citizens in order to push back the desire for information and participation. A contradictory structure of needs in the individual came into play: the desire for free self-determination does not exist in isolation but alongside of subjective needs and desires for reassurance in the face of repression suffered by not recognising it as such,

205

11.13 *In einem kühlen
Grunde*, linocut, Georg
Sluyterman de Langeweyde,
1939

not believing oneself to be affected, compensating for the fact or regarding it as inevitable. These are needs which generally manifest themselves in conflict situations and they compete with the desire to settle the conflict and arrive at a solution. To decide between these equally real but contradictory needs in such a way that a resolution of the conflict is circumvented, leads to conformism and integration that objectively runs counter to self-interest. To address desires for self-deception, aloofness, compensation or fatalistic renunciation of all action, belongs to possible functions of art – and not only since the era of Nazi fascism. By activating these needs and desires and actually satisfying them, art also manages to dismantle the contradictory need for liberation.[78] References to this escapist function of art are frequently found in descriptions of what happened at that time, as when in 1983 it was stated in connection with the consequences of the suppression of art in Hamburg: 'Most of the artists took refuge in landscape painting because there a slightly abstract and atmospheric Naturalism was more readily accepted',[79] and when contemporaries spoke of a 'need ... if at all possible, to escape from social pressure to a truly personal, inner realm', namely that of artistic work.[80] That art also provided the public traditionally[81] with means of escape and comfort had already been observed by contemporary commentaries.[82]

This strategy of control – not to eradicate private needs but to turn them into a means to defend and serve them falsely – is very obvious in the two exhibitions held in 1937: *Degenerate Art* and the *Great German Art Exhibition*. Indeed, here were concerned the needs of a vast number of visitors who do not deserve the same contempt[83] as the exhibition *Degenerate Art* or the same ridicule as the *Great German Art Exhibition*. The two most striking elements of 'popular' art appreciation[84] are plausible enough to have survived[85] their demagogic abuse by the Nazi régime and are the subjects today of current work on art. This applies even to the desire for *recognisability* of the representation: an example of how simple insistence on a connection between art and life, albeit formulated in a more demanding fashion, can become a permanent programme, is Hilton Kramer's *laudation* of Neo-Expressionism in the catalogue of the exhibition *Zeitgeist* (Spirit of the times), Berlin 1982.[86] The public's dominant attitude toward art applied criteria of *craftsmanship* to the works;[87] this 'craftsmanlike' attitude towards art feels affronted by spontaneous methods of presentation. Instead of viewing this merely as petty-bourgeois narrow mindedness,[88] one should recognise in it the traces of a respectable concern: the desire to connect the work of the artist with activities whose social meaning is recognisable. Walter Bachauer (also in the *Zeitgeist* catalogue) regards this 'craftsmanlike' attitude as having been finally overcome by Neo-Expressionism.[89] But instead of taking leave of it, I think it would be more constructive to take the issue of work seriously: artistic work and craftsmanship, industrial

207

and socially useful work in general. Several exhibitions around 1970 did this,[90] and the public continues to do so.

The negative and stultifying effects on the development of German art, of Nazism's repression of all art trends regarded as 'modern' has often been discussed. This repression served to clear a space for the art of the Nazi régime and awarded it a further context-determined theme: that these works obviously negated modern developments constituted a part of their message and was celebrated as something positive.[91]

The means of this process of oppression are described in part in Georg Bussmann and Peter Klaus Schuster's London Royal Academy catalogue articles. 'Activities between terror and demagogy', as Hildegard Brenner put it,[92] accompanied the struggle for power even before 1933. When the Nazis came to power, they undertook a radical re-staffing of posts on the basis of the law concerning officialdom of 7 April 1933.[93] This law's criteria concerning race and political convictions put the seal on the loss of their positions for numerous teachers and academics, many of whom were not even given a chance to conform.[94] The same criteria applied to membership of the newly created *Reichskammer der bildenden Künste* (Chamber of the visual arts).[95] It was impossible to participate in the public art world without being a member. Membership could be withdrawn[96] at any time, as indeed happened in the case of Karl Schmidt-Rottluff, so members lived under a continual compulsion to conform. Over and above this, the president of the *Reichskammer der bildenden Künste* had the power to prohibit individuals from exhibiting (as in the case of Otto Dix, 1941)[97] and could also close down entire exhibitions which were not in favour.[98]

This administrative oppression was supplemented by journalistic oppression. The Führer's 'speeches on Culture', the statements and speeches of lesser officials like the *Landeskulturwarte* (literally: Wardens of culture of a German land) all achieved a high circulation thanks to the daily press and newly created art journals so that any attack or defamation by them effectively meant economic ruin.[99]

However, true to a basic principle[100] of any strategy aimed at making people conform, punishments were supplemented by rewards. The vacant posts were open to both old and new Nazis; new positions were created in newly founded institutions of cultural administration. Special administrations, like the *Generalbauinspektion* (General Buildings Inspectorate), offered contracts to selected architects; the director, Speer, also purchased many paintings for the *Reichskanzlei*.[101] Locations for works of art which conformed to the system were cleared. For example, in Hamburg, Ernst Barlach's relief of a mother mourning on the town's war memorial was destroyed in 1938 and made way for an eagle sculpted by Hans Ruwoldt[102] (see plate 11.14), a fact not mentioned by Ruwoldt's biographer.[103] Many new buildings were erected for the state and the party, providing a multitude of commissions for sculptors, painters and crafts-

11.14 War Memorial, Hamburg, Klaus Hoffmann, 1930–31, with relief by Hans Ruwoldt, 1938–1939

men who wanted to work for the Nazi régime.[104] Thus, in 1941, Will Grohmann was able to remark – perhaps ironically – that 'never before in German history have there been so many and such rewarding commissions as since 1933, but also never before have there been so many workers to carry them out'.[105]

Thus the reasons why these workers adapted to the Nazi system – indeed frequently *offered* their services[106] – were not only fear of sanctions, but also hope of advantages. Many such reasons for conformism have been named, either at the time or since, by the artists themselves or by critical contemporaries; nevertheless, an overview of this chapter in the history of German artists appears to be lacking.

One group of motivations can be described as personal (and therefore not new). It encompasses those who strove for recognition by the upper ranks of society,[107] aspired to be influential artistically,[108] to procure administrative power[109] and, naturally, to maintain their material existence.[110] The general significance of this last reason was stressed, for example, by Roh in 1948.[111] Both individual artists and associations like the Bund Deutscher Architekten and the Werkbund[112] tried, in various situations, often using conformist – and even racist[113] – arguments, to conserve existing principles,[114] art trends[115] or institutions[116] through integration in the Nazi system. These are factual or issue-related grounds given for adapting to the system.

Halfway between personal and factual motivations of participation was an additional factor which at the time was continually evoked and expected: enthusiastic devotion to the Führer. Hitler's personal influence on the art of the 'Third Reich' is a favourite theme of the aforementioned 'Hitler vogue'; after 1945, the artists themselves referred less frequently and sometimes in a more distanced way[117] to the impression that Hitler had made on them, either as a person[118] or as a construction of former propagandists.[119] Of course, this may be due to the fact that factual grounds for conformism were better suited as apologia. Anyway, a compilation of all the grounds given to date represents a step away from the fable that personal allegiance was also the main factor involved in binding supporters to the fascist art world.[120]

To date, these reasons have hardly been analysed at all,[121] although the term 'conformism' has figured centrally in many an exhibition title and text. Frommhold's essay, published in 1978, entitled 'Between resistance and conformism: Art in Germany 1933–45',[122] emphasised correctly that far more had actually taken place than merely a number of individual processes of conformism. The concept he introduced at this point of a 'general' or overall conformism designates a change of general mood but not much more, for Frommhold is not concerned with the theory of social psychology.[123]

In my opinion, more can be done when the following is considered. In several cases, external conformism led to a change in inner attitudes,[124] as Dietrich Grünewald demonstrated in his examination of 'Simplicissimus' cartoons.[125] To suppress or to rationalise external pressures as being their motive would be particularly applicable to artists. For to follow external commands, not of one's own free will, goes against any form of group norm of artists. Especially in the twentieth century, artists have laid particular stress on following impulses from within, not from without as Carl Hofer put it.[126] Conformism, which runs counter to this, is therefore more painful for artists than for members of other professions accustomed to receiving and carrying out instructions: acceptable grounds are only accessible if the subjective attitude is changed at the same time. Thus the ideal of an artist's *inner* drive turns into an agency of his adjustment, urging towards a 'conformity of attitudes'.[127]

Not only artists who had hitherto been 'unpolitical' became active in fascist art, but also some who had previously had socialist leanings. The brothers Luckhardt[128] became adherents to the theories of Möller van den Bruck, a direct ideological precursor of NS fascism and in 1934 they planned to top a 'Haus der Arbeit' with a glass cult edifice in the shape of a crystal. Nerdinger explains this in terms of intellectual history since German fascism actually did profess to integrate both humanitarian and socialist[129] fundamental ideas. In this connection, in the area of visible utopias, Brecht's reference to a 'formalistic procedure'[130] is very convincing. A complementary explanation from social psychology can be

seen in a sort of parathymia, whereby an emotion can be turned into its opposite, if it is subjected to very harsh repression (according to Hartley[131]). These are *possible* explanations for inner changes which otherwise remain enigmas. The mechanism at work in the individual case is unascertainable now in most cases. The forthright question as to whether specifically artistic causes of conformism exist also reveals a counterargument. Whenever artists have bound themselves to norms, these have been 'higher' ones[132] which are not affected by changes in governments and administrative guidelines. Wolfgang Abendroth demonstrated in a lecture given in Marburg in 1983,[133] that such high principles not only prevent opportunism but can also conceal it. As a 'protective ideology', suited to this purpose in the field of science, he analysed references to 'objective science'. It seems to me that the perpetual references to 'Germanness'[134] and 'The Germanness in Art'[135] in statements by artists, art historians and organisations since 1933 constitute a parallel to this. In official usage the term served as a delimitation[136] as well as a means of rejecting art which was not in favour, but it was used in a different form by artists who collaborated with the régime: it was often used to justify this collaboration on the grounds that they served higher aims.

What did 'Germanness' actually mean? Theodor Fischer admitted that 'We can gladly dispense with a definition. We don't even want to think too much about what is German.'[137] But attempts nevertheless to provide a definition[138] have all been so vague that what many artists held in good faith cannot be refuted, if they believed that 'Germanness' was best served by the Nazis.

The observations and considerations raised so far suffice to awake doubts that the relationship between art and oppression in fascist Germany can be described simply as a collision of diametrically opposed elements. Notwithstanding, this is the usual version: the cliché[139] sees on the one side a régime that issued directives and exerted repression, and on the other, persecuted artists and controlled art – 'politics' appears as the oppressor of 'art'. The many instances of this view are either in the form of catch-phrases or half-truths: for example, as Rave asked in 1949, 'how was contemporary art evaluated by the authorities, that is, by representatives of the state?[140]

In this way, certain questions are excluded, such as: were artists merely victims, or were they in part active agents[141] of oppression? Furthermore, is the defencelessness of artists merely to be regretted or can it be explained? The cliché that politics issued orders and art obeyed them, falls down in the face of the verifiable and long-known fact, cited by Hinz, that no pre-arranged official and binding programme for art existed.[142] Early on, historical research found that 'the' ideology of German fascism was too vague and contradictory a conglomeration[143] to provide artists with more than obscure rhetoric such as 'Romanticism of steel' (Goebbels, 1933) and 'cultural stamp of the German race' (Hitler, 1935).[144] The

211

orders from above were only more clear about what are *no longer* had to be; thus the régime was quite satisfied with relatively neutral art, as in fact was produced in massive quantities.

Designs for overtly oppressive Nazi art came from conformist or openly fascist *artists*.[145] Artists could present 'programmes',[146] submit 'suggestions'[147] or even 'expectations' placed on the government.[148] It was they who designed the oppressive art of the régime, in particular its totally unrealistic ideal of race.[149] And it was Hitler who was in a position to *choose*,[150] which he did in his speeches.[151]

In the case of the relief at the entrance to the former Dietrich-Eckart-Bühne in Berlin discussed above, the design was the winning entry in a competition. The sculptor Wamper took up an idea from a work on 'Thing' plays, which was not an authorised work,[152] as the basis for his two groups of figures facing each other. His design was accepted, it was not officially dictated to him. It is interesting that the patron had a far more forcible influence on the comparatively less oppressive – superficially – landscape paintings by Gradl: Hitler chose him personally to execute this commission, a 'clearly defined artistic assignment' and supervised its execution.[153] The Führer liked the more private painting genres in general better than the works of propaganda.[154]

A second argument against the cliché of politics oppressing art is the fact that the fascist régime was to a great extent *composed* of artists as rulers and officials. Hitler, the former painter and amateur architect,[155] was only one of them (shown above in a picture by Fritz Erler, plate 11.12). Contemporaries celebrated both Hitler's pictures and the artistry he introduced into the control of the state;[156] later authors saw this as his personal motive for desiring control of art or as merely a personal whim or as a subtle ideology.[157] Albert Speer started his career as an 'architect without commissions'.[158] The motivation of the rivals Rosenberg and Goebbels could also be considered: Rosenberg was a former landscape painter[159] and Goebbels retained grotesque literary ambitions up to the end.

More illuminating is the extensively realised *principle* of the Nazi régime of considering artists as public officials[160] and installing them in such positions. Art was to be administered by artists,[161] One of the presidents of the 'Chamber' who both exemplified and propagated this, Adolf Ziegler (plate 11.15) was at the same time a leading Nazi artist and from 30 June 1937, head of the 'Degenerate Art' campaign. This campaign was not directed primarily against the artistic components and meanings of modern art,[162] but had a far more concrete political purpose. The Nazi regime, never entirely sure of the people's affection,[163] needed images of an enemy;[164] *visible* images which military conflict was unable to provide before the outbreak of war in 1939. To provide such images which supposedly represented and depicted the ideals of the nefarious systems of democracy and communism[165] the régime misused modern

11.15 Adolf Ziegler, president of the Reichskammer der Bildenden Künste

painting and sculpture, and to carry out the 'Degenerate Art' campaign it also misused people who *as artists* had become opponents and rivals of modernism.[166] But the imaginary enemy had to stand for something *political.* On one page, the 'Degenerate Art' exhibition guide book points the finger at Bolshevism, anarchism and socialism'.[167] The cliché 'politics attack art' is inadequate here. A strong minority of lesser-known artists had been actively involved in formulating art policy[168] and administration and had joined the 'Fighting League for German Culture', as local investigation has shown.[169] Thus to the words: 'Never before[170] was art so oppressed' must be added: 'Never before were artists such oppressors'.

When these facts are only mentioned in passing or ignored altogether by specialist literature, it may be because the view obtains that the artists were not acting in their capacity as *artists*, but as state or party officials.[171] Many contemporary and later accounts, though, argue against this view and assess the striving for administrative power as a continuation of competitive struggles between artists as individuals and also as groups.[172] Competition on the market has often been the driving force behind certain lines of argument in art theory. Particularly the opposition to modern art trends was a theme of confrontation between various artist groups for years[173] before it became an administrative doctrine.

Artists, who did *not* develop art for the purposes of oppression and who did *not* wield power as fascist officials, represent very necessary and generally admirable counterpoles. Nevertheless, I doubt whether all the respectful words dedicated to them up to now in exhibition and book titles are appropriate and enlightening: 'Persecuted and Seduced'[174] – epithets of innocence from 1983; 'Art Deprived of its Power'[175] assuming the actual possession of power which was then stolen (1985).

In my opinion, the authors nearer the heart of the matter are those who regard these artists as defenceless *because of* their fixation on the separation of art and politics and because of their own isolation from the political opponents of German fascism.[176] This isolation often possessed the innocence of a lack of appreciation. I refer here to such as Kandinskij,[177] who didn't read newspapers, but in giving his opinion of the situation in 1933 could speak of 'the befogged heads' of others, and in the same connection, recommended joining the 'Fighting League for German Culture', and credited Willi Baumeister with a useful role within that organisation.[178] Indeed, many statements by artists from this time[179] are just as confused and ill-informed, that seeking explanations, I cautiously consulted an apparently relevant anthropological work by Geyer (1954).[180] He describes forms of constricted consciousness, of 'blinkered' attitudes specific to certain professional groups, who became obtuse in areas outside their own range of competence – the contemporary expression is *Fachidiotie* – the idiocy of specialists. Geyer describes this phenomenon with reference to philosophers, lawyers, physicians and theologists, but he fails to consider whether in the case of artists a constriction of their professional visual field can occur. The very idea appears to be out of line, so strong is the belief in the universality of art. However, many artists emphasised that they do not desire a comprehensive view of the world, at least not the world at hand, through and in which they exist. This applies in particular to political and social structures.[181] The Nazi rulers, of course, were quite content with this.[182] Regarding their grasp of politics, Hitler saw artists as innocent children;[183] the 'blinkered' perspective was also very comfortable for artists of the Nazi régime like Breker, for example: it did not affect his usefulness

at the time and was useful as an apology later – his own description of this is informative.[184]

Hitler's allusion to 'children' is only a comparison, but Frommhold's psychopathological metaphor 'schizophrenia'[185], which stands for blindness to political connections, is most doubtful;[186] but then 'blindness' is equally a metaphor. In order to call this phenomenon by its proper name, it is necessary to delineate a form of social insensibility which is found among specialists: in the case of artists, as specialists for emotions.[187]

The enduring actuality of this theme seems to be confirmed by Glucksmann's recent remarks on 'La Bêtise'. Referring to preparations which could lead to a Third World War, he is afraid 'that the fault of our grandfathers, who cheered Hitler or surrendered to him, was less fatal than the faults *we* are in danger of committing'.[188] The perilous tendency to screen off the spheres of society and politics from one's area of interest gained additional impetus under Nazi rule. The effects continued to be felt after 1945 as when Karl Hofer carried the polarity of 'politics' and 'art' to extremes in the words: 'We come to the conclusion that the most deplorable, most criminal human activity of all is politics.'[189] This might not be put so explicitly today but there are, nonetheless, disquieting signs that disassociation from politics and society constitutes a considerable element in the self-awareness of contemporary artists.[190]

I have spoken here critically of the 'state' and particularly of 'artists'; lack of space has prevented a detailed discussion of 'patrons.'[191] Of course, it is not sufficient to refer to this one particular group involved in art.[192] For art historians[193] *too* in fascist Germany suggested means of oppression,[194] functioned as officials of the regime,[195] presented arguments which were blind to politics.[196] And today, too, many art historians prefer an interpretation of their subject which suppresses the political implications of art[197] and thus inhibits political reflection.

Patterns of post-war patronage

Carla Schulz-Hoffmann

Within the context of an examination of the problematic of German art in the twentieth century, the question as to whether the possibilities and limitations of the sponsorship of art can be of any special importance to the debate is justified, since the presupposition would be that we are dealing with specific mechanisms that are different from those of other countries. For this approach to the problem is only important to an understanding of certain correlations within German art after the period of National Socialism and World War II if there are substantial differences – and this is the only period of time that can reasonably be examined within this framework.[1]

There is in fact one principal difference between the sponsorship of art in the Federal Republic and in the other countriues of Europe, and it is integrated into the constitution: Articles 30, 70 and 83 guarantee the cultural sovereignty of the *Länder* (states) and substantially limit the role of the Federal Government to that of an observer. Among other things, the constitution states the following unequivocally: 'In as much as this constitution does not decree or permit any other regulation, the execution of governmental authority and the fulfilment of governmental obligations is the affair of the States',[2] and: 'The States have the right to pass laws, in as much as this constitution does not confer the power of legislation to the Federal Government.'[3] As there are no special provisions appertaining to cultural affairs with regard to domestic German questions,[4] the implication of these sentences is a constitutionally based autonomy of the States in cultural matters. Since the result is an unusual diversity of cultural sponsorship measures, the consequences of these regulations are far reaching and, it would appear, generally positive.

When the 'Fathers of the Constitution' legislated the autonomy of the states, one of their intentions was, beyond doubt, at least partially to continue a tradition that is the result of the particularism so typical of Germany. It is well known that Germany did not adjust to a central capital until quite late, specifically until after the unification of the Reich in 1870/71, and even then it was with qualifications. Berlin was never able to attain the evolutionary and quasi-organic cultural position of London or Paris. Quite the contrary was true: there were a multitude of smaller

court capitals that had traditionally taken on this function and that continued decisively to influence it. The unification of the Reich superimposed a centralised government on the evolved organism. This centralised government was never able to become quite organic, and Jacob Burckhardt's characterisation of its basic tendency was to the point:

The nation is, above all, (seemingly or actually) desirous of power. The particularist existence is abhorred like a hitherto existing shame; any activity for the former is insufficient for the compelling individuals; they only want to belong to something larger, thus clearly betraying that power is their primary, and culture at best their remotely secondary goal. Above all, they want to assert the collective will to the outside, to spite other peoples.[5]

The horrible consequences of these power-based political views and their catastrophic after-effects under the National Socialist reign may have been, given their tragic proximity to the young republic, sufficient motivation to develop a different structure. The only way to guard against aberrant authoritarian developments, such as the one the dictatorial, centralistic system of the NS regime represented in the extreme, was to separate and thus to limit the powers of the individual. If National Socialism had normatively tried to establish *one* German art, the goal now had to be the opposite: its diversity and complexity in all its facets had to be expressed. This was and is more assured in a system that is comprised of smaller and equal organisations such as the states, than in an edifice hierarchically governed from the top.

One pertinent and initial result of this basic organisation is that only the individual states of the Federation have a cultural ministry in the Federal Republic of Germany, and thus they dispose over the final authority in matters of education, the promotion of the arts and sciences, and in other cultural affairs. One of the consequences is that the states not only have the right, but also the responsibility to support cultural development: 'As a corollary of their constitutionally guaranteed cultural autonomy, the Länder have an obligation to finance culture. They are called upon to preserve, promote, and subsidise arts.'[6] And quoting the relevant passages in the Bavarian Constitution, the author continues: 'Art and science are to be fostered by the state and the municipalities' and 'In particular, they shall provide funds for the support of creative artists, scholars, and writers who give evidence of serious artistic or cultural activity. Apart from the municipalities, the Free State of Bavaria is therefore required by the Constitution to make a contribution to the financing of culture.'[7] And even if the criterion of selection addressed here is more than problematical, the delegation of authority to the states does at least bring about a quantitative improvement of culture in comparison to a non-federalist government. The practical consequences are a multitude of varying cultural institutions and sponsorship mechanisms whose numbers are indeed considerably enhanced by the unspoken competition between the states and the state and municipal institutions. This does not

217

only apply to the museums that are spread out throughout Germany in an almost unimaginable profusion and that have proliferated to an imposing degree during the last few years, due to an overwhelming number of newly constructed buildings. Just look at Stuttgart, Munich, Düsseldorf, and Cologne. It also applies to the whole policy of exhibitions and direct state and municipal subsidies to the arts.

Naturally, the quantitative offerings all too often outweigh the qualitative offerings, and in addition to this, activities that elaborate on historically safe topics are given greater emphasis than are daring new approaches that are more intransigent with regard to representational requirements.

But nevertheless, the efforts to be as diversely effective as possible in a broadly sketched spectrum are remarkable. Among other things, I am referring to the numerous exhibitions by professional associations that offer comparatively good marketing possibilities and to sponsorship programmes that are supported by state as well as municipal institutions. Frequently the problems of these initiatives are to be found less in their own structure than in the fact that the most gifted young artists often shy away from participating in the exhibitions of professional associations and the accompanying antiquated jury process (*Juryungsverfahren*). If we include the art societies that exist in almost every larger city and that have traditionally put more efforts into sponsoring non-conformist art, the result is a relatively tight net of mutually complimentary activities. Nor should we underestimate the sponsorship role of the private sector. In many localities it supports the acquisition policies of the state and municipal institutions and purchases objects that could hardly be obtained with public means. The State Gallery of Modern Art in Munich, for example, would be suffering from an extensive gap in contemporary works from artists like Beuys, Baselitz, Kiefer and Penck were it not for the support it got from the Galerie Verein. Similarly, without private support, the National Gallery in Berlin would not have been able to make its spectactular Barnett Newman acquisition; and this is not even to mention the almost limitless contributions the collector Ludwig made to, among others, the museums of Cologne.

But these activities are no more typical for Germany than for other countries and are indubitably greatly surpassed in the United States. The backdrop of German history is what imbues them with a special meaning; this history is what necessarily imparts to them a greatly enhanced significance and direction.

Following the National Socialist period and its pervasively desolate consequences, the important thing was principally a new beginning, as well as a need to conjoin the devastated culture of Germany to the standards of the world. Since cultural policies were a part of Germany's reparation and simultaneously an encouragement to unshackled thought, they also contained an element of didacticism. Ultimately, this gave rise to

private sponsorship organisations as well as to initiatives such as 'documenta,' the ramifications of which can hardly be overestimated. Thus, in 1955, Werner Haftmann wrote the following about National Socialism's effects on culture in the introduction to the catalogue of 'documenta;' 'The damage was really inflicted on the nation, on its awareness of contemporary culture, on its passive desire for culture. The massive use of the beguiling agents of the dogma of mass contentment shocked it out of the specific continuity of thought that, alone, could make it capable of understanding the expressions of modern art.'[8] And he concludes by saying that the 'documenta' exhibition was 'targeted at the rising generation, was for its still unknown painters, poets, and thinkers, so that they will recognize the foundation that had been prepared for them and what needs to be managed, and what to be overcome. The justification and the dignity of our modern spirit is always the awareness of our freedom to go forward.'[9] Far removed from any nationalistic constrictions, this relates and related to the representation and thus also the support of young art, regardless of its nationality, a factor that is, beyond doubt, a result of the traumatic experiences of the National Socialist period and thus has a particularly international orientation.

In conclusion, let me refer to some nation-wide activities by both state and private organisations that do not impede the autonomy of the states. Actually, they supplement them.

In the pamphlet 'What is the Federal Government doing for Culture?' the following response is given to the question 'Who looks after the cultural responsibilities of the Federal Government?':

The responsibilities for the cultural obligations assigned to the Federal Government by the Constitution in spite of its federalist principles are shared by several ministers: The main responsibility rests with the Minister for Internal Affairs since his office is the focal point of the Federal Government's sponsorship of art and culture; this is where comprehensive conceptual programs are developed. A second large area, the entire range of European and other foreign cultural policies, is the responsibility of the Minister of Foreign Affairs.[10]

Within this framework the 'comprehensive conceptual programmes' – they are only hinted at with names like *Nationalstiftung* (National Endowment), *Bundeskunsthalle* (Federal Art Gallery), and *Kunstfonds e.V.* (Art Foundation Association) – are of special interest. In terms of direct support, the *Kunstfonds e.V.* is given a position of pre-eminence. Founded in 1980 to sponsor contemporary fine arts, it supports individual artists as well as comprehensive projects while simultaneously trying to make contemporary art accessible to the public at large. Its founding members were representatives of the most important German artists' organisations: the *Bundesverband Bildender Künstler* (Federal Association of Artists), the *Deutscher Künstlerbund* (German Artists' Association), the *Gemeinschaft der Künstlerinnen und Kunstfreunde* (GEDOK) (Association of Female Artists and Friends of the Arts), the *Bundes-*

219

verband Deutscher Galeristen (Federal Association of German Gallery Owners), the *VG Bild-Kunst* (VG Picture-Art), as well as the artist Rune Mields as the representative of the non-organised artists. This broad spectrum guarantees an openness, reflected in the results up to now, 'of how democratic processes can be realised in the cultural arena without necessarily leading to uniformity and homogeneity'.[11] So far its results – they are shown in art exhibitions in the region around Bonn – have been an at least respectable beginning in spite of its relatively limited financial means (five million DM spread out over five years).

Within this framework, a small but highly regarded joint effort by the Federal Government and the states is also worth mentioning: Given to the Prussian king by the industrialist Edouard Arnold in 1910, the Villa Massimo in Rome now contains 12 apartments that are available to especially gifted young painters, sculptors, architects, authors and composers as studios for one year. While the Federal Government is responsible for the upkeep of the academy, the states nominate the applicants for a joint selection process and finance the participants' stay.

These comprehensive activities, of which I have only mentioned a few here, are supplemented by private initiatives, for example the *Privatinitiative Kunst* (PIK) (Private Initiative Art), founded in 1980, 'an association of artists, gallery owners, publishers, collectors, museum employees, and friends of the arts that has set itself the goal of maintaining and enhancing the rightful space of the fine arts'.[12] So far this group has been, among other things, especially active in support of increased sponsorship for the so-called *Kunst am Bau* (Art in Construction) as well as in support of social security for artists, something that was realised in 1983.

If all of these activities are added up, and I have only named a few here, the result is astonishing – and not only quantitatively. Naturally many improvements are still necessary in all of the mentioned areas – in particular with regard to the many questions associated with the criteria of selection and the tendency to sponsor safe art – but all in all the special historical situation of the Federal Republic does seem to assure a wider range of sponsorship options than is common. And in the future the aversion to narrow-minded nationalist viewpoints that, with good reason, is almost anxiously nursed in Germany, will hopefully prevent the one-sided particularistic constrictions that are prone to appear in many places in favour of an unbiased support of varying artistic tendencies. That is, after all, one of the gauges of the democratic awareness of a country.

The city IV

Berlin 1870–1945: an introduction framed by architecture

Iain Boyd Whyte

In the mid-1920s Robert Park noted the unique ability of the metropolis 'to spread out and lay bare to the public view in a massive manner all the human characteristics and traits which are ordinarily obscured and suppressed in smaller communities. The city, in short, shows the good and evil in human nature in excess. It is this fact, perhaps more than any other, which justifies the view that would make of the city a laboratory or clinic in which human nature and social processes may be conveniently and profitably studied.'[1] Before founding the Chicago school of urban sociology, Park had studied in Berlin under Georg Simmel, and his experience of the new German capital at the turn of the century had a powerful influence on his response to the city. For if the great city, the *Weltstadt* or metropolis is uniquely revealing as a laboratory of human behaviour, then Berlin has special status among the great cities of the world as a monument to the extremes of human inventiveness and folly.

Compared to its immediate cousins – Vienna, Paris or London – Berlin was a late developer in both physical size and political significance. Although the population of Berlin grew from 29,000 in 1700 to 172,000 in 1800, it was only one among several German *Residenzstädte* at the beginning of the nineteenth century. A hundred years later the situation was entirely changed: The political dominance of the German states by Prussia resulted in the unification of Germany in 1871, with Berlin as capital. This political pre-eminence was matched by the industrial significance that the city gained during the relatively late process of German industrialisation, and these two factors put unique demographic pressures on the city. In nineteenth-century Britain, for example, the burden of administration, banking and finance was centred on London, while the industrial and manufacturing base was located in the great cities of the north. In the new German state, by contrast, the enormous local, national and military administrations, and the burgeoning manufacturing, financial and service sectors were all centred on the same city, Berlin. The effect on the population of this simultaneous expansion on several fronts was predictably dramatic. In 1865, when the population was 597,571, Werner von Siemens invented the first dynamo and thus laid the basis for the great Berlin electrical industry. Between 1866 and 1868 the

13.1 Berlin from the Kreuzberg, around 1830

old city walls were removed. In 1870 the Deutsche Bank was founded and the population had reached 774,452. A year later Berlin became the capital city and the 'Ringbahn' was opened, a railway loop beyond the old city limits. In 1880 the city had over a million inhabitants, and by 1910 over two million. By this time, however, as a result of industrial dispersal and a highly developed railway and electric tramway system, the adjoining towns such as Charlottenburg, Spandau, Rixdorf/Neukölln or Weissensee, which were still administratively autonomous, were expanding faster than Berlin itself. Thus in 1910, when the population of the Berlin administrative area was 2,071,000, the total population of Greater Berlin was 3,734,000. The impact of this growth, which was unprecedented in Europe in both its extent and speed, can be clearly seen in two views of Berlin taken from the Kreuzberg, the city's only natural hill. The first, to be dated around 1830, shows a *Residenzstadt* contained within city walls and surrounded by fields and meadows (see plate 13.1). The same vista in 1913 shows the church towers and the quiet restraint of Biedermeier Berlin buried under a new cityscape of tenement houses, railway stations, factories and belching chimneys that extended right up to the Kreuzberg and beyond (see plate 13.2).

This surging growth demanded radical planning measures, which, in turn, produced the characteristic Berlin housing type – the *Mietskaserne*. The Hobrecht Plan of 1858–62 proposed a system of wide boulevards interspersed with matchingly large squares. Although initially limited by

1 Johanniskirche
2 Heilige Geist-Kirche
3 Kriminalgericht
4 Matthäikirche
5 Elektrische Hochbahn
6 Kreuzbergstraße

7 Kapernaumkirche
8 Kraftstation der Hochbahn
9 Nazarethkirche
10 Siegessäule
11 Dankeskirche
12 Reichstagsgebäude

13 Gnadenkirche
14 Lukaskirche
15 Anhalter Bahnhof
16 Sebastianskirche
17 Stephanuskirche
18 Dorotheenstädtische Kirche

19 Himmelfahrtskirche
20 Dreifaltigkeitskirche
21 Golgathakirche
22 Johannes Evangelistkirche
23 Kreuzbergdenkmal
24 Königliche Bibliothek

13.2 Berlin from the Kreuzberg, 1913

an outer ring, the plan and the building regulations that went with it provided the development model not only for Berlin, but also for the surrounding suburbs until the end of the Wilhelmine monarchy in 1918. In his original plan Hobrecht proposed that the large blocks between his boulevards should be subdivided by smaller streets and green areas. The public bodies responsible for building the streets chose to economise, however, by ignoring these subdivisions, and thus promoted the spread of the *Mietskaserne* – the five-storey apartment block ranged around one or more courtyards with a single access on the street front. By ranging a series of courtyards of diminishing size one behind the other, some housing light industry, the speculator could maximise the return on a deep site with a narrow street frontage, leading in extreme cases to such celebrated results as Meyer's-Hof in Ackerstrasse, Wedding, which boasted no less than six courtyards (see plate 13.3).

The *Mietskaserne*, however, was only one of the many manifestations of Berlin's frantic development. Equally extreme and just as characteristic of the new cityscape were the public and official buildings that employed a powerful Neo-Baroque to glorify the Hohenzollern monarchy, the new state, the army and the church. Reinhold Begas's National Monument for Kaiser Wilhelm I or Raschdorff's Cathedral (plate 13.4), both from the mid-1890s, are typical of the genre. Although the court, the aristocracy and the military enjoyed an unquestioned social pre-eminence, the wealth in the city lay elsewhere, and it is significant that in the early years of the

225

13.3 Meyer's-Hof,
Berlin-Wedding, 1910

new century the second richest Berliner after the Kaiser was not an aristocrat, but the Jewish entrepreneur Friedländer-Fuld.[2] Between the two social extremes of the Hohenzollern court and the *Mietskaserne* courtyard blossomed a large and remarkably mobile bourgeoisie, which was at home in the new western suburbs. Here the *Mietskaserne* gave way to the *Mietshaus*, and Zille's *Miljöh* bowed to the educated tastes of the newly rich. A contemporary observer put it as follows:

Out there, where the swanky piles of the rich line Kurfürstendamm, where the 'Jugendstil' buildings of the 'Bavarian' quarter indulge in excessive lapses of taste;

13.4 The recently completed Berlin Cathedral, architect Julius Raschdorff, 1905

out there, where the money rolls, the servant girls wear white bonnets and the doormen adhere to aristocratic notions of precedence, and where Berlin is actually Charlottenburg, Schöneberg or Wilmersdorf; out there lies Berlin W. Out there is where 'one' lives. One has eight to twelve rooms, a lift, an official paper costing fifty Marks permitting the use of the lift, and an uncertain feeling that one might from time to time get trapped in it.[3]

For the very rich there were houses in the Tiergarten, or in the Grunewald villa-colony, which was developed in the 1890s. The distance from the Wedding *Mietskaserne* to the Grunewald villa could not be measured simply in kilometres. As the little rich girl explained in one of Robert Walser's marvellous Berlin vignettes:

227

13.5 Kurfürstendamm 42,
Berlin-Charlottenburg,
architects, Berndt and
Lange, 1901–1902,
photograph 1910

Daddy and I live in the most exclusive district. Districts that are quiet, meticu-
lously clean and of a certain age are exclusive . . . One hardly sees any poor people,
e.g. workers in our district, where the houses have their own gardens. Daddy says
that the classes affected by poverty live in the North of the city . . . What is that –
the North? I know Moscow better than the North of the city. I've got lots of
postcards sent to me from Moscow, Petersburg, Vladivostock and from Yoko-
hama. I know the beaches in Holland and Belgium, the Engadine with its hills
reaching to the sky and its green meadows, but my own city? Perhaps Berlin is a
mystery to lots and lots of people who live here.[4]

The little rich girl was not alone in finding the *Weltstadt* Berlin
incomprehensible. How was one to react to the giant that had sprung out
of the sandy soil in less than half a century? The comparative lack of
historical or religious tradition was aggravated by the recurring Berlin

13.6 Bayerischer Platz,
Berlin-Schöneberg, 1909

mania for demolishing anything more than fifty years old, which guaran-
teed that little could survive of the historic fabric. For these reasons the
city was in many ways more similar to New York or Chicago than to its
European rivals in the early years of the century. This prompted a
positive, if superficial response to the city as the *Stadt der Zukunft*, as the
future made real. In the eighteenth and nineteenth centuries enquiring
Germans like Moritz, Forster, Schinkel, Engels and Fontane travelled to
England to discover the future. By the turn of the century the future could
be experienced in Berlin. It was a vision of endless movement and vitality,
of anonymous masses flowing past according to the mysterious laws
imposed by the metropolis. After his first visit to Berlin in 1902, Bruno
Taut reported back to his brother Max in Königsberg:

I always felt happiest on the great traffic arteries of Berlin, Leipziger Strasse and
Friedrichstrasse, where the life of the city pulsed most vigorously. The throng is
particularly odd when viewed from the bus, and I had the feeling that the people,
electric railways, etc., were bustling around down below simply to give me this
picture.[5]

The attraction of the city was not merely its abstracted vitality, however,
but the resulting anonymity and liberality. Walser noted this in his
account of a walk through Berlin in the early morning, just as day was
breaking:

That's the beauty of the city – one's attitudes and behaviour disappear among thousands of others. Observations are transitory, judgements hasty, and it goes without saying that everything is instantly forgotten, done with. What's just gone past? An Empire facade? Is it worth turning round again to give the old building another look?[6]

Yet it was precisely this anonymity and rootlessness that provoked the wrath of the critics, with Berlin as their particular target. The attacks came from all parts of the political and intellectual spectrum – extreme left to extreme right. On the right, the basis for the polemical attack on the cities was laid by Wilhelm Riehl's 4 volume work, *Die Naturgeschichte des deutschen Volkes als Grundlage einer deutschen Sozialpolitik*, which appeared between 1851 and 1869. Riehl's work provided the basis for a whole range of pseudo-Darwinist theories of urban degeneration, which openly proposed a return to rural values and hierarchies as a means of stemming the spread of social democracy. The message was taken up by Heinrich Sohnrey's journal, *Das Land: Zeitschrift für die sozialen und volkstümlichen Angelegenheiten auf dem Lande*, first published in 1892, and later by Fritz Lienhard and Adolf Bartels in their influential *Heimatkunst* journal, *Heimat, Blätter für Literatur und Volkstum*, which first appeared in 1900. Lienhard's proposition, that the nation should resist the corrupting metropolitan influence, was summed up in his motto: 'Los von Berlin!' The impact of the *vaterländisch-konservativ* movement on the visual arts and, in particular, on the perception of human nudity is covered in Jill Lloyd's essay in this volume.

The conservative attack on the city found a persuasive, if unwitting ally in the newly emerging discipline of sociology, and the nature and significance of this contribution is the subject of Ira Katznelson's essay. In the celebrated paper 'Die Großstadt und das Geistesleben', written in 1903, Georg Simmel referred to 'the passionate hatred of personalities like Ruskin and Nietzsche for the metropolis – personalities who found the value of life only in unschematized individual expressions'.[7] These two figures can conveniently be seen to prefigure two responses to the metropolitan dilemma that were particularly relevant to Berlin. Ruskin, along with Morris, Proudhon, Stirner, Bakunin and Kropotkin were the favoured prophets for a whole series of mainly literary communes that were established in the countryside around Berlin at the turn of the century. Typical results were the *Friedrichshagener Kreis* or the *Neue Gemeinschaft* commune, involving, among others, the brothers Heinrich and Julius Hart, Wilhelm Bölsche, Bruno Wille and Gustav Landauer. These literary groups sought to re-establish the mutualist principles of the *Gemeinschaft* in the context of a small rural community. The commitment to the land, however, was tempered by the attractions of the metropolis, and a compromise was achieved by choosing sites within a short suburban train ride of Alexanderplatz. Although interesting as practical experiments in anarcho-socialism, the literary communes were shortlived. A more lasting impact, however, was achieved by the *Deutsche Gartenstadtgesellschaft*, founded in 1902 as a direct offspring of the *Neue Gemeinschaft* group. As its name implied, the new formation was based on the English model – Ebenezer Howard's Garden Cities Association. Also like the English model, the *Gartenstadtgesellschaft* espoused a reformist socialism that aimed to defuse the revolutionary potential of the urban proletariat by improving living standards – Howard's 'Peaceful Path to Real Reform'. As the founding statutes explained:

The Deutsche Gartenstadtgesellschaft is a propaganda society. It sees the winning over of the public to the garden city cause as its principal aim. The ultimate goal of a progressive garden city movement is internal colonization, which will promote industrial decentralization and an even distribution of industrial life across the land through the planned development of garden cities.[8]

Although from quite different motives, the revisionist socialists were proposing exactly the same solution as the radical conservatives and anti-semites to the problems of the cities in general and Berlin in particular. In reality, and in the tradition of the literary communes, the *Gartenstadtgesellschaft* constructed garden suburbs for the bourgeoisie rather than garden cities for the proletariat, and in doing so created a precedent for the great Berlin housing estates of the 1920s (Plate 13.8).

As early as 1900 in his *Philosophie des Geldes*, Simmel had noted 'a deep longing to bestow on things a new meaningfulness, a deeper significance, a value of their own ... The consequences and correlations of money have hollowed them out and made them indifferently inter-

13.8 Gartenstadt
Falkenberg, Berlin,
architect Bruno Taut, built
by the Deutsche
Gartenstadtgesellschaft
1913–1914

changeable'. The Ruskinian return to pre-industrial values, if only in the suburbs, offered one way back to 'significance' via nature and craftsmanship. But Simmel also implied another alternative, with a distinctly Nietzschean pedigree. His text continued:

The lively movements in art, the search for new styles, for style as such, symbolism, even theosophy, are symptoms of the demand for the new, more deeply felt meaning of things – whether each thing thereby receives a new, more soulful emphasis, or whether it acquires this through being placed in some new relationship that redeems it from its atomisation.[9]

Simmel is here amplifying Nietzsche's plea for a selective arrangement of the world for the sake of survival: 'The reality is ugly. We possess art lest we die of the truth.'[10] Through artistic intervention the fear of *Zersplitterung*, of fragmentation and atomisation can be removed by recombining the apparently disparate elements. Anticipating the violent imagery of Expressionism, Zarathustra explained:

Verily, my friends, I walk among men as among the fragments and limbs of men. This is what is terrible for my eyes, that I find man in ruins and scattered as over a battlefield . . . I walk among men as among the fragments of the future – the future which I envisage. And this is all my creating and striving, that I create and carry together into One what is fragment and riddle and dreadful accident. And how could I bear to be a man if man were not also a creator and guesser of riddles and redeemer of accidents?[11]

In its random, almost demonic growth the metropolis was regarded by the Expressionist generation as a riddle, as a series of accidents that could only be comprehended through the creation of new interrelations. By forcibly associating the disparate or by stressing discontinuity, by switching at will from the tragic to the absurd, from logic to arabesque, the Expressionist writers and poets went beyond the despairing realism of naturalism to construct a reading of the city that more closely reflected the complexity of emotions experienced in the metropolis. A stanza from Georg Heym's poem 'Berlin' (1910/11) typifies the Expressionist technique:

> The train halted for a while at the points.
> The ear was captivated by a sound.
> From the wall of an old house resounded
> Three timid violins with delicate strings.[12]

In a very similar spirit, but in prose, Alfred Wolfenstein used a bus with no brakes to penetrate into the essence of the city:

The machine drove hooting into the sleeping town. In the fresh air full of stars and gardens the wheels churned forward on both pavements. Bay-windows sprung out, splintered, piles of sewing-baskets plummeted down. Display windows bounced on the roadway, the store gave up all its wares, so that the air was full of sparkling gifts, calenders, slippers, dummies, herrings, plush furniture. Criss-crossed by the whirl of fallen trees and street lights, the goods plunged onto the square, which trembled at the dreadful sight . . . New corners fell to the brake-less drive, nightcaps scattered out of a host of piled-up beds, but nowhere a pair of lovers.[13]

Such attempts to comprehend the dangers and pleasures of Berlin find an obvious parallel in Georg Grosz's cityscapes, such as 'Metropolis' (1916/17) or in 'Homage to Oskar Panizza' (1917/18).

Should Nietzsche's 'dreadful accident' prove irredeemable, however, the results would be apocalyptic – another Expressionist *leitmotif*, and one which became reality in the 1914–18 war. While the battlefields gave flesh to Ludwig Meidner's visions of destruction, the food shortages, which were particularly acute in Berlin, appeared to confirm the Darwinist theories of urban entropy (see plate 13.9). The result was a brief but complex fusion of many of the pre-war readings of the city. An archetypical product of this amalgam was Bruno Taut's book *Die Auflösung der Städte* (the dissolution of the cities), written early in 1920 (plate 13.10). By this time, the abandonment of the Workers' Councils in favour of parliamentary democracy, the success of the *Freikorps* in suppressing the extreme left, and the murder of political leaders like Liebknecht, Luxemburg and Landauer, all suggested that the new German republic would not be the anarcho-socialist utopia favoured by the pre-war *Literaten*, a prospect that had gained a brief credibility in the early months of peace. Taut's polemic, therefore, can be seen as a coda to the whole era of Expressionistic, millenarian expectations. Following the pseudo-

13.9 One of the 'Gulaschkanonen' introduced in Berlin in March 1916 to alleviate the food shortages

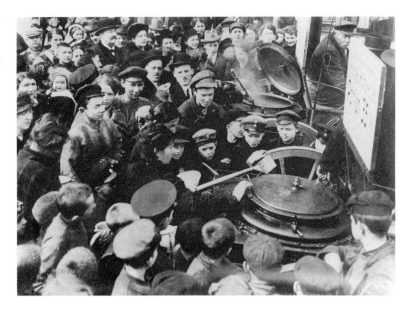

Darwinist theorists, and doubtless influenced by the terms of the Versailles Treaty, Taut insisted that the era of the city and of the manufacturing economy was over. The cities should be abandoned and allowed to collapse. Taut's alternative were small, mutualist communities dispersed on the land, as proposed by Landauer and Kropotkin, who were quoted at length in the prefatory selection of texts. Taut's drawings show the city collapsing in Meidnerian chaos, to be replaced by clusters of rural communities with circular plans that give symbolic form to the self-containment and harmony of the new *Gemeinschaft*. Inevitably, Zarathustra appeared among the texts, condemning the centralised state and its agent, the city dweller, as 'superfluous':

> Only there, where the state ceases, does the man who is not superfluous begin: does the song of the necessary man, the unique and irreplaceable melody, begin. There, where the state *ceases* – look there, my brothers. Do you not see it: the rainbow and the bridges to the Superman?[14]

Taut's bridges were built in the customary materials of Expressionist architecture, steel and coloured glass. This combination had been arrived at by Taut and the poet Paul Scheerbart in the years immediately before the war, in a process analogous to that of the Expressionist writers. By creating a new relationship between industrial materials and such abstract concepts as aesthetic delight, comfort, beauty, and health, the historical accident of industrial building was 'redeemed'.

In redeeming technology and its products the Expressionists created the conditions necessary for the technolatry of the 1920s. It is not mere chance that many of the leading architectural functionalists of the Weimar years – Gropius, Scharoun, Bruno and Max Taut, Hans and Wassili Luckhardt – had belonged to the Crystal Chain group, a late flowering of Expres-

13.10 Bruno Taut, *Die Auflösung der Städte*, 1920

sionism. As Taut explained in *Die Auflösung der Städte*, 'Technology is now something entirely different from what it was in the stone age of factory chimneys.'[15] Later in the same year he told his associates in the Crystal Chain that he was resolved to abandon fantasy in favour of 'absolutely palpable utopias that "stand with both feet on the ground"'.[16] This fundamental change of heart was echoed in 1920 by the painter Max Beckmann, who surveyed the previous decades and concluded:

From a thoughtless imitation of the visible, from a feeble, archaic degeneration into meaningless decoration, from false and sentimentally bombastic mysticism,

235

we may now hopefully arrive at a transcendental objectivity, which comes out of a deeper love of nature and humanity.[17]

To a certain degree, this dream of a humanistically informed objectivity was realised in the massive housing programmes that distinguished Berlin in the 1920s. The basis for these programmes was laid in a series of legislative reforms introduced after the war. The Greater Berlin law of 1920 removed the friction between the old city and its neighbours by absorbing some seventy municipalities and rural districts into one administrative area whose boundaries remain intact today, albeit on opposing sides of the Berlin Wall. A new Prussian law on house construction of 1918, and the 1925 zoning laws and building ordinances forbade courtyard housing, and thus banished the *Mietskaserne*.

The new city administration, the planning and building ordinances and the positive assessment of technology and industrial techniques were all essential prerequisites for the housing programme. The organising genius who brought these components together was Martin Wagner, *Stadtbaurat* of Berlin from 1926 to 1933. In the face of the private building sector's inability to satisfy the pressing need for housing, three of the largest German trades' unions established the Deutsche Wohnungsfürsorge AG (Dewog) and its Berlin subsidiary, the Gemeinnützige Heimstätten-, Spar- und Bau-Aktiengesellschaft (Gehag). Wagner was a leading figure in both, and openly used his political contacts in the SPD city council to acquire large tracts of building land on generous terms. As Wagner himself explained: 'Fundamental housing reform cannot be achieved via piecemeal building activity on a small-scale financial basis.'[18] His alternative involved large developments, standardised building elements and highly industrialised methods 'such as those achieved by Ford in the automobile industry'.[19] These were all features of Gehag's showpiece development, the *Hufeisen* (horseshoe) estate in Britz on the south-eastern outskirts of Berlin, which was built in 1925–30 to the design of Bruno Taut and Martin Wagner (plate 13.11). Yet in spite of the vigorous adoption of the latest techniques of prefabrication and industrial building, there were clear conceptual links to the debates of the previous two decades. The dominant elements of the plan, the horseshoe enclosure itself and the lozenge-shaped green beyond both, derived directly from Taut's utopian schemes in *Die Auflösung der Städte*, while the row housing developed the type that he had used before the war as advisory architect to the *Gartenstadtgesellschaft*. The reformist ideals of the *Gartenstadtgesellschaft* also survived, and the planning of the estate and of the individual units was directly aimed at creating a new socialist *Gemeinschaft*. What the political revolution had failed to achieve was now to be created through architecture. Echoing the Activist dogma of the war years, which assigned the artist the role of social and political reformer, Taut claimed that through the medium of domestic design, the architect 'will become an ethical and social creator'.[20] In a similar spirit,

Wagner described himself as the *Regisseur der Weltstadt*, as the controlling spirit who brought together economic development, improved communications and rationalised housing to create ideal living conditions for the urban working classes.

In spite of the enormous achievements of the Gehag, both quantitative and qualitative, the reforms in housing design and finance advocated by Taut and Wagner were only partially successful. While they greatly overrated the ability of architectural design to promote social reform, they underestimated the resistance of the administrative institutions to radical change. Way back in 1914, during the celebrated Cologne debate, Taut had recommended that the Deutscher Werkbund would best realise its aim to improve the standard of German design by giving absolute, dictatorial authority to one artist. This was a theme that recurred in his wartime writings and in the 1918 aspirations that the *Arbeitsrat für Kunst* briefly held during the November Revolution. Although nothing came of this in 1918, the paradoxical union of socialistic aims and dictatorial means survived in the housing programme – in Wagner's *Regisseur der Weltstadt*. His dynamic conception of the city constantly reacting to new demands and conditions under the guidance of the all-powerful *Regisseur*, was difficult to reconcile with the slow and long-winded workings of the democratic process. This conflict was particularly acute in the area of compulsory purchase for redevelopment and came to a head at the end of the decade with the Betcke case, which, according to Ludovica Scarpa, marked the end of city-scale planning in the Weimar Republic.[21] These fundamental problems of political practice led Wagner to resign from the SPD in 1931.

13.12 Fritz-Reuter-Allee,
Berlin-Britz, architect Bruno
Taut, 1925–1930

Wagner's laudable ambition was to provide 'a healthy home for every German', yet the impact of the Gehag estates on working-class housing was very limited. The success of Wagner, Taut and their collaborators in building estates on virgin sites in leafy suburbs was achieved to a considerable extent at the expense of the traditional working-class areas such as Wedding, Moabit or Prenzlauer Berg. The public money which might otherwise have been spent on transport and public facilities in these central boroughs was diverted to the new estates in the suburbs. Attracted by the better facilities in the new estates, the more able members of the working population moved away from the centre, further enfeebling the poorer inner city boroughs. A list of Gehag tenants published in 1927 makes this very clear: Out of 1,800 tenants 800 were public officials, white collar workers, and foremen. There were also 81 printers, typesetters and photographers, 79 architects, 41 teachers, technicians and engineers, 32 trade union officials, 16 musicians, and 57 self-employed journalists, writers, and artists (both Erich Mühsam and Heinrich Vogeler lived in the *Hufeisen* estate). At the bottom of the list came unskilled workers, numbering only 85 in total.[22] In spite of Wagner's attempts to bring down unit costs through rationalised building methods, the rents of the new estates were too high for the great majority of workers, and Gehag's contribution to housing the urban poor was minimal.

The rationalised building methods developed in the mid-1920s and the ability to repeat standard elements and units were hailed at the time as harbingers of a collective aesthetic. Taut wrote of collectivism as a 'style-determining factor',[23] while another Berlin architect, Fred Forbat, proposed that 'the house is a part of the whole, just as the individual inhabitant is a member of the community [*Gemeinschaft*].[24] Following

Nietzsche's definition of culture as the 'unity of artistic style in every manifestation of societal life',[25] the designers and architects of the Jugendstil period had pursued the vision of a total interpenetration of art and life. This vision was now revived under the banner of rationalisation, Fordism and functionalism, with an architecture in which neither the individual inhabitant nor the individual object was privileged. Taut's so-called 'Red Front' at Britz or the blocks by Gropius and Bartning at Siemensstadt were uniform, exactly repeating and could, in theory, be extended infinitely. Obvious visual parallels exist between this architecture of anonymity, the factory assembly line, or the dancing of the Tiller girls, who enjoyed great success in Berlin at this time: The single apartment, the individual worker's arm, or the dancer's leg were significant only in the larger context (plate 13.14). In this sense, the spirit of 'objectivity' or *Sachlichkeit* did penetrate the realms of housing, work and leisure, but not necessarily as the expression of a collective or proletarian culture. Indeed, as the decade progressed, the modern impulse lost its specifically socialist, or *Gemeinschaft*-oriented character, and gained what Alexander Schwab called in 1930 its 'double-face' – 'bourgeois and proletarian, capitalist and socialist, one might almost say autocratic and democratic'.[26] This is entirely consistent with Siegfried Kracauer's description of the Tiller Girl phenomenon as the 'aesthetic reflex of the rationalism pursued by the dominant economic system'.[27] Similarly, Franz Hessel noted and applauded the market forces that brought *Sachlichkeit* to the facades of Kurfürstendamm (plate 13.15):

The dreadful pinnacles, projections and canopies of what we used to call the 'carbuncle houses' disappear behind the architecture of the signs and hoardings

13.14 Tiller Girls rehearsing
in the *Scala*, Berlin, 1927

... New shops constantly appear as the big firms in the city centre set up their bright, modern branches ... Glass, metal and wood are given new tasks, and colour joins the old Berlin grey and faded yellow. And as soon as a house becomes dilapidated or just in need of repair, the young architects give it the page-boy haircut of a simple, clear facade, and clear away all the fancy curlicues.[28]

Yet as Siegfried Kracauer's description of the *Haus Vaterland* makes clear, the commercial appeal of *Neue Sachlichkeit* was only skin deep and its emotional appeal for the masses non-existent. The central feature of this great dance hall was, as Kracauer described:

a sort of enormous hotel lobby, over whose carpets even the guests of the Adlon Hotel could have strode without feeling humiliated. It outdid the severity of 'Neue Sachlichkeit', for only the very latest is good enough for the masses. But nowhere was the secret of 'Neue Sachlichkeit' revealed more dramatically than here. Behind the pseudo-severe architecture of the lobby grinned Grinzing. Only one step and one was in the depths of the most voluptuous sentimentality ... The room in which the 'Heurige' was held offered a marvellous view of distant Vienna. The tower of St. Stephen's stood out against the starry sky, and an illuminated tramcar slid across the Danube Bridge. In other rooms flanking the 'Neue Sachlichkeit', the Rhine flowed by, the Golden Horn glowed, and Spain stretched beautifully towards the south.[29]

Kracauer had trained as an architect, and his reservations about the emotional emptiness of *Neue Sachlichkeit* were becoming commonplace by 1930, even among the architectural avant-garde. While the end of *Neue Sachlichkeit* and of functionalist architecture and design have generally been ascribed to the Nazi rise to power in 1933, in reality their demise began significantly earlier. The uniformity and anonymity that were regarded as appropriate expressions of the collective will of the *Gemein-*

13.15 Kurfürstendamm 42, Berlin-Charlottenburg, project to redesign the facade, architects Alfred Wiener and Hans Jaretski, 1929; compare plate 13.5

schaft were not necessarily ideal expressions of the capitalist *Gesellschaft*. This conflict came to a head, appropriately enough, at Siemensstadt – the housing estate for employees of the electrical giant Siemens. According to Manfredo Tafuri, the split between those whose sought to subjugate the work of art to the process and those who advocated the special status of the individual object was 'one of the most serious ruptures within the modern movement'. In Tafuri's words:

Gropius and Bartning remained faithful to the concept of the housing project as an *assembly line*, but contrasting with this were Scharoun's allusive irony and Häring's emphatic organic expression. If the ideology of the *Siedlung* consummated, to use Benjamin's phrase, the destruction of the 'aura' traditionally connected with the 'piece' of architecture, Scharoun's and Häring's 'objects' tended instead to recover an 'aura', even if it was one conditioned by new production methods and new formal structures.[30]

241

13.16 Goebelstraße,
Berlin-Siemensstadt, housing
blocks by Hugo Häring
(left) and Otto Bartning
(right), all 1929–31

Goebelstraße marked this division, with Bartning on one side and Häring on the other (plate 13.16). The uncertainties made explicit in Siemensstadt also found an airing in the contemporary press, which was full of articles about the demise of *Neue Sachlichkeit*. From the left came calls for a redefinition of goals, now that the formal language of Modernism had been devalued by popular acceptance, and the 'aura' that had been intentionally shed by the socialist theorists had been recovered by capitalist assimilation.[31] Significantly, several of the leading socialist designers such as Ernst May, Bruno Taut and Hannes Meyer left Germany at this time to work in the USSR. Perhaps responding to this crisis in confidence, the popular and right-wing press also pressed home the attack. A typical headline, to an article by the respected critic Ludwig Sterneaux, read 'Berlin is sick of naked facades! "Neue Sachlichkeit" in housing does a somersault – will to form or bluff?'[32] In practical terms, the economic crisis and the discontinuation of state subsidies for housing in 1931 marked the end of an era in Berlin's development in which housing not only led the architectural debate, but also mirrored political developments as the heady socialist dreams of 1918 became compromised through exposure to political and economic reality.

The thesis that the modernist impulses of the Weimar years were stifled purely by the philistinism of the Nazi party is symptomatic of the analysis of Nazi *Kulturpolitik* that has dominated historical accounts for the last forty years. It is based on an attempt to isolate the Nazi interlude as a unique phenomenon that has no place in the continuum of German cultural history. In his celebrated *Outline of European Architecture*, Pevsner dismissed Nazi architecture in one sentence;[33] similarly, Nazi

painting was banished with equal brevity from the recent Royal Academy exhibition of twentieth-century painting.[34] By thus isolating the culture of Nazi Germany as unworthy of attention, the critic implicitly accepts the claims of the Nazi propagandists, that the art and architecture of the Third Reich were somehow unique, the products of the mystical rapport between a messianic leader and the *Volkswille*, with no direct historical precedents, no contemporary parallels and no internal contradictions. This was the official party line, as proposed, for example, by Gerdy Troost:

Inspired by the most profound belief in his mission, the Führer is working to transform 'the word of stone' that our age is destined to speak into a statement of national socialist belief, into a true expression of the German soul ... The buildings of the Führer are testimony to the ideological turning point of our era. They are built National Socialism.[35]

The reality, however, was quite different. The styles most favoured by the Nazis – giant neo-classicism and cosy *Heimatstil* were by no means unique, either historically or geographically, to Nazi Germany. Conversely, the particularly German tradition of *Neues Bauen*, officially vilified by the party as *Kulturbolschewismus*, enjoyed a continuing, albeit restricted existence in Germany between 1933 and 1945.

The 'architecture parlante' of the Third Reich adopted a wide spectrum of already-existing styles and types to promote the confusingly diverse message of a régime that sought to portray itself as worldly yet nationalist, urbane yet *völkisch*, technocratic yet rustic. All these traits could be found in Berlin, echoing many of the debates that had engaged the city's intellectuals, architects and planners since the beginning of the century. In their attacks on the *Asphaltkultur* of the Weimar Republic the Nazi theorists drew on the arguments and prejudices of the *fin-de-siècle* conservative critics like Theodor Fritsch, Lienhard and Bartels. There were also direct links between the radical conservative lobby of the 1900s and the new party ideology: Paul Schultze-Naumburg, for example, published *Hausbau* in 1904 – a plea for a return to rural housing types – and went on to write two very influential books that set out to reveal the racial degeneracy behind Modernism, *Flaches oder geneigtes Dach* (1927) and *Kunst und Rasse* (1928). These services to party ideology gained him the chair of architecture at the Weimar Bauhochschule in 1930, when the Nazi party gained partial control of the Thuringian provincial government. In the model housing estates, such as the SS-Kameradschaftssiedlung in Berlin-Zehlendorf (plate 13.17), the village-scale housing was entirely in accord with Schultze-Naumburg's precepts, while the ambition to create a *Gemeinschaft* of residents with shared political convictions was distantly reminiscent of the Gehag estates, but at the opposing end of the political spectrum.

Similar houses, with rustic shutters and high-pitched roofs were built for the workers at the Heinkel factory at Oranienburg, north of Berlin

13.17 'SS-Kameradschafts-siedlung', Berlin-Zehlendorf, architect Entwurfsbüro der Gagfah, technical director Hans Gerlach, 1937–39

(plate 13.18). But here they were set beside steel and glass factory sheds, models of functionalism. Both houses and factories were designed by the same group, led by Herbert Rimpl, a former assistant of Walter Gropius. This contrast delineated clearly the role assigned to functionalism in the Nazi state: While it was unacceptable and *bolschewistisch* in the context of housing, it was entirely welcome in industrial buildings whose only symbolic or ideological message was one of technical accomplishment, and particularly the strength of the armaments industry. In a passage that might have been written by Behrens to describe his AEG factories, Gerdy Troost proclaimed:

Out of the very essence of technology, the power of a regulative 'Weltanschauung' can develop analogous forms. Buildings are created that express measure and order, working through clear, economical lines to symbolize the precise, exact work carried out within. With their freely exposed concrete, steel and glass, they make a striking impression. How light, inventive and ambitious these technical buildings are! Here the artistic will to form has triumphed over matter.[36]

Not only did this gospel of dematerialisation and structural integrity hark back to the roots of *Neues Bauen*, it also pointed the way forward to the architecture of post-war Germany, to the towers of the *Wirtschafts-wunder*.

In contrast to Gropius or Bartning at Siemensstadt, who modelled the form of their housing on the uniformity and repetition of the work process, the architects of the Heinkel complex distinguished vigorously between the factory and the home and created a variation on the 'urbs in rure' theme previously favoured by the Garden City movement. This programmatic differention of architectural languages to match varying

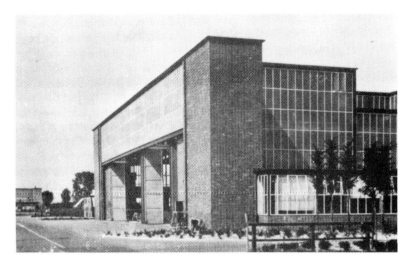

functions was carefully developed to embrace almost every aspect of building. Thus the *Rohbau* Functionalism typical of public buildings at the end of the Weimar Republic survived in the Nazi era, where it was used for low-ranking party, military and public buildings. A domestic variation of this style with hints of a Classicist pedigree was also used for the detached houses that were built in Berlin's western suburbs for medium-ranking party officials. For more important personages and for prestigious buildings, however, monumental Neo-Classicism was judged appropriate.

This was the architectural language of Albert Speer, appointed *Generalbauinspektor* for Berlin in 1937. Speer's commission was, in Hitler's words, 'to raise the city to a level of such structural and cultural eminence, that it can compete with any capital city in the world'.[37] The new *Reichshauptstadt* was to be renamed 'Germania' (plate 13.19). Speer's plans are too well known to need detailing here. Stylistically, his architecture was in general accord with the pared-down Neo-Classicism favoured for northern European public buildings in the 1930s, ranging from the Parliament Building in Helsinki to Leeds University Library. There were also clear historical precedents closer to home – the most obvious being Behrens's Neo-Classicist works around 1910, like the Mannesmann office building in Düsseldorf or the Imperial German Embassy in St. Petersburg. Significantly, Speer's office commissioned the elderly Behrens in 1939 to design a new head office for the AEG to be built on the proposed north-south axis. Even the idea of driving a monumental north-south axis through Berlin was not new, but taken from the Mächler plan of 1917–19. Speer's work was distinguished by its vast scale, but the memory of Haussmann's plan for Paris, or of Seddon and Lamb's proposal for a *Valhalla* at Westminster – a vast tower dwarfing Big Ben – makes clear that megalomanic schemes for imperial capitals were not the

245

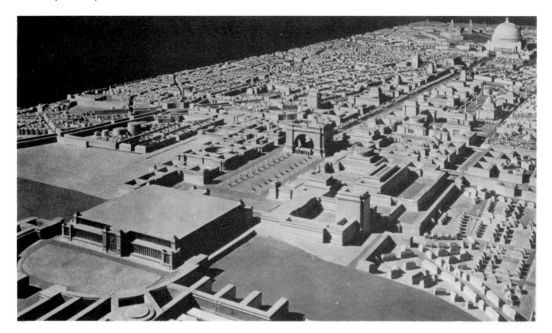

13.19 Model of the proposed north-south axis for Berlin, planned by the 'Generalbauinspektion', director Albert Speer, final version, 1942

exclusive preserve of the Nazi party. Paris was clearly seen as the great rival; on the very evening of France's capitulation Hitler issued a directive that: 'As quickly as possible, Berlin must be architecturally remodelled to express the status gained through the magnitude of our victory, as capital of a powerful new empire.' The work was to be completed by 1950, and the directive concluded: 'All state, provincial and city authorities, as well as party agencies, are to provide whatever support is required by the 'Generalinspektor für die Reichshauptstadt' for the realization of his task.'[38] It was this virtually unlimited power to restructure a metropolis, invested in the hands of one architect, that made Speer's position unique in modern history.

The seeds of this subjugation of the city to what Walter Benjamin called the 'aestheticization of politics' were sown in 1936, the year of the Berlin Olympics. Thomas Wolfe's description of the games, first published in 1940, carried a premonition of what was to follow:

The sheer pagaentry of the occasion was overwhelming, so much so that he began to feel oppressed by it. One sensed a stupendous concentration of effort, a tremendous drawing together and ordering in the vast collective power of the whole land. And the thing that made it seem ominous was that it so evidently went beyond what the games themselves demanded ... For the duration of the Olympics Berlin itself was transformed into a kind of annex to the stadium. From one end of the city to the other, from the Lustgarten to the Brandenburger Tor, along the whole broad sweep of Unter den Linden, through the vast avenues of the faery Tiergarten, and out through the western part of Berlin to the very portals of the stadium, the whole town was a thrilling pageantry of royal banners – not merely endless miles of looped-up bunting, the banners fifty feet in height, such as might have graced the battle tent of some great emperor.[39]

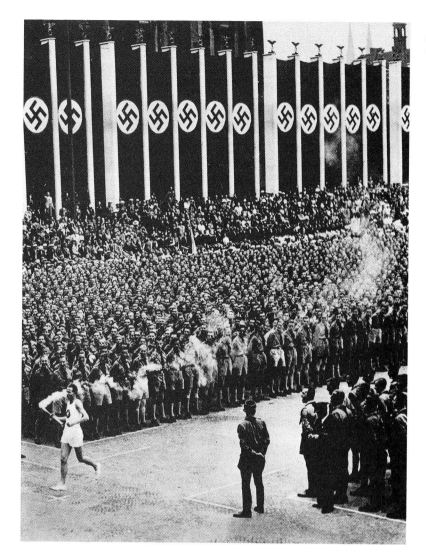

13.20 'Festival of Youth' in
the Lustgarten during the
Olympic Games, Berlin 1936

In 1942 this combination of military might and urban spectacle was
embodied in Speer's appointment as Minister for Armaments and War
Materials. This prompted Hans Stephan, a employee of Speer's 'General-
bauinspektion für die Reichshauptstadt Berlin' (GBI) to draw a cartoon
suggesting how the land might be cleared for the new axis, with the help
of a giant cannon. Using the slave labour inherited by Speer from the Todt
organisation and stone hewn by concentration camp inmates, the GBI
cleared large areas of the inner city and began building the first
monuments of 'Germania'. The task of clearance was completed, how-
ever, with terrible finality by the bombs and shells of the Allies.

The most lasting contribution of the Nazi interregnum to German
culture was the destruction and division of the former capital and the

13.21 Caricature by Hans Stephan to mark Albert Speer's appointment as Minister for Armaments and War Materials, 1942

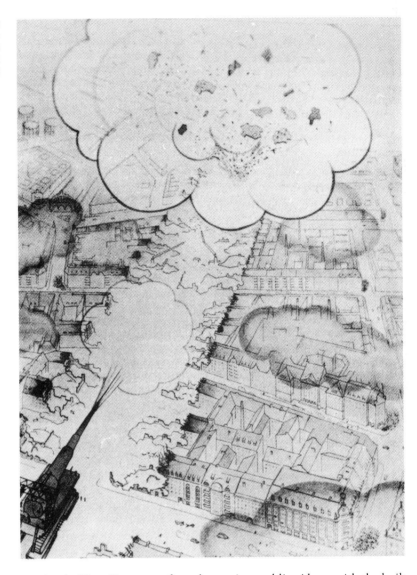

creation in West Germany of a polycentric republic. Along with the built fabric, cultural and historical continuities were also destroyed or divided, and new ideological foundations had to be established. The invention of histories that were both plausible and acceptable was a dominant preoccupation in the immediate post-war years, and one which still exercises the energies of Berlin's artists and their apologists. In the architectural context, the post-war search for history was ideologically constrained. Anything vaguely reminiscent of Speer's Neo-Classicism was taboo, although the Soviet Monument in Treptow, built in 1946-1949 with stone salvaged from the *Reichskanzelei*, was a notable exception to

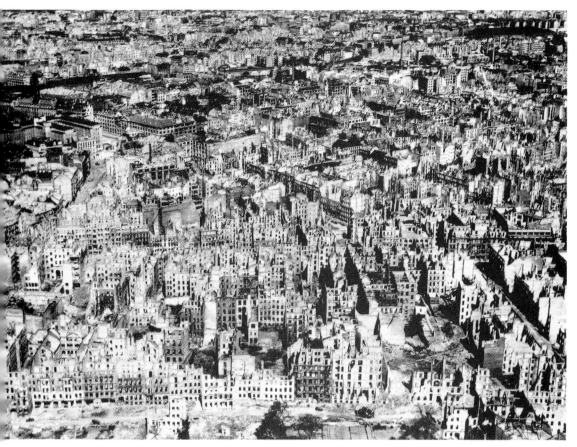

13.22 The ruins of Berlin, 1945

the rule. This limitation, coupled with the economic constraints of the immediate post-war years and the political division of the city precluded the historical reconstruction of central Berlin. The same economic restraints suggested, as they had done in 1918, a return to simpler manners, and several of the early plans for the reconstruction of Berlin proposed a garden city, with modest buildings set in landscaped parks. The traditionalist lobby, however, was also compromised through its adoption by the Nazi ideologists, and in the Allied Zones a long and bitter debate ensued between traditionalist and the Modernist interest groups for the architectural soul of the new Germany. In both its content and the personalities involved, this debate followed almost seamlessly from the disputes of the late 1920s, which were polemically focused around the question of flat or pitched roofs. Only in the early 1950s, when the effects of the Marshall Plan and the first stirrings of the *Wirtschaftswunder* pointed to an industrial future, did the Modernist faction emerge as undisputed victor.

With both Neo-Classicism and traditionalism consigned to historical

249

13.23 *Gropiusstadt,* Berlin-Neukölln/Buckow, shopping centre, architect Hans Bandel, 1965–67

limbo, the way was cleared for the revival of 1920s *Neues Bauen* that dominated West German architecture until the mid-1970s. There were several points in favour of this revival. As the specific product of the Weimar republic, *Neues Bauen* could be seen as the architecture of democracy, albeit a failed democracy. Given a simplifying historical account, *Neues Bauen* and its proponents could be portrayed as both the enemies and victims of the Nazi régime. Physically, the lightness, openness and transparency of the new functionalism was in total contrast to the massive masonry of Speer and the GBI, and could be readily seen to symbolise the open, democratic society of the *Bundesrepublik*. While all these features commended the functionalist revival, there were strong arguments against it. The most convincing was the obvious discrepancy between the social and political conditions of the Weimar years and those that prevailed in the post-war *Bundesrepublik*. This was the theme of a very acrimonious correspondence between Martin Wagner and Richard Döcker, the chairman of the *Bund Deutscher Architekten* and a vigorous advocate of functionalism. Writing from Harvard in opposition to the *Neues Bauen* revival, Wagner explained: 'Why? Because you are offering form without content, because you have no religion, no philosophy, no "Weltanschauung", no standpoint in your bones.'[40] The empty formal-

13.24 Matthias Koeppel, *Damals war's* (Those were the days), 1974

ism of much post-war German architecture confirms Wagner's fears. A comparison between Wagner's *Hufeisensiedlung* and the neighbouring Gropiusstadt estate (plate 13.23), built in the 1960s, makes clear the vast differences in both social programme and design quality. While the *Hufeisensiedlung* represented a committed – if not entirely successful – attempt to remodel society through architecture, the peripheral housing estates of the 1960s have proved a social disaster in an enclosed city with a falling population and acres of empty land near the city centre. Here, as elsewhere, the models borrowed from the 1920s were inappropriate to the needs of the 1960s, and the historical continuities invoked were quite invalid. As they had done in their youth, the old ladies dancing in Matthias Koeppel's painting *Damals war's* (1974) turned their back on *Sachlichkeit* and gazed longingly at the ruins of the *Haus Vaterland* (plate 13.24).

A detailed account of the rebuilding of Berlin after 1945 and of the historical narratives that informed this rebuilding can be found in Vittorio Magnago Lampugnani's essay in this volume. The use of history to support commercial interests or merely arbitrary stylistic preferences was not limited, however, to architecture. In the 1970s the Critical Realist school of painting acquired semi-official status as the representative of a Berlin continuum that stretched back to the realism of the twenties, to artists like Dix, Beckmann, Schlichter and Hubbuch.[41] A decade later, Neo-Romanticism and Neo-Expressionism are hailed as ' "a gash of fire" ... which spans Germany's cultural heritage'[42] The validity of such claims are the subject of Rosalyn Deutsche's essay. The industry of writing and rewriting history to fit the demands of the moment shows no signs of

abating in Berlin. The heated discussions over the proposed Museum of German History, and the massive series of exhibitions and publications planned for 1987 to mark 750 years of Berlin are obvious manifestations of the tendency. This may reflect not only the general mid-1980s tendency towards historical revisionism, which is by no means limited to Germany, but also a deeper historical insecurity that is specific to Berlin. In 1932, long before the city was bombed, burned and divided, Wilhelm Hausenstein surveyed Berlin through Bavarian eyes and concluded:

It is as if it were grounded on nothing; but a nothing that is *the* nothing – a nothingness elevated into an essence ... Think of Vienna, Paris, of the old cities in southern and western Germany, whose very essence and nature is their rootedness. Berlin has no provenance, as it were, no rootedness or history.[43]

The centrality of the city in social theory

Ira Katznelson

Chicago is one of the most incredible cities. By the lake there are a few comfortable and beautiful residential districts, mostly with stone houses of a very heavy and cumbersome style, and right behind them there are little old wooden houses such as one finds in Helgoland. Then come the 'tenements' of the workingmen and absurdly dirty streets which are unpaved, or there is miserable macadamization outside better residential districts . . . When they finish work at five o'clock, people must often travel for hours to get home . . . With the exception of the better residential districts, the whole tremendous city – more extensive than London! – is like a man whose skin has been peeled off and whose intestines are seen at work.

So wrote Max Weber when he visited Chicago in 1904. He had little to say as a social theorist about this city, or others like it. But he made clear in his diary entries that Chicago was a metaphor for capitalist modernity: magnificently though frightfully fragmented, 'a mad pell-mell', extraordinarily unequal, characterised by 'a tremendous intensity of work', loosely integrated, composed of a mosaic of nationalities each in its own territory, yet marked by an uncaring individuality: 'undoubtedly one could take ill and die without anyone caring!'[1]

This astonishment was quite characteristic; it was no more than the common sense of the time. In his descriptions of Chicago, and of New York, Weber used some of the same imagery that later found expression on the canvases of Beckmann, Kirchner and Meidner.

If we walk on Max Beckmann's Iron Footbridge of 1922 to enter the new Frankfurt we see a still imposing church to the left, but just ahead is a factory, its chimney spewing smoke rising toward, and higher than, the church spire. And here is Weber on Chicago: 'But on the horizon all around – for the city continues for miles and miles, until it melts into the multitude of suburbs – there are churches and chapels, grain elevators [and] smoking chimneys.' Or, walk with Ernst Kirchner to the centre of the burgeoning Berlin of the early 1910s to join the showy, class-specific, energetic parade of the Friedrichstrasse. Or squeeze into Ludwig Meidner's crowded protest march and witness his urban apocalypse. And then attend to Weber's description of the 'hell' that 'has broken loose in the "stockyards"', the 'haze and smoke' of a city whose streets have a condition that is 'utterly hair-raising', and of workplaces of 'steam, muck and blood'.[2]

This kind of astonished representation of the city reflected and confirmed a view of reality common to most of the leading social theorists of the late nineteenth and early twentieth centuries. It is this perspective, grounded in the social differentiation of industrial, capitalist societies, made manifest in the big city, that I wish to hold up to examination. I plan to so do by looking at the role of the city in modern social theory.

There is a sense in which this is a perverse choice. The city as such was neither central in a descriptive sense, nor manifestly the main subject, of such great theorists as Marx, Durkheim, Weber, Tönnies and Simmel. Each dealt with the city, of course, but only as a small part of the larger project of coming to terms with an industrial, capitalist, state-centered, modernity.

Just the same, the large modern city was an inescapable and constitutive element of all their considerations of these hallmarks of the modern world. Each understood in his own way a point made more recently by Raymond Williams, when he wrote that 'city life, until our own century, even in a highly industrialized society, was still a minority experience, but it was widely and accurately seen as a decisive experience, with much more than proportionate effects on the character of the society as a whole'.[3] The large city – as a central arena and symbol of modernity; as the product and locale of such fundamental social processes as state-making and capitalist development; and as the generative locale for the formation of collective identities and collective action – thus provided an inescapable setting and subject for nineteenth- and twentieth-century social theory, albeit a setting and subject usually only tacit or implicit.

If good social theory must begin, as I think it must, by rejecting the position that nothing is real unless it is signified, as well as the contrary position that representations are mere reflections corresponding to reality, the central task of social theory is the mapping of actual and possible connections between the real and the signified.

The ways social theorists in a variety of traditions have constructed these analytical and cognitive maps suffer in part from an insufficient and distorted appreciation of *space* as an integral element of economic, social and political life, and of the ways the organisation of social space can stimulate an exploration of less visible, though fundamental, social processes. The key source of this distortion, I will try to show, is a central strand of nineteenth- and twentieth-century social theory which focuses on the connections between social differentiation and social order. Its main postulates, I will claim more indirectly, also have narrowed the visions of the city expressed in literature and in the visual arts.

I

Modern big cities are a post-sixteenth-century phenomenon. From the eleventh to the sixteenth centuries towns grew at a rather slow, even pace.

They were nodes of trade and craft production within feudalism's system of parcellised sovereignty. Each town, like each of the basic units of feudalism, fused political, economic and symbolic power; in Max Weber's terms, a 'fusion of fortress and the market'. Each was an administrative centre and a place where economic activities were based on principles of market exchange.

Weber's *The City* studied the urban centres of feudalism because he wished to join the debate about whether medieval towns were in fact goads to capitalist development and precursors of larger sovereign nation-states. He identified the town's specificity by contrasting it with the oriental city, where, for reasons of the strength of such ascriptive ties as religion or caste, autonomous urban communities did not develop; and with earlier western cities of antiquity, whose economies were based on war and plunder, not the rational market capitalism characteristic of the medieval town. Weber thus concluded that neither the oriental nor ancient western cities could have led to modern states and capitalism. The medieval western city, by contrast, was conducive to the development of both.[4]

We will see below how Weber's analysis of the feudal town hints at an alternative to what came to be the dominant approach. Here, the relevance of Weber's portrait is less whether he provides us with a persuasive way to study the city nor is it whether he was right in suggesting that the medieval city proved the undoing of feudalism (this debate continues to have a very lively existence). Rather, it is the fused, ordered character of the towns with which he dealt; for it is just this unity that could not survive the transition from feudalism to capitalism through mercantilism.

The first post-feudal modern cities were political capitals, the homes of royal courts: London, Paris, Amsterdam, Antwerp, Seville. Their fate was tied to absolutist states and to a mercantile international economic order. The societies in which they were embedded were characterised by a new division of property and sovereignty; and by a concentration of both in explosively growing urban centres.

In these cities the internal unity of the towns described by Weber was threatened not only by changes in size and density which breached the old walls and reorganised ancient quarters, nor only by more complicated relationships within the dominant classes now that political authority and private wealth-seeking were established as related but distinctly autonomous activities. What also challenged the old unities was the beginning of new patterns, in space, between places of work and places of residence. Fused in the workshops of the medieval city, work and home began to separate for the political and economic élites of the capital cities. Merchants who traded on a world scale began to construct homes away from the centre; in turn, state officials increasingly began to work in the new office blocks of the crown at the city centre.

The second group of modern cities, the industrial centres built in the nineteenth century at the sites of old villages, like Manchester, or on empty prairies, as in Chicago, even more dramatically altered the traditional organisation of urban space. The industrial cities were built as places of work according to the logic of capitalist accumulation. And even in the older political capitals, as chimneys joined churches to define the landscape, both the pace and character of change were astonishing.

What were the new cities of the nineteenth century like? They were certainly places of high indeterminacy and of bewildering alterations to established ways of life and patterns of social relations. These changes were expressed most dramatically by a massive reorganisation of the urban form, whose most characteristic shift was the accelerating and fundamental separation of work from home.

This separation consisted of at least three interrelated and overlapping historical processes. First, the household ceased to be the main unit or location of production. Second, whole areas of large towns and cities came to be devoted *either* to residential use or to factory production. Third, the residential areas of the city became increasingly homogeneous in both the Marxist and Weberian senses of class. With the division of city space into separate districts defined by their functions, and with the growing homogeneity of the residential areas, the city came to be defined, and to define its residents, in terms of their connections to the now increasingly autonomous markets for labour and for housing. The job and the residence became distinctive commodities to be bought and sold by the discipline and logic of money and the marketplace. Older bonds no longer were determinative.

Within the built form of the city patterns of daily life were shaped by a new transportation technology and new paths to and from work; by a centralisation and demarcated definition of cross-class public space; indeed by the very emergence of class, in both the Marxist and Weberian senses of the term, at the workplace and in the residence community, as the building blocks of the urban, industrial, capitalist social structure.

In the embrace of these changes, the physical city began to define patterns and zones of activity, and in them, new spheres of freedom. For working people, the various separations of work and home made possible the development of a spatially bounded, institutionally rich, independent working-class culture in their neighbourhoods of the city. The contrast between the supervised, authoritarian world of work, and the free sphere of the neighborhood was captured by George Gissing in his *Nether World:*[5]

It was the hour of the unyoking of men. In the highways and byways of Clerkenwell there was a thronging of released toilers, of young and old, of male and female. Forth they streamed from factories and workrooms, anxious to make the most of the few hours during which they might live for themselves ... Public-houses began to brighten up, to bestir themselves for the evening's business. Streets that had been hives of activity since early morning were being abandoned to silence and darkness and the sweeping wind.

If working people were free from property, they were now also free, once they had left the workplace, to create something of an autonomous culture. As the city was reorganised in space, the places where people lived became increasingly homogeneous. The capacity of people to buy or rent real estate determined where they might live. As a result, parts of the city became settlements of people sharing class attributes in Weber's sense of the capacity to consume goods and services offered in the marketplace. From the more macroscopic perspective of the city as a whole, however, urban areas were now much more heterogeneous than they once had been.

It should not be surprising that the massive shifts in urban form and social geography, taken together, proved a puzzle for various social groups and classes, and for social theorists. It should also not surprise that the break-up of the more integrated city prodded many theorists to develop new principles of order, group cohesion, and social control. The main result of this quest was the paradigm of differentiation, which became the centrepiece of many major works of social theory in the late nineteenth and early twentieth centuries. This world view was more than just a new cosmology; it provided the most important grammar and vocabulary for representing the new city and its new patterns of social space.

II

The results of massive shifts in the nineteenth-century city shocked such observers as Weber and Meidner and stimulated the view that social differentiation is the hallmark and 'the inevitable product of social change'. In this view, ably summarised by Charles Tilly, 'the state of social order depends on the balance of forces between processes of differentiation and processes of integration and control; rapid or excessive differentiation produces disorder'.[6] From this vantage point, rapid social change and its disorienting possibilities are the central general processes of modernity. This perspective is condensed in such dichotomous pairs as Maine's status and contract; Durkheim's mechanical and organic solidarity; and Tönnies' *Gemeinschaft* and *Gesellschaft*.

To be sure, these antinomies are not identical. Tönnies stressed the new importance of the market for urban differentiation. For him, the contrast between pre-capitalist and capitalist cities lay in the new pervasive *Gesellschaft*, which he conceived to be an

artificial construction of an aggregate of human beings which superficially resembles the *Gemeinschaft* in so far as the individuals live and dwell together peacefully. However, in the *Gemeinschaft* they remain essentially united in spite of all separating factors, whereas in the *Gesellschaft* they are essentially separated in spite of all the uniting factors ... everybody is by himself and isolated and there exists a condition of tension against all others ... nobody wants to grant and produce anything for another individual, nor will he be inclined to give ungrudgingly to another individual if it not be in exchange for a gift or labour equivalent that he considers at least equal to what he has given.[7]

Durkheim by contrast referred to the new order in terms of the movement from relations of constraint ('mechanical solidarity') to relations of shared values ('organic solidarity') that produce authentic forms of co-operation in the small-scale settings of the new, differentiated city.

These, of course, need not be contradictory positions. The new urban neighborhoods of nineteenth-century cities were profoundly shaped by market forces in real estate, for example, which often tore social bonds asunder. At the same time, many of the homogeneous neighbourhoods created as a result of the operation of local real estate markets became homes to people who shared so many attributes that the development of quite dense and solidaristic networks of social organisation was facilitated.

From an analytical perspective, what is most striking is that both the view of differentiation as *Gemeinschaft* and the view of differentiation as 'organic solidarity' share a world view, and an interpretation of what the massive changes in capitalism, the state and the city meant. Charles Tilly has summarised the key principles of this perspective:[8]

1 'Society' is a thing apart; the world as a whole divides into distinct 'societies', each having its more or less autonomous culture, government, economy, and solidarity.
2 Social behaviour results from individual mental events, which are conditioned by life in society. Explanations of social behaviour therefore concern the impact of society on individual minds.
3 'Social change' is a coherent general phenomenon, explicable *en bloc*.
4 The main processes of large-scale social change take distinct societies through a succession of standard stages, each more advanced than the previous stage.
5 Differentiation forms the dominant, inevitable logic of large-scale social change; differentiation leads to advancement.
6 The state of social order depends on the balance between processes of differentiation and processes of integration or control; rapid or excessive differentiation produces disorder.
7 A wide variety of disapproved behaviour – including madness, murder, drunkenness, crime, suicide, and rebellion, results from the strain produced by excessively rapid social change.

This orientation was given its greatest plausibility by the experienced changes in the city, which appeared to conform to this meta-description of reality. The richest, and most influential, development of this perspective, at least for subsequent treatments of urbanism, was by Georg Simmel, and it is important to dwell for a few moments on his contribution.

Simmel's corpus was in part an attempt to come to terms with the metropolitan culture of Berlin. One of the best known of his essays, 'The Metropolis and Mental Life', published in 1903, dealt with the impact of the city as such; and by his own testimony, his major works, including his first book, *Social Differentiation* (1890) and *The Philosophy of Money*

(1900) were animated by shifts in the character of city life. 'Berlin's development from a city to a metropolis in the years around and after the turn of the century'. Simmel observed, 'coincides with my own strongest and broadest development'.[9] Much more so than his main contemporaries Weber, Sombart and Tönnies, Simmel concentrated on contemporary experience, including that of the customer and the resident of the big city. His central questions concerned the elaboration of market relations in the differentiated city, and their effects on social relations.

In his first book, Simmel stressed how with increased differentiation the total individual dissolves into elements; the result is the construction of human ties of a more varied sort with people who share partial traits and relationships. As a consequence, new group relations become possible, and there is an acceleration of forms of social interaction. A decade later, in *The Sociology of Money*, Simmel maintained this perspective, and, in an important addition, linked it explicitly to exchange relationships in urban society, a perspective developed even more fully as an urban analysis in 'Space and the Spatial Structures of Society', which comprises the penultimate chapter of Simmel's *Sociology* (1908). The themes in this chapter are also taken up in 'The Metropolis and Mental Life'. In these works the key elements of a sociology of differentiation in space are elaborated. These include impersonality, detachment, isolation, segmented friendships, commodification of relationships and, above all, the significance of boundaries. Perhaps the most brilliant contribution lies in Simmel's use of these elements to discuss alternative ways social relationships may get anchored in space. He contrasts the medieval city from which it was difficult to exit to the residential mobility of the twentieth-century city. Although this freedom exists, Simmel observes, particular social groups become anchored to distinctive territories. These spaces tend to get named, thus individualised as separate; and each of these territories tends to have one or more special locations of buildings (a church, a marketplace, a school, a transport centre) that gives it a focus, a hub of activity, an identity, and a boundary.

This way of seeing urban space had profound implications for thinking about order in society. For if society was now internally differentiated, then society now had to face basic new problems of social control. An integrated society could be self-regulating, but a differentiated one might dissolve into disconnected fragments.

These themes were developed most clearly with regard to their implications for a modern urban-based civilisation in the political sociology of Louis Wirth, who, together with his Chicago School of Sociology colleagues, was deeply influenced by Simmel. When Wirth wrote a preface to a revised edition of Robert Park's famous 1915 essay on the city, he singled out Simmel's urban essay as 'the most important single article on the city from a sociological viewpoint', and Wirth's own 1938

essay, 'Urbanism as a Way of Life', resonates with Simmelian themes, albeit on a selective basis.[10]

Wirth's critique of the city left out Simmel's insight that metropolitan differentiation made unparalleled individual and group self-development possible through the creation of new, relatively homogeneous, 'free' social areas. Instead, Wirth underscored the problems differentiation posed to social cohesion. In his argument, the city was more than just a fragmented social and spatial order; it was also a divided and disorganised moral order. In this sociological analysis, Wirth highlighted an older, conservative lament. Thus, for example, Carlyle in 1831 had described industrial city dwellers as 'strangers ... It is a huge aggregate of little systems, each of which is again a small anarchy, the members of which do not *work* together, but *scramble* against each other.'[11]

In this analysis, Wirth sided rather more with Tönnies than with Durkheim. Primordial integrative ties had been replaced by more artificial, secondary ones. Shared values had been shattered. The fragmentary and partial normative features of city life could not maintain social control (in the sense of the capacity of the society as a whole to regulate itself in accordance with shared aims). The consequences could be seen in political disorganisation and an increase in such pathological behaviour as personality disorders, crime and weakened family life. In this analysis he presented in refracted form élite fears of contact with the new immigrant working class masses, which were most often expressed in metaphors of health and disease.

Urban differentiation and its negative consequences were likely to get worse over time, Wirth thought, because spatial fragmentation and the collapse of a unified system of norms were driven by fundamental features of the new city: its density and its concomitant competition for scarce space, a competition that produced increasingly homogeneous districts, social boundaries, and the quest for social avoidance of the less desirable.

Wirth's response was to seek secondary, mechanical substitutes for the loss of primary mechanisms of social integration. He made a strong normative plea on behalf of rationality, planning and social science as the vehicles for achieving at a secondary level the kind of societal co-ordination no longer available in the fragmented, differentiated city.

In conservative hands, this vision was a plea for the imposition of order by authoritarian means if necessary. But it is important to remember that the differentiation perspective was not just a reactionary position; it was also the common sense of critics of capitalism on the left. Engels, for one, heralded some of Simmel's and Wirth's themes when he wrote of

the brutal indifference, the unfeeling isolation of each in his private interest becomes the more repellant and offensive, the more these individuals are crowded together, within a limited space. And, however much one may be aware

that this isolation of the individual, this narrow self-seeking is the fundamental principle of our society everywhere, it is nowhere so shamelessly barefaced, so self-conscious as just here in the crowding of a great city. The dissolution of mankind into monads, of which each one has a separate principle, the world of atoms, is here carried out to its utmost extremes.[12]

The differentiation perspective, in fact, has been less a subject for contest between right and left than has the common sense view of urban life, one that has been elaborated in many ways by geographers and sociologists, by politicians and leaders of protest movements, by novelists and artists. The portrait of differentiation *versus* order has provided the stock imagery of urban life. The paintings of Beckmann, Meidner and Kirchner, share in this common imagery, and thus in the underlying analysis of what ails modern urban society.

III

This analytical tradition of differentiation and these depictions of cities have been immensely appealing, in part because they seem so readily to make sense of social reality. But this appearance is based on quite the flawed assumptions that the basic units of social analysis should be the individual and society; and that the ways society and the individual shape and constrain each other should provide the main objects of social science investigation. I propose, following a line of analysis recently developed by Charles Tilly, to hold these assumptions up for examination and critique; then to indicate how, each in his own way, Marx and Weber departed from them; and finally to suggest how an alternative perspective might help us ask better questions about the city, and to see the city with more depth of vision.

To look at society–individual interactions from the dominant socio-logical perspective is, first, to assume that society itself is a meaningful, autonomous unit; and, second, that individuals internalise society and its norms, and thus that individual action and dispositions are socially conditioned. Individuals as carriers of societal patterns and values are the basic units of disposition and action; hence all social theory and social analysis ultimately must be methodologically individualist.

These assumptions may seem obvious – they are very deeply ingrained not only in our social science but in our culture – but even a cursory examination shows them not to be. The concept of a 'society' bounded in space only has some cohesion if it can be said to constitute a system. Yet, as Tilly observes, as an empirical matter society in the sense of an interactive group never occurs. The world is divided into nation-states, of course, with identifiable boundaries, but such processes and activities as family life, production and communication sometimes take place in social fields much smaller than these units of citizens, and sometimes on much larger fields, even sometimes on a global scale. When 'boundaries of

different sorts of action do not *coincide*', Tilly writes, 'the idea of a society as an autonomous, organised, interdependent system loses its plausibility'. He proposes, as an alternative to the reification of society as the pivotal unit of analysis that we adopt the 'idea of multiple social relationships' of different scale.[13]

Methodological individualism has recently taken on the aura of profundity in the social sciences; and, of course, there is the obvious sense in which the individual is the irreducible unit of social analysis. But a naked individualism, whether or not it is tied to a more holistic societal analysis, is profoundly misleading. Individuals are meaningful as social actors only insofar as they *interact*. When Wirth borrowed from Simmel, it was this essential insight of Simmelian sociology that he neglected. The basic units of action are not individuals at all, but networks and relationships; and the basic framework of action is not society, but such social processes as proletarianisation or state-building that pattern ties between people in determinative ways.

From the vantage point of the society–individual antinomy, the problem of differentiation appears as the problem of social order precisely because it becomes more difficult for individuals in a differentiated world to internalise societal values; differentiation produces a fragmentation of values. From the perspective of relationships and social processes, it becomes clear that the differentiation problematic itself is fundamentally flawed. Thus, for example, if we were to become interested in Weber's problem of state-building and in the relationships of citizens to state authorities, we would immediately face the reality that the construction of modern nation-states was as much the story of the concentration of sovereignty in the centre than it was a story of differentiation between states. Or, if we were to concentrate on Marx's problem of the develop-ment of modern capitalism, and on the relationships of employers and their work forces, we would have to deal with the profound dedifferenti-ation of production and the implosion of capital that were hallmark characteristics of capitalist industrial development.[14]

By contrast to this kind of orientation, the differentiation *versus* order model is a very blunt analytical instrument. It simplifies the modern experience, and reduces it to the familiar dichotomies of traditional and modern, individual and society.

With regard to cities, the differentiation perspective presents a plaus-ible social and spatial representation, but at the very great cost of closing off questions about the fundamental social processes that affect and shape city life, about the networks of relationships that, in their great variety, define urbanity and its contradictions, and about the enormous range of alternative patterns of spatial relations, class formation, and collective action that characterise the modern city.

The new mix of uniformity and variation in the nineteenth century was neither a process to itself nor simply the result of autonomous urban

factors. Rather, most fundamentally, differentiated urban patterns were the product of very large-scale processes which surmounted the agency of the city dwellers affected by them. These included such essential features of capitalism as uneven development in space as a result of highly concentrated industrialisation; a radical shift in the new scale of work and production; and a tendency to convert land into real estate. Also in the sphere of the economy, there was a massive expansion and extension of the market into all spheres of civil society, free time and personal expression.

The city was also a dependent result of a new role for the state, which created the organisational framework necessary for capitalist market-places, and which, through its use of fiscal incentives to builders, and by direct development, planning, and regulation by building codes and zoning, gave direction to the production of the physical city. At the same time, the modern nation state centralised power in the city, helped stimulate its growth and shaped its form. States further reinforced the new segregation of city space by invoking its powers to tax, police, and administer in ways that were differentiated by social geography.

Let us return to Weber's *The City*. Although he did not write a comparable analysis for nineteenth- and twentieth-century cities, the way Weber approached the subject of the medieval town presents a very fertile example of the social process–network alternative to the differentiation perspective.

A central theme of the study concerns contrasts the occidental and oriental city in terms of key differences in the nature of interactive groups: guilds and territorial associations in the west; clans and castes in the east; and between the ancient and medieval cities of the west in terms of the relative importance of military clans in the ancient city, and occupational associations in the medieval city. Further, Weber locates these groups and the networks in which they were embedded in terms of such basic social processes as the development of rational economic activity and of the emergence of autonomous bases of political authority. What finally distinguished the medieval from the ancient city was the political triumph of those groups that were the carriers of rational, market-centred, capitalistic economic activity. Thus for Weber, the sociological and historical dimensions of urban analysis fuse in a much more richly textured way than the simple dichotomies of the differentiation–order perspective could possible allow.

Or, consider Marx. Each of his three main analytical projects – an understanding of epochal transformation; a model of the logic of the capitalist economy; and the development of social theory concerned with the relationships between capitalist development and such other social processes as politics, kinship and culture – suggests issues for urban analysis significantly more deep and more varied than the differentiation orientation. What was the role of the city in the transition from feudalism

263

to capitalism? How is city space a constitutive element of capitalist relations of production and consumption? How is the differentiation of urban space shaped by the logic of capitalist accumulation? What is the relationship between a fragmented city space and class formation?

I do not mean to suggest that the issues that produced and gave force to evolutionary differentiation theory are no longer with us, for they are still our questions: anonymity and alienation; ways the city insinuates itself into intimate relations and into civil society; the circulation of material goods and of images; the milling of crowds; the dissolution and construction of human bonds. We still want to ask if the city is a unified experience or a mere division and assemblage of disordered elements, and if these, separately and together, constitute an appealing spectacle or a horror.

If these are still good questions, they cannot be confronted, I wish to suggest, by the direct and seductively obvious route of the differentiation problematic. When we cross Beckmann's footbridge into the city, let us remember to inquire after the social processes that produced the landscape we join him in seeing, and about the various social relationships that bind the people in the factory and the church, and in the other arenas of city life. And let us recall the methods and perspective of Max Weber as the remarkable analyst of medieval towns when we try to make sense of his horror-stricken jottings as a tourist in the New World.

The painted city as nature and artifice

Jill Lloyd

Adolf von Menzel's *Berlin–Potsdamer Eisenbahn* (The Berlin–Potsdam railway), 1847 (plate 15.1) shows the dramatic sweep of a railway line headed by a black steam train, symbol of the industrial age, travelling outwards from the city to the country, and forging a new relationship of contact and exchange between the two. The image was prophetic as Berlin expanded at an unprecedented rate during the second half of the nineteenth century to become, after London and Paris, the third largest European city. After the unification of Germany in 1870, Berlin was named capital of the Empire, and indemnity money from France provided the wherewithal to transform the city into a thriving industrial metropolis. Between 1870 and 1910, the population of Berlin increased from 826,000 to over two million, and 60 per cent of Germans had converged on the growing cities.

During this period of fast industrialisation and urbanisation, the reality of increased mobility between town and country was countered by a dramatic experience of rupture and contrast, manifested in the cultural polemics of city versus country. This involved a complex of attitudes ranging from radical polarisation by conservative factions, who mourned the loss of Germanic roots in the landscape and regarded the cities – especially Berlin – as embodying all the evils of progress, to attempts at reconciliation through modernist projects like the garden city. Frequently the distinctions between these extreme positions were not clear cut. In the middle ground there emerged an intricate network of relations, which render attempts to divide the period crudely into polarities of modernity versus tradition, or progress versus regression historically inaccurate. The following study will attempt to locate these areas of interchange with reference to the theory and practice of painting, looking specifically at the work of Adolf von Menzel, (1815–1905), Ernst Ludwig Kirchner, (1880–1937) and Ludwig Meidner, (1884–1966), whose engagement with these issues acknowledge in various ways the shifting and contradictory foundations of modernity itself.

It was before the failure of the 1848 bougeois revolution that Menzel produced his positive image of the civilising, progressive forces of industry, symbolised by the railway. A year later the powers of liberal

Jill Lloyd

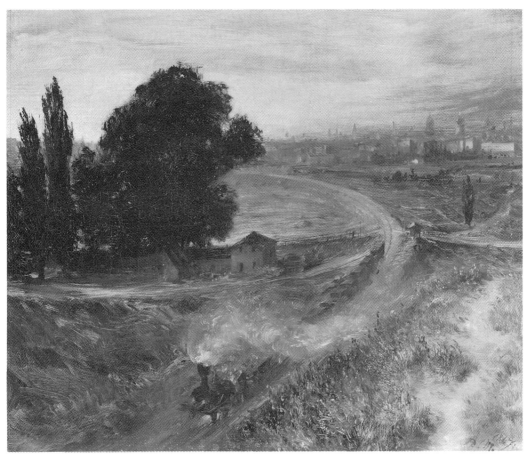

15.1 Adolph von Menzel,
*Die Berlin–Potsdamer
Bahn* (The Berlin–Potsdam
railway), 1847

social democracy guiding the industrial boom were shaken, and Menzel increasingly pictured contemporary society in an ironic, critical light. The enlightened monarchy of Frederick the Great became his ideal of civilisation, to which he compared the shallow artificiality of his own times, a brittle mask for the baser 'natural' instincts we find surfacing in *Das Ballsouper* (the ball supper), 1878. Here the crowd jostles and pushes, stepping on one others' elegant costumes; the officers struggle to hold simultaneously plate, glass and helmet. The ideal unity between nature and civilisation, expressed in *Flötenkonzert Sancoussi* (Flute Concert Sancoussi), 1852, by the synthesis of natural and artificial light, has been superceded by a brash artificiality which releases rather than controls the baser instincts. The unity of nature and artifice is ironically ruptured and, on occasion, physically severed by transparent barriers like the railing in *Im Zoologischen Garten* (At the zoo), 1863, (plate 15.2), which act like two-way mirrors reflecting both the 'savage within' and nature without. Who, in this case, is behind the bars, the casual animals or the fashionable onlookers?

15.2 Adolph von Menzel, *Im Zoologischen Garten* (At the zoo), 1863

When we move inside the railway carriage in *Fahrt durch die schöne Natur* (A journey through beautiful nature), 1892, (plate 15.3), we find a variation on the same theme. The subject of the painting is not the romantic view the title suggests, but a crowd of city dwellers, crammed into their elegant costumes, whose access to nature is frustrated at every turn. Both windows are blocked by figures, and the woman stares gormlessly at another traveller's back as she clasps her civilised bouquet of dried flowers. Behind a traveller waves his Baedecker at a sleeping companion while nature slips by unseen. To the right another figure goggles in the direction of the spectator, direct contact between eye and nature blocked by spectacles and binoculars, as if only in terms of such giant magnification is an experience of natural beauty possible. At the centre of the composition a child sleeps peacefully, apparently finding within itself that which the others vainly search for outside. Once again an ironic rupture between nature and artifice, which are also the paradoxical ingredients of Menzel's artistic realism, replaces the positive mediation between city and country we found in the *Berlin–Potsdamer Eisenbahn*.

267

Jill Lloyd

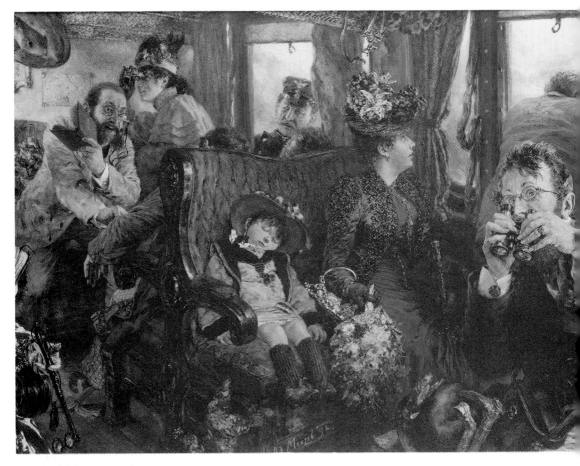

15.3 Adolph von Menzel, *Fahrt durch die schöne Natur* (A journey through beautiful nature), 1892

Menzel, who was himself an outsider inside Prussian court life, selling successfully to middle-class patrons while never fully integrating into either social group, uses this paradox of content and style to throw into question the relationship between civilisation and nature. Previously stable and coherent while civilisation was seen as an inevitable and positive force, it was a relationship experienced as mutable and problematic in his own age.[1]

One response to this situation was the attempt made by artists and writers subscribing to conserve, *völkish* ideology to fix and stabilise the relationship between civilisation and nature, town and country, under new terms of reference. In place of unity and coherence they proposed a relation of absolute opposition. From the mid-nineteenth-century publications like Wilhelm Riehl's *Land und Leute* (Land and People), 1857–63, described the countryside with its traditional values and contact with the recurring cycles of nature as a conservative alternative to modern urbanisation. The culture of the German *Volk*, Riehl suggested, was

fundamentally opposed to mechanised, materialistic civilisation, repre-
sented by the cities and 'rootless' peoples like the Jews. Julius Langbehn
in *Rembrandt als Erzieher* (Rembrandt as Educator), 1890, described, 'the
Berlin–Jewish spirits' as 'a distinct political and intellectual force in the
great debates between Modernism and tribal-volkish primitivism'.[2]
Although Berlin had been elevated to the seat of Empire in 1871 and was
regarded as a symbol of national unification, it came to be used by the
conservative nationalists as a metaphor for the negative effects of
modernisation – fragmentation and alienation, which undermined their
romantic concept of a national spiritual unity.[3]

Related to the conservative polarisation of city versus country was the
cult of nudism or *Freikörperkultur*, one of a series of reform movements
which evolved in the 1880s and 1890s advocating such antidotes to urban
civilisation as vegetarianism, *Naturheil, Bodenreform, Licht-Luft Thera-
pie* and *Kleiderreform*.[4] In 1906 the newly founded *Deutsche Bund für
Lebensreform*, (German Association for Reformative Living) described its
aims as:

A renewal of the bodily and spiritual strength of the people through education
about the laws of nature. By these means the German Association for Reformative
Living encourages individual initiative to reform personal lifestyle … and
eventually to create a true, humane cultural community.[5]

In 1893, these principles were put into action at the *Vegetarischen
Obstbaukolonie Eden*, (Vegetarian Fruit-Culture Colony Eden) in
Oranienburg, north of Berlin, which was felt to offer an ideal alternative
lifestyle to the neighbouring city, defining once again in oppositional
terms the impact of modernity:

In Eden the sale of alcohol is forbidden, there are no tobacconists, no porno-
graphy, no modern cinema, no cabaret, no gambling, no casinos … all such
concerns are turned away at the gate of Eden.[6]

Although the alternative lifestyle at the famous naturist colony *Monte
Verità* in Ascona attracted many progressive figures in politics and the
arts, the anti-modernist stance of projects like Eden involved more
typically the infiltration of conservative and often anti-semitic elements

In this network of reform movements nudism played a central role. In
1902 the *Verein für Körperkultur* (Society for Physical Culture) was
founded and a year earlier the first *Licht-Luft Sportbad* (Sunshine and
Fresh Air Water Sports Club) for men opened on Kurfürstendamm,
Berlin. Already in the 1890s one of the major spokesmen for nudism,
Heinrich Pudor (who assumed the Germanic surname Scham) established
himself at Loschwitz near Dresden and published a series of pamphlets
influenced by the writings of Friedrich Nietzsche and Julius Langbehn,
which, in a spirit of radical conservatism, attempted a theoretical
justification for nudism. Pudor conceived of man as a potential work of
art, a Greek god, who had been perverted and made ridiculous by the

269

15.4 Fidus, *Lichtgebet*
(sun-worship)

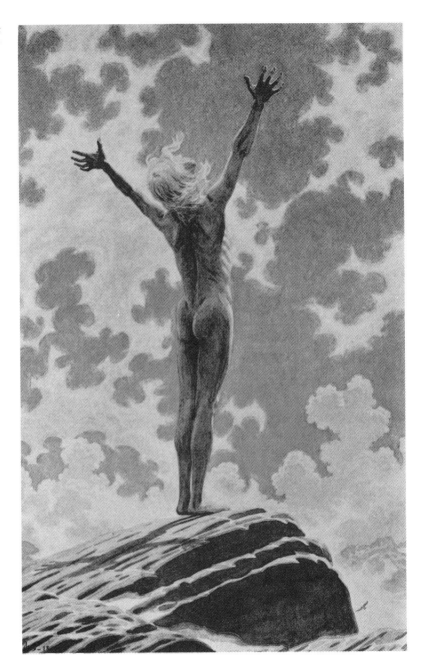

trappings of civilisation. Modern men with their sunshades, curtains, clothes, hats, houses and cities were mere mannikins (*Kleiderpuppen*), disguised by the illusionistic trappings of dress and cut off from their instincts:

In effect the man of today is little more than a head – little more than a face – as for the rest, you see nothing of it.[7]

Pudor's pessimistic prognosis for the further development of modern society cited perverted evolutionary models, indebted to Lamarck rather than Darwin. For example, hats, he claimed, would soon displace head hair just as clothes had displaced all-over body hair. By 1917 humans shall be born wearing hats. Evolutionary regression to a 'pure' vegetable state is however used as a positive image of regeneration: 'Man must learn to think of himself as a plant – then he shall begin to grow nicely again.'[8] While civilised man is like a camelia in a hot house, his true 'natural' state is that of a fir tree in a wood or an oak on a high mountain.

Visual representations of such ideas can be found in Jugendstil illustrations by Fidus (alias Hugo Höpfner), published in contemporary periodicals like *Die Schönheit* (Beauty), *Sphinx*, and *Jugend* (Youth). His depiction of a nude figure raising his arms to worship the sun in the gesture of the *Lichtgebet* (Sun-worship) (plate 15.4) became a kind of visual catch-phrase for the aspirations of *Freikörperkultur* (Nudism).[9] In his illustration to the poem *Glück* (Happiness), we find two bestial images of sexuality, the Christian snake twined around the woman and the Darwinian ape clutching the man's loins, juxtaposed to the positive image of asexual children dancing in front of a frieze of leaves. Nudism, in both Pudor's and Fidus' terms, was intended to promote a pure, *gut und gesund* attitude to the human body rather than regression to 'animal' sexuality.

Returning to Pudor's absurd notion concerning the evolutionary danger of hats, we find variations of these ideas occurring on many levels of popular imagery during the period. For example, in the *Berliner Illustrierte Zeitung* 1910 an illustration of exaggerated modern headwear is pictured as a 'regressive' tribal headdress with the caption, 'A fashion which hopefully won't make its way to Europe!' Elsewhere we find modern and tribal headwear ironically juxtaposed under the caption 'Spring Fashions.' (plate 15.5). The comparison between women, children and natives in this montage is typical of the use of Darwinian principles as a weapon to riducule women and tribal society, and to affirm male superiority by means of the 'objective' mask of the photographic eye.

In these popular images the boundaries between civilisation and the 'wild', the 'other', begin once again to slip and slide. In Pudor's writings, too, despite his attempt to polarise radically civilisation and nature, a paradoxical relationship between artifice and nature recurs. Stripped of the disguise of civilisation, he insists, man in his natural state of nudity will become a work of art, governed by a neo-classical ideal of beauty, often reflected in the poses struck by male models in contemporary nudist photographs, and with *völkish*, anti-semitic overtones. Pudor's vision of the heroic, blond-haired, red-lipped, bronze-bodied Germanic men of the future predicts the ideals of National Socialism. Although a right-wing

15.5 'Frühlings Muden'
(spring-fashions), *Berliner
Illustrierte Zeitung*, 1910

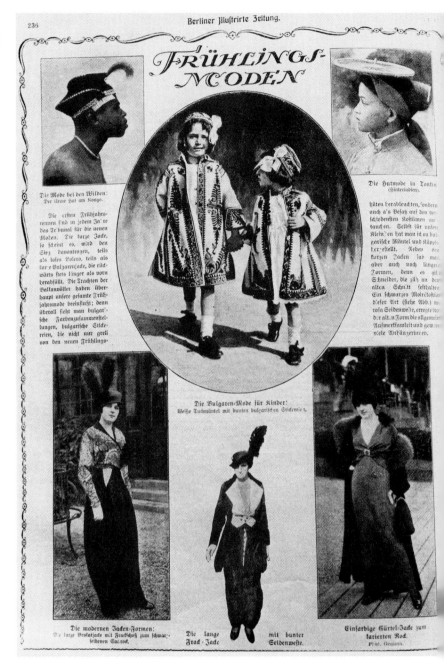

conservative tone dominated the pre-1914 nudist cult, *Freikörperkultur* (nudism), and *Bodenreform* (land reform) were often conceived as a way out of the rigid alternatives of contemporary politics. Fidus' illustration for the magazine *Deutsche Volkstimme, Organ der deutschen Boden-*

reformer (The German people's voice, agent of the German Land Reform Movement), depicted a three-pronged rune pointing towards alternative political paths. Communism leads in the direction of misty, treacherous mountain peaks, while capitalism points towards a lethal cliff edge. *Bodenreform* follows the direction of a long, straight pathway crowned by a vision of palm trees and a glowing sun rising behind a citadel. The city is reconciled with nature in terms of an illusory resolution to the contrasts and contradictions of modern experience, here literally pictured in the form of an oasis.[10]

The modernist answer to the conservative polarisation of city *versus* country was to propose a positive rather than a nostalgic reconciliation of nature and urban experience, for example in the garden city movement or city Impressionism. In 1908 August Endell published his essay *Die Schönheit der großen Stadt* (The beauty of big cities), which attacked rigid polarisation in favour of a positive, celebratory response to Berlin and to modernity. He condemned the popular 'regressive' cults advocating a return to nature or to idealised visions of the past, which, although presented in the guise of authenticity, were in fact: 'Surrogates, imitations ... as if the nature which these shallow people know was not a nature wholly formed by the hand of man. As if all culture, all human creation was not also natural'.[11] The elevation of nature, the past or art into an imaginary Golden Age in the name of unity and cohesion missing in the modern world, had the effect, Endell insisted, of sundering ideals from contemporary reality and thus fragmenting and splintering modern man's understanding. The city, he continued, should not be regarded as a polar opposite to nature, but rather as an arena where nature and artifice interact to create a distinctly modern beauty, a relative beauty conditioned by the changing effects of light and weather on the city landscape.

Endell considered the French Impressionists to have demonstrated most successfully this distinct modern beauty by painting the effects of mist and rain, dusk and sunlight on the tree-lined boulevards and parks. In fact, local equivalents for this type of city Impressionism could be found within the Berlin Secession. Max Liebermann, Walter Leistikow, Max Slevogt, to name but the prominent figures, all depicted the city parks and lakes in a loose Impressionist mode. Lesser Ury's paintings of carriages and cars in west-end Berlin and the *Tiergarten*, which depict the shimmering, softening effects of rain and reflected light on the harsh lines of the city come close to fulfilling Endell's theories. But Endell did not consider any of his German contemporaries capable of matching in their own terms the achievements of the French, and called on the energies of a future generation:

Only then will it become possible to regard the beauty of the cities as a self-evident virtue, like the beauty of the mountains, the plains, the lakes. Only then shall our children grow up in confident possession of this virtue, just as we grew up in confident possession of countryside beauty.[12]

273

During the course of his essay Endell attempted to reinterpret nationalist ambitions in a progressive, modernist light. He condemned narrow-minded nationalism which falsely elevates the achievements of the Germans over other nations; but he affirmed the necessity for a strong, personal engagement with one's own time and place: 'thereby *Heimat* is not fixed and static, but rather growing, constantly transforming and dependant on our lifestyle and ways of seeing'.[13] Endell dismissed the tendency to look to the past or to the vanishing countryside for models of national unity and invoked instead

the authentic love of the Fatherland, the passionate love of the here and now ... Only constantly renewed attempts to express what we experience can help to dispel confusion and to bring about a unified national feeling.[14]

Despite their conflicting positions, the ambitions underlying Pudor's conservative polarisation of city and country and Endell's modernist reconciliation are in fact similar. Both are guided by an ideal of national unity transcending the fractures and fragmentation of modernity. Pudor's vision of this unity is determinedly anti-modernist and located in oppositional terms to the forces of urban change, while Endell attempts to integrate the transient, mutable qualities of modern experience into a higher sense of unity. Hence the polarisation of city and country on the one hand and the synthesis of nature and artifice on the other. But it should be noted that the conservative and modernist positions are not fundamentally at odds. Both aspire to transcend the contradictions of the modern situation and to achieve a state of unity lacking in real political and historical terms. Only their methods and approaches differ. On the level of metaphor and language too we find an underlying similarity between modernist and conservative theory. Endell's use of images drawn from nature like the forest and the waves to describe the movement of crowds and traffic in the city are precisely those used in conservative crowd theory, for example Gustav Le Bon's *Psychologie des Foules* (The psychology of crowds), 1895.[15]

Where, we might ask, should we locate the Expressionists in this network of debate and discussion about the relationship between city and country? There is certainly no single answer to this question. Endell had called on a new generation of German city painters to uncover the conditions of urban beauty, and August Macke's paintings show how the Impressionist mode praised by Endell could be updated in Expressionist terms. His depictions of city zoos and parks show the 'wild' tamed and appropriated by civilisation, transformed into a gentle urban exoticism which pervades the whole city, as brightly coloured hats perched in shop windows became interchangeable with parrots and birds in the zoo. Both are visually consumed by elegant urban strollers like the woman in *Frau vor Hutladen* (Woman in front of a hat shop), 1914 (plate 15.6), just as we, the spectators, visually consume the charming paintings. Whereas Menzel depicts contemporary civilisation as a veneer of artifice thinly

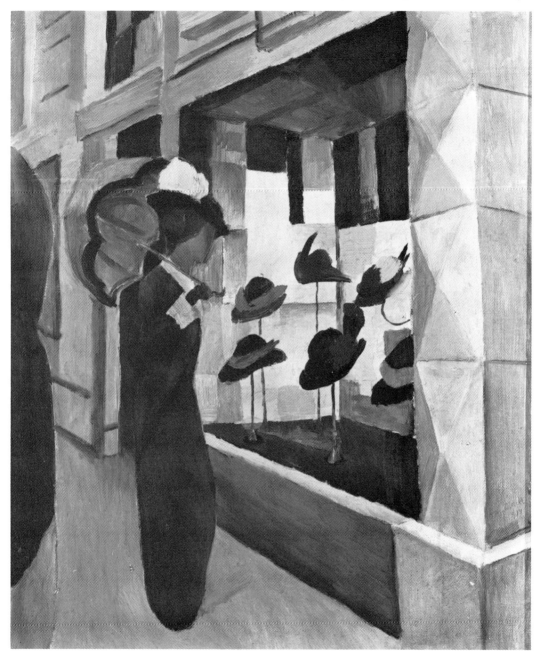

15.6 August Macke, *Frau vor Hutladen* (Woman in front of hat shop), 1914

masking 'natural' instincts in the struggle for the survival of the fittest, Macke's paintings exude an optimistic fusion of civilisation and nature, with the former firmly in control. Their urban scenes present two sides of the same coin; and it was a coin easily flipped in the volatile conditions of

275

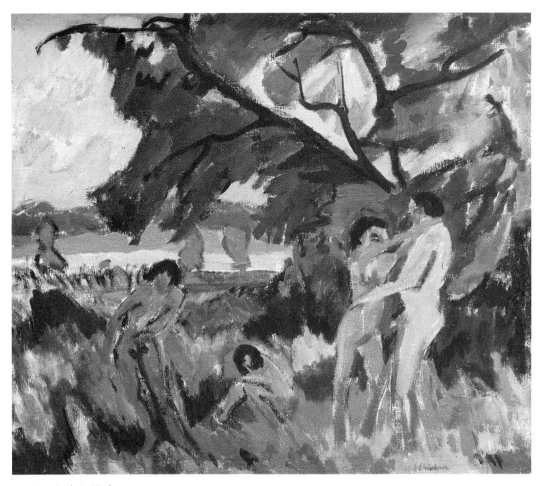

15.7 Ernst Ludwig Kirchner, *Spielende Nackte Menschen unter Bäume* (Nudes playing under a tree), 1910

the modern age. For example, a contemporary article in the popular idiom of the *Berliner Illustrierte Zeitung* described the Berlin aquarium as a tropical *Urwaldfluß* (jungle river), with living crocodiles at the heart of the city.[16] Could the 'wild' be so easily contained?

Attempts have been made to interpret the alternating phases of Ernst Ludwig Kirchner's work too in terms of the city *versus* country debates. For example, Professor Dube writes: 'The nude in the landscape reflects the ideal unity in nature, the figures in the big city streets show his alienation and misplacement.'[17]

Certainly Kirchner's Moritzburg bathers paintings like *Spielende Nackte Menschen unter Bäume* (Nudes playing under a tree), 1910, (plate 15.7), treat the theme of liberation from civilised constraints and regeneration by fusing the figures with the forces of rhythms of nature in a vitalist, Nietzschean spirit. The bold complementary colours and gestural brushwork knit the figures into the landscape so that the right-hand

woman is as green as the tree behind her; restored, as Pudor advocated, to a vegetable state. At points Kirchner's themes and motifs crossed with the contemporary nudist cult. The vignette he carved to celebrate the foundation of *die Brücke* in 1905 quotes the famous nudist *Lichtgebet*;[18] and in 1911, together with Erich Heckel, he designed a poster depicting the popular nudist motif of naked archers for the *Internationale Hygiene-Ausstellung Dresden*, (International Hygiene Exhibition), organised to celebrate the preventative powers of alternative medicine.[19] *Die Brücke* had ample opportunity to become acquainted with the local nudist movement, promoted by Pudor, who, in 1906, listed eleven establishments in the Dresden area practising *Nacktkultur* (nudism), including Eduard Bilz's newly opened *Lichtluftbad* (sunshine and fresh air baths), situated between Radebeul and Moritzburg. In Moritzburg itself the *Oberen Waldteich* was used as a *Naturbad* by the *Verein für Volksgesundheit Dresden Nord und Umgebung* (The North Dresden Association for Community Health), from the summer of 1910.[20]

On the level of underlying principles, the writings of Friedrich Nietzsche were a primary source of inspiration for both *Freikörperkultur* and the Dresden Expressionists, but several points of difference suggest divergent readings of Nietzsche. The Nietzschean image of the archer, which recurs as a leitmotif in *Also Sprach Zarathustra* (Thus spoke Zarathustra), (1883–5), to suggest the mood and aspirations of the superman, was interpreted by the nudists in the light of neo-classical aesthetics (plate 15.8) such as guided Pudor's notions of 'natural' beauty. A second poster design for the 1911 Hygiene Exhibition by Paul Rößler conforms closely to the aesthetics of the nudist movement by depicting two mounted warriors in the style of Greek vase painting.[21] In contrast the archer motif in Kirchner and Heckel's design, like their contemporary bathing scenes, is consciously primitivist in style and spirit, drawing on non-European sources like the Palau beams Kirchner sketched in the Dresden Ethnographic Museum in June 1910. Although he had known of the beams several years previously, they became relevant for Kirchner only during the 'primitivist' Moritzburg summers, when the artists bathed nude in the open air and played with boomerangs and bows and arrows.[22] Hence Kirchner matched the style of Palau to the theme of his bather compositions. The proximity of Karl May in Radebeul, whose Red Indian adventure stories reached a peak of popular acclaim at this time, may have encouraged this primitivist vein;[23] but final justification is found, once again, in Nietzsche. In *Die Wille zur Macht* (The will to power), 1906, we read:

Man as a species does not represent any progress compared with any other animal. The whole animal and vegetable kingdom does not evolve from the lower to the higher – but all at the same time, in utter disorder over and against each other . . . the domestication (the culture) of man does not go deep – where it does it at once becomes degeneration . . . The savage (or in moral terms the evil man) is a return to nature – and in a certain sense his recovery, his cure from culture.[24]

277

15.8 Nudist, pre-1914

Kirchner's depiction of liberated sexuality in his bather paintings also differs from the asexual aspirations of the nudists, affirmed in Fidus' illustrations, described by Janos Frecot as a new kind of '*Lichtgeisthafte Pruderie*',[25] and often put into effect via sexual segregation in the nudist colonies. Kirchner's depiction of female bathers breaks with the male-oriented bias of pre-1914 nudism; but the merging of the female figure into the surrounding vegetation in *Spielende Nackte Menschen unter Bäume* (Nudes playing under a tree) conforms to clichéd representations of

woman as nature – a counterpoint to the blatant artificiality of his later city prostitutes. Certainly the summer of 1910 was the fullest realisation of *die Brücke*'s aims to forge an 'alternative', liberated arena for living and art making, but their paintings should not be interpreted simply as idealistic counter-images to degenerate civilisation. In Kirchner's contemporary cabaret and circus paintings we find urban scenes infused with the same spirit of Nietzschean vitalism and reference to 'primitive' models.[26] They are comparable scenes set in opposite locations. Moreover, when we look at bather paintings which precede and follow the 1910 experience we find more finely wrought, complex relations between city and country references, and between images of nature and of artifice.

For example, Kirchner's *Liegender Blauen Akt mit Strohhut* (Reclining blue nude with straw hat), 1909, painted during the previous summer in Moritzburg presents a play between the 'artificiality' of art making – Kirchner's bold handling of the blue body and complementary yellow hat

– and the 'naturalness' of the motif. The jaunty modern hat is complementary in terms of subject as well as colour contrast, and it marks out the nude as determinedly modern and direct in the tradition of Manet's *Déjeuner sur l'herbe*, 1863, rather than timeless and rooted like the nymphs and peasants who populated the symbolist and realist wings of late nineteenth-century landscape painting. Erich Heckel's *Zwei Menschen im Freien* (Pair in the open), Vogt, 1909–14) (plate 15.9) makes oblique reference to traditional depictions of Adam and Eve expelled from paradise via the position of the woman's head and arms. The *Obstbaukolonie Eden* in Oranienberg recalls the popularity of such references amongst the naturists, but the visual allusion here suggests Eden after rather than before the Fall; a knowing paradise which was the context for Kirchner's depictions of sexual encounters in his bather scenes.

In the autumn of 1911 Kirchner and his *Brücke* colleagues moved finally from the baroque city of Dresden to industrial Berlin, a move which must have sharpened the real contrast between their experiences of nature during the summer bathing trips and the modern urban milieu. But instead of more radical polarisation, Kirchner's work during this period displays an increasingly complex play on the relationship between nature and artifice; as if he found it more difficult to separate out his experiences of the city and the country, of inside and outside spaces. In his Fehmarn bathers, like *Vier Badende zwischen Steinen* (Four bathers between rocks), 1913 (plate 15.10), the figures look increasingly like the carved wooden sculptures which appear in contemporary still lifes rather than nudes. Indeed, Kirchner was carving wooden figures from driftwood he found on the beach and he used these together with photographs to construct his bather compositions – methods which belie the immediacy and spontaneity of the 1910 nudes. In these works the wooden sculptures are 'brought to life' as bathing figures, and the figures are simultaneously transformed into works of art, reminiscent of African statuettes rather than the Greek idols Pudor visualised. But the paintings operate in a similar area of paradoxical interchange between artifice and nature, which Kirchner had been exploring for some time in his studio scenes. In numerous drawings and graphics the nude models in the studio rhyme with the surrounding carvings and paintings in a relationship of mutual contradiction. Often, as in *Frau im Waschzuber*, (Woman in a washtub), 1911, (plate 15.11), their bath tubs act as plinths, stranding the figures in a peculiar intermediary zone between artifice and nature, which is the conceptual space of the studio. What was new in 1913 was the transference of this dialogue into the natural space of the open air.

A second development in the Fehmarn bathers was the introduction of city figures – often Kirchner's accompanying girlfriend and her sister – into the countryside scenes. Whereas the trappings of civilisation, like the hat in *Liegender Blauen Akt mit Strohhut*, had acted as piquant foils to

15.10 Ernst Ludwig
Kirchner, *Vier Badende
zwischen steinen* (Four
bathers between rocks),
1913

nudity, these figures often add a disruptive, contradictory note to the landscape and bathing scenes. They tend either towards the monumental, for example, *Frau und Zwei Buben im Segelboot* (Woman and two boys in a sailing ship), 1914, or the diminutive, like the two miniscule figures in *Gut Staberhof Fehmarn* (Staberhof country seat, Fehmarn), 1913 (plate 15.12). In his cartoons for the *Königstein wall paintings*, 1916, the abrupt juxtaposition of nude and fashionably dressed figures is pushed to the limits of caricature as a truly disruptive combinatiuon of contradictory elements, rather than the elegant union of nature and civilisation we find in August Macke's city landscapes. Increasingly Kirchner translates the conflict he sensed between these two areas into abrasive sexual confront-ations.

The same disruptive and expressive confrontation of opposites recurs in Kirchner's Berlin street scenes, where he conflates nature and artifice into single and powerfully contradictory images. The women in *Fünf Frauen auf der Straße* (Five women on the street), 1913 (plate 15.13) and *Potsdamer Platz* (Potsdam Square), 1914, are caricatures of artificiality (the other side of the coin from woman as nature in the 1910 bathers), genuine *Kleiderpuppen*, based partly on the iconography of contempo-

281

15.11 Kirchner, *Frau im Waschzuber* (Woman in a washtub), 1911

rary fashion plates (see plate 15.14). But a tribal rawness replaces the elegant mannerism of his source, and the women, although constructed from artifice are also the focus of powerful, 'uncivilised' instincts of sexuality and aggression, stalking in city landscapes illuminated with lurid natural colours – green and flesh pink. The paradoxical interaction of nature and artifice, which Menzel handled with a light ironic touch forty years previously, has here become an expressive conflation of opposites. The city itself has become the 'wild', the 'other', as Georg Simmel realised in his 1903 essay on *Das Geistesleben und die Großstädte*

15.12 Kirchner, *Gut Staberhof Fehmarn* (Staberhof country seat, Fehmarn), 1913

(The mental life of big cities), where he described man's battle to preserve his identity in the city as the modern equivalent of primitive man's battle to survive in the face of nature and the elements.[27] Also similar to Simmel's description of city experience is Kirchner's combination of physical proximity and mental distance in the relationship between the figures.

The notion of the city as a battleground between progressive and regressive forces, between nature and civilisation, recurs in the rich, multi-layered symbolism of Alfred Kubin's illustrated novel *Die Andere Seite* (The other side), 1909.[28] Kubin's description of Perle, the city dominated by the forces of death, sleep and ecstacy, personified by Klaus Patera, until the wind of change and pragmatism blows in with Hercules Bell from America, mixes a dominant expressive mode with ironic

283

15.13 Kirchner, *Fünf Frauen auf der Straße* (Five women on the street), 1913

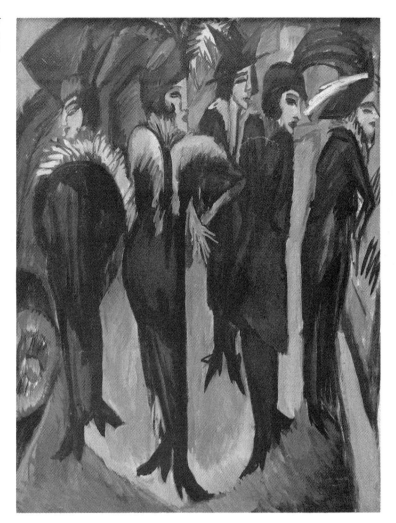

devices. For example, the religious cult of organic matter, as opposed to technology, in Perle involves the worship of excreta and a horror of metals. During the battle at the end of the book between Patera and Bell the city itself slips back into the primal mud, so that the triumph of progress and regression are closely related. Of course, Bell's victory is compromised as Patera remains lord of death and dreams, and when the narrator awakes he acknowledges these two forces dividing the world, neither holding absolute sway. He concludes: 'The real hell begins when this contradictory play of opposites [*wiedersprechende Doppelspiel*] continues within ourselves.'[29]

The other major painter of Berlin street scenes before 1914, Ludwig Meidner, was not impressed by Expressionism. In his essay, 'Anleitung zum Malen von Großstadtbildern' (Introduction to painting big cities),

Sommermäntel und Capes.

1914,[30] he particularly condemned primitivising tendencies, which he considered inadequate to express the sophisticated nuances of modern city life. Inspired by Futurist theory and practice following the *Der Sturm* Futurist exhibition in the spring of 1912, Meidner advocated a modernist engagement with city subjects, although his essay also responds to local discussion about the aesthetics of city painting, especially August Endell's theories. Like Endell, Meidner saw the city as the modern *Heimat*, but he directly attacked the Impressionists' depictions of the city as nature, the painting of boulevards as if they were flowerbeds. Meidner rejected both the techniques and approaches of Impressionism, advocating a more

285

exact, penetrating vision and the intellectual advantages of painting from memory rather than *en plein air*. The new city painters were to celebrate the age of engineering, expressed in the geometry of the city which gave a new *raison d'être* to avant-garde cubist style. Rather than turn the city into nature, he advocated turning nature into artifice, translating the experiences of city life into a new nervous and expressive geometry. Light, rather than recording the weather effects, should be used to create dramatic contrasts and divisions of space.

Meidner's practice as a city painter, however, only partially conforms to the thorough-going urban Modernism of his later theories. Before the impact of the Futurist show, Meidner was already, in 1911 (and in a similar vein to Max Beckmann), taking the changing face of the city as his subject. Paintings like *Gasometer Berlin Wilmersdorf*, 1911, set up a compositional structure which recurs in almost all his later city paintings: the city is situated in the background plane and nature in the foreground, reversing the compositional principle we find in Menzel's *Der Hausbau* (Builder), 1875, where nature is in the process of being literally bricked up behind the picture plane. In Meidner's paintings nature is always nearer to the spectator, and the city converges forwards. In his fully fledged modernist city paintings after 1912, Meidner is preoccupied by the fate of the individual in the city. *Ich und die Stadt* (myself and the city), 1913, shows the artist's own head (I have pointed out that the city was constantly associated with the intellect), surrounded by a distorted city panorama. The clump of green trees behind his head form a kind of halo between him and the man-made city. Meidner's drawing *Straßenkämpfe* (Street battle), 1914, makes explicit the struggle for the survival of the fittest, the barbaric evolutionary battle set in the city streets, which threatens the security of the sensitive individual.

In the spring of 1912 Meidner, together with the artists Richard Janthur and Jacob Steinhardt, founded an artists' group called *Die Pathetiker*, referring like the contemporary literary club, *Der Neopathetische Kabarett*, to the Nietzschean notion of pathos as 'a more intense experience of life'.[31] In the summer and autumn of 1912 many members of the avant-garde literary circles attended weekly gatherings in Meidner's studio in Berlin-Friedenau. The influence of apocalyptic city poetry by Jakob von Hoddis and Georg Heym certainly helped to shape Meidner's own apocalyptic vision. Like von Hoddis in his poem *Weltende* (End of the world) 1911, Meidner shows us a constructed, artificial world literally ripped apart by natural forces – light, wind, fire and flood; often the city seems caught in a whirlwind of destruction. A series of natural disasters during these years, including Halley's comet in 1910, which had always been taken as an augur of disaster, the Messina earthquake in 1909 and the sinking of the Titanic in 1912, confirmed the general suspicion that natural forces were beyond technological control. Max Beckmann, who admired and supported Meidner's work and shared his distaste for the

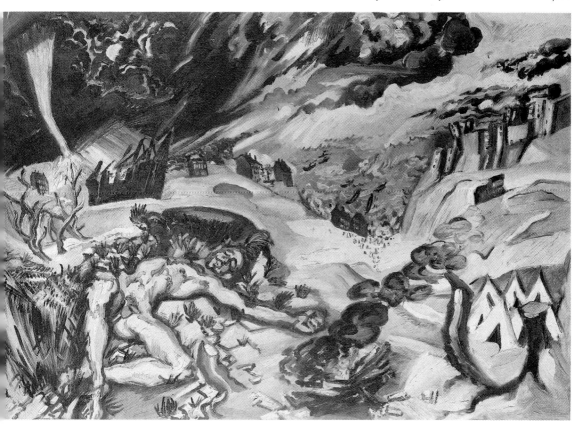

15.15 Ludwig Meidner,
*Apokalyptische
Landschaft* (Apocalyptic
landscape), 1913

decorative, abstracting tendencies of Expressionist Modernism, also depicted these disasters as part of the inevitable cycle of human destiny.[32] But while Beckmann continued to work in the traditional genre of history painting, translated into a contemporary mode, Meidner pursued a self-conscious avant-gardist direction.

Many of Meidner's apocalyptic subject paintings were titled 'landscape', despite their urban settings, *Apokalyptische Landschaft*, 1913, depicts a city exploding into fragments and on the reverse side a Beckmannesque nude, lying in a splintered landscape. This figure recurs in a second *Apokalyptische Landschaft*, 1913 (plate 15.5) occupying the foreground space while the natural forces of fire and flood wreak havoc on the city behind. Man and the landscape are the tragic victims of the battle between nature and technology, and the nude figure is like a felled bather. These compositions acknowledge the futility of dividing city and countryside into watertight categories; the disasters in the one necessarily affect the other. *Die brennende Stadt* (the burning city), 1913, repeats the compositional arrangement of a burning urban background and a foreground 'stage' of men on the outskirts of the city. The figures in this

287

case, dressed in earth-brown costumes, seem to be regressing, crawling back into massive crevices in the ground to escape the chaos behind, grimacing with animal-like expressions. Man is no longer the agent of his own disaster as he appeared in Menzel's sharp-eyed critical depictions of social pretensions in the modern world; rather he is the tragic victim of forces beyond his control. Meidner, like Kirchner, relocates social and political realities in a battleground of 'universal' forces, although Kirchner's depictions of sexual confrontation in the street scenes address the reified conditions and economic alienation of the modern world more directly. In this sense, he creates richer, more suggestive images, which are anchored to reality at the same time as they evoke conflicts beneath the surface of experience. These conflicts are explicitly stated in Meidner's paintings, and correspondingly, he polarises the city and nature, the elements and technology, within the urban arena, rather than conflating these oppositions, as Kirchner does, into single and powerfully contradictory images.

From this survey of the treatment of city *versus* country in German painting before 1914, it is possible to draw some tentative conclusions, and to ask new questions about the heritage of this tradition in the Weimar years. The classic conservative polarisation of city *versus* country and the classic modernist position of synthesis and reconciliation both tried to resolve the contradictions of modern historical experience in their times. Between these two extremes there remained a complex area of shifting and conflicting relationships which Menzel, Kirchner and Meidner took in different ways as the subject matter of their art, and which Kirchner expressed primarily through his complex and multivalent notions of the 'primitive'.

I would not suggest that these artists were working with a fully developed sense of the historical contradictions of their times. Menzel's ironic critique of modern civilisation was socially specific but functioned only within the wider context of his nostalgic ideal of enlightened monarchy, Meidner addressed not the social and political contradictions of his times, but rather a 'naturalised' battle of forces beyond man's control. Kirchner's work relates to both these alternatives. On the one hand his street paintings of Berlin prostitutes engage with some of the social and psychological effects of the urban capitalism. But he also translated these issues into sexual polemics, into a battle of male and female forces, relying very often on clichéd views of femininity which conform to the ethics of sexual politics in Wilhelmine Germany.[33] This combination of alternative modes in Kirchner's work, his tendency to combine historical awareness with his Expressionist sense of 'natural' and 'universal' forces, prepared the ground for the modern tradition of city painting which was inherited by such politically engaged artists of the Weimar period as Otto Dix and George Grosz.

In Dix's *Prager Straße*, 1920 (plate 15.16), which refers back to

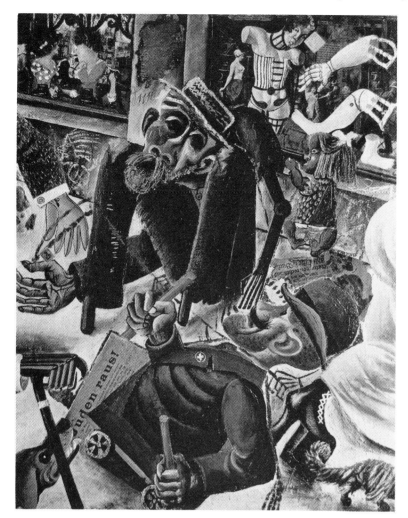

15.16 Otto Dix, *Prager Straße*, 1920

Kirchner's depictions of figures on a street corner beside a shop window, we find many of the issues under discussion recurring in a new idiom. The city street has become a collection of artificial parts, the bits and pieces left behind after the Holocaust and montaged on to the painted surface. At the same time, the 'natural' struggle for the survival of the fittest – and here the battered humans are reduced to the level of animals – has been exaggerated to a pitch of caricature which encompasses both ironic and expressive modes. Like Menzel, Dix's criticism is socially specific and used as a weapon to attack bourgeois society. He leaves us in no doubt about the role man has played in creating this state of affairs. The pathetic cripple in the foreground still sports his Wilhelmine moustache, and he is juxtaposed to a newspaper slogan, 'Jews Out!' Recent publications on Dix[34] have raised the question of whether this should be read as a critical

289

attack on a social and political level, or whether it is just a statement about the inevitable cycles of human nature; the victim of one generation cannot wait to get his hands on the next in line. In my opinion, *Prager Straße* is a political painting, and it has the rare quality of conveying today something of its original critical power. But is is significant that it too combines specific social and historical critique with the tendency to visualise the conflicts and contradictions of city life in terms of a battle of 'nature' and universal forces. In this particular instance the two aspects go hand in hand to drive home the political message; but the balance is a delicate one. Dix's decision to locate his critique *both* in history *and* in nature seeks to combine potentially incompatible ingredients, militating both for and against political change. In *Prager Straße* the combination works in a mutually reinforcing way but, in a slightly different combination, they could equally well cancel each other out and, by fusing in this way, defuse Dix's critical power.

Town planning and architecture in Berlin 1945–1985

Vittorio Magnago Lampugnani

At 'zero hour': preconditions for and objectives of reconstruction

By the end of World War II more than a thousand European towns and some 24 million residential buildings had been largely destroyed. In West Germany 2.3 million dwellings out of 10.5 million were irreparable ruins, nearly half of the total number damaged. At the same time, numerous refugees from the Eastern territories – more than 8 million in 1948, 10 million in 1953 – required additional living space. In 1948 the housing demand was estimated at 6.5 million, and still amounted to 1.3 million in 1960.

For a nation that had twice signed an unconditional capitulation in May of 1945, and which had an industrial plant that was limited by the Allied Control Council one year later to 50 per cent of the pre-war level, the material meeting of these necessities alone posed an enormous problem. Still, the problem of ideologically and psychologically 'coping with the past' was a much more fundamental one. Consequently, the architect Otto Bartning, who in the twenties distinguished himself with an Expressionist re-interpretation of Gothic space in his design for the *Sternkirche* (star church) and who was to become the President of the Federation of German Architects in 1951, interpreted the general mood of the time when he proclaimed in 1946, 'Reconstruction? Technically and financially impossible, I tell you; what am I saying? Psychologically impossible!'[1]

German architectural culture did indeed find itself confronted with the task not only of compensating for an unprecedented lack of dwellings but also, in this compensation, demonstrating a new *Weltanschauung*, or philosophy of life. There was the desire to distance oneself vehemently from the dark times of National Socialism and to show this by way of architecture and town planning. As a result of this exaggerated demand, which also found no support in the political and social reality of the newly evolving Federal Republic of Germany, reconstruction was already pre-programmed.

Traditionalists and Modernists in the immediate post-war period

Most of the prominent architects involved in the very first phase of Germany's reconstruction were representatives of a traditional, locality-bound architecture; its formal simplicity and correct craftmanship best met the ideological and economic requirements of the moment. They had survived the Third Reich for better or worse, with large and small concessions, and the degree to which they were politically compromised ranged from the 'inner emigration' of a Heinrich Tessenow, for whom even his nearly almighty pupil and General Building Inspector for the redevelopment of the Reich capital under the National Socialist regime, Albert Speer, was unable to procure orders to the open agitation of a Paul Schmitthenner, who publicly polemicised after 1933 against the 'architectural bolshevism' of avant-garde architects on behalf of the reactionary *Kampfbund für deutsche Kultur* (Fighting League for the German Culture).

The modernist architects competed with the traditionalist architects for predominance in the reconstruction of Germany. A number of them, Walter Gropius for one, had emigrated to the United States of America in the thirties; others, Hans Scharoun for example, had remained in Germany – nearly unemployed. Their time now seemed to have come: for most of them (often with a bit of exaggeration), were able to present themselves personally as victims of National Socialist persecution, and stylistically they were able to boast of having represented the Weimar Republic with their 'white architecture' – likewise within the scope of a decidedly generous historical perspective.

In 1947 the Marshall Plan was passed as part of the anti-communist Truman doctrine; in the autumn of the same year the American military government arranged for Gropius to go on a lecture tour of Germany, on the occasion of which he once again advocated Bauhaus ideas and praised Scharoun as the 'best planner and architect' in the country. The mightiest victorious power paradoxically re-exported to an insecure Germany the very same architecture it had taken from Germany a decade and a half earlier; but what at the time had the pathos of social reformism showed itself in the meantime to be more conciliatory, a pacified symbol of freedom and individualism. The order placed with Hans Schwippert in 1948–49 for conversion of the Pedagogical Academy into the Bundeshaus (Parliament buildings) in Bonn, the provisional capital of the newly founded Federal Republic of Germany, confirmed the putative suitability of modernist architecture for representation of democracy: its 'honesty', its 'transparency' and its 'candour' were supposed to reflect the same properties in the young nation. In the meantime, this ideological suggestion did not keep, for instance, the building of the Foreign Office (by Hans Feese) or the Federal Criminal Investaigation Office (by Herbert Rimpl, once the planner of the town known as 'Stadt der Hermman-Göring-

Werke', now Salzgitter) from being erected in the fifties in a dry, heavy, monumental style.

The superficial enthusiasm for the light, cheerful and 'liberal' International Style was, for one, a reaction to the conservative attitude that had been spreading in the likewise newly founded German Democratic Republic after the Reconstruction Act was passed in 1950: there, after initial hesitation, care of the national cultural heritage was raised to the central principle of architectural and urban-development plans. The director of the German Academy of Architecture, Kurt Liebknecht, fought the ascetically internationalist examples of the *Neues Bauen* (new architecture) and passionately advocated a revival of the local tradition of building.

But it was, precisely, the political division of Germany that promoted the bonds between the estranged architects in the Federal Republic, and despite all the rivalry the contacts between traditionalists and modernists never broke off. As early as 1947 the names of those who signed the moving call for reconstruction, in which the 'visible collapse' was recognised in nearly biblical tones as an 'expression of the spiritual breakdown' and the demand was made for the simple and valid,[2] included those of Willi Baumeister, Richard Döcker, Egon Eiermann, Hans Schmidt, Hans Schwippert, Max Taut and Wilhelm Wagenfeld next to that of Heinrich Tessenow. The harmony celebrated its soulful climax in 1951, two years after constitution of the two new German states and at the same time as the restrictions on production were dropped in the Federal Republic: at the second round of talks at Mathildenhöhe in Darmstadt, to which Otto Bartning (also a co-signer of the appeal of 1947) had invited ten German architects to a debate with Martin Heidegger, José Ortega y Gasset and Alfred Weber, modernists like Hans Scharoun, Hans Schippert, Sep Ruf and Egon Eiermann were sitting next to conservatives like Paul Bonatz (former colleague of Frita Todt in the construction of the Reich autobahns), Wilhelm Kreis (former General Building Commissioner for the design of German war cemeteries) and Richard Riemerschmid. The general theme of the event, 'man and space', led to a discussion that was just as vague as it was non-committal, and it was at this abstract level above that a conciliatory accord was struck.

'Denazified' town planning: plans and realisation 1945–1953

This accord belied the architectural and, above all, the town-planning reality of Germany's reconstruction: these displayed in more than clear fashion not only the sharp contradictions between traditionalists and modernists but also their contradictory mixtures and links to each other.

No sooner was the war over than people were reflecting on the reconstruction of the cities and making innumerable plans. Up until the currency reform of 1948 they of course remained on paper; but even there

they already revealed those desperate attempts at architectural and town-planning denazification that were mainly to have disastrous consequences in the construction-happy period of the 'economic miracle'.

The planning merry-go-round that started up in Berlin, which had just barely escaped Hitler's and Speer's brutal redevelopment intentions, was emblematic. The first to demonstrate the chameleon-like, ideological adaptiveness of architecture and town planning was Otto Kohtz, a former protagonist of the Expressionist period of the early twenties. In his phantasmagoric 'Reconstruction Proposals for a Metropolis', which he drew up shortly before the capitulation of the German Wehrmacht in the destroyed city of Berlin, he laid out Speer's 'Grand Road' in even huger dimensions; instead of the 'Hall of the People', however, he envisaged, in keeping with the circumstances, a gigantic Ziggurat of rubble, a memorial to the still-raging war.

The nonchalance was not to continue long. In the middle of 1946 a plan by Walter Moest and Willi Görgen, later called the 'Zehlendorf Plan', was shown at the exhibition entitled 'Planning for the Reconstruction of Berlin'. The proposal is comparatively conservative; its only decisive innovation is the demonstrative destruction of the system of axes envisaged by Speer: the north–south 'cross-town road' runs past Friedrichstrasse train station, the historic, existing east–west axes broken up by simply eliminating the middle section through Tiergarten. The questionable town-planning result of this equally questionable architectural denazification: Unter den Linden stops abruptly at the Brandenburg Gate as a cul de sac.

The structural plan for the Berlin area ('collective plan'), which was elaborated under the direction of Hans Scharoun, the first Municipal Building Commissioner after the war, and introduced to the public a few weeks after the war, and introduced to the public a few weeks after the 'Zehlendorf Plan', made a more decisively clean sweep of history – and not only recent history. Practically nothing is left of historic Berlin: instead of the evolved urban structure of the past the glacial valley of the Spree river provides the morphological orientation. The existing radial street structure is replaced with an orthogonal network of motorways. In between are largely homogenous quarters in which 80,000 people were to have lived in an area of 500 hectares; for the most part in single-family homes amidst greenery. The working sections are laid out parallel to the residential sections. Only the old centre of town around Museum Island is ironically exempted from the radical cure as a memento. Scharoun himself wrote, 'What is left after bombing attacks and the "Endkampf" [final battle] brought about a mechanical shake-up makes it possible for us to design a town landscape' in which 'a new living order develops out of nature and buildings, high and low, narrow and wide.'[3]

The Berlin 'collective plan' did not arise in empty space: it went on from both the German tradition of the *Volksheimstätte* (people's

homestead) and the international one of the 'new city' as formulated in the twenties by Le Corbusier (*Une ville contemporaine*, 1922), in the thirties by Nikolai Alexandrovich Miliutin (schematic drawing for Sotsgorod) and in the forties by the English group MARS (Master Plan for Greater London, 1942). It did not (characteristically) represent a completely worked-out town plan but a vague schematic model for future urban developments.

The planning ideas that immediately followed, like those of Karl Bonatz and Walter Moest or those of Richard Ermisch (both in 1947), kept their distance from the modernist frivolity of the group around Scharoun and oriented itself more to the historic town; but, in the last analysis, it was the 'collective plan' that moulded the ideas of the following generation of planners – in Berlin and beyond its borders.

So much for the plans; town-planning reality looked different. In the years immediately following the end of the war, reconstruction began hesitantly and followed traditional patterns. The destroyed cities were first cleared of rubble, dwellings were repaired on a make-shift basis, gap sites filled with cheap and formally modest houses. At the same time, small-town suburban housing estates arose in the areas on the edge of town, the building of privately owned homes being promoted by the state. For a while it looked as if the romantically resigned visions that Max Taut had conjured up in his brochure *Berlin im Aufbau* (Berlin in reconstruction) were to become reality: spreading out next to towering monumental ruins of the past were dwarfish estates consisting of plain single-family homes and small tranquil gardens. In a regionally tinged retreat from social reality, the 'new Germans' were supposed to become a people of self-suppliers and land-cultivating townsmen.

In the meantime the competing fronts of traditionalists and modernists were scattered between Germany's towns: in Munich, Münster, Freiburg and Würzburg on the one hand, which were marked by the former, careful reconstruction in which the historically evolved basic layout of the city was preserved began in the early fifties; in Berlin, Frankfurt, Hanover and Cologne on the other hand, where the latter set the tone, a 'new construction' was implemented which altered the basic street structure – namely, almost exclusively in line with the exaggerated requirements of motor-vehicle traffic. After the confrontation with practical experience the many-sided and complex theoretical disputes largely yielded to simple political polarisation: the towns ruled by the Christian Democrats were rebuilt conservatively, those run by the Social Democrats were redesigned with progress in mind. But, of course, there was no lack of contradictory examples: the most striking one is Hanover where the 'traditionalist' planners and architects Paul Bonatz, Gerhard Graubner and Konstanty Gutschow collaborated from 1948 on under the 'modernist' Municipal Building Commissioner Rudolf Hillebrecht (who headed the architects' office of Konstanty Gutschow after 1937 and worked on Speer's Staff for

the Reconstruction of German Cities after 1943). For Hillebrecht 'the war had seen to long overdue urban renewal', which made it possible for him to 'get a designing grip' on the city with the help of organically swinging traffic routing that corresponded to the 'new feeling of movement'.[4] Hanover did in fact succeed with exemplary consistency in keeping to the *Zeitgeist* and in turning what was once an architecturally self-contained and functionally mixed urban structure into an unattractive and desolate conglomeration of monofunctional islands constantly washed by a stream of vehicles flowing in gigantic channels of traffic.

This metamorphosis – in Hanover as elsewhere – was by no means an easy operation. After all the rubble had been cleared it was already possible to see that the destruction wrought by the war had not been quite so thorough as many a progressively minded planner had hoped. And even where the bombs of the Allies had left a *tabula rasa*, the streets with their subterranean technical infrastructures as well as the foundation walls and cellars of the old buildings still traced out the historical urban texture.

Nor was this material situation able to hold back the euphoric surge of renewal. The traces of the town were thoroughly erased until late in the fifties. In Berlin – by no means an exception – a whole nineteenth-century quarter, which had been bombed out but left with its basic layout, was eradicated piece by piece. It was the Hansaviertel, and in its place the heroic emblem of reconstruction was to arise with the International Building Exhibition in Berlin (*Interbau*).

Demolition and buildings 1945–1953

The first reaction after May 1945 was the quite understandable desire to get rid of a past, the horrors of which were still all too present. The unspeakable spirits of National Socialist terror had to be exorcised; to do so it appeared necessary to destroy the symbols they built.

The first monumental structures were blasted in Nuremberg in 1945; the two pantheons erected on Munich's Königsplatz in 1935 according to the plans of Paul Ludwig Troost, the first 'Architect of the Führer', followed two years later. In Berlin the Prinz Albrecht Palace was levelled, a baroque town palace which was converted by Karl Friedrich Schinkel from 1830 until 1835, becoming the main office building of the SS in the 1930s; the same happened to the former School of Arts and Crafts, which the Gestapo had taken over. At the same time the first buildings of the university town on the west end of the east-west axis shamefacedly disappeared under the rubble of the Teufelsberg. The granite of the bombed out New Reich Chancellory, Speer's paradigmatic work, was used, *inter alia*, in the Soviet memorial in Treptow.

But the demolition involved by no means solely the relics of the Third Reich. Right after its constitution, the German Democratic Republic

demonstrated its symbolic disassociation from the memories of the same Prussian past it was to overzealously rediscover a few decades later by blowing up the only damaged Berlin Town Palace, the classical baroque masterpiece of Andreas Schlüter – an idea, by the way, that Hans Scharoun had also had somewhat earlier, although with other ideological implications. In the west, after all, quite serious consideration had been given to razing Heinrich Strack's Victory Column a few years earlier. The demolition that continued in the fifties and sixties, usually as irresponsible as it was malicious, saw the Federal Republic of Germany and the German Democratic Republic unified in their helpless attempts to 'cope with the past'.

The 'Town planning of democracy' 1954–1968

The feverish economic upswing that began in the early years of the Federal Republic and euphorically greeted as a 'miracle' was rooted in barren soil. The democratisation that had taken place in the political sector in 1945 had not spread to industry. The economic configurations of power had only gained in strength in the course of the new activity of the post-war years: the trusts had expanded, the groups had become multi-national. The law of maximum profit also applied to the building trade. The political, social and architectural opportunity of reconstruction was largely wasted in the hectic effort to be as fast and cheap as possible.

German town planning in the late fifties and sixties, which concentrated mainly on housing to make up for the deficits left by the war, was almost without exception a sad chapter in the history of architecture. At the typological level, the spartan floor plans developed during an economic slump for the ethically moulded demand for the *Wohnung für das Existenzminimum* (subsistence-level dwelling) were continued during the economic boom in the service of maximum profit. At the formal level, the sober architectural language of the *Neue Sachlichkeit* of the twenties was adopted and trivialised because of its simplicity and its suitability for fast and cheap mass production of components. At the town-planning level, the guidelines of the *Charte d'Athènes*, the theoretical manifesto of the 'functional town' written in 1933, were followed only as long as their cartesian schematism entailed financial savings; the rationalistic postulates were usually ignored when it became a matter of including a generous amount of public greenery in plans, building infrastructural facilities like kindergardens, schools and shops or even achieving a more effective and comprehensive reorganisation of the entire urban area by means of expropriations.

The contradictions already turned up in the results of the international competition *Hauptstadt Berlin* (Capital city of Berlin), which was announced in 1957 as the paradoxical culmination of attempts to gain planning control over greater Berlin, that is, nine years after the division

297

of the city, and for which the participants had to act as if this division had never happened or could, at the least, be rescinded at short notice.

In the plan that won the first prize, and for which Friedrich Spengelin, Fritz Eggeling and Gerd Pempelfort took responsibility, such prominent places in the former central area as the Platz der Republik, Siegesallee and Kemperplatz have disappeared without trace. On the Spree river, which was expanded to form a lake (curiously, the revival of one of Speer's ideas), there rise, instead of the monumental buildings of the nineteenth century, the avant-garde Modernists' prismatically abstract combinations of structures. To the north of the Landwehrkanal a few short rows of buildings and a couple of blocks arbitrarily strewn among the greenery; a motorway constitutes the north–south connection and plunges under the otherwise untouched, amorphous area of the Tiergarten, which is inadequately structured only from the east–west axis. It is not by chance that the book by Johannes Göderitz, Roland Rainer and Hubert Hoffman with the suggestive title of *Die gegliederte und aufgelockerte Stadt* (The structured and loosened-up town) appeared in the same year.

The plan with which Hans Scharoun won the second prize does not propose anything much different, although it falls within the scope of a different language of architectural form. Here, too, the north–south motorway runs beneath the Tiergarten; above it, on the bank of a Spree river with a new, wider course there opens a new, skewed Platz der Republik. The Charlottenburger Chaussee has become an element of the green areas, Unter den Linden a pedestrian zone. In the south there is a vestige of the diplomatic quarter similar to a garden city, a small seed of what was later to proliferate into the 'Cultural Forum', as well as gigantic highway crossings and huge parking lots in the middle of the greenery. The idea of the town landscape had been concretised in planning.

In the meantime, reality caught up with the boldest and most sinister dreams of the planners. Starting at the end of the fifties, due to false land policies and brutal speculation, downtown plots of land began falling into the hands of corporations, so that office and administration buildings increasingly drove the residential side out of the town centres. The separation of dwelling and workplace demanded by Le Cosbusier in the twenties was realised – only differently: lifeless, monofunctional dormitory suburbs spread out of control on the edges of the towns while the glass boxes belonging to banks and insurance companies ate their way through the historic building substance spared by the war. Cities were cut up by motorways to permit innumerable commuters to travel from the periphery to the centre and from the centre back out to the periphery again. The business areas, the scene of chaotic traffic and feverish life during the day, began to remain empty in the evening and at night; the people began to retire in isolation from each other to suburban estates, at best apathetic, green ghettos hanging on congested urban areas like parasites. To top it all off, commercial pedestrian zones, which

additionally had a one-sided effect on the already disturbed urban equilibrium, were set up in historical town centres that had often been reconstructed as nostalgically as incorrectly from the point of view of the preservation of the architectural heritage. Their penetrating kitsch was supposed to compensate the inhabitants for the inadequate aesthetic and emotional quality of their environment: natural, thoroughly mixed urban life was replaced with artificial shopping strolls between doubtful 'furnishings', the citizen being relegated to a passer-by and consumer.

In 1954, in the middle of the upswing that was to lead to the 'economic miracle', an honorary committee consisting of 110 associations and organisations was established to put together the International Building Exhibition Berlin (*Interbau*) as an exhibition of constructed architecture. The Hansaviertel, a badly damaged urban quarter on the edge of the Tiergarten, which was finally cleared for the good purpose, was chosen to be its core. In the competition for its restructuring the plan submitted by Willy Kreuer, Gerhard Jobst and Wilhelm Schiesser was awarded the first prize; instead of the formerly densely developed, urban and self-contained quarter it provided for individual buildings among greenery.

In the first place, an architectural and town-planning reason tipped the scales for the decision: as in the proposals and realised projects of the twenties and thirties the constricted town of the nineteenth century was to be countered with an estate containing extensive greenery and bright, well-ventilated dwellings. But there was, in fact, a political reason: both the architecture of wooden neo-classicism, which barely two decades earlier had almost irreparably placed its bleak stamp on the capital of the Reich, and that of socialist realism, which in the meantime determined reconstruction behind the 'iron curtain', were to be confronted with the International Style as an expression of the new, progressive and liberal spirit. The development in East Berlin was, of course, the more important motive and in every respect the more obvious competition. For on the other side of the border Hermann Henselmann had initiated the development of Stalinallee (completed in 1960) with the *Hochhaus an der Weberwiese* (high rise on the Weberwiese) built in 1951–1952, a project with the same theme as *Interbau*: 'living in the town of tomorrow'. What the east was trying to do with the help of the past the west undertook with ahistorical frivolity.

Thus, in harmony with the political climate of the Adenauer era and cold war, the international architectural élite was invited under the exuberant mottos of 'Heads Planning for the Town of Tomorrow' and 'Berlin Calls the World'. For the most part they were recruited from the heroes of the 'Modern Movement': in Hansaviertel Alvar Aalto, Walter Gropius and Oscar Niemeyer each built one tall residential block; Arne Jacobsen created a group of flat atrium houses; Le Corbusier built an *Unité d'Habitation* outside the quarter. There were further projects strewn throughout the town ('all of Berlin is a building site'). The

299

exhibition was opened in the summer of 1957, one year later than intended.

From the propaganda point of view it was a success: the public was highly interested in the rationally produced, healthy, easy-to-run family dwelling units in a good location. Nevertheless, on the architectural and town-planning balance sheet the result is not a positive one. For the pathetic (cum demagogical) claim 'to show the free world's technology and creative power in its wide variety of forms'[5] bred an inadequately co-ordinated collection of structural individualities, with little cultural substance behind their unfounded arrogance. The family idyll of the 'green town', in which an ideal freedom seemed achievable only at the price of dispensing with social obligations, did not turn urban for all the surrounding nature. What had been planned as a model became at the most an ideologically legitimised special case.

At first, however, the special case was looked upon and used as a model in many places. In its wake there arose numerous extensions to towns and satellite towns, first based on linear buildings such as the *Neue Vahr* in Bremen (1957–1962), later on towering, chain-like, staggered developments such as Frankfurt's Nordweststadt (1959 ff.).

German housing-estate construction of the sixties and seventies celebrated its most canonical and frightening high point with the Märkisches Viertel in Berlin. The planning began in 1962 under the direction of Werner Düttmann, Georg Heinrichs and Hans Christian Müller; the architects involved included Ernst Gisel, Ludwig Leo, Oswald Mathias Ungers and Shadrach Woods. The residential area, with twelve schools, fifteen day nurseries, four churches, various community centres and one indoor swimming pool to serve its 17,000 flats for 60,000 persons, was mainly supposed to accommodate people who had been driven out of the centre of town by the effects of redevelopment. The large multi-storey buildings were joined together to form large open spaces and 'loosened up' with colour, but they were the targets of fierce criticism, chiefly because of their boundlessness and lack of feeling.

The architecture of prosperity 1954–1968: buildings and demolition

The German 'economic miracle' decided in principle the victory of modernist architecture over traditionalist. Wherever it bowed to economic dictates and 'objective constraints' it was mediocre without exception; on the other hand, wherever it acted contrarily and independently it developed a remarkable width of expression and lively pluralism.

The concert hall of the Berlin Philharmonic Orchestra, (Philharmonie) built in Berlin from 1956 to 1963, represents the climax of Hans Scharoun's work. Tent-shaped with an almost provisional feeling from

the outside, the inside of the building opens up an enormous wealth of spatial experience: a labyrinthine foyer, branching stairs, off-set floor heights and, finally, the vibrating cavern of the large, centrally placed auditorium. The stairs and galleries make the structure function like a town within a town. The room for the audience is broken down into various, irregular podiums so as to structure its size and make it acquirable; the orchestra and hall are combined. The elegantly graceful ceiling bestows a sense of security on the hall despite its dimensions. As with nearly all of Scharoun's designs, the intricately angular floor plan provides for constant visual surprises. A synthesis that is just as wilful as it is persuasive is achieved in the way he personally comes to terms with human functions and artistic gesture.

The design for the Staatsbibliothek Preussischer Kulturbesitz in Berlin (National Library of the Prussian Cultural Heritage) was developed between 1964 and 1967. Construction began in 1969 but was not completed until 1978, six years after Scharoun's death. Despite all the fascination of its own, the complex lacks the freshness of the Philharmonic, but it embodies no less Scharoun's statement of intent: 'The humane ... is still our desire today. Thus it is today our wish that the movement of life should not ... grow rigid too soon, should not be perfected prematurely – not even in the area of technology: that instead of perfection there should be improvisation that leaves the path to development open.'[6]

The heroes of the German modernists in the twenties, who emigrated nearly as a body to the United States of America during the era of the National Socialist régime, were also called back. In 1957 Walter Gropius built a house for the Berlin *Interbau*, and from 1976 to 1978 a building for the Bauhaus Archive originally intended for a slope at Darmstadt's Rosenhöhe was likewise erected in Berlin after a somewhat unfortunate revision. Ludwig Mies van der Rohe, whose bold design for a theatre in Mannheim had been rejected just a few years earlier, built the New National Gallery in Berlin between 1962 and 1968. He took over the structural and formal scheme from his 1957 project for the Bacardi administration building in Santiago, Cuba: a square waffle ceiling of black steel on eight steel columns moved away from the corners. Beneath it he placed, far to the back, a filigreed glass wall as a transparent enclosure of space. The overall severely symmetrical structure is mounted on a large pedestal, the form of which is also cut out of a square; more exhibition rooms are to be found underneath. With this building Mies van der Rohe's striving for the perfect archetype reaches an enigmatic zenith that includes in its elementary quality the experience of the Greek classical age as much as the romantic, classicistic yearnings of a Karl Friedrich Schinkel.

Over and beyond these subversive historic moments, which it accepted and took over with composure, the morganatic marriage between high

capitalism and architectural Modernism was so solid that it could easily afford to tolerate some extramarital escapades. Indeed, since the fifties there has been room for traditionalism oriented to craftsmanship, side by side with large industrialised projects.

Appallingly (but by no means accidentally) all the new architectural achievements materialised before the background of an equally thoughtless and ruthless series of demolition measures that by no means ceased after the mid-fifties. There is no lack of disgraceful examples. An instructive one, *inter alia*, is the destruction of the Ethnological Museum in West Berlin, a dignified and quiet neo-baroque building that was needlessly torn down in 1961 in order to legitimise at another place construction of the new, unattractive museum buildings of the ambitious *Kulturforum*. At the same time, the last explosives were detonated in the Grand Entrance Hall of Franz Schwechten's historic and fascinatingly beautiful Anhalter Train Station, of which, thanks to the careful and wilful official acts of destruction that have been taking place since 1959, only the melancholy ruins of the facade remained standing. In the meantime, Karl Friedrich Schinkel's *Allgemeine Bauschule* (General School of Architecture) fell in the other half of Berlin, also for no reason at all.

Such prominent demolition actions were only the tip of the iceberg of a far-reaching campaign of destruction that fed on a bad political con-science, an impulsive urge to 'cope with the past' and blind faith in progress – with strong support, of course, from the simple-minded ambition of the public institutions to put themselves on stage and from unrestrained profiteering on the part of private speculators. Its victims were chiefly the simple residential buildings of the same turn of the century period which was still being simplistically portrayed as a dark adversary to the yet non-existent concept of 'Modernism'. Even urgent and articulate protests like the essays Wolf Jobst Siedler compiled in 1964 in his much-read book *Die gemordete Stadt* (The murdered town) went unheard for a long time and had no effect. Only after the development of a new consciousness, which was forced on the public by the student revolt at the end of the sixties and the energy crisis in the early seventies, was it gradually possible to put an end to the squandering of culturally valuable points of identification and living space that was equally valuable from the economic point of view.

The late end of wastefulness and the Janus-faced rediscovery of history

The deep crisis the legitimacy of the state went through under the attacks of the 'extraparliamentary opposition' was to continue for a long while and also leave its traces in architectural culture. At first it was directly reflected in the newly awoken attention to participatory procedures, in

order to involve those concerned in the planning of their housing, and to do-it-yourself building systems that were supposed to make the dream of one's own home come true, with circumvention of industry and bureaucracy.

Another disruption of the idyll of the 'economic miracle' was soon to appear and lead to the final collapse of its house of cards. In the seventies the public gradually realised that many raw materials on which man depends cannot be renewed; that the environment cannot be plundered and polluted without paying a heavy penalty; and that life on earth can only be preserved if an overall ecological equilibrium is striven for, rather than uncontrolled demographic and technological expansion. The international oil and energy crisis brought about by the oil-producing Arab states in 1973–74 was the first concrete symptom of the impending danger.

The oil crisis made its greatest impact on public consciousness. Part of the architectural world reacted quickly to the new (not least, economic) needs and nimbly adapted to 'energy-saving', 'biological' and 'ecological' construction. But the serious search for appropriate, energy-oriented forms of architecture is still in the initial stages and often does not go beyond a more or less fashionably revived regionalism.

However, over and beyond this initially superficial reaction another more far-reaching one arose within the architectural culture of the late 1960s and the 1970s. The new consciousness, in which the preceding faith in technology and progress gave way to sceptical and selective reflection, entailed a basic (and long overdue) revision of the terms 'tradition' and 'Modernism': for the self-appointed Modernism threatened to behave backwardly and subordinate to the ruling economic system with its 'laws', while tradition suddenly revealed a progressive, sometimes subversive potential in as much as it offered resistance to the production and consumption processes of capitalism and helped to give new popularity to an imperiled craftsmen's tradition that had survived in the 'niches' of the system. This late rehabilitation, which Jürgen Habermas attempted in a 1980 prize-acceptance speech entitled 'Modernism – an Incomplete Project', like an unintentional epitaph for architectural Modernism, to which he referred *inter alia*.

Architectural history was restored to favour after the conscious asceticism of the avant-garde architecture of the twenties and early thirties, the shamelessly improper historicism of the later thirties and forties, the ahistorical mannerism of the fifties and the fashionable purism of the sixties: architectural culture tried to come to terms with the past in a more thorough, objective and sincere fashion. The laws of architecture as an independent discipline of its own were reconsidered within the scope of reflections on its autonomy, which ran parallel to the political de-ideologisation of the seventies and to the 'classical' abatement in the fine arts. While there was greater interest in the origin of architectural forms, formalism, hitherto used almost exclusively as a defamatory epithet,

303

entered the architectural discussion again. Drawing, as the original means of depicting architectural ideas, underwent intellectual revaluation after the period marked by the emphasis on realisation rather than on process.

In the Federal Republic of Germany there were primarily two forums at which the Janus-faced quality of the recovery of history was critically interrogated. The first was the Technical University of Berlin at which Oswald Mathias Ungers taught from 1963 to 1968; a dispute was kindled in his circles concerning the 'architecture of the city', and which was decisively influenced by Aldo Rossi's book of the same name, which appeared in Italy in 1966. The second forum was the Dortmund Architectural Convention initiated by Josef Paul Kleihues in 1975; there the major topics that stirred the international architectural avant-garde were provocatively and continuously discussed.

Back to the town 1969–1983

The central theme of the debates in the world of architectural culture in the seventies and early eighties was the town. The faith in the supremacy of functionalistic and hygienic aspects, in 'healthy' linear buildings with ingeniously optimised floor plans and a lot of light, air and sun in every flat in return for being surrounded by a frazzled urban space was obsolete, and the confidence in megalomanic housing-estate projects and large brutal structures that paid homage to the myth of an ominous 'densification' as a recipe for urbanity was thoroughly broken. Its place was taken by a new, partly nostalgic, though basically quite rational attention to the historical town with its comprehensible scale, its clearly formulated streets and squares as well as its easily identifiable and multifarious locations.

This attention entailed a whole wave of redevelopment projects in German towns that were forced about by the public pressure of citizens' initiatives and squatters, and in the course of which the still existing urban configurations were preserved and the building lines forming the same were repaired, supplemented or restored. The residential blocks dating from the nineteenth century, the charm of which was recalled in numerous exhibitions, experienced a renaissance. In the first phase the attempt was made to tidy them up hygienically: extra storeys were pulled down, rear buildings were pruned or even completely torn down, inner courts cleared of tradesmen's sheds and carriage houses, thus creating free space. In the second phase the illusion of a thorough 'purge' was given up in favour of a more sensible procedure: storeys that had been added on were viewed as informative, historical 'deposits' and left untouched if possible; side wings were left standing as spatially dividing elements even if some flats were in their shadows, and the courtyards were cautiously cleared of only what had to be.

A pace-setting example is block 118 in Berlin-Charlottenburg, which

the office of Hardt-Waltherr Hämer and Marie-Brigitte Hämer carefully redeveloped between 1975 and 1980. The buildings that were worth preserving were modernised, those not worth preserving replaced; the rear buildings on the courtyards were kept; the entire interior of the block was planted with greenery. In this connection the primary concern was not even the aesthetic but the social requirements: the people living in the houses before redevelopment were not driven out by higher rents but were involved in the redevelopment process themselves.

In the meantime, attention to the historical town also generated a series of new plans. Their first chance to be realised was provided with the establishment of the *Bauausstellung Berlin GmbH* in 1979, which was appointed to develop an exemplary planning concept for the last, large, empty urban areas of central Berlin and to present it to the public at an exhibition of constructed architecture. The terribly dilapidated sections of Kreuzberg known as Luisenstadt and SO 36 were carefully redeveloped under the direction of Hardt-Waltherr Hämer; under the direction of Josef Paul Kleihues the frazzled urban texture is now being sewed together again with new architecture in Tegel, on Prager Platz, the southern Tiergarten quarter and, above all, in Southern Friedrichstadt, which is still war-worn and destroyed by planning measures. What *Interbau* 1957 showed in an isolated area is supposed to be demonstrated by the International Building Exhibition Berlin as an integrated measure in the heart of the city: for it is no longer a matter of the abstract 'town of tomorrow' but of conscientiously coming to terms with a specific locality, its features, qualities and contradictions. With the help of the great reputations in international architectural culture a concrete and methodically transferrable model was created in 1987, concretely illustrating how a humane town of the eighties can and must look.

The architecture of uncertainty 1969–1983

During the seventies and on into the eighties the rivalry between modernists and traditionalists continued to smoulder, sometimes flaming up into open dispute. However, the argument was pursued with reversed roles: the modernists were recruiting from the older generation and going increasingly on the defensive to uphold the now aged values of what was once the new; the traditionalists were now the young, in a position to attack and advocating something new with their recourse to the very old – namely classical architectural history.

Such a new 'traditionalist' architectural attitude developed around the person of Oswald Mathias Ungers. As early as 1960 Ungers together with Reinhard Gieselmann wrote: 'Technology is not art ... If the methods of technically functional architecture are followed, the result is uniformity, monotony ... The consequence is that blocks of flats look like schools, schools like office buildings, office buildings like factories ...'[7]

It was a long time before he was able to realise his architectural ideas: for more than ten years after the block of flats in the Märkisches Viertel (1967–1968) Ungers' dispute with architecture was only pursued on paper. Nevertheless, the influence of his teaching, in which he derived the forms of his buildings from systematic morphological transformation studies, endeavouring to bring out the 'poetry of the place', this competition entry for the student dormitory in Enschede, Holland, a programmatic project whose bold collage of archetypal architectural forms is influenced by the Roman Villa Hadriana, was drawn up as early as 1964 with the colaboration of Johannes Friedrich Geist and Jürgen Sawade. The designs for the new construction of the Wallraf-Richartz-Museum in Cologne (1975) and for the new construction of the Hotel Berlin (1977) mark the intellectual and creative evolution of Ungers' 'architecture of memory'; neither was built. Not until the project for the residential park on Berlin's Lützowplatz (1980) did Ungers have a new opportunity to submit his ideas on architecture to discussion as concrete, constructed works.

The development of the second protagonist of the renewal of German architecture in the late sixties, Josef Paul Kleihues, is different. He was able to realise his programmatic building at a relatively early date: from 1972 to 1974 (design: 1969–1973) he constructed the first stage of the main workshop for Berlin's municipal cleaning service, the second building phase following from 1977 to 1980 (design: 1975–1976). The facility, which is used to service and repair the motorpool for the rubbish collection service and street cleaners, is a tripartite work: in the centre nave there are the shops, the materials and spare-parts store as well as staff rooms, in the side naves the regularly arranged halls which the vehicles can drive directly into. The prefabricated concrete parts, which have been left visible, and the large areas of glazing are determined by strict geometric dimensional co-ordination which takes that of Karl Friedrich Schinkel's General School of Architecture as a model while displaying traces of the industrial architecture created by Peter Behrens around 1910.

Thus, the keynote of Kleihues' 'poetic rationalism', more severe and less fragmentary than Ungers', had been struck. The following buildings were to confirm this tone: the forcefully dry block 270 on Berlin's Vinetaplatz (1971–1978) or the elegantly structured hospital in Berlin-Neukölln (1973–1985).

The new 'traditionalists' by no means supplanted the modernists; they remained in business and absorbed the impulses of the new consciousness of history with greater or lesser intensity. It is true that as late as 1979 late Modernism presented two of its very own, grotesquely paradigmatic scions, namely the brutal urban motorway superstucture by Georg Heinrichs and Gerhard and Klaus D. Krebs as well as the monstrous International Congress Centre by Ralf Schüler and Ursulina Schüler-

Witte, both in Berlin; but they were projects that were begun in 1962 and 1967 respectively. They came from another epoch and, like dinosaurs, they stumbled into a 'different' age that caricatured their clumsy strangeness. As for the rest, however, 'Modernism' itself reacted to the new times.

Until late in the seventies the architectural scene in the Federal Republic remained dominated by more or less commercialised 'Modernism'; the designs that were contrary to it, or at least not a part of it, largely remained architecture for the drawer. Events did not turn until 1978 when the British avant-garde architect James Stirling won the competition for the extension of the Staatsgalerie and new construction of the Kammertheater in Stuttgart with a monumental and elegantly formalistic design. With this he put the new 'traditionalist' currents in the focus of public attention and international discussion – and West Germany's building activity.

In addition, within a general surge of nostalgia and as a crestfallen reaction to the destructive frenzy of the fifties and sixties there arose a vehement re-evaluation of the preservation of the national heritage, which sometimes produced strange results. Not only were valuable and less valuable individual buildings and 'ensembles' protected, conserved and restored: there were also fantasies of backdrops consisting of medieval houses on 'historic' streets and squares; 'old' houses were rebuilt according to approximate plans at the wrong places and, curiously, it almost came about that a baroque town palace was to be found not once but twice in the same town – namely the Ephraim-Palais that was to be reproduced in both East and West Berlin. As during the demolition euphoria the Federal Republic of Germany and the German Democratic Republic found themselves cosily unified in antiquarian historicism: with the costly reconstruction of the opera house in Frankfurt am Main and the *Schauspielhaus* (theatre) on Gendarmenmarkt in East Berlin, both German states tried to demonstrate the late rediscovery of their own past.

The facts of the formulations and the blurred contradictions

An extremely wide variety of approaches is revealed by a look at the latest development of architecture in the Federal Republic of Germany, which is focally more condensed in Berlin under the influence of the International Building Exhibition but nevertheless displays remarkable points of crystallisation in Frankfurt, Hamburg, Stuttgart and Munich. In view of a panorama in such tumult (and naturally in view of the fierce polemics that continue to flare up between the groups) the search for a uniform denominator may appear pointless, the mannerisms of a terrible simplificateur.

Nevertheless, it cannot be denied that under the disenchanted eye the polarisation of modernists and traditionalists, which runs through this entire survey of 38 years of particularly feverish and contradictory activity

is discreetly but obviously disappearing. The terms flutter, frazzle, turn inside out, change places with each other, fade away and finally become completely inadequate. In fact, modernists and traditionalists, the entire variety of German architecture in the seventies and early eighties have something in common: primarily the feeling that everything 'has already been said'. In a world that fancies itself as already poetically developed there is only the way out that pop art already arrived at: *répétition différente*. What has already been said is used again in such a way that it becomes 'different' due precisely to its re-use. Peter Handke describes it in his book *Wunschloses Unglück* (Perfect misfortune) that appeared in 1972:

In the beginning I was still proceeding from the facts and looking for formulations for them. Then I noticed that in my search for formulations I was already drawing away from the facts. I now proceeded from the available formulations and sorted out in addition ... the occurrences already provided for in these formulations.

It seems as if today's avant-garde can do nothing more than simply that for the time being: in architecture as well.

Representing Berlin: urban ideology and aesthetic practice

Rosalyn Deutsche

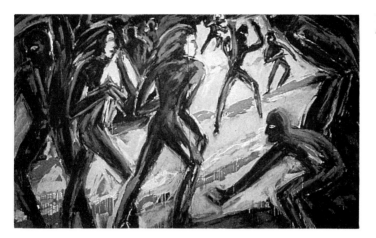

17.1 Helmut Middendorf, *Electric Night*

17.2 Louise Lawler, photograph from *Interesting*, an installation at Nature Morte Gallery, New York, 1985

On the threshold of *German Art in the 20th Century*, visitors to the Royal Academy find themselves face to face with two canvases by Ernst Ludwig Kirchner – *Berlin Street Scene* (1913) and *Friedrichstrasse, Berlin* (1914) (see plates 17.3 and 17.4). The effects of the encounter are, of course, not uncalculated. Rather, this immediate confrontation with

309

Rosalyn Deutsche

17.3 Ernst Ludwig Kirchner,
Friedrichstrasse, Berlin

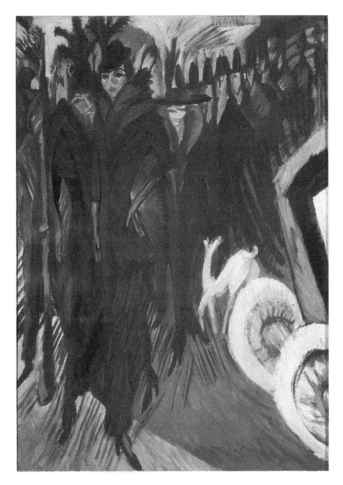

Kirchner's impassioned city paintings – and with the prostitutes in the paintings – solicits viewers' emotional responses in order to channel them toward predetermined ends. It exhorts at once the audience's acquiescence in a version of art history institutionalised at the Academy as a chronicle of the durability of German Expressionism: its creation in the early twentieth century; its suppression by the Nazi régime; and its post-war, post-occupation resurfacing. Essentially comprising a display of Expressionist works which proliferate in superabundance at both limits of the fascist period, the exhibition attempts to define Expressionism as a national artistic style and to associate it with personal and historical salvation. But like the construction of all historicist continuities, this representation of modern German art as part of an unfolding romantic continuum is founded on the act of establishing as a separate domain the art practices that rupture its coherence. The exhibition's subtitle, *Painting and Sculpture 1905–1985*, marks such a repression,

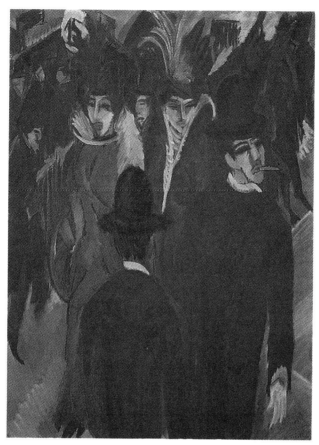

excising with a single categorical stroke the photomontage production of Berlin Dada and, especially, John Heartfield's photomontages for *AIZ*. The consequences are obvious. Since, at various moments in the artist's career, Heartfield's aesthetic practice was explicitly both anti-fascist and anti-Expressionist, because it linked Nazism to the logic of capitalism and Expressionism to bourgeois ideology, its presence would have diverted the narrative course of a presentation that equates the 'survival' of Expressionism with national liberation. The decision to include only artistic forms conforming to conventional productive and distributive modes cannot, then, be dismissed as a practical response to the inevitable exigencies of curatorship, permitting, as one of the organisers explains, 'the concentration and concision necessary to the exhibition'.[1] Neither can it be neutralised as a vagary of individual taste nor exalted as a liberal response to cultural pluralism. Instead, it appears as a defensive operation launched against the very perception by the museum public of that troublesome material which forms the exhibition's structuring absence.

The circumscription of the field of German art so that it includes only

311

painting and sculpture serves still other purposes which, like the thesis of the 'triumph' of Expressionism, are presaged by the placement of Kirchner's street scenes at the entrance to the exhibition. For in as much as the activities of Heartfield and the Dada movement that spawned his work were concentrated in Berlin, their removal to a position outside the official boundaries of German art in the twentieth century perpetuates a tendentious identification of Berlin with Expressionism, its denomination as an 'expressionist city'. The stage is thus set for an uninterrupted dialogue between mutually reinforcing urban and aesthetic discourses that ahistorically define Berlin as a mythical metropolis and Expressionism as a transcendent artistic style. Indeed, by situating Kirchner's icons of Brücke *Grosstadt* painting at the source of a remodelled tradition of modern German art, the curators also positioned Urban Expressionism as that art's consummate achievement and Berlin as its privileged location. Insinuating a bond between the two, the opening of the exhibition foreshadows its literal end – the final room containing canvases by artists credited with 'rediscovering' the national artistic heritage in 1960s West Berlin. Throughout the intervening galleries, the curators strive to fulfil yet another agenda announced at the show's outset: to provide the most lavish pedigree to date for contemporary German pseudoexpressionism.[2]

In this regard, the Royal Academy exhibition crowns and probably signals the demise of a legitimating process inaugurated in the late 1970s. During the following years, a principal strategy for endowing the 'new German painting' with the authority of artistic tradition consisted of classifying its numerous manifestations according to a variety of standard art-historical criteria – geographical location, chronological period, group identity, iconography or style. Virtually all the resulting typologies reserved a category for a group of paintings designated as representative of Berlin and, more broadly, of the 'urban situation'. Facilely describing this work as 'urban' in art journals, exhibition catalogues and the mass media, its supporters sought to invest it with social relevance even as, in so doing, they resurrected a concept of the urban that is as vague, retrograde and cynical as the aesthetic notions the painting embodies. The fact that such claims were advanced at a moment when urban conflicts had erupted with a striking clarity in Berlin as in other western cities compels an interrogation of this alliance of urban and aesthetic ideologies – how it defines the social process of urbanism and its tangible form, the city. Why, we should enquire, are we routinely asked to believe that an oil painting of Van Gogh standing beside the Berlin Wall is a significant – indeed emblematic – depiction of contemporary Berlin?[3] (See plate 17.5.) On what basis is this painting accorded such a rank and not, instead, Hans Haacke's installation, *The Broadness and Diversity of the Ludwig Brigade*, a work whose subject matter and exhibition format addressed the interconnections among political, economic and cultural conditions

17.5 Rainer Fetting, *Van Gogh und Mauer*

specific to its Berlin context? (See plate 17.6.) Or why – to raise even more disturbing questions – has Rainer Fassbinder's play, 'Garbage, the City and Death', revealing associations between real-estate speculation and city government, been prevented from opening in Frankfurt due to alleged anti-Semitism while canvases of mythologised street figures in the form of primitivist stereotypes circulate internationally as representations of urban reality? (See plate 17.1.) What institutional events produced these constructions and which art-historical discourses were enlisted in the process? Whose interests in contemporary urban struggles do they ultimately serve?

In *The Allround Reduced Personality (Redupers)*, feminist filmmaker, Helke Sander, recounts the activities of a group of women who are producing a photographic documentary about West Berlin. 'What the women see', Sander has stated

who don't view reality through ideological blinders – does not serve to uphold the existing image of Berlin. West Berlin is different from other cities, among other

313

17.6 Hans Haacke,
*Broadness and Diversity of
the Ludwig Brigade*,
installation view, 1984

things because a wall leads around it, and because an elaborate system of ideological interpretations has been developed for the special status of Berlin. This is what the women realize after reflecting on their encounter with the city.[4]

Insisting on the specific historical features and ideological positioning that distinguish Berlin from other cities, Sander's film also intimates that Berlin's urban space is internally fissured by divisions other than those produced by the Wall. The experience of the city varies, for instance, with the gender of its inhabitants. In contrast to these conclusions about Berlin's *differences*, celebrants of the city's new 'art scene' assert that circumstances in Berlin typify a universal, if heightened, 'urban experience'. Universalising their own experience and presupposing a one-to-one correspondence between Berlin and the 'urban condition', they frequently contend that neoexpressionism quintessentially embodies that condition because of its necessary connection to the archetypal modern city.

Far from an intrinsic bond, however, this link has been forged discursively; it was strengthened over the last few years by a series of exhibitions held in London and Berlin, a series to which *German Art in the 20th Century* can be considered the latest addition. Scrutiny of this exhibition history reveals permutations in the organisers' publicly stated convictions, changes that culminate in reversal: from an initial purported commitment to a politicised art practice that denies aesthetic neutrality, they retreated, following the tenor of the period, to an uncritical assertion of art's autonomy and redemptive purposes. Serving as functionaries in a period of triumphant reaction, they exploited the Berlin location common to strongly contrasting art practices as a support for both these positions.

In 1979 the Whitechapel Art Gallery mounted *13°E: Eleven Artists Working in Berlin*, proclaiming its opposition to a concurrent show of contemporary German Critical Realism and German art of the 1920s

displayed at the Institute of Contemporary Arts and entitled *Berlin: A Critical View*. The Whitechapel's catalogue attacked the 'official' stature of Critical Realism, a position perceived to result from the Berlin Senate's financial support of the ICA show and its denial of funds for the Whitechapel event. Considering the array of international exhibitions and publications about Berlin art that followed (and others currently in the planning stage[5]), this show appears to have introduced a pertinent topic. In his catalogue introduction, the Whitechapel's director maintained that the exhibition intended to explore the issue of what it means to represent Berlin. The show was motivated, he contended, by an interest in 'the work of artists using art as a means of social enquiry or political struggle',[6] and the participating artists were chosen because their work addressed social questions and the conditions of artistic production in West Berlin. The title of Christos Joachimides' lengthy catalogue essay, 'The Strain of Reality: West Berlin and the Visual Art 1963–1978', promised to explicate the relationship between the social reality of the city and its art production. Instead, platitudes about Berlin's isolation or undefined West German crises provided a vague backdrop for an impressionistic list of artists and events.

Joachimides might have seemed a logical choice to 'establish a context' for the art being shown at the Whitechapel since the gallery's director envisioned the show as 'extending the discussion started in the important manifestation *Art into Society, Society into Art* organised by Christos Joachimides and Norman Rosenthal at the ICA in 1974'.[7] Dedicated to investigating connections between German art and ideology, this earlier exhibition comprised artists attempting to formulate new means of intervention in existing economic and political formations. Participants opposed concepts upholding the sovereignty of the artwork or notions that political meaning resides only in a work's mimetic reflection of empirical 'social' referants. Among the contributions to the show, Hans Haacke's *Solomon R. Guggenheim Museum Board of Trustees*, for example, detailed the economic and political dealings of the corporate affiliations of the New York museum's board. This work offered significant possibilities for the development of aesthetic practices aimed at exposing, rather than concealing, the ideological underpinnings of powerful cultural institutions that help determine aesthetic discourse and the reading of artistic texts. Other artists in *Art into Society* stressed the necessity of rejecting traditional working methods and models of art distribution. The exhibition as a whole signalled a desire to expose the material conditions of art production and the mechanisms of power operating behind the art institution's facade of neutrality.

Insofar as this was its purpose, it is contradictory that a prominent position among the art practices presented at the 1979 Whitechapel show, which claimed to extend the earlier exhibition's political concerns, was accorded to 'a new form of expressive figurative painting in Germany'.[8]

For it was precisely this 'new' painting and its validating apparatus that resuscitated the full idealist mythology of studio production – individualism, originality, universality – and resurrected the authority of traditional art institutions – the gallery and museum. Notwithstanding this conflict, an awareness of neoexpressionist painting was listed as a motivating factor in the Whitechapel exhibition which, in fact, introduced German neoexpressionism to London. Indeed, as the introduction states, 'the moment ... was propitious'.[9] Since the entire Whitechapel project made no attempt to conceptualise connections between art and social relations in Berlin but merely linked them by association, it imparted an aura of political engagement to all the work included. The Berlin site of the work was employed in a slippery argument to secure a place for the new German painting as a significant mode of socially concerned art practice to which the exhibition was supposedly dedicated. This effect was bolstered by positing a unity to the various Berlin practices represented in the form of their distance from Critical Realism. Placed against the rigidity of that style and of the Berlin Senate, the Whitechapel show proclaimed its commitment to personal freedom, freedom from government control and a freedom attributed, by extension, to the new Berlin painting.

By now it is well known that in 1981 'expressive' painting apparently won the campaign to represent Berlin. In London it was ensconced at the Royal Academy as part of an international blockbuster, 'The New Spirit in Painting'. The following year, Joachimides and Rosenthal co-curated the large Berlin *Zeitgeist* exhibition in the Martin-Gropius-Bau, this time with the full patronage of the Berlin Senator for Science and Cultural Affairs as well as numerous other governmental agencies and corporations. *Zeitgeist* dispensed with any lingering pretence of diversity; the show consisted almost entirely of work in an expressionist mode. The history of these exhibitions is familiar and need not be rehearsed here. It should be noted, however, that *Zeitgeist*'s curators asserted more confidently than before the belief that an intrinsic relationship existed between the art on view and the location of the exhibition. 'Is it merely a coincidence that Berlin is the site of this event', Joachimides mused, 'or are there inner affinities to the art of which [*sic*] ZEITGEIST is showing?'[10] Responding affirmatively to this query, he shifted the basis of this kinship from that proposed in the earlier shows: no longer was the bond established by artists' enquiries into Berlin's social conditions but, on the contrary, it resided precisely in their retreat from them. As Joachimides concluded:

Outside, an environment of horror, made up of the German past and present. Inside, the triumph of autonomy, the architectural 'Gesamtkunstwerk' which in masterly and sovereign manner banishes reality from the building by creating its own ... For us the question is how does an autonomous work of art relate to the equally autonomous architecture and to the sum of memories which are present today.[11]

Berlin, then, was transformed into a city distinguished as the natural site of art practices that disavow their relation to 'reality'. Under the aegis of representing Berlin, Joachimides declared his contempt for social reality by reasserting the notion, only recently challenged in contemporary art practice, that the aesthetic occupies a sphere distinct from the social.

Comfortably sheltered within the walls of the Martin-Gropius-Bau were canvases by a group of artists known collectively as the 'violent painters', 'painters of the new vehemence', or, simply, 'the boys from Moritzplatz'. In 1977, the artists who formed the nucleus of the group – Rainer Fetting, Helmut Middendorf, Salomé and Bernd Zimmer – opened the Berlin co-operative Galerie am Moritzplatz where their first solo exhibitions as well as numerous group shows were held. In 1980, their work was featured at the Haus am Waldsee in Berlin in an exhibition entitled *Heftige Malerei*, and, under this rubric, the group soon gained international recognition as a major contributor to the German renaissance of painting.

Like other renaissance men, the 'Moritzplatz boys' sought to establish a continuity between their work and German artistic tradition, turning for special inspiration to pre-war *Brücke* Expressionism. Appropriating iconographic models, they filled their paintings with variations on standard Brücke motifs – anxious artists and models, primitivised nudes, primitive figures and statuettes, Berlin streets – and updated the *Brücke*'s café, circus and cabaret images with pictures of contemporary 'subcultural' entertainment establishments – discotheques and new-wave music spots. They also adopted the high-contrast colour, spatial dislocations, scale distortions, harsh brushwork and primitivising techniques of *Brücke* painting, reiterating the painterly codes of 'spontaneous', 'unmediated' expression. They placed themselves, then, within national and local traditions – German painting in pre-war Berlin.

A number of historians and critics embellished these fictions, applauding the artists for rediscovering German Modernism following its eclipse under both the Nazi régime and years of American cultural dominance. Fragile threads of uninterrupted continuities with the past were unearthed. The figure of K. H. Hödicke, the Moritzplatz painters' teacher, provided one such coveted linkage: as a third-generation Expressionist painter, he had studied with those who, in turn, had studied with the last of the original Expressionists, Max Pechstein and Karl Schmidt-Rottluff, at the Hochschule der Künste in Berlin.[12] Filtered through this history, Berlin emerged as a city in which expressive painting had never died and, consequently, as a place where the primacy of the free and autonomous self posited in Expressionism also remained eternally alive. Descriptions of Berlin as a 'painterly city' became a commonplace. These post-war histories were highly selective – ignoring major developments in twentieth-century art hostile to Expressionism – or confusingly all-inclusive – identifying 'trends' without distinguishing theoretically

among them. Superficial and misleading dichotomies between, for example, abstraction and figuration or intellect and emotion obstructed the recognition of more profound differences in post-war art practice. Alternative analyses were already available, however. In 1977, Benjamin Buchloh had viewed the artistic situation in Europe differently, proposing that the most significant development in European art discourse of the 1960s was its shift from aestheticism towards a consideration of the historical, social and political phenomena that condition modes of artistic perception and production.[13] Instead of proposing false dualisms, Buchloh, concerned with radical practices of the 1960s and 1970s, theorised a paradigmatic change in the concepts, categories, relationships and methods of art practice – from a formalist paradigm to one of historicity. This new dimension of inquiry, he wrote, 'demanded from the critical viewer a different kind of opening up of traditional fields of vision'.[14]

Recourse to authority and tradition inevitably reversed this direction; the new German painters were placed within a historical continuum by shutting out such critical assessments and freely discarding the critical dimensions of recent art. Because these revisionist accounts attempted to recover a national artistic experience as a natural cultural reservoir from which to draw, it was to be expected that they would marginalise those twentieth-century art practices which questioned a belief in unmediated experience or the idealist tenet that meaning is fixed, transcendent and directly available in unchanging works of art. Such marginalisations, achieved through omission or accommodation, included the lack of any serious consideration of the implications of Berlin Dada and Heartfield, the exclusion of overtly politicised practices such as that of Haacke, as well as the inappropriate assimilation of the contemporary work of Gerhard Richter and Sigmar Polke to a monolithically conceived German painting. Additionally, descriptions of recent German art frequently presented false conflations of movements. Perhaps the crudest, although by no means exceptional, example is the work of one German promoter of Moritzplatz painting who grouped the movements of the late 1960s and early 1970s – minimalism, conceptualism, critical realism, etc. – under a single unifying characteristic – emotional distance from subject matter.[15] This assessment obviously stemmed from the wish to establish as *radical* violent painting's retreat into subjectivism and emotionality.

For the 'violent painters', however, tradition was most consistently resurrected in the subject of the 'big city' with which, it is claimed, they are deeply involved. Supporters describe their 'savage' brushstrokes, 'hallucinatory' colours, 'expressive' distortions, and iconography as essentially 'urban'; their use of figurative imagery is cited as evidence of a willingness to confront concrete reality. To constitute themselves in the tradition of big city painters, Fetting and Middendorf produced hectic, *Brücke*-influenced street scenes and Zimmer, nature scenes intended to

express the notorious anti-urban yearnings of a city dweller. Writers absorbed this work into an art-historical category – Urban Expressionism – and identified it with the most famous examples of Urban Expressionism – Kirchner's Berlin street scenes executed between 1913 and 1915 and commonly assessed as the artist's mature contribution to a national German culture. Unfailingly, descriptions appearing in art journals and catalogues related the work of the Moritzplatz group to the work of Kirchner. Hödicke was extolled for reaching back to Kirchner, 'newly discovering the city as artistic Muse' and imparting this source of inspiration to his students,[16] who, dubbed 'children of the big city', were named Kirchner's legitimate heirs. The designation, 'Urban Expressionism', or '*Grosstadt* painting', not only offered violent painting a safe niche in German artistic continuity but also helped position it as an art of social critique, a 'reflection' of social conditions or an important act of social protest.

But on what premises does the original art-historical claim for Urban Expressionism as a critical social statement rest? What beliefs about art and the city enabled it to be understood as representative of the urban experience? Urban Expressionism is a subcategory of a broader art-historical discourse about paintings of the modern city. Characterised to a great extent by the construction of arbitrary, eclectic and frequently whimsical typologies of 'city painting', this discourse in general, but especially the concept of Urban Expressionism, is based with few exceptions on attempts to detect in artists' paintings and writings their responses to city environments that remain only superficially examined. It thus exemplifies the relentless empiricism of mainstream social art history which regularly concerns itself with paintings of the city because of what is commonly believed to be their inherently social iconography. This branch of the discipline, hostile to theory, systematically rejects forms of analysis which penetrate beneath the surface of observable social phenomena, confining itself, instead, to interpreting artists' registration of 'things as they are'. According to one historian of city painting who has endeavoured to distinguish these responses in visual representations of Paris, Berlin and New York from 1890 to 1940, 'one cannot expect those attitudes to be highly precise'.[17] Imprecision is, however, the principal feature reproduced in the art-historical discourse as well. In this regard, mainstream art history has functioned in a manner similar to mainstream urban sociology. 'If there has been an accelerated development of the urban thematic', writes the French sociologist Manuel Castells,

this is due very largely to its imprecision, which makes it possible to group together under this heading a whole mass of questions felt, but not understood, whose identification (as 'urban') makes them less disturbing; one can dismiss them as the natural misdeeds of the environment. In the parlance of the technocrats, the 'city' takes the place of explanation, through evidence, of the cultural transformations that one fails to (or cannot) grasp and control . . . The urban ideology is that specific ideology that sees the modes and forms of social organization as

characteristic of a phase of the evolution of society closely linked to the technico-natural conditions of human existence and, ultimately, to its environment.[18]

Imprecision in art-historical discourse about the urban cannot, then, be regarded as a mere defect in otherwise sound, if underdeveloped, views of the urban, an error that might be corrected by developing more sharply focused categories of 'city painting'. For the greater the clarity of the categories, the more successfully they obscure the fact that imprecise social analysis is the ideological heart of a discourse that defines its objects of study as, on the one hand, the city, divorced from a wider theory of society and, on the other, city painting, divorced from an understanding of the social production, determinants and effects of representation. Naturalising definitions of the city complement the discipline's notions of representations as the product of sovereign and free subjects; both are apotheosised in Urban Expressionism, the masterful subjective transformation of the city, and both name urban phenomena in terms of individual psychologistic experience.

When city painting is thus characterised as the subjective product of individual consciousnesses, the embodiment of responses to immediate appearances or felt experiences, or even as a reflection of reality, the active role these representations perform in mediating consciousness and producing meanings for the 'urban experience' is ignored. In contrast, Manfredo Tafuri, examining this role, has proposed that twentieth-century avant-garde art performed the task of inventing visual codes to embody the experience of the city freed from any awareness of the basis of that experience in the capitalist mode of production. These codes were further separated from that foundation by their deployment in autonomous art objects as the rhythm of shock embodied in successive waves of avant-garde movements followed the continual technical revolutions of industrial production. Tafuri believes this to be as true of the art of protest as of any other. 'The picture', he writes,

became a neutral field on which to project the experience of the shock suffered in the city. The problem now was that of teaching that one is not to 'suffer' that shock, but to absorb it as an inevitable condition of existence.[19]

Describing the cultural operations that encouraged adaptation to existing social circumstances, Tafuri is referring in the last sentence of this passage to the art of assemblage that succeeded the Expressionists' registration of trauma, the art that transformed shock into a 'new principle of dynamic development'.[20] But the task of mythologising the conditions of the city as inevitable was assumed in other forms by writers on Urban Expressionism who formulated the essentialist terms which have been rallied in support of contemporary German 'violent painting'. Urban Expressionism, we are told, was inaugurated through the *Brücke* artists' contact with the city of Berlin where by 1911 the major members of

the group had moved from Dresden. Its birth has been repeatedly portrayed in the following terms:

The Expressionist trend linked up with the rhythm and motoricity of the big city, bringing something new into being – Urban Expressionism ... The encounter between the Expressionism of the Brücke artists and big city life was comparable to an effervescent reaction, in which Expressionism lost its innocence. The pathos of Urban Expressionism, an emotion provoked by that mutually influential exchange reflected an accumulation of values that enhanced emotive elements and combined to generate a highly emotional aura: rhythm, dynamics, motoricity, agitation, tension, ecstasy.[21]

Confusing and vaguely conceptualised, this account nonetheless reveals the elements that make up the standard model of Urban Expressionism: the essence of the city is its 'natural' environment of dynamism, excitement and tension; this atmosphere produces an urban 'sensibility' or personality type in its inhabitants – agitated, neurasthenic, exhilarated; the heightened emotions produced in the individual are deposited on the surface of expressionist paintings in the form of seismographic heightened colour, radiating and agitated brushstrokes and energetic contours that register the individual's presence. Kirchner's street scenes have been portrayed as a 'transcription in painting of ecstatic nervousness ... like colourful stroke storms that release enormous psychic tensions'.[22]

More astute proponents of Urban Expressionism retain these principal concepts but elaborate them through 'sociological' corroboration of the existence of a universal 'urban personality'. To do so, they have frequently directed their attention to Georg Simmel's famous 1903 essay, 'The Metropolis and Mental Life'.[23] Employing this essay to furnish an explanation of human behaviour in the modern city as it is manifested in paintings, art-historical accounts isolate it from the larger body of Simmel's writings, from its philosophical context and from the developing field of twentieth-century urban sociology within which it occupies a crucial position. Through uncritical reliance on and reductive falsifications of Simmel's work, they seek to authoritatively explain and validate Expressionism. They end up perpetuating an ideology of the city and promoting a mystifying social theory in which the city figures prominently. Simmel's essay appeals to historians of Expressionism because it formulates the metropolitan situation in terms of the individual's confrontation with 'external' society, presuming individuals to be prior to the social and free in relation to themselves. Thus Simmel's analysis of urban life has been utilised to sanction the argument that all forms of Expressionism, including New York Abstract Expressionism, are necessarily urban. Painterly gestures that reveal the artist's presence are proposed as 'solutions' to the urban problem. Solutions, however, are justified by the terms in which problems are formulated. In prevailing art-historical formulations of the urban problematic, the individual struggles to resist absorption in a 'mass identity'.[24] An essential dilemma,

321

the 'urban problem' becomes a local instance of the battle posed in expressionist ideology between the individual and 'civilisation'.

Simmel's analysis of the modern city was considerably more complicated than art-historical texts reveal. It appears in those accounts already filtered through its later ideological interpretations and distortions. Simmel viewed the modern city as the locus of what he considered to be the salient characteristic of modern life: heightened tension between the free, inner life of the individual, on the one hand, and, on the other, objective culture. Objective culture comprised the complex of products and formations external to the self and objectified throughout history. This tension, Simmel asserted, was the modern form of primitive man's conflict with nature. He defined subjective culture as the domain of the individual's assimilation of the objective culture and attributed the dissonance of modern life to an increasing gap between the growth of objective culture and the cultural level of the individual. The city was the arena of this clash. Through an analysis of the mechanisms that city dwellers develop to adapt to their environment, Simmel arrived at the conclusion that the metropolis is the place of interaction between two kinds of individuality: the full expression in the individual of a 'general human quality' and a romantic unique individualism. According to his argument, the increase of external stimuli in the city intensifies emotional life. Together with the unique social relationships resulting from the concentration of large numbers of people and from the spatial distribution in the city, this intensification creates a crisis for the individual personality. But these urban features also furnish the conditions – loosened social ties and the fragmentation produced by a broadened social formation – for the full development of individualism.

Simmel's description of city life in terms of human adaptation to environmental forces passed into American urban sociology via Robert Park and Louis Wirth, leading figures of the Chicago School of Sociology. Park had attended Simmel's hugely popular Berlin lectures in 1899/1900 and his student, Wirth, subsequently described Simmel's 'Metropolis' essay as 'the most important single article on the city from the sociological standpoint'.[25] The Chicago urban sociologists developed a concept of 'urban culture' based on the perspective of human ecology, the social theory that accompanied the institutionalisation of sociology as a recognised discipline in American universities. Within this ecological perspective, forms of metropolitan social life were explained in terms of the relation of human populations to environments in which certain processes tend to remain constant and invariable. Frequently resorting to biologistic analogies, this version of ecological theory presumed that the balance of forces in any area of human habitation produced an orderly grouping of population and institutions; patterns of city growth and market forces were regularly explained through laws of competition, dominance, succession and invasion. A specific cultural content was

assigned to the city conceived as an ecological form, so that social relations became attributable to semi-natural processes and the urban problem was seen as one of social integration. In his highly influential 1938 essay, 'Urbanism as a Way of Life', Wirth formulated a concept of urbanism as a constellation of traits forming the characteristic style of life in cities. The determinants of urban culture were size, density and heterogeneity of population. Wirth's richly detailed analysis accorded in many respects with the reality of experience in the modern city, but by limiting his investigation of the sources of this experience to the three empirically observable qualities he selected, Wirth also marginalised the wider social structure and causes of the urban condition. Additionally, his concentration on demographic determinants of culture negated the determining actions of cultural processes themselves. 'In formulating a definition of the city', he warned,

it is necessary to exercise caution in order to avoid identifying urbanism as a way of life with any specific locally or historically conditioned cultural influences which, while they may significantly affect the specific character of the community are not the essential determinants of its character as a city. It is particularly important to call attention to the danger of confusing urbanism with industrialism and modern capitalism ... Different as the cities of earlier epochs may have been by virtue of their development in a pre-industrial and precapitalistic order from the great cities of today, they were, nevertheless, cities.[26]

Absorbing in a particularly reductive form the concepts that dominated, until recently, major sociological thought on the urban, social historians of Urban Expressionism have consistently, if unknowingly, heeded Wirth's cautionary advice. Even as those working in the field of urban studies have complicated the ecological legacy of environmental determinism or abandoned the model altogether, art discourse continues to accept as given ahistorical determinants of urban relations and, consequently, to disengage the city from its historical context entirely. Positing a social content to the city considered as a transhistorical form – generally viewing the modern city as the result of a necessary technological progression – it has perpetuated beliefs in the ultimately individuating aspects of anonymous city life and a resulting 'urban personality'. Centred on its exacerbated individualism, this metropolitan type provides the discipline with pseudosociological support for the idealist notion of the artistic subject posed in the expressionist model of art production.

Since the late 1960s, however, interdisciplinary studies have reposed the urban problem, fundamentally transforming what is understood as 'the urban'. Numerous critiques of the dominant schools of urban sociology and urban planning preceded alternative theorisations that discard functionalism and place the urban system within the wider social structure. These new and varied formulations cannot be summarised here. Of overarching importance, however, is their insistence on the *political*, rather than *essential*, character of spatial organisation. They

presuppose the existence of historical users of the city rather than abstract urban personality types. In the field of political economy, the city has been studied as the locus of reproduction of labour power, of production and consumption. Tendencies within Marxist thought, where urbanisation formerly occupied a peripheral position, have attempted to define the urban question in relation to struggles over the quality of everyday life, the role of the production of space in ensuring the survival of capitalism, or the heightened contradictions between social consumption and the form of production. Common to these and other approaches to the city is the refusal of empiricist notions of social relations generated by given or necessary spatial forms and the exploration, instead, of what Henri Lefebvre called the social production of space. Today, space is understood as produced and meaningful.

Attention to the politics of urban space was stimulated in part by ghetto uprisings in the cities of the United States and by the growth of urban social movements as an important factor contributing to the events of 1968 in European cities. Chronologically, it coincided with attention by artists to the politics of aesthetic space, and with the development of art practices that explored the material conditions of art production. At this time, artists began to call attention to and intervene in the power relations structuring their work's spatial and discursive sites, thus radicalising the perceptual focus of earlier contextual art. Without wishing to posit any necessary connection between these two developments, one can observe that 'new vehemence' painting and the cultural apparatus that validated it performed a reactionary function in relation to both. In the artistic sphere, they reasserted aestheticist ideals of art's autonomy and transcendence. And, immediately following the development of new forms of urban social conflict in Berlin, they intensified talk of the 'urban' in a form that repressed its political implications. Aspiring to 'express' the urban experience, they launched a veritable offensive against understanding it by producing an iconography of the city as a scene of 'primal' conflicts in paintings promoted as self-expression. The city was constructed as a universal, timeless place where archaic rituals are enacted and where 'the unifying element is the self'.[27] This regression to urban ideology is only one aspect of a more comprehensive retreat from historical inquiry that characterises neoexpressionism, a retreat fequently articulated in a language of historical investigation and, further, clothed in the attractions of historical 'justice'. Recourse to 'urbanism' to glorify 'violent painting', for example, parallels the contention that other German painters are symbolically confronting the problematic weight of German culture and expiating the Nazi past. 'The new German painters', we are told,

perform an extraordinary service for the German people. They lay to rest the ghosts – profound as only the monstrous can be – of German style, culture, and history, so that the people can be authentically new. They are collectively given the mythical opportunity to create a fresh identity.[28]

Neoexpressionists offer this opportunity by ignoring the present historical conjuncture and mystifying the past through the claim that art's redemptive power can transform history. Exploring, in another context, the meaning of this concept of 'working through the past', Gertrud Koch has identified, following Adorno, the operations of such mystification – 'the process of converting fascism and Nazism into myth, which began in the mid 1970s'. 'Part of this re-modelling of reality is the extinguishing of concrete memories ... and the displacement of these memories by mythic re-interpretations.'[29]

Shifting between past and present, critics have, in this manner, linked Moritzplatz painting to Kirchner's street scenes by scorning changed historical conditions between Kirchner's Berlin and the present cold-war city. A recent article in a German magazine typifies this suppression of difference:

No city has more right to talk about paintings because there the tradition of painting was never interrupted even when the word 'painting' seemed to vanish from art history. The reason is that Berlin provides a theme for painting – the urban situation.[30]

The subject of this article is, however, a very specific 'urban situation' – the Kreuzberg section of West Berlin. And while the author views it as an unchanging painterly theme – an 'expressionist city' – the contemporary context of Moritzplatz painting differs substantially from the Berlin of Kirchner's day. According to numerous art publications Kreuzberg possesses three main attractions: inexpensive rents for large studio spaces; a tension-filled atmosphere and desolate surroundings that inspire an artistic retreat to an 'internal' world of images; and an environment of anonymity that is liberating for the individual. Blatantly exploiting Kreuzberg as an exciting environment for artists for whom the world serves as a backdrop, this article exemplifies a disturbing tendency in the international art press to romanticise impoverished urban neighbourhoods.[31]

Apologists for violent painting display this exploitation most flagrantly not when they ignore Kreuzberg's social problems but when they cite them in order to weave them imperceptibly into the fabric of the neoexpressionist *Zeitgeist*. Wolfgang Max Faust, for example, in one of his numerous tributes to Berlin's painters, lists 'minorities' and the 'latent violence produced by the concrete disasters of public housing' among the painters' 'big-city' subjects.[32] Certain aspects of the Kreuzberg environment are routinely noted by writers on the Moritzplatz group to prove the art's social significance: Kreuzberg is in direct proximity to the Berlin Wall; it is the home of the majority of Turkish *Gastarbeiter* in West Berlin; and it has been the scene of intense conflict between an official urban renewal policy and alternative movements such as the squatters. The historical situation of contemporary Kreuzberg, then, includes the Cold War and increasing militarism, and its historical urban condition consists of rampant real-estate speculation, vast unemployment and the

325

social and political problems raised in the capitalist centre by its imperialist policies in the Third World.

Kreuzberg houses one-third of Berlin's foreign workers, mostly Turks, who comprise thirteen per cent of West Berlin's population. The current group of foreign workers was first actively recruited by the West German Federal Labour Office in the mid-1950s when Germany had exhausted its own post-war industrial reserve army and tapped the latent surplus population of southern Europe and, later, Eurasia for labour to fuel the 'economic miracle'.[33] The official guest-worker system was, from its inception, an institutionalised programme of discrimination, attempting to force the foreign workers to remain mobile, temporary and silent. Nonetheless, the import of foreign labour created a new population of permanent ethnic minorities in West Germany who are now, in a period of economic crisis, the target of government attempts to repatriate them and assaults by right-wing parties who make useful scapegoats of them as the cause of Germany's present economic ills. Strikingly underrepresented in the developing service sector, these workers are now largely dispensable, facilitating the attempt to export unemployment and social problems by expelling 'foreigners'.

Not surprisingly, *Gastarbeiter* are subject to discrimination in housing and tend to live in the worst inner-city conditions. Left predominantly to housing-market forces, their pressing needs are manipulated by speculating landlords. In Kreuzberg, for example, when landlords abandoned buildings, stopped services and forced out tenants in the hope of reaping profits from future reconstruction projects, they could easily rent underserviced apartments to Turkish foreign workers desperate to find temporary quarters anywhere. This desperation is in part engendered by government regulations that have frequently made the right of foreign workers to bring their families to West Germany contingent on the worker's ability to provide adequate housing. The complex housing situation in West Berlin that takes advantage of foreign workers also produced in 1979 the squatters movement – organised groups of people occupying abandoned buildings and co-operatively putting them into working order as an alternative to official reconstruction and profitable luxury modernisation. Squatters, forming self-help networks and tenants' rights offices, also protested the City Senate's plans to tear down housing and proposed that public funds be allocated to tenants to restore buildings instead of to landlords. Thus, the squatters implicitly defined the terms of the housing problem differently than they were generally posed in official urban renewal debates. Whereas these debates centred around the use of existing building stock as opposed to new development, the squatters reinserted this controversy into the context of the city's social structure, challenging the rights of privately owned real estate and the allegiances of the state in allocating urban resources. Their actions called attention to the fact that questions of architecture and urban space

are always already politicised issues. In 1981, the squatters' movement reached its height when the police forcibly evicted the occupiers in violent confrontations.

No doubt Faust is referring to guest-workers and squatters when he identifies minorities and the violence of housing struggles as two of Moritzplatz painting's urban subjects. But in what sense can they be claimed as the subject of this work? We can only presume that Faust believes that the standard expressionist stylistic and iconographic signifiers of violent metropolitan *emotion* – visible painterly gestures, glaring colour, angular forms, frenzied figures, anxious expressions, crowded canvases – adequately respond to and reflect social violence. The assumption that the expression of emotion is itself an inherent 'big-city subject' returns us to the basic formulations of Urban Expressionism. It cynically capitalises on real urban problems while suggesting that violence is intrinsic to the city landscape. Faust's laudatory attitude toward the artists' images of minorities contains more sinister implications. For in the midst of conditions produced by an episode of imperialist exploitation, the new vehemence painters produce images of foreigners that resurrect the most predictable codes of early twentieth-century primitivism whose relation to modern imperialism has been excavated in some of the most important recent art criticism. Numerous paintings exploit Third World peoples as fantasy images for sensuous identification by western artists and viewers; Fetting's self-portraits as a semi-nude Indian conflate the self with the Other in order to revolt against sexual 'repression'. Such outdated exoticism and chauvinism in coded representations ultimately subjugate foreign cultures as images mirroring the painters' own regressions.

It is, however, the most exceptional feature of Berlin's specific urban landscape – the Berlin Wall and divided city – that figures most prominently in Moritzplatz paintings and in apologies for this work where it is converted into the expression of a universal condition. The Wall is most frequently manipulated, as in the group's emblem, *Van Gogh and the Wall*, as a metaphor for a spiritual situation – the heroic disease of artistic alienation – just as the physical amputation of Berlin serves as a metaphor for nineteenth-century notions of the artist's romantic isolation. The Wall thus emerges as a symbol of a psychosociological view of urban life: the division it produces is described in terms that transform it into a concrete embodiment of the schizoid character of the 'urban personality' or of the urban segmentation of social relations. Perceived as essential, rather than historical, these divisions can only be overcome in redemptive artworks.

Recently, to supplement their iconographic renderings, Berlin neoexpressionists, along with visiting artists, have painted directly on the Wall. This activity has engendered commentaries that intersect with more significant issues about art and contemporary urban politics. One precise

point of intersection is the contested terrain of site-specific art practice. Initiated in 1982 by Johnathan Borofsky's *Running Man* executed during the *Zeitgeist* exhibition, these paintings by professional artists are confined to the section of the Wall where the institutionalised artworld is concentrated – between the Martin-Gropius-Bau and the Künstlerhaus Bethanien. Having gained notoriety in the mass media, they were described last year in *Art in America* as 'predominantly Neo-Expressionist', 'extraordinary political statements' and 'site-specific artworks'.[34] Another critic has also characterised Borofsky's paintings as 'site-specific installations' and nominated them for the position of exemplary public art.[35] Precisely because they fit so securely within the conventional parameters of neoexpressionism, however, the Wall paintings fail to confront the political nature of their site or to politicise art practice itself. Instead, they participate in the current backlash against the critical concerns that motivated site-specific practice in the first place. Although it has been claimed that the wall paintings are so unique that they 'cannot be separated either visually or emotionally from past and present history' in Berlin,[36] the principal content embedded in these images of generic figures and New York style graffiti is individual authorship manifested in a signature image. Therefore, they produce no analysis of the specificities of their site but, rather, efface them.

The designation of these works as 'site-specific' and as public art participates in a prevalent tendency to trivialise both concepts by either reducing them to the status of an artistic style or collapsing their concerns into those of populism or functionalism.[37] To resist this depoliticisation and restore site-specificity to the position of a critical practice and, more importantly, to radicalise it in accordance with new circumstances it is necessary, as Douglas Crimp has recently attempted, to redefine it.[38] Crimp examined site-specificity in relation to the controversies surrounding Richard Serra's public sculptures, particularly those located in Bochum, West Germany and in the Federal Plaza in New York City. No matter how one feels about Serra's work as public art or whatever one's juridical opinion on the fate of *Tilted Arc*, it is nonetheless necessary to shift the conventional terms of debate to higher ground. Whereas the available positions on Serra's public work are usually represented as, on the one hand, support of artistic freedom and, on the other, responsiveness to the 'will of the people', Crimp situated Serra's production within a consideration of the ideology of the public and the role of modern public sculpture as it has developed in bourgeois society. In the course of his argument, he traces a history of the evolution of site-specificity beginning with its introduction into contemporary art by minimalist artists in the 1960s as a materialist critique of the idealism embodied in 'formalist' notions of the autonomy of the artwork. Minimalists conducted this critique by directing attention to the context of the art object and to the contingency of perceptual experience. Yet the minimalist project of

incorporating 'the place within the domain of the work's perception succeeded', according to Crimp, 'only in extending art's idealism to its surrounding site. Site was understood as specific only in a formal sense; it was thus abstracted, aestheticized.'[39] The historical context of modern art's existence within a specific system of production was still masked. Later, and in diverse ways, artists extended the notion of the site to incorporate the material conditions of art's production and circulation. They examined the art object's institutional framing conditions whose apprehension had been blocked by prevailing ideologies of aesthetic autonomy or by the assimilation of all art to a universal tradition and ontological essence. Some artists analysed the social and political character of the site, intervened directly in institutional environments and in other aspects of the discursive formation that constitutes the space of the artwork. Attention to contextual specificity by figures as different as Daniel Buren, Louise Lawler, Hans Haacke and Babara Kruger contained at least one common imperative: the desire to talk about institutions instead of simply using them and, in so doing, to alter rather than affirm the sites of artistic display. These artists attempted to perceive the meaning of institutions as interested and *particular* – phallocentric, western, capitalist – rather than universal and transcendent. Similarly they appealed to an actual, historically positioned spectator rather than attempting to construct an abstract viewing subject. Artists engaged in producing a critical *public* art also addressed mechanisms of power as they are exercised through notions of a universal public sphere. Their work sought to restore the ability to perceive the conflicts and contradictions that divide the public site, the relations of power disavowed by attempts to conjure up a coherent public realm.

Despite these developments in site-specific public art, it has become increasingly common to hear from journalists and critics that art created to decorate government buildings is, by definition, socially committed or that works located in the plazas of corporate headquarters automatically qualify as public art. Such assessments frequently invoke the platitude that art existing outside standard art institutions is 'democratic' and accessible while that inside these spaces remains private and 'elitist'. Art that performs a function, such as providing seats or lunch tables for office workers in the city, is singled out for special commendation while the actual functionalism of this 'new public art' – its role in glamourising corporate images, promoting real-estate ventures, and censoring the meaning of urban development – is unexamined because its city sites are fetishised as physical rather than social spaces. Such work is site-specific only as an affirmation and justification of those spaces. Much of this 'public' art simply transfers the dominant discourses that circulate inside the museum to a sphere outside its walls. The painting on the Berlin Wall is merely one example. Celebrating the 'masterful' transformation of reality by individualists, it remains strictly inside museological discourse.

17.7 Hans Haacke, oil
painting from *Broadness
and Diversity of the Ludwig
Brigade*, 1984

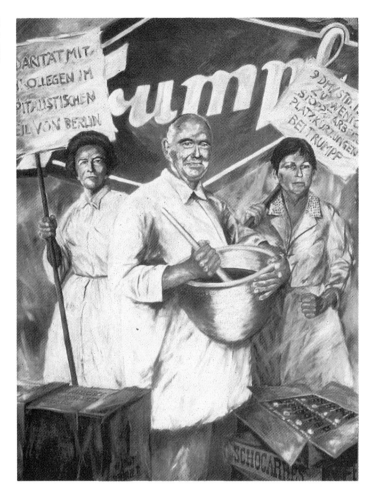

The inclusion of this work under the rubric of site-specificity represents
an appropriation of radical language to bolster the pretensions of work
that withdraws into an imaginary, private realm of timeless meanings,
psychological indeterminacy and self-expression. Through these tactics it
attempts to transform its highly specific site into a universal one and
presents itself as an act of spiritual transcendence of the Wall's divisions.

Critical site-specific art, in contrast, investigates the intersection
between two material processes: the social production of the site and the
social production of aesthetic perception. Refusing universalising pro-
nouncements, Hans Haacke's installation, *The Broadness and Diversity
of the Ludwig Brigade* (1984) (plates 17.6, 17.7 and 17.8), to which I
referred at the beginning of this essay, defines its Berlin location as a social
site and simultaneously addresses the politicised space of representational
economies. Against aesthetic conceptions of the Berlin Wall as a structure

17.8 Hans Haacke,
billboard from *Broadness
and Diversity of the Ludwig
Brigade*, 1984

dividing isolated realms and symbolising mythical oppositions, Haacke's work explores the dialectic between the Wall's dividing and connecting functions. It investigates the interdependencies of the two power blocks supposedly confined on either side of the barrier. Consequently, the 'Ludwig Brigade' repudiates the doctrine of imaginary transcendence of the Wall's divisions by making visible the frightening similarities that already exist and the concrete unity evaporated by spiritual visions of wholeness. Whereas the 'new German painters' claim that their work spiritually heals symbolic breaches, it is in fact aesthetic practices such as Haacke's that surmount barriers – the ideological boundaries drawn around phenomena which thereby preserve an aspect of autonomy while they are structurally related. But far from positing a set of abstract or generalised interdependencies, Haacke's concerns in the Ludwig project are historically specific. Like most of the artist's work, *The Broadness and Diversity of the Ludwig Brigade* explores interrelations between on the one hand, art and on the other, economic and political power. And like many of Haacke's installations, it does so in a format that juxtaposes two kinds of information that normally occupy distinct institutional or discursive realms. This binary structure furthers Haacke's goal of unveiling contradictions in a variety of situations. It is, however, especially resonant in Berlin where it replicates the city's physical and ideological landscape – the confrontation of the two Germanies across the Wall. For the context of the Ludwig piece is a historical scene not only of self-evident ruptures but of concealed interconnections: East and West Germany are propagandistically defined in relation to each other; the Cold War is used to ensure internal political control in both countries; and the autonomy of a socialist economy is highly relative in a restructured system of global capital and 'joint ventures'.

Mounted at the Künstlerhaus Bethanien, a gallery in Kreuzberg located near the Berlin Wall, *The Broadness and Diversity of the Ludwig Brigade* incorporates the Berlin fortification into a work that, as Walter Grass-kamp has written, 'probes with emblematic precision the cultural, political and economic import' of its subject.[40] In addition to addressing the symbolic meanings of its physical site, Haacke's exhibition coincided with a particular event: a West Berlin exhibition, first organised in Oberhausen, of Peter Ludwig's collection of East German art. The exhibition was jointly sponsored by the State Art Trading Agency of the GDR and the Ludwig Institute for Art of the GDR. Under the title, *Durchblick* (Seeing through), the Oberhausen show cast Ludwig as a generous mediator between the two German states, overcoming years of separation. Just as the new German painters claim to reconcile oppo-sitions by artistic means, so Ludwig projects an image of himself as orchestrator of cultural unification. Haacke's concurrent installation materialised out of scrupulous research into the precise nature of Ludwig's border-crossing. It examines the workings of the Leonard Monheim Corporation in which Ludwig serves as chairman and whose Trumpf chocolate products are produced in West Berlin and, through special agreements, in East Germany.[41] It also focuses on The Ludwig Institute for Art and International Understanding which, among other ventures, promotes and purchases East German art. The interface between Ludwig's economic and cultural exchanges form the content of Haacke's work which arose from the artist's attempt to trace the myriad elements dispersed throughout a complicated mechanism of economic, political and cultural power. In the subject of Ludwig's operations Haacke concentrated an intricate web of issues: the extent to which western multinationals control the world economy; the access of such companies to profitable markets in socialist countries; the collaboration of 'actually existing socialism' with a global structure of power relations; exploitative working conditions in eastern and western Europe; and the legitimating function of cultural institutions in contemporary political régimes.

On either side of a tall barrier which bisected the gallery, simulating the division of Berlin by the Wall, Haacke counterposed two representational systems – one embodied in an unaltered western advertising poster appropriated from the Leonard Monheim Corporation and the other in an original oil painting. The painting portrays Ludwig outfitted like an old-fashioned chocolate dealer and positioned between two women who carry picket signs protesting specific instances of Monheim's exploitation of workers – unemployment due to automatisation of the Trumpf plant in West Germany and the low wages in East Germany that help expand the company's profits. Monheim's chairman Ludwig presides over the image from beneath a rendering of the red and white, diamond-shaped logo for Trumpf chocolates. The word 'Trumpf', translated in English as 'trump'

and semantically and phonetically akin, in both languages, to 'triumph', unfurls like a banner across the top of the canvas. This word, like other stylistic and iconographic components of the work, generates multiple associations. Hieratically composed so that it suggests the arrangement of symbols on a playing card, the painting in fact plays on the word 'trump'. To a viewer who reads all elements of the painting in relation to each other and also to the entire installation, Ludwig's interests – the interests of capital – ultimately appear to rank, like a trump card, above all others. His cultural alliances with the east, instead of beneficent acts or proofs of artistic cultivation, emerge as powerful moves in a winning strategy of economic domination. Centred beneath the logo of a private multinational, but holding a container inscribed 'People's Owned Enterprise, Candy Factory of Dresden', the figure of Ludwig blending ingredients in his bowl literalises the interdependencies of systems that represent themselves as economic alternatives. And dressed as an old-fashioned confectioner (the posture is modelled after a 1928 photograph by August Sander) while assuming a place at the head of a workers' brigade, the smiling leader of Leonard Monheim appears trumped up in conflated guises as a good fellow – representative of German tradition, friend of the people and the nation's cultural benefactor. A group of inscriptions strategically deployed throughout the painting designates links between various public and private, cultural and business, corporate and state enterprises.

Similarly, Haacke's meticulously designed 'montage' blends together artistic styles associated with the two German states. It mimics the conventions of Soviet-style socialist realism and alludes to agitprop posters. Yet the loose gestural paint surface connotes the recent 'loosening' of artistic prescriptions in the East German art establishment's current era of 'broadness and diversity'. Parodying sloganeering pronouncements by eastern bloc governments on art's political functions and offsetting such rhetoric with its own militant content, the painting points to the lack of criticism of state policy in official – supposedly 'broad and diverse' – 'socialist' art. Haacke's critique emerges with its fullest force when his painting is seen next to the photographic source he used for the portrait of Ludwig. Taken at the first exhibition of Ludwig's collection of East German art, this image depicts Ludwig standing with Bernhard Heisig, a powerful member of the Artists Association of the GDR. Behind them is Heisig's own ingratiating painting of Ludwig. As the literal background for a cultural meeting of the two Germanies, Heisig's canvas – as distant as possible from a critique of either East German government policy or of the western 'class enemy' – exemplifies the obedience of East German art organisations to the desires of the state. 'Actually existing socialist art' depends on what Grasskamp labels 'politico-economic calculations at higher levels'.[42] The thick paint and agitated surface of Heisig's painting, qualities associated with artistic 'freedom', ironically underscore this restrictiveness which directly serves Ludwig's interests.

Since it is most familiar to us as a symptom of the neoexpressionist revival in West Berlin, such painterly painting elicits speculation about further similarities between the two Germanies. On both sides of the Wall gestural brushwork is promoted as a sign of loosened repression while supporting, in different ways, existing systems of power. Privileged signifier in bourgeois artistic codes of spontaneity and individual freedom, it accompanies in western art a resurrection of the prestige of the oil medium. In a statement that could serve as an enlightening caption to the photograph of Ludwig, Heisig and Heisig's painting, Haacke has commented on the correspondence between the aura of oil painting and that of political power:

> the medium as such has a particular meaning. It is almost synonymous with what is popularly viewed as Art – art with a capital A – with all the glory, the piety, and the authority that it commands. Since politicians and businesses alike present themselves to the folks as if they were surrounded by halos, there are similarities between the medium and my subjects.[43]

Haacke's own painting of Ludwig strategically employs loose brushwork and is also executed in oil. Situated in a West Berlin gallery as part of an installation about the cultural legitimation of power relations, this choice of style and medium evokes two readings. Primarily, it indicates the validating function of approved East German art but it alludes as well to a complimentary role performed by the official celebration of self-absorbed romantic individualism in the art of the west.

Indeed, Ludwig's interests are advanced not only by East German cultural authorities but also by the aestheticist ideas informing the new West German painting, which, not surprisingly, the industrialist also collects. Ludwig's image as unifier of Germany through cultural exchange can only compel belief if one presupposes that art is transhistorical, severed from the material conditions of its production. Enforcing distinctions between cultural and other levels of the social formation, and concealing the social relations of art itself, this assumption, embodied in the return to painting also permits Ludwig to transpose his financial interests into cultural ones. Neoexpressionist notions that the act of unification is a spiritual operation independent of action in the real world also support assertions that Ludwig is 'seeing through' the Wall. They ignore, however, the identity of those forces which, protected by the alibi of art, benefit from such penetration. It is precisely this dissociative mechanism that Haacke's work 'sees through'. In *The Broadness and Diversity of the Ludwig Brigade*, this moment of perception is the enabling act that allows the viewer to develop a politicised vision, one which discerns the connections between the poles of false dualisms and which erodes the mystifying form of their appearance as discrete entities. For Haacke's installation invites its audience to consider relationships beyond those delineated in the painting of Ludwig. It asks them to extend their observations to encompass the correlations between the painting

and the Trumpf advertisement hung on the opposite wall. Placing the viewer in a space divided between the two pictures so that she becomes the producer of the work's meaning rather than consumer of the pictures' products, it challenges the committed spectator to unravel a complicated and secretive web of contacts between East and West Germany. But it also raises questions about the affiliations between the representational codes of the two images and between the operations of state-controlled art in the east and corporate-controlled art in the west. These reflections require viewers to rejoin connections that exist not only between two political systems, two Ludwig factories or even between Ludwig's cultural and economic activities. Viewers must also decipher the concrete relations existing between the aesthetic and political domains, relations severed on the register of everyday appearances and in idealist aesthetic thought. In this respect, the physical splitting of the gallery and the movement it demands if one is to scrutinise the complete work, is emblematic. For the political mobilisation of the viewer that it encourages constitutes one of the most significant differences between academic site-specificity and Haacke's contextualist practice. Because it addresses the collaboration between business interests and cultural organisations, Haacke's installation directs attention to its aesthetic site. Insofar as it assembles representational elements that mediate experience, transforms and juxtaposes them so as to interrupt the smooth transmission of their messages, the work intervenes in the discursive institutions of representation. And to the extent that it articulates the place of representations in a concrete network of oppressive social relations, the work also intervenes in its broader site – the political climate of contemporary Berlin.

How might an expanded comprehension of art's social sites pertain

when the urban process is the specific object of aesthetic inquiry? One answer can be sought in a project by Louise Lawler installed in May 1985 in a gallery located on New York's Lower East Side (plate 17.9). Like Kreuzberg in Berlin, the Lower East Side is currently the setting of what the media calls an 'artistic renaissance'.[44] And like the Ludwig Foundation for Art and International Understanding, the 'East Village art scene' helps produce an atmosphere favourable to the interests of big capital. The Lower East Side is presently in the throes of gentrification, a process prevalent in many United States cities; it therefore exemplifies the abandonment by the Reagan state of urban reform, an abandonment officially promulgated as an 'urban renaissance'.[45] Producing a change in the class composition of central city neighbourhoods, gentrification replaces poor residents with members of the upper-middle class. In so doing it performs crucial, if contradictory, functions in restructuring the late capitalist economy. Creating the material conditions to reproduce the new white-collar labour force, it destroys housing and services for a traditional working class that once held jobs in the city's quickly declining manufacturing industries. The displacement it precipitates has generated a crisis of survival for the redundant group, a crisis manifested in the tens of thousands of homeless people living on New York's streets. The full implications of the phenomena can only be comprehended if it is understood as part of a broader attack on working-class living standards – cutbacks in social services and relatively lower wages. But gentrification also fulfils another important need for overaccumulated capital, expediting its flight from sectors where profits are falling to inflated areas such as investment in the built environment. The Lower East Side, then, an urban space whose dominant function was once to reproduce a working-class community has become the 'East Village', a neighbourhood defined as a spatial product of the real-estate market.

As part of the unique packaging of this commodity, the new commercial art scene, emerging in its full outlines by 1983, helped facilitate gentrification. The physical preconditions had been prepared years in advance by the abandonment or neglect of the area's existing housing stock and consequent devalorisation of real-estate values. When galleries and artists, assuming the task of the proverbial 'shock-troops' of gentrification, moved into inexpensive storefronts and apartments, they aided the mechanism by driving up rents and displacing residents. Numerous art journals, catalogues, videotapes and museum exhibitions circulated images of the neighbourhood which, like artworld representations of Kreuzberg, transform poverty and 'urban decay' into the ingredients of a romantic Bohemia permitting the unrestrained growth of individual freedom. Similarly, the art originally packaged under the East Village label and promoted by East Village 'critics' wholeheartedly embraced the expressionist revival. It consisted largely of paintings embodying a return to the artistic goal of liberation through self-expressive, autonomous artworks.

Louise Lawler, however, belongs to that group of artists who continue to insist on the historical contingency and collective nature of aesthetic meaning. Her works force attention to the material conditions, social environments and discourses of aesthetic display and to the functions of art in contemporary social relations. To do so, they include their own exhibition context as part of their material. Frequently locating her projects in the network of equipment rallied by the cultural apparatus to legitimate and position art objects – using gallery invitations, installation photographs, press releases, wall labels, etc. – Lawler disturbs notions of artistic autonomy and stable aesthetic meanings by employing elements of the framing apparatus to question its own authoritative claims to truth-value. She effectively uses these material forms as both targets and weapons. Her gallery installations, as one critic succinctly put it, concentrate on presenting the gallery 'rather than being passively presented by it'.[46]

When Lawler presented an East Village gallery, she altered it 'to infer', as she explained in the show's press release, 'another kind of space, one that is redolent with the institutionalisation of self-interest, where money gets money' (see plate 17.10). Transforming the interior to resemble a bank lobby, she painted the walls with a commercial style supergraphic and employed corporate typography to stencil the 'logo', INTEREST-ING, on the gallery's rear partition. Segmented by the edge of a green

17.11 Louise Lawler, photograph from *Interesting* 1985

stripe that bisected the wall, the smaller word INTEREST became the installation's *leitmotif*. By converting the space in this way, Lawler did not naively equate the art gallery with the financial institution as a principal actor in the housing market on the Lower East Side. Nor did she simplistically inform her audience that galleries deal in commodities. She *did* attempt to intervene in the dominant production of meanings that takes place within East Village galleries and the broader validating structure of the art world. Whereas these institutions deflect interest from the role they are playing in urban social conditions, Lawler's installation confronts that function; first calling attention to the gallery itself and then infiltrating it with connotations of the real-estate, housing and art markets framing it. The word INTEREST resonated in the redesigned space with implications of self-interest and the financial interests represented by the East Village art scene. It also hinted at the acquiescence of that scene in the activities of still more powerful economic interests.

With trenchant humour, Lawler also commented on the relation between resurgent aestheticist ideologies and contemporary urban reality. On one side of the gallery she placed a counter similar to those where bank customers prepare their transactions. In place of withdrawal and deposit slips, this counter held press releases referring to the exhibition's urban context and to the art scene's 'use and abuse' of the Lower East Side neighbourhood. Across the room, Lawler hung three Cibachrome photographs accompanied by a wall text employing the layout and typography of museum labels (plates 17.11, 17.12 and 17.13). Instead of providing a pedigree for an artwork, however, this label related an Aesop's fable. And just as museum labels attempt to definitively fix the meaning of art objects, the fable concluded, conventionally, with a moral that imposes constraints on the text's plurality of meanings. This fable, concerning the

wages of greed, narrates the adventures of a dog who carries a piece of meat in his mouth. Crossing a bridge, he is tricked by his reflection in the water below so that he opens his jaws to snatch the meat he thinks he sees there and drops his own food into the water. Confused by an illusory image of himself, he loses his grip on reality.

Like the animals in the fable, the inanimate object in Lawler's photographs can also be used to tell a tale. This story, too, alludes to the consequences of illusions about the self. The object is dramatically lit against rich, deeply saturated monochromatic backgrounds and in the installation the photographs were framed and matted like valuable art photography. The photographed object itself, however, is far from a precious commodity. It is, instead, an inexpensive Japanese toy called the Gaiking Bazoler. A mechanistic and aggressive little creature, the Gaiking Bazoler wears an exaggerated and cartoon-style facial expression that can be minimally altered by attaching different noses selected from a supply of standardised parts. Or it can be viewed from a limited number of angles. Lawler had photographed the Gaiking Bazolers before her East Village show but since her work argues against the contention that immutable meanings reside *inside* self-contained artworks, she continually reuses pictures in contexts that alter their meanings. In this installation, the sham

339

17.13 Louise Lawler, wall
text from *Interesting* 1985

Aesop

The Dog and His Shadow

Translation adopted from William Caxton, 1484.

In time past was a dog that went over a bridge, and held in his
mouth a piece of meat, and as he passed over the bridge, he
perceived and saw the shadow of himself and of his piece of meat
within the water. And he, thinking that it was another piece of
meat, forthwith thought to take it. And as he opened his mouth,
the piece of meat fell into the water, and thus he lost it.

He that desires to have another man's good often loses
his own.

ferocity of the commercial novelties, displaying their 'individual' expressions, functioned as spoofs of East Village art, a commodified and childish Expressionism which strains after effects as it repeats habitual gestures. Lawler's own photographic blowups and over-elaborate handling of the Gaiking Bazolers utilised the seductive techniques of both commercial photography and auratic artistic presentation. Her treatment mimicked the hyperbolic manner in which pseudoexpressionist products and the East Village art scene itself are artificially inflated by the marketplace and propped up by an art discourse that espouses transcendent values while capitulating to the conditions of the culture industry. The photographs represent, in Lawler's words, an 'expressionism that has "rolled-over".' Lawler's parodic re-enactment of this inflationary procedure and her deployment of the Gaiking Bazolers in the East Village installation emphatically deflate the pretensions of such work. But re-presented in this chapter in order to supplement, rather than supplant, its original critique, the INTERESTING exhibition also deflates the claim that recycled Expressionism confronts the realities of the urban situation. For as Lawler's (de)fetishised objects remind us, in the context of devastation on New York's Lower East Side, solipsistic exercises in bombastic self-expression – products of the illusory 'urban personality' – gloss over the true sources of urban brutality – the concrete politics of space. They can only serve those powerful interests whose presence in our cities we have every reason to fear.

(1985)

Notes

GENERAL INTRODUCTION

1 *German art in the 20th century 1905–1985*, London, Royal Academy of Arts; Munich, Prestel Verlag, 1985.
2 Theodor Adorno, 'What is German?' Trans. T. Levin, *New German Critique*, 38, (1985).
3 For a particularly helpful and subtly differentiated effort at the problematisation of such historiographical discourses see Geoff Eley and David Blackburn, *The peculiarities of German history*, Oxford, 1984.
4 I am extremely grateful to Charles Maier who has allowed me to read the manuscript of his forthcoming book on the subject: *The unmasterable past – history, holocaust and German national identity*, Cambridge MA. I have relied heavily on his lucid and useful summaries of the main arguments of this debate.
5 Charles Maier, *The unmasterable Past*.

I INTRODUCTION – AGAINST THE CLICHÉ

1 See the exhibition catalogue, *1945–1985, Kunst in der Bundesrepublik Deutschland*, Nationalgalerie, Berlin, 1985, p. 18. Honisch does refer to Uecker, Graubner, and Richter when he uses the word *Eigenwert* (self-value), but he clearly gives his statement a general (and thus falsifying) character. What could have convinced the exhibitors to shift the birth date of the Federal Republic of Germany – it was constituted in 1949 – to 1945 remains a mystery.
2 Joachimides in the exhibition catalogue, *German art in the 20th century*, p. 12: 'Germany's cultural heritage, governed by an expressive vision and by a feeling for the world marked by Romanticism'. This derivation is even questionable if one adheres to the thesis of the exclusive expressivity in the twentieth century.
3 *German Art in the 20th century*, p. 18. Rosenthal does justifiably refer to irrational elements within the theories of the Bauhaus, but it is certainly not possible to state that this attempt to integrate the irrational was the dominant trait. But if Rosenthal's theory is correct, it becomes all the more difficult to understand why he begrudged the Bauhaus its amount of space in the exhibition.
4 Anthony Pevsner, *The Englishness of English Art*, London, 1956.
5 Werner Haftmann, *Malerei im 20. Jahrhundert*, Munich, 1954, p. 432: 'Especially Germany ... no longer appeared capable of any artistic efforts ... This so obviously visible lethal element ... strongly supported ... the always present tendency to flee. A complete literature of cultural criticism came into being ... that advised ... to retract all of the modern efforts in general and to

return to old, safe positions. Agreement on these was quickly reached. They were: Christianity, humanism, democracy.' Haftmann states in several places that his understanding of 'humanism' was specifically directed towards the Greek and Roman antiquity. Some more aspects of this topic are discussed in my essay; 'Humanismus und Primitivismus, Probleme früher deutscher Nachkriegskunst', *Jahrbuch des Zentralinstituts für Kunstgeschichte*, 3 (1988) pp. 290–320.

6 See my discussion of the exhibition *Symboles et Réalités. La peinture allemande 1848–1905* (Musée du Petit-Palais, Paris 1984/85), in *Gazette des Beaux-Arts*, Chronique des Arts, April 1985.

7 Exhibition catalogue, *Dreimal Deutschland. Lenbach, Liebermann, Kollwitz*, Hamburger Kunsthalle, 1981/2.

8 Rosenthal in exhibition catalogue, *German Art in the 20th century* p. 20: 'Adorno is reputed to have said that after Auschwitz it was impossible for poetry ever again to be written.' Adorno's authentic statement can be found in: *Gesammelte Schriften*, 10/1, Frankfurt, 1977, p. 30: 'Cultural criticism finds itself confronted with the last stage of the dialectics of culture and barbarism: to write a poem after Auschwitz is barbaric . . . The critical spirit is no match for absolute objectification as long as it remains with itself in self-sufficient contemplation.'

9 *Herzensergießungen eines kunstliebenden Klosterbruders* (1797) is the title of a romantic text by Heinrich Wackenroder. I am alluding to it because the exhibitors are claiming a continuity from German romanticism to expressionism.

10 Wolfgang Fritz Haug, *Der hilflose Antifaschismus*, Frankfurt, 1967; second ed., 1968.

11 See Michel Contat/Michel Rybalka, *Les écrits de Sartres*, Chronologie, bibliographie commentée, Paris, n.d., p. 564.

12 The most important document for the expression of revolutionary realism in Germany is the exhibition catalogue *Revolution und Realismus. Revolutionäre Kunst in Deutschland 1917–1933*, Staatliche Museen zu Berlin, 1978/79. Also see my contribution, 'Realismus' in Werner Busch, Peter Schmoock, eds., *Kunst – die Geschichte ihrer Funktionen*, Weinheim and Berlin, 1987, pp. 674–713.

3 ABSENT GUESTS

1 'To show it as it really was.'

2 Statement made by Christos M. Joachimides at Critics' Forum on the exhibition held at the Royal Academy, 28 November 1985.

3 David Elliott 'A view from the bridge: German art in the twentieth century, 1905–1985', *The Burlington Magazine*, 127 (Dec. 1985), 849–57. In this I examine the many historical lacunae in the structure and presentation of the Royal Academy exhibition.

4 Joachimides, 'A Gash of Fire Across the World', in the catalogue to the exhibition *German Art in the 20th Century*, Royal Academy of Arts, London; Prestel-Verlag, Munich, 1985, p. 11

5 Joachimides, note 2 above.

6 *Revolution und Realismus. Revolutionäre Kunst in Deutschland 1917 bis 1933*, Berlin, Altes Museum, 1978; *Weggefährten Zeitgenossen. Bildende Kunst aus drei Jahrzehnten*, Berlin, Altes Museum, 1979. See also Ullrich Kuhirt, *Kunst der DDR*, 2 vols, *1945–1959, 1960–1980*, Leipzig, E. A. Seemann Verlag, 1982. These catalogues provide an invaluable official codification of

art in the GDR; for non-official views published in the west, see the catalogues *Zeitvergleich, Malerei und Grafik aus der DDR*, Hamburg, Galerie Brusberg, 1983 and *Tradition and Renewal: Contemporary Art in the German Democratic Republic*, Oxford, Museum of Modern Art, 1984.

7 In spite of its 'realist' title the exhibition encompasses avant-garde art by both German and Soviet artists as well as examples of Dada, Neue Sachlichkeit and Soviet Socialist Realist art. Although focusing primarily on German art 1917–1933 other radical artists such as the Hungarian, Lajos Kassák or the Belgian, Frans Masreel are also included. This reflects the diversity of pictorial expression possible within the 'Untied Front' before the pronouncement of the doctrine of Socialist Realism.

8 An excellent digest of the ideology and roots of Socialist Realism is given in C. Vaughn-James, *Soviet Socialist Realism. Origins and Theory*, London, Macmillan, 1975.

9 Kuhirt, *Kunst der DDR*, gives this narrative and a useful bibliography as does Karl Max Kober in 'Der Anfänge der Kunst der DDR' in *Weggefährten Zeitgenossen*, pp. 25–36.

10 This exhibition was subsequently held every four years and continues to the present. Its inauguration predates the four-yearly *Dokumenta* exhibition of international art held in Kassel in the Bundesrepublik.

11 Carl Hofer 'Kunst und Politik' and Oskar Nerlinger 'Politik und Kunst', *Bildende Kunst*, 10 (1948), p. 20 ff. During 1947 Hofer had, for a time, been involved in Becher's *Deutsche-Russische Kulturbund* but by the end of the decade he had turned away from any rapprochement with the DDR.

12 Information on this is given in Siegfried Gohr 'Art after the War', in *German Art in the 20th Century*, pp. 465–7.

13 *Weggefährten Zeitgenossen*.

14 Rudolf Kober, 'Zur Entwicklung der Kunstvermittlung in der DDR', *Weggefährt–Zeitgenossen*, p. 410.

15 Until the early 1970s most leading artists were expected to make 'Brigade' pictures which showed the lives of construction workers'. The idealism of the genre evaporated, however, and such artists as Bernhard Heisig, Sighard Gille and Willi Sitte showed these workers in a consciously unheroic light. See Kuhirt, *Kunst der DDR*, vol. 2, illustrations 175, 184, 201 and 204 showing respectively: Heisig, *Der Brigadier*, 1969/70; Tübke, *Brigade Schirmer*, 1972; Stelzmann, *Schweisser*, 1971; Gille, *Gerustbauer – Brigadefeier*, 1975–77.

16 Brecht's relations with the ruling Party were complex and often stormy. About the 1953 uprising he wrote: 'The SED has made mistakes which weigh heavily on our socialist party and have turned workers against it. I am not a member but I respect many of its historic achievements and I feel myself bound to it when Fascist and warmongering riff raff attack it, not for its mistakes, but for its good qualities', (from an unpublished MS). Both Brecht and Paul Dessau had, however, been in conflict with Party ideologues over the production of *Die Verurteilung des Lukullus* for the State opera in 1951. Critics said that the Opera should be cancelled but Brecht insisted on the validity of his contract and in an unprecedented confrontation with the Council of Ministers negotiated a postponement of the production without significant addition to the text or amendments to the music. At the same time Brecht satirised the crude *Kulturpolitik* of the Art Commission which was trying to reduce aesthetic issues to the level of ideological dogma. See John Willett, *The Theatre of Bertold Brecht*, London, Eyre Methuen, 1977, pp. 198–206.

17 Of the art schools in the GDR Dresden is the oldest and most established; Leipzig, a printing centre, specialises in illustration, print-making and typo-

graphy (*Buchkunst*) as well as in fine art; Halle, an industrial city, specialises in design and Berlin covers design and fine art. Students study five years for a degree and places are severely limited: in the Berlin Kunsthochschule für bildende Kunst, for example, only twenty-five students may be studying painting at any one time. In a planned economy it is, of course, important that the supply of qualified artists should not exceed the demand for their work. After graduation artists submit portfolios of work to the Künstlerverband. Membership is offered on the quality of the work and once a member a basic minimum wage is ensured. While it is not necessary to be a member of the *Künstlerverband* to exhibit, only submissions from members are considered in leading galleries and for the quadrennial *Kunstausstellung der DDR* held in Dresden. The *Verband* is also involved in the allocation of most public commisions.

18 From notes made by the author from a television broadcast of the official opening of the Congress of the *Künstlerverband*, November 1983.

19 See A. Behne 'Kunst als Waffe', *Die Weltbühne*, 34 (1931), pp. 301–4.

4 POST-WAR DEBATES

1 See exhibition catalogue, *1945–1985. Kunst in der Bundesrepublik Deutschland*, Nationalgalerie, Berlin, 1985 (hereafter Cat. Berlin 1985), p. 17.

2 Uwe M. Schneede, 'Verschwommen wie hinter Milchglas', *Frankfurter Allgemeine Zeitung*, 14 March 1981.

3 Werner Haftmann, *Malerei im 20. Jahrhundert*, 4, Munich, 1965, p. 474.

4 See for example biographies of Sonderborg, Hoehme and Baselitz in Cat. Berlin 1985, pp. 197, 388, 434.

5 See exhibition catalogue, *documenta 1*, Kassel, 1985, p. 475.

6 Haftmann, *Malerei im 20. Jahrhundert*, 4, p. 475.

7 Similar arguments were heard in the United States. See David Craven, 'The Disappropriation of Abstract Expressionism', *Art History*, 8, 4 (1985), p. 500ff.

8 See the debates on tendencies and party political allegiance in Michael Müller, *Autonomie der Kunst. Zur Genese und Kritik einer bürgerlichen Kategorie*, Frankfurt, 1972, p. 199ff.

9 *German Art in the 20th Century. Painting and Sculpture 1905–1985*, Royal Academy, London, 1985 (hereafter Cat. London 1985), p. 58.

10 Ernst Busche, 'German Art in the 20th Century, 1945–1985/ Kunst in der Bundesrepublik Deutschland', *Kunstchronik*, 39, 4 (1986), p. 129.

11 Werner Schmalenbach, *Bilder des 20. Jahrhunderts*, Munich, 1986, p. 246 (the only mention of Wols in this book).

12 See *Deutsche Kunst im 20. Jahrhundert. Malerei und Plastik 1905–1985*, Staatsgalerie, Stuttgart, 1986 (hereafter Cat. Stuttgart 1986), plate 301a.

13 Peter Inch, ed., *Circus Wols. The Life and Work of Wolfgang Schulze*, Todmorden, 1978; Werner Hofmann, 'Der Maler Wols', *Werk*, 46, 5 (1959).

14 Edward Lucie-Smith, ed., *Kunst der Gegenwart*, Frankfurt, 1978, p. 31. See also Cat. Stuttgart 1986, p. 214.

15 Lucie-Smith, ed., *Kunst der Gegenwart*, p. 145.

16 Hofmann, 'Der Maler Wols', p. 184.

17 Haftmann, *Malerei im 20. Jahrhundert*, 4, p. 474.

18 Hofmann, 'Der Maler Wols', p. 184.

19 Compare Wols' photographic studies of minerals and plants with, for example, his illustrations of René Solier's *Naturelles*, Paris, 1946, *Wols. Aquarelle, Druckgraphik, Staatliche Kunst-Sammlungen*, Kassel 1985, nos 17–24, (hereafter Cat. Kassel 1985).

20 Laszlo Glozer, *Wols the photographer*, 2, Munich, 1978, p. 9ff; Inch, *Circus Wols*, no page reference.
21 Haftmann, *Malerei im 20. Jahrhundert*, 4, p. 474. It must be added that even the most hardened monads have points of reference in the world and their statements are saturated with social elements.
22 Roland Barthes, *Arcimboldo*, Geneva, 1978, p. 26
23 Barthes, *Cy Twombly*, Berlin, 1983, p. 26ff.
24 Jean-Paul Sartre, *Situations IV Portraits*, Paris, 1964, p. 430.
25 Walter Benjamin, 'Über einige Motive bei Baudelaire', *Gesammelte Schriften*, Vol. 1, 2, Frankfurt, 1974, p. 645.
26 Hans-Georg Gadamer, *Die Aktualität des Schönen*, Frankfurt, 1983, p. 10.
27 Theodor W. Adorno, 'Die Kunst und die Künste', *Ohne Leitbilder-Parva Aesthetica*, Frankfurt, 1968, p. 189.
28 Benjamin, 'Über einige Motive bei Baudelaire', p. 650.
29 Maurice Merleau-Ponty, 'Eye and Mind', *Phenomenology, Language and Society. Selected Essays*, London, 1974, p. 291.
30 Benjamin, 'Über einige Motive bei Baudelaire', p. 650.
31 Benjamin, *ibid.*, see also Jürgen Manthey, *Wenn Blicke zeugen könnten*, Munich and Vienna, 1983, p. 55ff.
32 Merleau-Ponty, 'Eye and Mind', p. 299.
33 *ibid.*, p. 307; Merleau-Ponty, *Phénoménologie de la perception*, Paris, 1945, p. 173ff; Helmuth Plessner, *Gesammelte Schriften*, Vol. 3, *Anthropologie der Sinne*, Frankfurt, 1980–90, especially p. 55ff; James J. Gibson, *Wahrnehmung und Umwelt*, Munich, 1982, p. 302ff.
34 Merleau-Ponty, 'Eye and Mind', p. 299ff.
35 *ibid.*, p. 305ff.
36 Sartre, *L'Imaginaire*, Paris, 1940, p. 242: 'un ensemble irréel de *choses neuves* ... qui n'existent point *dans les tableaux* ... mais qui se manifestent à travers la toile et qui se sont emparées d'elle par une espèce de possession'.
37 *ibid.*, p. 240: 'En fait le peintre n'a point *réalisé* son image mentale: il a simplement constitué un analogon matériel tel que chacun puisse saisir cette image si seulement on considère l'analogon. Mais l'image ainsi pourvue d'un analogon extérieur demeure image.'
38 *ibid.*, p. 240: 'Il n'y a pas réalisation de l'imaginaire, tout au plus pourrait-on parler de son *objectivation*'.
39 Exhibition catalogue, *Paris–Paris*, Centre Pompidou, Paris, (hereafter Cat. Paris 1981), p. 124; compare the meaning of jazz in *La Nausée*.
40 Exhibition catalogue, *Wols 1913–1951*, Nationalgalerie, Berlin, 1973 (hereafter Cat. Berlin 1973), p. 18.
41 Haftmann, *Malerei im 20. Jahrhundert*, 1 (1954), p. 463ff.
42 *ibid.*, 4 (1965), p. 424.
43 Wols, *Aufzeichnungen. Aquarelle-Aphorismen-Zeichnungen*, ed. Werner Haftmann, Cologne, 1963, p. 55.
44 *ibid.*, pp. 46, 48.
45 *ibid.*, pp. 32–43.
46 Sartre, *Situations IV*, pp. 408–34.
47 Cat. Berlin 1973, p. 9 (my emphasis).
48 *ibid.*
49 Walter Biemel, *Jean-Paul Sartre*, Reinbek, 1964, p. 9.
50 Giacometti's importance for Sartre becomes clear in his essays on the artist's sculptures and paintings which appear in *Les Temps Modernes*, 1947/48 and 1954. See also Sartre, *Situations IV*, pp. 347–63; Sartre, *Situations III*, Paris, 1949, pp. 289–305; Georges Limbour wrote criticism and articles for *Les Temps Modernes*, published by Sartre.

51 The volume appeared in 1964; the text on Wols pp. 408–34.

52 Sartre, *L'Imaginaire*, p. 235: 'Nous appellerons "situations" les différents modes immédiats d'appréhension du réel comme monde. Nous pourrons dire alors que la condition essentielle pour qu'une conscience imagine c'est qu'elle soit "en situation dans le monde" . . . C'est la-situation-dans-le-monde, saisie comme réalité concrète et individuelle de la conscience, qui est motivation pour la constitution d'un objet irréel quelconque et la nature de cet objet irréel est circonscrite par cette motivation. Ainsi la *situation* de la conscience ne doit pas apparaître comme pure et abstraite condition de possibilité pour tout imaginaire mais comme motivation concrète et précise de l'apparition de tel imaginaire particulier.'

53 Sartre, *Situation IV*, p. 33: 'ce sont les contradictions et les conflits de l'époque qui les surexcitent jusqu'á leur donner une sorte de double vue. Il est donc vrai qu'une oeuvre d'art est à la fois une production individuelle et un fait social.'

54 Cat. Berlin 1973, p. 33.

55 Ione Robinson, 'Wols à bâtons rompus', *L'oeil*, 60 (1959), p. 74

56 Sartre, *Situations IV*, p. 421: 'il m'a cité une fois: "Les objets . . . me touchent, c'est insupportable, j'ai peur d'entrer en contact avec eux." '

57 *ibid.*, p. 409

58 *ibid.*, p. 409.

59 Cat. Kassel 1985, Nr. 7, 43–5.

60 Cat. Kassel 1985, Nr. 58a–d.

61 Sartre, *La Nausée*, Paris, 1938, p. 7.

62 *ibid*, p. 219: 'Et à ce moment précis, de l'autre côté de l'existence, dans cet autre monde qu'on peut voir de loin, mais sans jamais l'approcher . . .'

63 See Paul Arthur Schilpp, ed., *The Philosophy of Jean-Paul Sartre*, La Salle IL, 1981, pp. 74–6.

64 Edmund Husserl, *Ideen zu einer reinen Phänomenologie und phänomenologischen Philosophie*, Vol.I, The Hague, 1950, p. 44.

65 Sartre, *L'Imagination*, Paris 1936, p. 162: 'mais l'image *est un certain type de conscience*. L'image est un acte et non une chose. L'image est conscience *de* quelque chose.'

66 Michel Contat and Michel Rybalka, *Les Écrits de Sartre*, Paris, pp. 557–9, 560–4.

67 *ibid.*, p. 561: 'je dis ce que vois, simplement.'

68 *ibid.*

69 See Sartre, *L'Imagination*, p. 139 ff; compare Sartre's phenomenology with Bernard Waldenfels, *Phänomenologie in Frankreich*, Frankfurt, 1983, pp. 63–126.

70 See Sartre's critique of Surrealism: Sartre, *Qu'est-ce que la littérature?* Paris, 1948, p. 226 ff and *Situations IV*, p. 432; also Dietlinde Schmidt-Schweda, *Werden und Wirken des Kunstwerks. Untersuchungen zur Kunsttheorie von Jean-Paul Sartre*, Meisenheim, 1975, p. 95.

71 For Sartre's relationship with Cubism see the friendship with Kahnweiler, Picasso and others.

72 Glozer, *Wols*, p. 33.

73 *ibid.*, p. 34 ff.

74 *ibid.*, pp. 33–5.

75 Sartre, *Situations IV*, p. 415.

76 *ibid.*, 'Prise de vues et projection simultanées.'

77 *Zeichnungen und Aquarelle*, Goethe Institute, 1985 (hereafter Cat. London 1985), Wols, Nr. 6, fig. p. 33.

78 See note 65.

79 See Sartre, *L'Imaginaire* p. 227 ff.

80 Wols, *Aufzeichnungen*, p. 5.

81 Ursula Peters and Bernd Vogelsang, ' "Das blaue Phantom." Wols und die Malerei der 50er Jahre', *Museen der Stadt*, Cologne, 1980, p. 1867.

82 Elfriede Schulze, 'Wols', *Die Kunst und das schöne Heim*, 57, 10 (1958), p. 369.

83 Sartre, *Qu'est-ce que la littérature?*'. p. 15.

84 Cat. London 1985, *Wols*, Nr. 2, fig. p. 27.

85 Glozer, *Wols*, p. 104; on p. 32, fig. 32, Glozer illustrates a further watercolour by Wols from the Circus series.

86 *ibid.*, p. 30 ff; about Calder's *Circus*, see exhibition catalogue, *Paris–New York*, Centre Pompidou, Paris 1977, (hereafter Cat. Paris 1977), pp. 445–9.

87 Glozer, *Wols*, p. 111 and p. 105, fig. 186.

88 Robinson, 'Wols', p. 72; Jürgen Claus *Theorien Zeitgenössischer Malerei*, Reinbeck, 1963, p. 110 ff.

89 Contat and Rybalka, *Sartre*, p. 564. See also *Verve. The French Review of Art*, 56 (July–Oct. 1939), p. 44.

90 Sartre, *Situations IV*, p. 395 f.

91 Husserl, *Phänomenologie*, p. 44.

92 Sartre qv. Biemel, p. 21 (my emphasis).

93 Claude Lanzmann, *Shoa*, 2, Preface Simone de Beauvoir, Düsseldorf, 1986, p. 5.

94 *ibid.*, p. 7.

95 Sartre, *La Nausée*, p. 123.

96 *ibid.*, p. 117.

97 Contat and Rybalka, *Sartre*, p. 560.

98 *ibid.*, p. 563.

99 Sartre, *Situations IV*, p. 424.

100 *ibid.*, p. 425: 'l'altérité de l'être'.

101 Chuang Tzu, *The Complete Works*, trans. Burton Watson, New York and London, 1968, pp. 349–56.

102 Chuang Tzu, *Complete Works*, p. 40: 'To use an attribute to show that attributes are not attributes is not as good as using a non-attribute to show that attributes are not attributes.' Sartre and Wols are using an older translation of the text which uses, instead of 'attributes' and 'non-attributes', 'fingers' and 'non-fingers'. Wols should have known the German edition and translation by Richard Wilhem: Tschuang Tse (i.e. Chuang Tzu): *Das wahre Buch vom südlichen Blütenland*, Düsseldorf, 1912, or that edited by Martin Buber: Tschuang Tse, *Reden und Gleichnisse*, Leipzig, 1910.

103 Sartre, *Situations IV*, p. 424.

104 *ibid.*, p. 425: 'Certainement l'univers est en cause et l'expérience, découvrant à Wols la nature des choses, lui permet d'incarner le monde dans des objets qu'on n'y rencontre pas.'

105 Claus, *Theorien zeitgenössischer Malerei*, p. 107.

106 Sartre, *Situations IV*, p. 431 ff.

107 Contat and Rybalka, *Sartre*, p. 563.

108 Sartre, *Situations IV*, p. 430.

109 Lao Tzu, *Tao Tê Ching*, trans. Ch'U Ta-Kao, London, 1948, p. 58.

110 *ibid.*, p. 53.

111 Sartre, *Situations IV*, p. 428.

112 Wols, *Aufzeichnungen*, p. 22.

113 *ibid.*, pp. 25, 30.

114 Sartre, *Qu'est-ce que la littérature?* p. 13 f, p. 18.

115 Rolf Wedewer, *Bildbegriffe. Anmerkungen zur Theorie der neuen Malerei*, Stuttgart, 1963, p. 66ff.

116 Arnold Gehlen, *Zeit-Bilder. Zur Soziologie und Äesthetik der modernen Malerei*, 2, Frankfurt and Bonn, 1965, p. 185.
117 *ibid.*, p. 186.
118 Hofmann, 'Der Maler Wols', p. 180.
119 *ibid.*, p. 185.
120 Claus, *Theorien*, 1963, p. 41.
121 Sartre, *Qu'est-ce que la littérature?* p. 355.
122 Inch, no page reference.
123 Schulze, 'Wols', p. 369; see also Hofmann, 'Der Maler Wols', p. 186.
124 Sartre, *Qu'est que la littérature?* p. 355.
125 See Sartre, *L'Imagination*, 1936, p. 145.
126 Sartre, *Situations IV*, p. 431 f: 'objet autre, autre sujet'.
127 See Merleau-Ponty, 'Eye and Mind', p. 283 ff.
128 Sartre, *Situations IV*, p. 432.
129 See Biemel, *Sartre*, 43–51.
130 Contat and Rybalka, *Sartre*, p. 564.
131 Raoul Ubac, 'Die verkehrte Seite des Gesichts' (1942), *Theorie der Fotographie*, II, *1912–1945*, ed. Wolfgang Kemp, Munich, 1979, p. 252 ff; the German translation of Ubac's title is not quite correct; when Ubac speaks about 'l'envers de la face' as Sartre often does, it doesn't mean the 'wrong' side of the face but the 'back' side of it.
132 *ibid.*, p. 252.
133 See Alberto Giacometti, *Was ich suche. Zwei Gespräche, aufgezeichnet von Georges Charbonnier*, Zürich, 1973, p. 18 ff.
134 Sartre, *Situations III*, p. 293: 'Comment faire un homme avec de la pierre sous le pétrifier?'
135 *ibid.*, p. 299: 'distance absolue'.
136 *ibid.*, p. 300.
137 *ibid.*, p. 301: 'immédiate translucidité'.
138 Cat. Paris 1981, pp. 118–22; exhibition catalogue, *Westkunst. Zeitgenössische Kunst seit 1939*, Cologne, 1981 (hereafter Cat. Cologne 1981), pp. 141–43.
139 Cat. Paris 1981, p. 228; Cat. Cologne 1981, pp. 153–7.
140 Cat. Cologne 1981, p. 156 ff.
141 Glozer, *Wols*, p. 68ff.
142 *ibid.*, p. 76 ff.
143 *ibid.*, p. 76.
144 According to Klaus Mewes, 'Perspektive aus der Luft. Auswirkungen der Flugtechnik auf die bildende Kunst', *Absolut modern sein, Neue Gesellschaft für Bildende Kunst*, Cat. Berlin 1986, p. 317ff, a dialectic is to be made out of the mechanistic interpretation. Wols himself writes in an aphorism: 'Knock wood:-flight is wonderful, life is wonderful, but it is like the airforce: an agent of death.' (Cat. Berlin 1973, p. 18) Wols, like Sartre, makes the air raids and their effects the starting point for human existence. Cf. the history of the genesis of Sartre's *Behind Closed Doors* (Biemel, *Sartre*, p. 52).
145 Merleau-Ponty, 'Eye and Mind', p. 301.
146 Joo-Dong Lee, *Taoistische Weltanschauung im Werke Franz Kafkas*, Frankfurt, 1985, p. 92 ff.
147 *ibid.*
148 Illus. in Wols, *Aufzeichnungen*, p. 63.
149 Illus. in Cat. London 1985, Wols, Nr. 18 and illus. p. 46.
150 Illus. in Cat. London 1985, Wols, Nr. 23 and illus. p. 52.
151 Illus. in Wols, *Aufzeichnungen*, p. 19.
152 *ibid.*, p. 6.

153 *ibid.*, p. 77; also in Cat. London 1985, Wols, Nr. 12 and illus. p. 39.

154 Illus. in Wols, *Aufzeichnungen*, p. 75.

155 *ibid.*, p. 69.

156 See Andeheinz Mösser, *Das Problem der Bewegung bei Paul Klee*, Heidelberg, 1976, esp. p. 49ff.

157 Lee, *Taoistische Weltanschauung*, p. 37.

158 Sartre, *Situations IV*, p. 425: 'l'altérité de l'être'.

159 All Kafka quotations after Lee, *Taoistische Weltanschauung*, p. 97.

160 The four etchings appeared in Jean-Paul Sartre, *Visages, precédé de Portraits officiels. Avec 4 pointes-sèches de Wols chez Seghers*, Paris, 1948. The etchings are on p. 8 (frontispiece), 20, 29, and 37. There were 926 copies published; Nrs. 1–15 on chine, Nrs. 16–916 on Crèvecoeur du Marais, 10 copies 'H.C.' (hors commence) for the author and the artist. Folio size 19.5 × 12.9, print size 13.6 × 7.8 cm; the plates were printed in January 1948 at R. Haazen's in Paris; see also Cat. Kassel 1985, Nr. 58 a–d; for Sartre's texts see Contat and Rybalka, *Sartre*, p. 557 ff.

161 Contat and Rybalka, *Sartre*, p. 558.

162 *ibid.*

163 Cat.Düsseldorf 1983, *Francis Picabia*, Kunsthalle, p. xliii.

164 Cat. Cologne 1981, p. 206.

165 Lao Tzu, *Tao Té Ching*, p. 21.

166 Merleau-Ponty, 'Eye and Mind', p. 287.

167 *ibid.*

168 Brassai, *Gespräche mit Picasso*, Reinbek, 1985, p. 175.

169 *Das Kunstwerk*, (1948), p. 26.

170 Cat. Kassel 1985, p. 11.

171 In fact Wols' sister maintains the opposite; see Schulze, 'Wols' p. 368; but the witnesses who were involved argue in another way.

172 Sartre, *Situations IV*.

173 Lao Tzu, *Tao Té Ching*, p. 61.

174 Sartre, *Qu'est-ce que la littérature?* p. 356.

175 Wols, *Aufzeichnungen*, p. 53; Wols also knew well Lao's motto: 'Be humble, and you wil remain entire' (Lao Tzu, p. 32).

I should like to thank Irit Rogoff, MaryAnne Stevens, Marianne Heinz, Holm Bevers, Lothar Knapp, Martin Lang, Judith Klein, Herbert Molderings, Horst Bredekamp and Ulrich Müller.

Illustrations by Staatliche und Städtische Kunstsammlungen, Kassel.

5 HABERMAS AND POSTMODERNISM

1 Jürgen Habermas, *Der philosophische Diskurs der Moderne*, Frankfurt, 1985; *Die Neue Unübersichtlichkeit*, Frankfurt, 1985; 'Questions and counterquestions', in Bernstein, ed., *Habermas and modernity* Cambridge, MA, 1985.

2 Jürgen Habermas, 'Modernity versus postmodernity', *New German Critique*, 22 (Winter 1981); 'The entwinement of myth and enlightenment: re-reading *Dialectic of Enlightenment*', *New German Critique*, 26 (Spring–Summer 1982).

3 Andreas Huyssen, 'Mapping the postmodern', *New German Critique*, 33 (Fall 1984), p. 30.

4 Jacques Derrida, 'Différance', in *Speech and phenomena and other essays on Husserl's theory of signs*, trans. David Allison, Evanston, 1973, p. 143.

5 See, for example, Naomi Schor and Henry F. Majewski, eds., *Flaubert and postmodernism*, Lincoln, 1984.

6 Jean-François Lyotard, *The postmodern condition: a report on knowledge*, trans. Geoff Bennington and Brian Massumi, Minneapolis, 1984, p. 36.

7 *Les Immatériaux* was presented at the Centre Pompidou from 28 March to 15 July 1985. For a selection of texts reflecting on it, see the simultaneously published *Modernes et après; Les Immatériaux*, ed. Élie Théofilakis, Paris 1985.

It should be acknowledged that in certain of his writings, Lyotard himself emphasizes the impermeability of boundaries between radically commensurable spheres. See, for example, his dialogue with Jean-Loup Thébaud, *Just gaming*, trans. Wlad Godzich, Minneapolis, 1985. In the afterword to a volume by Samuel Weber, Lyotard is in fact criticised from a more rigorously Derridean perspective for being too obsessed with the purity and specificity of discrete language games. Instead, Weber asks him to be aware of their ambiguous interpenetration, that is, of the very ubiquity of *différance*, which is privileged by the postmodern temper.

8 Jacques Bouveresse, *Rationalité et cynisme*, Paris, 1984, p. 163.

9 Suzi Gablik, *Has modernism failed?* New York, 1984, p. 48.

10 Peter Bürger, *Theory of the avant-garde*, trans. Michael Shaw, Minneapolis (1984).

11 Charles Jencks, *The language of post-modern architecture*, New York (1984), p. 127f.

12 Robert Venturi *et al.*, *Learning from Las Vegas*, Cambridge, 1977.

13 Craig Owens, 'The discourse of others: feminists and postmodernism', in Hal Foster, ed., *The anti-aesthetic: essays on postmodern culture*, Port Townsend, Washington, 1983.

14 For a feminist-deconstructionist critique of Habermas, see Gayatri Chakravorty Spivak, 'Three feminist readings: McCullers, Drabble, Habermas', *Union Seminary Quarterly Review*, 35, 1–2 (Fall 1979–Winter 1980). For a feminist critique closer to his own position, see Nancy Fraser, 'What's Critical about Critical Theory? The Case of Habermas and Gender', *New German Critique*, 35 (Spring–Summer, 1985).

15 Lyotard, *The postmodern condition*, p. 72. This characterisation of Habermas is also taken for granted by Philippe Lacoue-Labarthe in his 1982 discussion with Lyotard at Cerisy-la-Salle. See the transcript, 'Talks', in *Diacritics*, 14, 3 (Fall 1984), p. 26.

16 *ibid.*, p. 66.

17 Dominick LaCapra, *Rethinking intellectual history: texts, contexts, language*, Ithaca, 1983, pp. 178–9.

18 Michael Ryan, *Marxism and deconstruction: a critical articulation*, Baltimore, 1982, p. 112f; Jonathan Culler, 'Communicative competence and Normative Force', *New German Critique*, 35 (Spring–Summer, 1985).

19 For an account of Habermas' break with the idea of a meta-subject, see Martin Jay, *Marxism and totality: the adventures of a concept from Lukács to Habermas*, Berkeley, 1984, chapter 15.

20 Thomas McCarthy, 'Rationality and relativism: Habermas's "overcoming" of hermeneutics', in John B. Thompson and David Held, eds., *Habermas: critical debates*, Cambridge MA, 1982; Joel Whitebook, 'The problem of nature in Habermas', *Telos*, 40 (Summer 1979); Henning Ottman, 'Cognitive interests and self-reflection', in Thompson and Held, *Habermas: critical debates*.

21 Jürgen Habermas, *Theory of communicative action*, trans. Thomas McCarthy, 2 vols., Cambridge MA, 1985.

22 Anthony Giddens, 'Reason without revolution? Habermas's *Theorie des kommunikativen Handelns*, in Bernstein, *Habermas and modernity*.

23 Martin Jay, *Marxism and totality*.
24 Jürgen Habermas, *Communication and the evolution of society*, trans. Thomas McCarthy, Boston, 1979, p. 130f.
25 Jürgen Habermas, *Der philosophische Diskurs der Moderne*, p. 361.
26 Jürgen Habermas, 'Modernity versus postmodernity', *New German Critique*, 22 (Winter, 1981), p. 9 (translation emended).
27 Martin Jay, 'Habermas and modernism', in Bernstein, *Habermas and modernity*.
28 Jürgen Habermas, 'Questions and counterquestions', p. 200.
29 *ibid*.
30 *ibid*., p. 201.
31 *ibid*. For another recent consideration of the issue of aesthetic rationality that draws in part on Habermas, see Martin Seel, *Die Kunst der Entzweiung: Zum Begriff der Ästhetischen Rationalität*, Frankfurt, 1985. Ironically, the inflationary expansion of different aesthetic experiences has itself been connected to postmodernism by Charles Newman. See his *The post-modern aura: the act of fiction in an age of inflation*, Evanston, 1985. Quantitative increase may not in fact be a fully satisfactory criterion of rationalisation.
32 Ironically, despite his opposition to Habermas, Lyotard can perhaps be read against the grain as expressing hope for something similar. Thus, Cecile Lindsay recently writes, 'By meticulously unmasking the operations of the various types of metanarratives, by turning the conditions of any narrative back upon itself, Lyotard's work points to a powerful potential for a dialogic situation among genres of discourse that have been kept separate and hierarchized.' See her 'Experiments in postmodern dialogue', *Diacritics*, 14, 3 (Fall 1984), p. 61. It is of course in a similar direction – without the overly intersubjectivist notion of dialogue – that Weber wants to turn Lyotard in the afterword to *Just gaming* cited above. But because Lyotard, like Habermas, is interested in preserving boundary maintenance to a greater extent than are the more rabid deconstructionists, he preserves the hope for some sort of actual dialogue. For unless there is a sense of relatively autonomous language games capable of interacting, then all we have is an undifferentiated soup of homogeneous heterogenity, a kind of absolute concreteness that paradoxically turns itself into pure abstraction.
33 Jürgen Habermas, 'Modern and Postmodern Architecture' in John Forester, ed., *Critical Theory and Public Life*, Cambridge MA.
34 *ibid*., p. 328.
35 See Frampton's 'Toward a critical regionalism: six points for an architecture of resistance', in Hal Foster, *The Anti-Aesthetic*. Frampton, to be sure, is no friend of postmodernism and acknowledges a debt to the Frankfurt School, as well as to Heidegger and Hannah Arendt.
36 Jürgen Habermas, *Der philosophische Diskurs der Moderne*, p. 392.
37 *ibid*., p. 393.
38 Jonathan Culler, in the essay cited in note 18, chides Habermas for marginalising literature and rhetoric in the name of philosophy. One might reply that the deconstructionist impulse in postmodernism is open to the reverse charge.
39 Habermas, *Der philosophische Diskurs der Moderne*, p. 240.
40 Albrecht Wellmer, 'Reason, Utopia and the *Dialectic of Enlightenment*., in Bernstein, *Habermas and modernity*, pp. 62–3.
41 Thomas McCarthy, 'Complexity and democracy, or the seducements of systems theory', *New German Critique*, 35 (Spring–Summer 1985), p. 50.
42 Peter Uwe Hohendahl, 'The dialectics of Enlightenment revisited: Habermas' critique of the Frankfurt School', *New German Critique*, 35 (Spring–Summer 1985), p. 25.

7 STRATEGIES OF PLEASURE AND DECONSTRUCTION

1 Fredric Jameson, 'PLEASURE: a political issue', *Formations of pleasure*, London, 1983, p. 13.

2 Mary Ann Doane, 'Film and the masquerade: theorizing the female spectator', *Screen* (Fall 1982), p. 87.

3 Richard Sheppard has described the position of several Berlin Dada members as anarcho-communist. For a discussion of this label, see R. Sheppard, 'Dada and politics', in *Dada: studies of a movement*, ed. R. Sheppard, Buckinghamshire, 1979, pp. 51–2.

4 Atina Grossmann, 'The New Woman and the rationalization of sexuality in Weimar Germany', *Powers of desire: The politics of sexuality*, ed. Ann Snitow, Christine Stansell and Sharon Thompson, New York 1983, pp. 156–7.

5 Atina Grossmann, 'Abortion and the economic crisis: the 1931 campaign against Paragraph 218', *When biology became destiny: women in Weimar and Nazi Germany*, ed. Renate Bridenthal, Atina Grossmann and Marion Kaplan, New York, 1984, pp. 66–86.

6 Gertrud Jula Dech, *Schnitt mit dem Küchenmesser DADA durch die letzte weimarer Bierbauchkulturepoche Deutschlands: Untersuchungen zur Fotomontage bei Hannah Höch*, Münster, 1981. Dech has identified the referents in *Cut with the Kitchen Knife* and located their mass-media sources. In addition, her study includes cogent analysis of the montage's inconography and the relationships between images of women, male political figures, technology, and animals. It should be noted that *Cut with the Kitchen Knife* was exhibited in the 1920 Dada Messe at Dr Burchard's gallery in Berlin.

7 Hanne Berguis, 'Femme-Artiste du Dadaisme berlinois', *Hannah Höch: collages, peintures, aquarelles, gouaches, dessins*, Musée d'Art Moderne de la Ville de Paris and Nationalgalerie Berlin Staatliche Museen Preussischer Kulturbesitz, 1976, pp. 33–8.

8 Miriam Hansen, 'Early silent cinema: whose public sphere?' *New German Critique* (Spring–Summer 1983), particularly pp. 173–84.

9 Images of androgyny and bisexuality are prevalent in Höch's Weimar work. The feminisation of the male body evident in *Roma* appears earlier as a technique of mockery in *Cut with the Kitchen Knife*. In *Roma*, in addition to these connotations, the pairing of the female flirtatious bodies also has a more positive sexual signification.

10 For a discussion of Gross's role in Berlin avant-garde circles, see Arthur Mitzman, 'Anarchism, Expressionism and psychoanalysis', *New German Critique* (Winter 1977), pp. 86–99.

11 *Die Erde* was a Berlin periodical on culture and politics whose contributors included Franz Jung, Otto Gross and Karl Liebknecht. Pertinent here is Otto Gross's essay 'Protest und Moral im Unbewussten', *Die Erde* (15 December 1919), pp. 681–5.

12 On the profound and disturbing contradictions between Hausmann's theory and his actual relationship with Höch, see Delia Güssefeld, *Hannah Höch: Freunde und Briefpartner, 1915–1935*, Magisterarbeit, Freie Universität Berlin, 1984; and Ellen Maurer, *Symbolische Gemälde von Hannah Höch aus den Jahren 1920–1930*, Magisterarbeit, Universität München, 1983, pp. 96–123.

13 Raoul Hausmann, 'Zur Weltrevolution', *Die Erde* (15 June 1919), p. 369. This translation and those to follow are mine.

14 Raoul Hausmann, 'Der Besitzbegriff in der Familie und das Recht auf den eigenen Körper', *Die Erde* (15 April 1919), p. 242.

15 Raoul Hausmann, 'Zur Weltrevolution', *Die Erde* (15 June 1919), p. 29.

16 Edouard Roditi, 'Interview with Hannah Höch', *Arts* (December 1959), p. 29.

17 Hannah Höch (1889–1978) was born in the small town of Gotha, the eldest of five siblings. Her father worked in a managerial position at an insurance agency. In 1912, at the age of 22, Höch went to Berlin to study at the Kunstgewerbeschule Charlottenburg but, with the outbreak of the war in 1914, returned to Gotha and did Red Cross and other volunteer work. She was finally able to move to Berlin in 1915 when she studied with Emil Orlik. At this time Höch met Raoul Hausmann (1886–1971). In subsequent years she worked at the Ullstein Verlag and exhibited with the Berlin Dadaists and other groups such as the Novembergruppe.

For further biographical information, see Heinz Ohff, *Hannah Höch*, Berlin, 1968 and Götz Adriani, 'Biographische Dokumentation', *Hannah Höch: Fotomontagen, Gemälde, Aquarelle*, ed. Götz Adriani, Cologne, 1980, pp. 7–52.

18 'Lettre ouverte au Groupe Novembre', (Offener Brief an die Novembergruppe, *Der Gegner*, 2, nos. 8–9, Berlin, 1920–1), *Paris-Berlin 1900–1933*, Centre National d'Art et de Culture Georges Pompidou, Paris, 1978, pp. 171–2.

19 Edouard Roditi, 'Interview with Hannah Höch', *Arts* (December 1959), pp. 24–9.

20 See, for example, Ernst Bloch, *Das Prinzip Hoffnung*, vol. 1, Berlin, 1954, a compilation of Bloch's ideas of the time and earlier.

21 See the chapter on Bloch in Fredric Jameson, *Marxism and form: twentieth-century dialectical theories of literature*, Princeton, 1971.

22 Höch's work should be read in contrast to and in the context of this unquestioning technological progressivism as evident in, for example, designs of the Bauhaus and of Kurt Schwitters. I have discussed such reified utopianism evident in much twenties design in: 'Advertising Utopia: Schwitters as Commercial Designer', *Art in America* (October 1985), pp. 134–9, 169.

23 Ernst Bloch, 'Nonsynchronism and Dialectics', (1932) *New German Critique* (Spring 1977), pp. 22–38.

24 Dech, *Schnitt mit dem Küchenmesser DADA*, p. 101.

25 *ibid.*, p. 159. The identical photograph can also be found in *Die Dame* (February 1919), p. 4. The Lotte Pritzel ad is in *Die Dame* (December 1919), p. 33. And drawings of Impekoven's impish dances are in *Die Dame* (December 1919), p. 8.

26 *Die Dame* (February 1922), p. 40.

27 To be specific about terminology: one aspect of physical pleasure can be considered the ideological relationship of the subject to her body, or, in Althusserian terms, the imaginary relationship of the subject to the real. Any subject's relationship to the real is always asymptotic. Thus a conscious response to one's own body is not the idealist oneness of 'getting in touch with your body', rather it is an imaginary relationship.

28 Elizabeth Kendall, *Where she danced: the birth of American art-dance*, Berkeley, 1979 gives such a multi-leveled analysis of early twentieth-century modern dance, primarily in an American context.

29 Richard Huelsenbeck, 'An Avant Dada', (1920) *Dadas on art*, ed. Lucy Lippard, Englewood Cliffs NJ, 1971, p. 47. Huelsenbeck is quoting himself here from the first Berlin Dada manifesto in 1918.

30 Two significant essays on pleasure and female spectatorship are Miriam Hansen, 'Pleasure, ambivalence, identification: Valentino and female spectatorship', *Cinema Journal* (Summer 1986), pp. 6–32 and Tania Modleski, 'Femininity and Mas(s)querade: a feminist approach to mass culture', *High Theory/Low Culture*, ed. Colin MacCabe, Manchester, 1986: pp. 37–52.

8 THE ANXIOUS ARTIST

I would like to express my gratitude to Maud Lavin who read through several versions of this paper and whose critical faculties and clarity of thought have greatly contributed to its writing.

1 Michel Foucault, 'What is an author?' in *Textual strategies*, ed. Jose V. Harari, Ithaca, pp. 141–60.

2 There are of course exceptions such as recent work by Klaus Theweleit, Stephen Heath, Paul Smith or by Victor Burgin in which the authors explore various forms of engagement with constructions of masculinity and its representations.

3 Michel Foucault, 'What is an author?'

4 Jonathan Rutherford, 'Who's that man?' in J. Rutherford and R. Chapman, *Male order – unwrapping masculinity*, London, 1988, p. 22.

5 Griselda Pollock, 'Artists mythologies and media genius, madness and art history', *Screen*, 21, 3. In this essay Pollock analyses the construction of individuated artistic genius through the reception of Vincent Van Gogh, claiming that 'The preoccupation with the individual artist is symptomatic or the work accomplished in art history – the production of an artistic subject for works of art' (p. 58) and arguing it through the work of such critics as Albert Aurier who in 1890 wrote of Van Gogh: 'In his categorical affirmation of the character of things, in his often fearless simplifications of form . . . even to the last particulars of his technique, he reveals himself as powerful, a male, a daredevil, frequently brutal and sometimes ingeniously delicate. And even more one can guess from the almost orgiastic expressiveness of everything he has painted, here is a man of exaltation, an enemy of bourgeois sobriety and minutiae, a sort of drunken giant, a terrible and maddened genius, often sublime, sometimes grotesque, always rising to the level that comes close to pathological states' (p. 66) – thereby, claims Pollock, critically prefiguring the artist's established historical personae.

6 The authority of the critic is equally constructed out of the possession and manipulation of this language of culture, see for example Edward Said's *The world, the text and the critic*, London, 1984 in which he says in context of a discussion of the recording work of Glenn Gould: 'Any occasion involving aesthetic or literary document or experience, on the one hand and the critic's role and his or her "worldliness", on the other, cannot be a simple one.'

7 Carol Duncan, 'Virility and domination in 20th century Modernism', in N. Broude and M. Garrard, eds., *Feminism and art history*, New York, 1982, pp. 201–22.

8 Richard Sennett, *The fall of public man*, London, 1986, p. 6.

9 Lankheit, *Das Freundschaft Porträt*, Cologne, 1957, deals with the German Romantic tradition of portraying friendship and artistic allegiance in group portraits of male artists with particular emphasis on the members of the Nazarene Brotherhood of St Luke who shared their lives as well as their work in a communal project in Italy.

10 Allotria catalogue, Munich Kunstverein, 1961. For a longer historical account of the interrelations between patronage and artistic production see Martin Warnke *Hofkünstler*, Cologne, 1984.

11 Rolf Andree, *Arnold Böcklin – Die Gemälde*, Munich, 1977, pp. 19–20.

12 *ibid.*, pp. 24–5.

13 *ibid.*, p. 21.

14 Kenworth Moffet, *Meier-Graefe as art critic*, Munich, 1973, p. 53.

15 Lionel Gossmann, 'Orpheus Philologus – Bachofen versus Momsen on the study of Antiquity', *Transactions of the American Philosophical Society*, 73, 5, (1983).

16 Critical historical perspectives adapted from Golo Mann, *The history of Germany since 1789*, London, 1968, and Hajo Holborn, *A history of modern Germany*, III, *1840–1945*, London, 1959–69.

17 For a masterly discussion of the writings of some of cultural pessimism's ideologues such as LaGarde, Langbehn and van den Bruck see Fritz Stern, *The politics of cultural despair*, Berkeley, 1961.

18 Winfried Ranke, 'Böcklinmythen' in Andree, *Böcklin*, p. 74.

19 See Michael Podro, *The critical historians of art*, New Haven and London, 1982, pp. 26–7.

20 Foucault, 'What is an author?'

21 *The works of Stephan George*, trans. Olga Marks and Ernst Morwitz, Chapel Hill NC, 1976, p. 199.

22 Such accounts dominate the standard literature on Liebermann such as the detailed biography and work analysis by Erich Hancke, *Max Liebermann – sein Leben und seine Werke*, 2nd ed., Berlin, 1923. Similarly the celebratory work *Max Liebermann* by Gustav Pauli which appeared as Vol. XI of *Kalssiker der Kunst*, Berlin, 1911 as well as the more recent study by Ferdinand Stuttmann, *Max Liebermann*, Hannover 1961.

23 I. K. Rogoff, *The public self – self portraits and cultural ideologies in German Modernism*, Ph.D. dissertation, Courtauld Institute of Art, London University, 1986, pp. 124–8.

24 The one exception in the existing Liebermann literature is Matthias Eberele's catalogue to the 1979 Berlin NeueNationalgalerie exhibition *Max Liebermann in seiner Zeit*, which looked at the work in a socio-historical context and began the task of dismantling the kind of normative mythological construct of aloof *grand bourgeois* which Liebermann himself has been so instrumental in establishing. The above is taken from Klaas Teeuwisse 'Berliner Künstlerleben zur zeit Max Liebermann', pp. 72–87.

25 Elias Canetti, *The torch in my ear*, New York, 1982, p. 29.

26 Lovis Corinth, *Selbstbiographie*, Berlin, 1925, (Delux Illustrated Edition), p. 68.

27 Fritz Stern, 'Art, politics and the heroic folk' in *The politics of cultural despair*.

28 Brücke manifesto, 1906, in translation quoted by Peter Selz, *German Expressionist painting*, 1957.

29 *Jorg Immendorf*, Exhibition Catalogue, Kunstverein Braunschweig, 1985, p. 176.

30 Peter Sloterdijk, *Critique of cynical reason*, Minneapolis, 1987, Chapter 1, p. 3.

31 *Die Zeit*, 14 (27 March 1987), pp. 49–56, 'Zeit Dossier – Kunst'.

9 THE FEMALE ARTIST

1 Catalogue *Projekt '74*, Cologne, 1974.

2 Catalogue *Rebecca Horn*, Centre d'art contemporain, Geneva, 30 April–30 May 1983, p. 12.

3 Catalogue *Isolde Wawrin – Malerei* Bonner Kunstverein, 4 October–19 November 1980.

4 Catalogue *Christa Näher*, Bonner Kunstverein, 10 May–12 June 1983.

10 SUPPORT AND OPPOSITION IN WILHELMINIAN CULTURE

1 Emil Rathenau, *Flottenumfrage der Münchner Allgemeinen Zeitung*, 13 (1898).

2 I follow here the work of Richard Hamann and Jost Hermand, *Epochen*

deutscher Kultur von 1870 bis zur Gegenwart, Vol. 4, *Stilkunst um 1900*, München, 1973, p. 32f.

3 *Die Reden Wilhelm II*, Vol. 3, p. 62.

4 Peter Paret, *Die Berliner Secession*, Berlin, 1981, p. 43.

5 Wilfried Feldkirchen, 'Staatliche Kunstfinanzierung im Kaiserreich', in Ekkehard Mai *et al.*, eds., *Kunstpolitik und Kunstförderung im Kaiserreich*, Berlin, 1982, p. 47.

6 Of course, there are gaps in the sources here. Also, I only give here excerpts from Renate Köhne-Lindenlaub, *Private Kunstförderung im Kaiserreich am Beispiel Krupp*, in Ekkehard Mai, *et al.*, eds., *Kunstpolitik und Kunstförderung im Kaiserreich*, p. 71ff.

7 Feldkirchen, 'Staatliche Kunstfinanzierung'.

8 *ibid.*, p. 43.

9 Peter Paret, *Die Berliner Secession, Moderne Kunst und ihre Feinde Deutschland*, Berlin, 1981, p. 135.

10 *ibid.*, p. 137.

11 *ibid.*, p. 150.

12 *ibid.*, p. 161ff.

13 *Verhandlungen des Reichstages*, Vol. 198, (n.d.), 1024–102.

14 *ibid.*, p. 1022.

15 *ibid.*, p.1006.

16 *ibid.*, pp. 1018–20.

17 Harry Graf Kessler, *Der Deutsche Künstlerbund*, Berlin, 1904, p. 13.

18 Rüdiger vom Bruch, *Weltpolitik als Kulturmission*, Paderborn, 1982, p. 48f.

19 G. W. F. Hegel, *Vorlesungen über Asthetik I*, Frankfurt, 1970, p. 137.

20 Sebastian Müller, *Kunst und Industrie*, Munich, 1974, p. 85ff.

21 One knows, of course, what type of depoliticalising and repressive intentions were bound up with this. See Peter W. Kallen, 'Idylle oder Illusion? Die Margaretenhöhe in Essen von Georg Metzendorf', in *Der westdeutsche Impuls 1900–1914*, Essen, 1984, pp. 48–95.

22 Müller, *Kunst und Industrie*, p. 125ff.

23 Jürgen Reulecke, '"Kunst" in den Arbeiterbildungskonzepten bürgerlicher Sozialreformer im 19. Jahrhundert', Ekkehard Mai *et al.*, eds., *Kunstpolitik und Kunstförderung im Kaiserreich*.

24 Hamann, p. 42.

25 Vom Bruch, *Weltpolitik*, p. 102.

26 The latter is assumed by Walter Grasskamp, *Museumgründer und Museumsstürmer*, Munich, 1981, p. 77.

27 Quoted from Paret, *Die Berliner Secession*, p. 226.

28 *ibid.*, p. 239.

29 Grasskamp, *Museumsgründer*, p. 37.

30 Quoted from Wulf Herzogenrath, 'Zur Funktion der Kunstvereine im 19. Jahrhundert', *Festschrift 150 Jahre Württembergischer Kunstverein*, Stuttgart, 1977, p. 128. Comments such as these and other points can also be found in: Ekkehard Mai, 'Kunstleben und Ausstellungswesen in Köln vom 19. zum 20. Jahrhundert', in *Der Westdeutsche Impuls 1900–1914, Kunst und Umweltgestaltung im Industriegebiet*, Cologne, 1984, pp. 23–41.

31 *Generalanzeiger für Elberfeld-Barmen*, 22, 2, (1913), with a statement by the governing board; quoted in Günter Aust, 'Sammlungen und Ausstellungen in Elberfeld und Barmen', in *Der Westdeutsche Impuls 1900–1914, Kunst und Umweltgestaltung im Industriegebiet*, Wuppertal, 1984, p. 139.

32 *ibid.*, p. 143.

33 *Barmer Zeitung*, 3, 2, (1912), quoted in *ibid.*, p. 136.

34 *Barmer Anzeiger* 31, 1, (1911), quoted in *ibid.*, p. 130.

35 *Barmer Zeitung* 14, 12, (1911), quoted in *ibid.*, 1984, p. 133f.

36 Here I follow Günter Aust; *ibid.*, p. 76ff.

37 Uwe Eckardt, 'Anmerkungen zu Wirtschaft, Gesellschaft und Kultur in Wuppertal', in *Westdeutscher Impuls 1900–1914*, Wuppertal, 1984, p. 14.

38 Aust, *Der Westdeutsche Impuls*, p. 85.

39 *ibid.*, p. 122.

40 *ibid.*, p. 90. Von der Heydt's collection was published in an early catalogue. The 1918 catalogue is, of course, an excellent source for getting information on the nature of this collection. The value of the introduction by Carl Georg Heise with respect to the history of ideas and social history is slight. Heise holds forth on the need for a clear definition of the tasks the museums and the collectors have in promoting art with statements like the following: 'It is one's task to do justice to the best artists of the period'. Most telling appears to me, however, his praise of August von der Heydt. It is the praise of a museum man who was a practical thinker and who found fault with Modernism. 'Through his collection of mainly Expressionist art he has performed a bold pioneer service. In the area of modern art and the most recent productions, an area that is really in confusion because of sophistical theories, he has given the head and the commission of the Elberfeld Museum the rare and welcomed opportunity to examine the new values through frequent viewing, in this way saving the town from making mistakes in buying works of art because of a lack of experience.' Carl Georg Heise, *Die Sammlung des Freiherren August von der Heydt Elberfeld*, Leipzig, 1918.

41 KED–Archiv P2–176, P–440, F1–247.

42 For a more detailed analysis than can be given here, see K. E. Osthaus, *Leben und Werk*, Recklinghausen, 1971; Sebastian Müller, 'Ästhetische Erlösermystik an der Quelle der funktionalistischen "Kulturrevolution", Zur Stellung des Deutschen Museums für Kunst in Handel und Gewerbe in der Kunstgeschichte', in *Der Westdeutsche Impuls 1900–1914*, Krefeld, 1984.

43 Quoted in Herta Hesse-Frielinghaus, 'Folkwang I. Teil', in K. E. Osthaus, *Leben und Werk*, Recklinghausen, 1971, p. 195.

44 Quoted in *ibid.*, p. 123.

45 Quoted in *ibid.*, p. 132f.

46 Quoted in Walter Erben, Karl Ernst Osthaus, 'Lebensweg und Gedankengut', in K. E. Osthaus, *Leben und Werk*, Recklinghausen, 1981, p. 23.

47 Karl Ernst Osthaus, 'Deutscher Werkbund', in: *Das Hohe Ufer*, 1, 10 (1919), p. 238f.

48 Especially Hermann Sturm, 'Vom solitären Gebäude über die Villenkolonie und die Gartenvorstadt zur "Auflösung der Städte",' in *Westdeutscher Impuls 1900–1914*, Hagen, 1984.

I I ART AND OPPRESSION IN FASCIST GERMANY

This contribution is the text of a lecture held on December 14, 1985, with a few additions that were left out due to limited speaking time.' Translated by Gloria Custance, Berlin. For further analysis see my 'München, 50 Jahre nach der Ausstellung "Entartete Kunst"', *Kritische Berichte*, 16.2 (1988), pp. 76–88; 'Wie gehen wir mit NS-Bauten um? Beispiele in Berlin', *Werk und Zeit* (1988), pp. 26–9; 'NS-Motive in der Gegenwartskunst – Flamme empor?', *NS-Kunst: 50 Jahre danach*, Marburg, 1989, pp. 95–114; 'Kunsthandwerkdesign für kleine Leute: Abzeichen des Winterhilfswerks 1933–1944', *Design in Deutschland 1933–1945*, Giessen, 1990; 'Kunst und Propaganda im NS-System', *Funkkolleg Moderne Kunst*, programme 20, Saarländischer Rundfunk, March 1990, text vol. 9, Tübingen, 1990.

1 On the choice of this terminology see Berthold Hinz, *Die Malerei im deutschen Faschismus*, Munich, 1974, p. 16.

2 According to *ibid.*, p. 139.

3 Hitler, 1937, according to *ibid.*, p. 159; of interest in this connection is Marcel Struwe, '"Nationalsozialistischer Bildersturm". Funktion eines Begriffs', in *Bildersturm. Die Zerstörung des Kunstwerks*, ed. Martin Warnke, Munich, 1973, pp. 133, 134.

4 Put forward again recently by Wieland Schmied, Christos M. Joachimides and Norman Rosenthal (personal communication); but see before this Hinz *Die Malerei im deutschen Faschismus*, p. 9 (see note 1).

5 The exhibition *Die dreissiger Jahre. Schauplatz Deutschland*, Munich, 1977, attempted to extend the alleged ideology-free section of the art of the period. By way of comparison see Hans-Ernst Mittig, 'Faschistische Sachlichkeits, in Cat. *Realismus. Zwischen Revolution und Reaktion 1919–1939*, Paris/Munich, 1981, pp. 368–72 of the German edition.

6 Adam C. Oellers, 'Zur Frage der Kontinuität von Neuer Sachlichkeit und Nationalsozialistischer Kunst', in *Kritische Berichte*, 6, 6 (1978), pp. 42–54.

7 Werner Rittich, 'Bilder der Arbeit', in *Kunst und Volk*, 5, (1937), p. 7.

8 See Hildegard Brenner, *Die Kunstpolitik des Nationalsozialismus*, Reinbek, 1963, p. 113: 'The department-store-type clichés of Homeland, "Scholle", and Nature as Comforter were sanctioned by the state.'

9 *Kunst und Volk*, 9, (September 1941), p. 38.

10 Hinz, *Die Maleri im deutschen Faschismus* (see note 1), and Hinz, *Art in the Third Reich*, New York, 1979.

11 See Cat. *Die Bilderfabrik*, Frankfurt on Main, 1973.

12 Here Cat. *Skulptur und Macht*, Berlin, 1983, has defined the criteria of comparison.

13 See Mittig, 'Faschistische Sachlichkeit', pp. 364–72 (see note 5).

14 Concerning continuity from the times before 1933 see Hinz *Art in the Third Rieich*, p. 65 and *passim*; Klaus Wolbert, *Die Nackten und die Toten des 'Dritten Reiches'*, Giessen, 1982, pp. 25–9. Concerning continuity between German fascist and later German art see several contributions in *Entmachtung der Kunst*, ed. Magdalena Bushart *et al.*, Berlin, 1985.

15 'Adler kehrte aus Westpoint nach Berlin zurück', *Berliner Morgenpost*, 7 August 1985.

The cast iron eagle, painted with oil and anti-corrosive paint, originally 4.5 metres high and equally as wide, was designed by Walter E. Lemke and erected in 1940. The eagle was only removed in 1962 to make way for radar equipment. I should like to thank Barbara Dornfeld and Wolfgang Schäche, Berlin, for the relevant information.

16 For more examples see Hans-Ernst Mittig, 'Reklame unter dem Nationalsozialismus', *Kunst Hochschule Faschismus*, Berlin, 1984, pp. 163–71.

17 Alexander and Margarete Mitscherlich, *Die Unfähigkeit zu trauern*, Munich, 1968; Theodor W. Adorno, 'Was bedeutet Aufarbeitung der Vergangenheit?' (1959), in Theodor W. Adorn, *Gesammelte Schriften*, vol. 10 part 2, Frankfurt on Main, 1977, pp. 555–72. On the continuing existence of this 'taboo', see Cat. *1945–1985. Kunst in der Bundesrepublik Deutschland*, Berlin, 1985, p. 316.

18 For an analysis of this see Hans-Ernst Mittig, 'Die gesellschaftliche Verantwortlichkeit des Kunsthistorikers' *Ikon 74. Kunstgeschiedenis: tussen liefhebberij en maatschappij*, Amsterdam, 1974, pp. 40–55. For an older example, see Cat. *Erste Internationale Handwerks-Ausstellung*, Berlin 1938, with political prefaces pp. 16–25, and much advertising. Proud of the resonance occasioned by the London exhibition in 1985 was, e.g., Julian Exner, 'Die

Unterschätzung ist vorbei. London bewundert Deutschlands moderne Kunst', *Der Tagesspiegel Berlin*, 22 Oct. 1985.

19 Cat. *Kunst in Deutschland 1898–1973*, Hamburg, 1973/4, Introduction.

20 Christos M. Joachimides, in *Art*, 6, 10 (1985), p. 46.

21 Anna Teut, *Architektur im Dritten Reich 1933–1945*, Berlin, Frankfurt and Vienna, 1967, p. 7.

22 Hinz *Die Malerei im deutschen Faschismus*, p. 11 (see note 1).

23 Wolbert *Die Nackten und die Toten*, pp. 23, 242 (see note 14). See also pp. 78–81 for more details of the difference in functions for the Nazi regime.

24 Gerhard Langemeyer, 'Erfahrungen mit argumentierenden Ausstellungen im Landesmuseum Münster', *Das Museum. Lernort contra Musentempel*, Giessen, 1976, pp. 121–36.

25 Hans-Ernst Mittig *et al.*, 'Albrecht Dürer zu Ehren', *Ausstellungsdidaktik im Albrecht Dürer Jahr 1971*, Technische Universität Berlin, 1972, pp. 23–6.

26 This had already been demonstrated by the debate on Karl Arndt's lecture 'The Pantheons . . . of the Nationalist Socialist Party', Ulm, 1968, which was in many respects a pioneer work; cf. *Kunstchronik*, 21 (1968), pp. 395–8.

27 Recently again Rosenthal and Schmied in the discussions of the London Symposium; and see *Art*, 6, 10 (1985), p. 30.

28 Klaus Herding and Hans-Ernst Mittig, 'Objektanalysen zur NS-Kunst – Reaktionen und Perspektiven', *Kritische Berichte* 4, 4 (1976), pp. 50–51.

29 Goebbels only intermittently in a different way; see Andreas Hüneke, 'Der Versuch der Ehrenrettung des Expressionismus als "deutscher Kunst"' 1933, *Cat. Zwischen Widerstand und Anpassung*, Berlin, 1978, p.51.

30 Struwe 'Nationalsozialistischer Bildersturm', p. 138, (see note 3).

31 *ibid.*, pp. 138–40.

32 Harold Hammer-Schenk *et al.*, *Kunstgeschichte gegen den Strich gebürstet? 10 Jahre Ulmer Verein 1968–1979*, Hanover, 1979; Klaus Herding and Hans-Ernst Mittig, *Kunst und Alltag im NS-System, Albert Speers Berliner Strassenlaternen*, Giessen, 1975, p. 73.

33 Cat. *Kunst im 3. Reich, Dokumente der Unterwerfung*, Frankfurt on Main, 1974, p. 3.

34 An early example is Hans-Jochen, 'Kunst, Architektur und Macht, Ueberlegungen zur NS-Architectur', *Philipps-Universität Marburg, Mitteilungen, Kommentare, Berichte*, 3, 9 (1971), pp. 51–2.

35 This was a primary aim of Herding and Mittig, *Kunst und Alltag* (see note 32);. recently Cat. *Skulptur und Macht*, Berlin, 1983.

36 Herding and Mittig, *Kritische Berichte*, 4, 4 (1976) (see note 28).

37 *Frankfurter Allgemeine Zeitung*, 16 November 1974. Comparable, although from a different viewpoint, was Franz Roh, '*Entartete*' *Kunst*, Hanover, 1962, p. 9.

38 Jörg Berlin, 'Kein Hitler-Bild für Mündige', *Was verschweigt Fest?*, Cologne, 1978, pp. 9, 15; cf. Herding and Mittig *Kunst und Alltag*, note 6 (see note 32).

39 Albert Speer, Karl Arndt, Georg Friedrich Koch and Lars Olof Larsson, *Albert Speer, Architecktur*, Frankfurt, Berlin and Vienna, 1978.

40 Hermann Giesler, *Ein anderer Hitler*, 3rd edition, Leoni on Starnberger See, 1978, accuses Speer in the defence of Hitler.

41 This is underestimated by Reinhard Merker, *Die bildenden Künste im Nationalsozialismus*, Cologne, 1983, p. 313; cf. Cat. Berlin, 1978 pp. 14–19 (see note 29).

42 *Die Dekoration der Gewalt, Kunst und Medien im Faschismus*, Giessen, 1979. New information on the way the media were put into the service of art policy is provided by Otto Thomae, *Die Propaganda-Maschinerie, Bildende Kunst und Oeffentlichkeitsarbeit im Dritten Reich*, Berlin, 1978.

43 Local research findings dominated a fairly recent conference concerning Fascism organised by the 'alternative' *Ulmer Verein* in Karlsruhe 1983, the results of which were not published.

44 Published to date: Cat. *Spuren der Aesthetik des Widerstandes, Berliner Kunststudenten im Widerstand 1933–1945*, Berlin, 1984/1985; Widerstehen – überleben', *Entmachtung der Kunst*, Berlin, 1985, pp. 141–55; *Artists and the Art Institutions 1933–45*, Lecture at the Study Day, The Nazification of Art, London 22–23 November, 1985.

45 Hildegard Brenner, *Ende einer bürgerlichen Kunst-Institution*, Stuttgart, 1972. The first to explore this area were Hildegard Brenner, *Die Kunstpolitik des Nationalsozialismus* (see note 8), and Joseph Wulf, *Die bildenden Künste im Dritten Reich*, 1963, new edition, Frankfurt, Berlin and Vienna, 1983.

46 Hartmut Frank, Introduction, *Faschistische Architekturen*, Hamburg, 1985; similar Fest 1982 (cf. Dieter Bartetzko, *Illusionen in Stein*, Reinbek, 1985, pp. 26–7); Albert Speer, *Erinnerungen*, Berlin, 1969, p. 95; Arno Breker, *Im Strahlungsfeld der Ereignisse*, Preussisch Oldendorf, 1972, p. 333. It is this same confusion that permits art works of almost arbitrary character to be suspected as fascist, cf. Cat. Berlin 1985 p. 31 (see note 17).

47 On the present state of this question, see Cat. *Skulptur und Macht*, Berlin 1983, p. 7 and *passim*.

48 An attempt in this direction is Mittig 'Faschistische Sachlichkeit' (see note 5).

49 Marco de Michelis, 'Faschistische Architekturen, *Faschistische Architekturen* pp. 22–41 (see note 46).

50 Wolbert, *Die Nackten und die Toten*, p. 26 (see note 14).

51 Thorsten Rodiek, *James Stirling, Die Neue Staatsgalerie Stuttgart*, Stuttgart, 1984.

52 Alfred Welti, 'Kraftmeiers Rückzieher', *Art*, 11 (1985), p. 13.

53 Further detail is given in Hans-Ernst Mittig, Die Reklame als Wegbereiterin der nationalsozialistischen Kunst', *Die Dekoration der Gewalt*, pp. 46–47 (see note 42).

54 Petra Dejas-Eckartz and Claudia Herbst, 'Zur Faschismus-Diskussion', Cat. *Faschismus, Renzo Vespignani*, Berlin, 1976, p. 6.

55 Above all the contributions of the author and Chup Friemert (see note 42).

56 Bettina Güldner and Wolfgang Schuster, Das Reichssportfeld, Cat. *Skulptur und Macht*, Berlin, 1983, pp. 43, 53; Rainer Stommer, *Die inszenierte Volksgemeinschaft, Die 'Thing-Bewegung' im Dritten Reich*, Marburg, 1985, pp. 134–42, 207.

57 With regard to torch and sword see Wolbert, *Die Nackten und die Toten*, pp. 207–16 (see note 14).

58 Teut (see note 21), p. 176; Herding and Mittig *Kunst und Alltag*, p. 28 (see note 32).

59 At the same time, here it is probably a compromise between the alternative orientations of 'folk' (*Völkisch*) and 'Hellenic', which was an issue during the preparations for the Olympic Games of 1936 and was resolved by resorting to racism, see Cat. *Auf den Spuren der Antike, Theodor Wiegand*, Bendorf, 1985, pp. 51–3.

60 Roh, *'Entartete' Kunst*, p. 69 (see note 37).

61 Karl Scheffler 1945, cited by Cat. Hamburg, 1973/1974 (see note 19), sub 1938 ('Animierkunst'); Adolf Behne, *Entartete Kunst*, Berlin 1947, p. 8 ('Ludenpfiff'); Eberhard Roters Cat. *Kunstdiktatur gestern und heute*, Berlin, 1963, p. 61 ('pornographic nudes') – concerning different works of NS art.

62 Fritz Alexander Kauffmann, 1941, cited by Cat. *Skulptur und Macht*, Berlin, 1983, p. 23 note 44.

63 For recent work on this theme see Burkhard Fehr, *Die Tyrannentöter*, Frankfurt on Main, 1984, pp. 62–8.

64 Cat. *Skulptur und Macht*, Berlin, 1983, pp. 74–81.

65 Cf. Speer, *Erinnerungen*, pp. 71, 72 (see note 46); Paul Schultze-Naumburg, *Kunst und Rasse*, Munich, 1928, p. 140. On the roots of these phenomena of unattainability, see Wolbert, *Die Nackten und die Toten*, pp. 158, 179, 231 (see note 14).

66 *ibid.*, pp. 51–60, 65; Kristine Pollack and Bernd Nicolai, 'Kriegerdenkmale – Denkmäler für den Krieg? *Cat. Skulptur und Macht*, Berlin, 1983, pp. 62–3. For a different view, Magdalena Bushart and Ulrike Müller-Hofstede, 'Akt-plastik', *ibid.*, pp. 13–14.

67 Cf. Schiller on St. Peter's cathedral: 'Meine Grösse ist die, grösser zu machen dich selbst', *Epigrams*; perhaps the cultured Speer was thinking of this quotation when he remarked that 'the most colossal church of christianity gave the impression of familiarity and clarity' (Speer *et al.*, *Architektur*, p. 8); but the space of his Great Hall, 220 metres high was intended to 'shatter' the visitor (Hitler according to Speer, *ibid.*, see note 39).

68 Measurements: 48 × 10.20 metres, height: 5 metres, Wilhelm Lotz, 'Ein Gang durch die Neue Reichskanzlei', *Die Kunst im Dritten Reich*, A, 3, (1939), p. 305.

69 Concerning the background see Adolf Rosenberg, cited by Cat. Hamburg, 1973/1974 (see note 19), sub 1934 and Dieter Bartetzko, Stefan Glossmann and Gabriele Voigtländer-Tetzner, 'Die Darstellung des Bauern', Cat. Frankfurt on Main 1974, pp. 144–61 (see note 33).

70 Angela Schönberger, *Die Neue Reichskanzlei von Albert Speer*, Berlin, 1981, pp. 44–51, 143, without seeing any connection with the paintings (p. 144).

71 For more detail see the following: Herding and Mittig, *Kunst und Alltag*, pp. 7, 42–4 (see note 32).

72 Mittig, 'Faschistische Sachlichkeit', p. 368 (see note 5); Mittig 'Reklame unter dem Nationalsozialismus', pp. 164–6 (see note 16).

73 On the separation of dining and politics see Speer *Erinnerungen*, p. 53 (see note 46).

74 On other subjects apart from specifically fascist stylisation see Mittig 'Faschistische Sachlichkeit', p. 364 (see note 5): everyday objects, industrial architecture, amongst other things, were integrated in a hierarchy of artistic assignments, in which the top was occupied by representative state and party art.

75 This contradiction was even apparent in the lives of those in power: Hitler 'took note only with reluctance of the paintings glorifying the regime, compulsory exercises in duty' (Albert Speer, *Spandauer Tagebücher*, Frankfurt, Berlin and Vienna, 1975, p. 586; cf. Hellmut Lehmann-Haupt, *Art under a Dictatorship*, New York 1954, pp. 90–1), lived rather an idle life (Speer, *Erinnerungen* pp. 98–9, 102–5; see note 46) and foiled Speer's attempts to be out of the reach of Hitler's adjutant's phone calls in out of the way places (*ibid.*, pp. 95–6).

76 Eike Hennig, 'Faschistische Öffentlichkeit und Faschismustheorien', *Aesthetik und Kommunikation*, 6, 20 (1975), p. 112.

77 Schönberger *Die Neue Reichskanzlei*, p. 171 (see note 70).

78 Hans-Ernst Mittig, 'Geschichten aus der Nazi-Zeit', *Aesthetik und Kommunikation*, 7, 26 (1976), p. 107. On possible explanations from a socio-psychological standpoint see Dagmar Stahlberg and Dieter Frey, 'Konsistenztheorien', *Sozialpsychologie*, ed. Dieter Frey and Roland Wakenhut, Munich, Vienna and Baltimore, 1983, pp. 214–21.

79 Sigrun Paas, 'Verfolgt und Verführt, Kunst unterm Hakenkreuz in Hamburg', Cat. of the same title, Hamburg, 1983, p. 15.

80 Freya Mülhaupt, 'und was lebt, flieht die Norm', 'Aspekte der Nach-kriegskunst', Cat. *Grauzonen*, Berlin, 1983, p. 217.

81 Herbert von Einem, 'Opening Speech', *Kunstchronik*, 21, (1968), pp. 368–9, but which sees this function of art as being implemented at far too late a stage.

82 For instance, Carl Linfert, cited by Jürgen Weber, 'Kunst als Persilschein', *Linkskurve*, 3, 2 (1982), 27–8.

83 See the contemptuous characterizing of the 'Massengeschmack' by authors cited and discussed in Jost Hermand, 'Neuordnung oder Restauration?' *Kritische Berichte*, 12, 2 (1984), 70–2.

84 A great role was played by the stated intent to appeal to the people (Hitler, 1937, see Hinz, *Die Malerei im deutschen Faschismus*, pp. 167–8; see note 1), particularly in contrast to the lack of communication practised by the former élite (Sigrun Paas, 'Deutsche "Kunst" und "entartete" Kunst', in Cat. Hamburg, 1983 p. 22 (see note 79).

85 Also see Behne, *Entartete Kunst*, pp. 11–12 (see note 61); Cat. Hamburg, 1973/4 (see note 19) sub 1946.

86 Hilton Kramer, 'Zeichen der Leidenschaft', Cat. *Zeitgeist*, Berlin, 1982, p. 18.

87 Paas, 'Deutsche "Kunst" und "entartete" Kunst', pp. 21–3 (see note 84); Teut *Architektur*, document no. 29 (see note 21); Eberhard Lutze, 'Sinnbilder deutschen Landes', *Kunst im Dritten Reich*, A, 3 (1939), p. 224 ('handwerk-liche Güte').

88 For instance Franz Roh, 'Geschichte der deutschen Kunst von 1900 bis zur Gegenwart', *Deutsche Kunstgeschichte*, 6 Munich, 1958, p. 151.

89 Walter Bachauer, 'Der Dilettant als Genie', Cat. *Zeitgeist*, Berlin, 1982, p. 23.

90 For instance Cat. *Funktionelle Skulpturen*, Recklinghausen, 1971; Hans Heinz Holz, 'Kritische Theorie des ästhetischen Zeichens', Cat. *documenta* 5, Kassel, 1972, p. 22.

91 Hitler 1937, cited by Hinz, *Die Malerei im deutschen Faschismus*, pp. 165–70 (see note 1).

92 Brenner, *Die Kunstpolitik*, p. 36 (see note 8).

93 Pavel Liška, *Nationalsozialistische Kunstpolitik*, Berlin 1970, p. 26; Paas 1983, p. 14–15 (see note 79).

94 For examples see Cat. Hamburg, 1973–4 (see note 19), sub 1937 (Baumeister); Brenner, *Ende einer bürglichen Kunstinstitution*, pp. 25–6 (Pechstein; see note 45).

95 Brenner, *Die Kunstpolitik*, pp. 54–63 (see note 8); Wulf ed., *Kunst im Dritten Reich*, 1983, pp. 108–17 (see note 45).

96 Concerning Schmidt-Rottluff see Brenner *Die Kunstpolitik*, document no. 54 (see note 8); Cat. Hamburg 1973–4 (see note 19), sub 1941.

97 Hans-Werner Schmidt, 'Otto Dix – "Der Krieg"', Cat. Hamburg 1983 p. 116 (see note 79).

98 For instance Paas p.18 (see note 79).

99 For instance *ibid.*, p. 21. On the prohibition of art criticism which led in the same direction see Pavel Liška, 'Zur Funktion der Kunstkritik im Nationalso-zialismus', Cat. Berlin, 1978 pp. 58–64 (see note 29); Thomae, pp. 133–41 (see note 42).

100 Eugene L. Hartley and Ruth E. Hartley, *Die Grundlagen der Sozialpsycholo-gie*, 1955, 2nd German edition, Berlin, 1969, p. 351.

101 Schönberger, *Die Neue Reichskanzlei*, p. 143 (see note 70).

102 Erwin Heizmann, 'Draussen vor der Museumstür', Cat. Hamburg, 1983 pp. 106–7 (see note 79).

103 Cat. *Hans Martin Ruwoldt*, ed. Heinz Spielmann, Hamburg, 1969.

104 Lehmann-Haupt, *Art under a Dictatorship*, p. 104 (see note 75); Speer, *Erinnerungen*, pp. 39–40, 42, 49 (see note 46).

105 Cited by Weber, p. 28 (see note 82). For many similar cases see Thomae *Die Propaganda-Maschinerie*, pp. 233–336 (see note 42).

106 For instance Paul Schmitthenner, *Baukunst im neuen Reich*, München, 1934, pp. 17–18, with a generalizing metaphor.

107 Informative in this respect is Breker *Im Strahlungsfeld der Ereignisse* (see note 46).

108 Wolfgang Voight, 'Die Stuttgarter Schule und die Alltagsarchitektur des Dritten Reiches', *Faschistische Architekturen 1983*, p. 239 (see note 46).

109 Thomae, *Die Propaganda-Maschinerie* (see note 42), pp. 34–5; concerning scholars: Roh, *'Entartete' Kunst*, p. 84 (see note 37).

110 Thomae, *ibid.*, pp. 127–33.

111 Franz Roh, *Der verkannte Künstler*, Munich 1948, pp. 315–18. He argues that this banal motive gives rise to the most jumped-up examples of self-justification.

112 Teut, *Architektur*, document no. 23 (Bund Deutscher Architekten, see note 21); 'Entmachtung der Kunst', p. 103 note 83 (see note 14 werkbund); Liška, *Kunstpolitik*, p. 18 (Nationalsozialistischer Deutscher Studentenbund) (see note 93).

113 For example, Kirchner protested that he was not Jewish ('habe auch sonst ein reines Gewissen', Brenner, *Ende einer bürgerlichen Kunst-Institution*, p. 124 see note 45); Carl Hofer gave the assurance that the whole area of art was virtually 'Jew-free' (Erhard Frommhold, 'Zwischen Widerstand und Anpassung', in Cat. Berlin, 1978 p. 11; see note 29).

114 Mittig 'Faschistische Sachlichkeit', p. 368 (see note 5).

115 Concerning Expressionism: Hüneke 'Der Versuch der Ehrenrettung', pp. 51–7; (see note 29); Winfried Nerdinger, 'Versuchung und Dilemma der Avantgarde im Spiegel der Architekturwettbewerbe 1933–35', *Faschistische Architekturen*, pp. 74–80 (see note 46).

116 Brenner, *Ende einer bürgerlichen Kunst-Institution*, p. 17 (see note 45).

117 Speer, *Spandauer Tagebücher*, pp. 609–10 (see note 75); partly Breker, *Im Strahlungsfeld der Ereignisse*, p. 138 (see note 46).

118 Speer, *ibid.*, especially pp. 32–4; Bruno Paul according to Brenner *Ende einer bürgerlichen Kunst-Institution*, document no. 143 (see note 45).

119 Speer, *ibid.*, pp. 60, 74.

120 *ibid.*, pp. 41, 43–4, 97, 153, 439, 491.

121 Roh, *'Entartete' Kunst*, p. 89–90 lets phases of conformism simply result from phases of increasing repression; he ignores the system of rewards (see note 37).

122 See note 113.

123 For more detail on this theme without explicit reference to art, see Gerhard Vinnai, 'Sozialpsychologie des Faschismus', *Kindlers 'Psychologie des 20. Jahrhunderts'*, 1979, vol 1, Weinheim and Basle, 1984, pp. 593–600.

124 Merely superficial conformism was expected, see Hitler cited by Teut, *Architektur* document no. 22 (see note 21); E. Högg, 'Deutsche Baukunst – gestern – heute – morgen', *Das Bild*, 4 (1934), p. 63.

125 Dietrich Grünewald, 'Die Einfalt des "Einfältigsten"', Cat. Berlin 1978, p. 41–50 (see note 29).

126 According to Mülhaupt, Cat. *Grauzonen*, Berlin, 1983 p. 218 (see note 80). Kandinskij demanded 'innere Fügsamkeit' to the 'inneren Trieb', see Martin Damus, 'Ideologiekritische Anmerkungen' *Das Kunstwerk zwischen Wissenschaft und Weltanschauung*, ed. Martin Warnke, Gütersloh, 1970, p. 49, who refers to the usefulness of this artist-ideology for fascist motives on pp. 63–4.

127 See Peter Steck, 'Konformität', *Handwörterbuch der Politischen Psychologie*, ed. Ekkehard Lippert and Roland Wakenhut, Opladen, 1983, p. 131; for

363

further differentiation see Erich H. Witte, 'Konformität', *Sozialpsychologie*, pp. 209–13 (see note 78).

128 Wassili Luckhardt's study 'Denkmal der Arbeit/An die Freude', 1919-1920 (Helga Kliemann, *Wassili Luckhardt*, Tübingen 1973, fig. 1; Udo Kultermann, *Wassili und Hans Luckhardt*, Tübingen 1958, p. 21).

129 Former members of the Werkbund were confident that nazism could bring about a classless society (Speer, *Erinnerungen*, p. 70, see note 46).

130 Bertolt Brecht, 'Bemerkungen zum Formalismus', *Über Realismus* 2nd ed., Frankfurt on Main, 1971, pp. 62–3.

131 Hartley and Hartley *Die Grundlagen der Sozialpsychologie*, p. 212 (see note 100).

132 Cat. Hamburg, 1973/4, p. 4 of the introduction (see note 19).

133 Wolfgang Abendroth, 'Universitäten im Faschismus', *Forum Wissenschaft*, 2 (1985), p. 4.

134 Hofer (Hüneke, 'Der Versuch der Ehrenrettung', p. 52; see note 29); Kirchner (Brenner, *Ende einer bürgerlichen Kunst-Institution*, documents nos. 124, 147; see note 45); Nolde (*ibid.*, document no. 149); 'Simplizissimus' (Cat. Hamburg, 1973/4 sub 1933; see note 19); several art historians (Roh, 'Entartete' Kunst, p. 111; see note 37; Hinz, *Die Malerei im deutschen Faschismus*, pp. 27–8 see note 1); Bund Deutscher Architekten (Teut, *Architektur* document no. 23; see note 21); Werkbund (*ibid.* document no. 26).

135 For the pivotal concept of the work, see Kurt Karl Eberlein, *Was ist Deutsch in der Deutschen Kunst*, Leipzig, 1934. For a critical appraisal see Roh, 'Entartete' Kunst, pp. 83–5; see note 37, for unsuspectingly copying see Joachim Obst, *Was ist deutsch an deutscher Kunst? ... Ein Ausstellungsbericht*, Zweites Deutsches Fernsehen 24 February 1986.

136 For instance Eberlein, *ibid.*, p. 3.

137 Teut, *Architektur*, document no. 56 (see note 21). Even Eberlein, p. 49 believed he was hardly in a position to name the inner characteristics (see note 135).

138 The chain of these attempts is never ending but does not produce anything new, see Christos M. Joachimides, 'A Gash of Fire Across the World', Cat. *German Art in the 20th Century*, London 1985, pp. 9–12.

139 Roh, 'Entartete' Kunst, pp. 9, 49 (see note 37); Cat. *Entartete Kunst, Bildersturm vor 25 Jahren*, Munich, 1962, *passim*. This cliché still dominated Cat. Berlin, 1978, p. 8, 16 (see note 29) and even *Entmachtung der Kunst*, p. 9 (see note 14). Art, that is 'real' art, thereby appears as genuinely progressive, but subject to repression. This cliché is put forward most vehemently when it is not only a question of confusing the issue of the role of artists but also of assigning fellow-traveller roles to oblivion, as in the case of Will Grohmann (Cat. *Kunstdiktatur gestern und heute*, Berlin, 1963, pp. 33; for more about Grohmann see note 105 above and Hermand, 'Neuordnung oder Restauration?' p. 69 (see note 83).

140 Paul Ortwin Rave, *Kunstdiktatur im Dritten Reich*, Hamburg, 1949, p. 7. Roh, 'Geschichte der deutschen Kunst, p. 153–4 (see note 88) and 'Entartete' Kunst, p. 101–04 (see note 37), refers only to persecuted artists; similarly the information board at the exhibition *German Art in the 20th Century*, London, 1985.

141 Perhaps it was such as they that Roh, 'Entartete' Kunst referred to under the heading 'cheerers-on' (p. 90) but this expression does not characterise these artists as protagonists. They are also ignored in the title of the exhibition *Widerstand statt Anpassung*, Karlsruhe, 1980.

142 Rave, *Kunstdiktatur* p. 49 (see note 140); Hinz, *Art in the Third Reich*, p. 23 (see note 10); Fischer-Defoy, 1985; *Entmachtung der Kunst*, p. 145 (see note 44). An example: 'I worked in supreme freedom' (Breker, p. 97; see note 46).

143 Hans-Jochen Gamm, *Der braune Kult*, Hamburg, 1962.

144 Goebbels, cited by Teut, *Architektur*, document no. 52 (see note 21), concerning theatre; Hitler cited by Hinz, *Die Malerei im deutschen Faschismus*, p. 144 (see note 1).

145 Hinz, *Art in the Third Reich* (see note 10); Wolbert *Die Nackten und die Toten* (see note 14).

146 Nerdinger, 'Versuchung und Dilemma', p. 86 (see note 115).

147 Teut, *Architektur*, document no. 52 (see note 21). Also publications such as Schmitthenner, *Baukunst* have this character (see note 106).

148 Bettina Feistel-Rohmeder, 'Was die deutschen Künstler von der neuen Reigierung erwarten', March, 1933 (cited by Teut, *Architektur* document no. 14 (see note 21); Hinz *Art in the Third Reich*, pp. 27–8 (see note 10).

149 Wolbert, *Die Nackten und die Toten*, pp. 185–6 and especially pp. 230–1 (see note 14).

150 Georg Bussmann, ' "Degenerate art" – A look at a useful myth', in Cat. London, 1985, p. 116 (see note 138).

151 Brenner, *Die Kunstpolitik*, p. 77 (see note 8); Herding and Mittig, *Kunst und Alltag*, p. 36 (see note 32) and note 80.

152 The reliefs reflect the *specific* polarisation of man and woman utilised by Wilhelm von Schramm, *Neubau des deutschen Theaters*, Berlin, 1934, p. 45 (cf. Brenner, *Die Kunstpolitik*, p. 98; see note 8).

153 Lutze, 'Sinnbilder' p. 218 (see note 87); Schönberger, *Die Neue Reichskanzlei*, pp. 142–3 (see note 70).

154 Cf. Schönberger, *ibid.*, p. 144 and note 75.

155 Speer, *Erinnerungen*, pp. 157–8 (see note 46).

156 Bund Deutscher Architekten, 1933, cited by Teut, *Architektur*, document no. 23 (see note 21); Goebbels, cited by Roh, *'Entartete' Kunst*, p. 41 (see note 37); cf. *ibid.*, pp. 46–7; Cat. Hamburg 1973/4(see note 19) sub 1939. Taking a cliché from the past, the established Nazi state was compared to a work of art (Liška, *Kunstpolitik*, p. 27 note 76; see note 93).

157 Cf. Rave, *Kunstdiktatur*, p. 36 (see note 140); Lehmann-Haupt *Art under a Dictatorship*, pp. 45–61 (see note 75); Liška, *Kunstpolitik*, note 75, 76 (see note 93); Hinz, *Die Malerei im deutschen Faschismus*, pp. 9–10 (see note 1).

158 Speer, *Erinnerungen*, p. 112 (see note 46). He wanted to remain an architect (Speer, *Spandauer Tagebücher*, p. 610; see note 75). That Speer represented a specific type found among the artists in power was recognised by Gert H. Theunissen, when in one of his complicated tracts he referred to Speer as a 'ruling technician', an 'Ingenieur-Minister' (Teut, *Architektur*, pp. 115–16; see note 21).

159 Rave, *Kunstdiktatur*, p. 33 (see note 140). Additional painters, agitators and officials were Wolfgang Willrich (Hans-Werner Schmidt, 'Die Hamburger Kunsthalle in den Jahren 1933–1945', Cat. Hamburg, 1983, p. 56; see note 79) and Hans Adolf Bühler (Liška, *Kunstpolitik*, p. 14; see note 93).

160 Brenner, *Die Kunstpolitik*, pp. 57–8 (see note 8).

161 *ibid.*, pp. 58, 60 for the period up until 1935 (p. 62).

162 This is suggested by Bussmann, 'Degenerate art', pp. 122–3 (see note 150).

163 *Meldungen aus dem Reich, Auswahl aus den geheimen Lageberichten des Sicherheitsdienstes der SS 1939–1944*, ed. Heinz Boberach, Neuwied and Berlin, 1965; Thomae, *Die Propaganda-Maschinerie*, pp. 18, 51, 73, 75 which lacks a fundamental assessment of the exhibition 'Degenerate Art' (pp. 339–42; see note 42).

164 See Vinnai, 'Sozialpsychologie', pp. 598, 599 (see note 123). Merker, *Die bildenden Künste*, p. 27 narrowed down to 'kulturelles Feindbild' (see note 41).

165 On the question of this double target see Brenner, *Die Kunstpolitik*, p. 13 (see note 8); cf. Hinz, *Die Malerei im deutschen Faschismus*, p. 48 (see note 1); at

the same time modern art served as a substitute for anti-capitalist tendencies that had already been awakened but in no way followed. The 'Degenerate Art' campaign – and the implicit anti-Jewish image contained in it – facilitated a bridging of the conflict between the 'Völkische' and other powers (see note 59 above.) Struwe, 'Nationalsozialistischer Bildersturm', p. 122 further states that in 1936 a consolidation of the system had been accomplished (however, cf. note 163 above for when unrestrained exercise of power began; see note 3). The end of rivalry, e.g. between Rosenberg and Goebbels, was a prerequisite of the campaign but did not require this excess.

166 Struwe, ibid., pp. 133–4; Hinz, Art in the Third Reich, p. 28 (see note 10).

167 Guidebook Entartete Kunst, ed. Fritz Kaiser, Berlin, 1937, reprint Munich, 1969, p. 13.

168 Before 1933; see Liška, Kunstpolitik, p. 11, 15 (see note 93).

169 See especially Cat. Hamburg, 1983 (see note 79) and Fischer-Defoy since 1984.

170 Struwe, 'Nationalsozialistischer Bildersturm', p. 122 (see note 3).

171 Barlach fundamentally rejected such a distinction: cited by Brenner, Ende einer bürgerlichen Kunst-Institution, document no. 15 (see note 45).

172 Concerning Paul Schultze-Naumburg: Robert Scholz, Paul Schultze-Naumburg, Kunst im Dritten Reich, A, 3 (1939), pp. 214–15; Speer, Erinnerungen, p. 77 (see note 46); concerning Speer ibid. p. 201 concerning Paul Schmitthenner: Brenner, Die Kunstpolitik, p. 38 (see note 8); concerning Wolfgang Willrich: Roh, 'Entartete' Kunst, p. 77 (see note 37); generel: Brenner, Die Kunstpolitik, pp. 55–6; Thomae, Die Propaganda-Maschinerie, p. 75 (see note 42); Hüneke, 'Der Versuch der Ehrenrettung', p. 51 (see note 29). For parallels in archeaology see Cat. Bendorf, p. 32 (see note 59).

173 Particular attention is paid to the conflict of 1911, although the fronts were not as clear then as is frequently supposed, e.g. Paas, 'Verfolgt und Verführt', p. 17 (see note 79); an in-depth analysis has recently been published: Ron Manheim, Im Kampf um die Kunst Een onderzoek naar de discussie in Duitsland over contemporaine knust in het jaar 1911, Doctoraalscriptie, Nijmegen, 1984.

174 Cat. Hamburg, 1983 (see note 79).

175 Entmachtung der Kunst, 1985 (see note 15).

176 Brenner, Ende einer bürgerlichen Kunst-Institution, p. 7, cf. p. 18 (see note 45); Hüneke, pp. 52–3, 73 (see note 29). Schlemmer remarked on the seeming incapability – particularly of artists – for solidarity; cited by Cat. Hamburg 1973/4 (see note 19) sub 1933: 'Kein' Stimm erhebt sich'.

177 His 'intellectually compelling view of the world' is acclaimed by Joachimides, Cat. London, 1985, p. 9 (see note 138).

178 Cat. Hamburg 1973/74 (see note 19) sub 1933; Frommhold, Cat. Berlin, 1978, p. 11 (see note 113).

179 See Schlemmer and Kirchner, cited by Frommhold ibid., pp. 11, 12; Hans M. Wingler, 'Ein Sohn aus bürgerlicher Familie', Cat. Berlin, 1978, p. 73 (see note 29).

180 Horst Geyer, Über die Dummheit, 11th edition, Wiesbaden, 1984, pp. 213–80. Looking back at his own life as a member of the SS, Geyer himself proves a certain kind of Fachidiotie. Cf. Benno Müller-Hill, Todliche Wissenschaft, Reinbek, 1984, pp. 41, 85, 151.

181 This mentality has been manifested once again in Künstlerpech/Künstlerglück, ed. Andreas Seltzer and Katharina Meldner, Berlin, 1985.

182 Discerning in this connection is Speer, Erinnerungen, p. 46 (see note 46); see also Joachim C. Fest, Das Gesicht des Dritten Reiches, Munich 1963, pp. 271–2.

183 According to Breker, Im Strahlungsfeld, p. 140 (see note 46), it was not an

immediate reference to art, but to Ziegler's attempt to negotiate with the opponents of war.

184 Breker, *ibid.*, p. 333; similarly, Albert Speer, *Spandauer Tagebücher*, Frankfurt on Main, Berlin and Vienna, 1975, p. 51.

185 Frommhold, Cat. Berlin, 1978, p. 11 (see note 113).

186 How metaphors from biology and medicine continuously flourished after 1945 is shown by Roh, 'Geschichte der deutschen Kunst', p. 151 (see note 88).

187 See Hans-Ernst Mittig, *Dürers Bauernsäule*, Frankfurt on Main, 1984, pp. 48–9. A durable because useful ideology combines emotion with irrationality; see for example Behne's ironic question 'Should artists think?' (*Entartete Kunst*, p. 36; see note 61). In this connection the role of Expressionism should be discussed, whose forms may have been rejected by the Nazi régime but whose irrationality and mysticism rightfully belong in the history of the causes of German fascism; John Willett 1974, cited by Speer, Arndt, Koch, Larsson, *Albert Speer*, p. 8 (see note 39).

188 André Glucksmann, *Die Macht der Dummheit*, Stuttgart, 1985, p. 12.

189 Mülhaupt, Cat. *Grauzonen*, Berlin, 1983, p. 220, cf. p. 218 (see note 80). Similarly generalising is Roh, 'Entartete' Kunst, p. 44: 'Der ins Politische abgeglittene Maler Adolf Hitler'. Similar, less radically formulated statements are analysed by Hermand, 'Neuordnung oder Restauration', pp. 69–70 (see note 83).

190 On the disregard of social consciousness *after* 1945 see Hermand, *ibid.*, p. 77.

191 See Mittig, 'Die Reklame als Wegbereiterin' pp. 42–5 (see note 53); and earlier, Herding and Mittig, *Kunst und Alltag*, p. 48 (see note 32). Joachim Petsch, *Baukunst und Stadtplanung im Dritten Reich*, Munich and Vienna, 1976 underestimates the importance of private patrons – see pp. 150–1, 155–9.

192 See Struwe's reference to collaborators in the art galleries in 'Nationalsozialistischer Bildersturm', p. 135 (see note 3).

193 Material on the following can be found in Harald Justin, *'Tanz mir den Hitler', Kunstgeschichte und (faschistische) Herrschaft*, Münster, 1982 and Roh, *'Entartete' Kunst*, pp. 111–14 (see note 37).

194 For instance Gert von der Osten, 'Das Gesicht des Feldherrn', *Kunst und Volk*, 5 (1937), 115; Hans Weigert, 'Die Bedeutung des germanischen Ornaments, *Festschrift Wilhelm Pinder*, Leipzig, 1938, p. 113. Cf. Brenner, *Die Kunstpolitik*, p. 71 (see note 8).

195 For a recent publication on this see particularly Cat. Hamburg, 1983 (see note 79).

196 For instance Wilhelm Pinder, cited by Cat. Berlin, 1978 p. 52 (see note 29). Hinz *Die Malerei im deutschen Faschismus*, p. 9 points to the origin as an ideology of artists (see note 1).

197 A striking instance, for example, in the selection of information and the examples but also in the interpretation of individual works such as Lehmbruck's *Fallen Man, 1915/16* (for more detail see Dietrich Schubert, *Die Kunst Lehmbrucks*, Worms, 1981, pp. 185–211) is Wieland Schmied, 'Points of Departure and Transformations in German Art 1905–1985', Cat. London, 1985, p. 48 and Fig. 40 (see note 138); Feininger's 'Cathedral of Socialism' is cheated of an important part of its name (p. 52, Fig. 48) as was already the case in Hans M. Wingler, *Das Bauhaus*, 2nd edition, Bramsche, 1962, p. 38.

12 PATTERNS OF POST-WAR PATRONAGE

1 The separation of Germany into two countries with different political systems as a consequence of the National Socialist period and World War II naturally also brought about a basic restructuring of cultural activities. And the

367

following remarks can thus only reasonably apply to the region the author is directly familiar with, in other words only to the problematic of sponsoring the arts in the Federal Republic of Germany. Having a different orientation, the sponsorship mechanism in the German Democratic Republic would need to be examined separately.

2 *Constitution for the Federal Republic of Germany* of 23 May 1949, Article 30, General Regulations concerning the separation of authority between the Federal Government and the States.

3 *ibid.*, Article 70.

4 The authority of the Federal Government is mainly restricted to negotiations abroad and to comprehensive activities: see below.

5 Jakob Burckhardt, *Weltgeschichtliche Betrachtungen*, Collected Works, 4, Darmstadt, 1956, p. 70.

6 Kurt Hentschel, 'Financing the Arts in the Federal Republic of Germany: From the viewpoint of a "Land"', in John Myerscough, ed., *Funding the Arts in Europe*, Studies in European Politics 8, London, 1984, p. 26.

7 *ibid.*

8 Quoted from 'documenta, Idee und Institution', *Tendenzen. Konzepte. Materialien*, ed. Manfred Schneckenburger, Munich, 1983, p. 34.

9 *ibid.*, p. 37.

10 'Was tut der Bund für die Kultur, Antworten auf zwei große Anfragen', ed., Press and Information Service of the Federal Government, Bonn, 1985, p. 13.

11 Lothar Romain, ed., *Kunstfonds e.V., Modell einer Förderung*, Cologne, 1986, p. 9.

12 Quoted from *Privatinitiative Kunst*, Grundsatzprogramm.

13 BERLIN 1870–1945

1 R. E. Park, E. W. Burgess and R. D. McKenzie, *The City*, Chicago, 1925, pp. 45–6, quoted by Andrew Lees, 'The Metropolis and the Intellectual', in Anthony Sutcliffe, *Metropolis 1890–1940*, London, 1984, p. 74.

2 See G. Masur, *Das kaiserliche Berlin*, Munich, Vienna, Zürich, 1971, p. 90.

3 E. Edel, *Berlin W. Ein paar Kapitel von der Oberfläche*, Berlin, 1906, in Eberhard Roters, 'Emporgekommen', *Berlin um 1900*, exhibition catalogue, Berlin, 1984, p. 54.

4 Robert Walser, 'Die kleine Berlinerin', *Die neue Rundschau*, 20, 3 (September 1909), 1357–8.

5 Bruno Taut, letter to Max Taut, 2 March 1902, private collection, Lehnitz.

6 Robert Walser, 'Guten Tag, Riesin!', *Die neue Rundschau*, 18, 5 (May 1907), 640.

7 Georg Simmel, *Die Großstadt und das Geistesleben*, translated Edward A. Shils as 'The Metropolis and Mental Life', in Donald N. Levine, ed., *Georg Simmel on Individuality and Social Forms*, Chicago and London, 1971, p. 329.

8 Deutsche Gartenstadtgesellschaft, 'Programm', quoted in Hans Kampffmeyer, *Die Gartenstadtbewegung*, Leipzig, 1909, p. 47.

9 Georg Simmel, *Philosophie des Geldes*, Munich and Leipzig, 1922, p. 449. Translation from Roy Pascal, *From Naturalism to Expressionism: German Literature and Society 1880–1918*, London, 1973, p. 154.

10 Friedrich Nietzsche, 'Der Wille zur Macht', *Gesammelte Werke*, vol. 19, Munich, 1926, p. 229.

11 Friedrich Nietzsche, 'Also Sprach Zarathustra', *Werke: Kritische Gesamtausgabe*, 6, volume 1, Berlin, 1968, p. 174.

12 Georg Heym, 'Berlin', in Wolfgang Rothe, ed., *Deutsche Großstadtlyrik vom Naturalismus bis zur Gegenwart*, Stuttgart, 1973, p. 108.

13 Alfred Wolfenstein, 'Über allen Zaubern', in Fritz Martini, ed., *Prosa des Expressionismus*, Stuttgart, 1970, pp. 158–9.

14 Friedrich Nietzsche, 'Also sprach Zarathustra', pp. 59–60.

15 Bruno Taut, 'Die grosse Blume', *Die Auflösung der Städte*, Hagen, 1920.

16 Bruno Taut, letter to Crystal Chain, 5 October 1920, in Iain Boyd Whyte, *The Crystal Chain Letters*, Cambridge MA, 1985, p. 155.

17 Max Beckmann, *Schöpferische Konfession*, Berlin, 1920, in *Berlin: A Critical View – Ugly Realism 20s–70s*, exhibition catalogue, London 1978, p. 14.

18 Martin Wagner, 'Neue Wege', *Wohnungswirtschaft*, 1, 8 (1924), 78.

19 Martin Wagner, 'Wohnungsbau in Großbetrieb', *Wohnungswirtschaft*, 1, 4 (1924), 30.

20 Bruno Taut, *Die neue Baukunst in Europa und Amerika*, Stuttgart, 1929, p. 7.

21 See Ludovica Scarpa, 'Martin Wagner oder die Rationalisierung des Glücks', in *Martin Wagner: 1885–1957*, exhibition catalogue, Berlin, 1986, pp. 13–14.

22 See Theo Hilpert, ed., *Hufeisensiedlung Britz 1926–1980*, Berlin, 1980, p. 85.

23 Bruno Taut, *Die neue Baukunst*.

24 Fred Forbat, 'Wohnform und Gemeinschaftsidee', *Wohnungswirtschaft*, 6, 10 (1929), 141.

25 Friedrich Nietzsche, in Alois Riehl, *Nietzsche als Künstler und Denker* (1897), Stuttgart, 1909, p. 54.

26 Alexander Schwab, *Das Buch vom Bauen* (1930), Düsseldorf, 1973, p. 67.

27 Siegfried Kracauer, *Das Ornament der Masse: Essays*, Frankfurt on Main, 1977, p. 54.

28 Franz Hessel, *Ein Flaneur in Berlin* (new edition of *Spazieren in Berlin*, 1929), Berlin, 1984, pp. 145–6.

29 Siegfried Kracauer, *Die Angestellten*, Frankfurt on Main, 1930, in *Berlin im Abriss*, exhibition catalogue, Berlin, 1981, p. 38.

30 Manfredo Tafuri, *Architecture and Utopia: Design and Capitalist Development*, Cambridge MA and London, 1976.

31 See, for example, Armand Weiser, 'Ein neuer Stil?', *Die Bau- und Werkkunst*, 6, (1929–30), 1–16.

32 Ludwig Sterneaux, 'Berlin hat die nackten Fassaden satt', *Der Montag*, supplement, 16 June 1930. For an account of the parallel reaction in literature against Berlin Modernism, see Jochen Meyer, ed., 'Berlin-Provinz: Literarische Kontroversen um 1930', *Marbacher Magazin*, 35 (1985).

33 Nikolaus Pevsner, *An Outline of European Architecture*, seventh edition, Harmondsworth, 1963, p. 411: 'Of the German buildings for the National Socialist Party in Munich and for the Government in Berlin the less said the better.'

34 Christos Joachimides, 'A Gash of Fire Across the World', *German Art in the 20th Century*, exhibition catalogue, London 1985, p. 11: 'One thing was very clear to us from the beginning: that which is denoted by the term "Nazi Art" would be excluded from our exhibition.'

35 Gerdy Troost, *Das Bauen im neuen Reich*, third edition, Bayreuth, 1941, p. 10.

36 *ibid.*, p. 73.

37 Adolf Hitler, Report on the conference of 19 September 1933, in Werner Durth, *Deutsche Architekturen: Biographische Verflechtungen 1900–1970*, Braunschweig, 1986, p. 131.

38 Adolf Hitler, Directive of 25 June 1940, in Hans J. Reichhardt and Wolfgang Schäche, *Von Berlin nach Germania*, exhibition catalogue, Berlin 1985, p. 32.

39 Thomas Wolfe, *You Can't Go Home Again* (1940), Harmondsworth, 1984, pp. 571–2.

40 Martin Wagner, letter to Richard Döcker, 6 June 1950, in Durth, *Deutsche Architekturen*, p. 353.

41 See, for example, *Berlin a Critical View*.
42 Christos M. Joachimides, *German Art in the 20th Century*, p. 12.
43 Wilhelm Hausenstein, *Ein Stadt auf nichts gebaut*, Berlin, 1984, p. 10 (originally the chapter 'Berlin' in *Europäische Hauptstädte*, Erlenbach, 1932).

14 THE CENTRALITY OF THE CITY IN SOCIAL THEORY

1 Marianne Weber, *Max Weber: A Biography*, New York, 1975, pp. 285–7.
2 *ibid.*
3 Raymond Williams, *The Country and the City*, New York, 1973, p. 217.
4 Max Weber, *The City*, New York, 1958.
5 George Gissing, *Nether World*, London, 1889; cited in Williams, pp. 222–3.
6 Charles Tilley, *Big Structures, Large Processes, Huge Comparisons*, New York, 1984, p. 50.
7 Ferdinand Tönnies, *Community and Association*, London, 1955, pp. 33–4, 64–5; Emile Durkheim, *The Division of Labor in Society*, New York, 1964.
8 Tilly, *Big Structures*, p. 11.
9 Cited in David Frisby, *Georg Simmel*, London, 1984, p. 34.
10 Louis Wirth, 'Urbanism as a Way of Life', *American Journal of Sociology*, 44 (July 1938).
11 Cited in Williams, *The Country and the City*, p. 215.
12 Cited in *ibid.*, pp. 215–16.
13 Tilly, *Big Structures*, p. 23.
14 There is a useful discussion of dedifferentiation in Charles Tilly, 'Reflections on the History of European State-Making', in Tilly, ed., *The Formation of National States in Western Europe*, Princeton, 1975.

15 THE PAINTED CITY AS NATURE AND ARTIFICE

1 Recognition of the paradoxical interface between artifice and nature in modern civilisation surfaces in its specifically modern form during the Romantic era. Heinrich von Kleist's *Über das Marionettentheater*, 1801, and Charles Baudelaire's *Le Peintre de la Vie Moderne*, 1863, are two key texts for an examination of this issue, which is explored more fully in my forthcoming study, *The Expressionist Dilemma: Primitivism or Modernity?* (in preparation).
2 See Peter Gay, *Freud Jews and Other Germans, Masters and Victims in Modernist Culture*, Oxford 1978, p. 178.
3 See in particular, Georg Mosse, *The Crisis of German Ideology*, London, 1966; and Fritz Stern, *The Politics of Cultural Despair*, Berkeley and Los Angeles, 1961.
4 A literal translation of these German catch-phrases would be: Natural medicines, Land Reform, Therapy with light and air. All translations in the text are by the author unless otherwise indicated.
5 'Eine Erneuerung der körperlichen und geistigen Volkskraft durch Aufklärung über die Naturgesetze … Auf diese Grundlage fordert der *Deutsche Bund für Lebensreform* … Selbsterziehung zur Neugestaltung des persönlichen Lebens … zur endlichen Einrichtung einer wircklichen, menschlichen Kulturgemeinschaft.' *Der Mensch*, 13, 52 (1906). Quoted in Frecot, Geist, Kerbs, *Fidus 1868–1948, Zur ästhetischen Praxis bürgerlicher Fluchtbewegungen*, Munich, 1972, p. 55.
6 'In Eden Wird kein Alkoholausschank geduldet … kein Tabakladen, kein Vertrieb von Schmutzliteratur, kein modernes Kino, kein Tingeltangel, kein Wettbureau, kein Spielklub auftun … Alle derartigen Betriebe würden schon

an der Grenze Edens zurückgewiesen werden.' Walter Eberding, '35 Jahre Obstbausiedlung Eden', in *Biologische Heilkunst*, 17 (1928). See Frecot, Geist, Kerbs, *Fidus 1868–1948*, p. 37.

7 'Eigentlich ist heute der Mensch nur Kopf, ja sogar Gesicht – denn von dem Übrigen sieht man ja nichts.' Heinrich Pudor, 'Nackende Menschen, Jauchzen der Zukunft', in *Dresdner Wochenblätter*, 1893, p. 23f.

8 'Der Mensch muß lernen sich als Pflanze zu betrachten – dann wird er schon wieder wachsen.' *ibid.*, p. 40.

9 Again German catch-phrases literally translated as 'Sunworship' and 'Nudist movement'.

10 Frecot, Geist, Kerbs, *Fidus 1868–1948*, p. 15.

11 'Surrogaten, Imitationen ... als ob die Natur, die diese oberflächlichen kennen, nicht ausschließlich von Menschenhand geformte Natur wäre. Als ob alle Kultur, alle Menschenarbeit nicht auch Natur wäre.' August Endell, *Die Schönheit der großen Stadt*, 1908, p. 8.

12 'Erst dann könnte es dahin kommen, daß die Schönheit der Stadt ein selbstverständliches Gut wird wie die Schönheit der Berge, der Ebene, der Seen, daß die Kinder im sicheren Besitze dieses Gut aufwachsen, so wie wir aufgewachsen sind im sicheren Besitz landwirtschaftlicher Schönheit.' *ibid.*, p. 12.

13 'Darum ist Heimat nichts Festes, Unwandelbares, sondern ein Werdendes stetig sich Änderndes und von unserem Leben und vor allem unserem Anschauen abhängig.' *ibid.*, p. 3.

14 'Die wahrhaftige Liebe zum Vaterland, die leidenschaftliche Liebe zum Heute und Hier ... Nur immer neue Versuche, das Empfundenen zu sagen, können helfen, die Verwirrung zu beiseitigen und in diesen Dingen ein einheitliches, nationales Fühlen entstehen zu lassen.' *ibid.*, p. 12.

15 Gustav le Bon, *Psychologie des Foules*, Paris, 1895, translated into German in 1895 under the title *Massenpsychologie*, and reviewed by Georg Simmel in *Die Zeit*, 5 (23 November 1985).

16 *Berliner Illustrierte Zeitung*, August 1913.

17 'Der nackte Mensch in der Landschaft reflektiert als Ideal die Einheit im Natürlichen, der Mensch in den Straßen der Großstadt zeigt seine Entfremdung, sein Unbehaustsein.' Wolf-Dieter Dube, 'Kirchner's Bildmotive in Beziehung zur Umwelt', in *Ernst Lutwig Kirchner 1880–1938*, exhib. cat. Nationalgalerie Berlin, November 1979-January 1980.

18 Illustrated in Georg Reinhardt, *Die Frühe Brücke. Beitrag zur Geschichte und zum Werk der Dresdner Künstlergruppe Brücke der Jahre 1905–1908*, Brücke Archiv, Heft 9–10, 1977–78, p. 23.

19 See Bernd Hünlich, 'Heckel und Kirchners verschollene Plakatenentwürfe für die Internationale Hygiene-Ausstellung, Dresden 1911', in *Dresden Kunstblätter 1984*, 5, p. 145f.

20 See Paul Rees, Edith Buckley, Ada Nolde and die Brücke. 'Bathing Health and Art in Dresden 1906–1911', in *German Expressionism in the UK and Ireland*, ed. Brian Keith Smith, University of Bristol, 1985.

21 Hünlich, 'Heckel und Kirchners verschollene Plakatenentwürfe', p. 147. The archer motif also features in Max Pechstein's poster design for the first exhibition of the *Neue Sezession*, at the Galerie Maximillian Macht, in May 1910. A letter from Kirchner to Heckel dated *c*. June 1910 (Annemarie Dube-Heynig, *Ernst Ludwig Kirchner Postkarten und Briefe an Erich Heckel im Altonaer Museum in Hamburg*, Cologne, 1984, p. 257), shows the archer motif in a depiction of the martyrdom of St. Sebastian.

22 Postcards from Erich Heckel in the collection of the Altonaer Museum Hamburg dated 11 August 1910 and 2 October 1910 respectively depict scenes of boomerang throwing and archery.

23 In 1911 August Macke also produced a series of paintings with Red Indian themes; for example, *Reitende Indianer* and *Indianer beim Zelt*.

24 'Die Domestikation (die 'Kultur' des Menschen) geht nicht tief ... wo sie tief geht, ist sie sofort Degenerenz (Typus: der Christ). Der 'wilde' Mensch (oder moralisch ausgedrückt: der bose Mensch) ist eine Rückkehr zur Natur – und in gewissem Sinne, seine Wiederherstellung, seine Heilung von der 'Kultur'.' Friedrich Nietzsche, *Der Wille zur Macht*, Stuttgart, 1964, p. 461f.

25 Frecot, Geist, Kerbs, *Fidus 1868–1948*, p. 51.

26 See for example, Ernst Ludwig Kirchner's paintings *Czardatänzerinnen*, 1908/20, Gordon, 1968, nr. 58, and *Drahtseiltanz*, 1909, Gordon, 1968, nr. 69.

27 Georg Simmel, 'Die Großstadt und das Geistesleben' in *Jahrbuch der Gebe-Stiftung zu Dresden*, 1903, p. 14.

28 Alfred Kubin, *Die Andere Seite*, Munich, 1909.

29 *ibid.*, edition Spangenberg im Ellermann Verlag, Munich, 1975, p. 277.

30 Ludwig Meidner, 'Anleitung zum Malen von Großstadtbildern', in *Kunst und Künstler*, 12 (1914), p. 299f.

31 Ernst Loewenson, lecture 1909/10, 'Die Dekadenz der Zeit und der Aufruf des Neuen Clubs'. Unpublished lecture discussed in Gunter Martens, 'Georg Heym und der Neue Club', in *Georg Heym Dokumente zu seinem Leben und Werk*, ed. K. L. Schneider and G. Burckhardt, vol. 4, 1968.

32 See Matthias Eberle, *Max Beckmann: Die Nacht, Passion ohne Erlösung*, Frankfurt, 1984.

33 See R. J. Evans, *The Feminist Movement in Germany 1894–1933*, London, 1976.

34 See in particular, Otto Conzelmann, *Der Andere Dix: Sein Bild vom Menschen und Krieg*, Stuttgart, 1983. To a certain extent Matthias Eberle confirms this reading of Dix's 'political' works in his book *World War One and the Weimar Artists: Dix, Grosz, Beckmann, Schlemmer*, London, 1985, p. 22f.

16 TOWN PLANNING AND ARCHITECTURE IN BERLIN

1 Otto Bartning, 'Ketzerische Gedanken am Rande der Trümmerhaufen' (Heretical Thoughts on the Edge of the Heap of Rubble), *Frankfurter Hefte, Zeitschrift für Kultur und Politik*, 1, 1, (April 1946), p. 64.

2 'Voices for Reconstruction. An appeal', *Baukunst und Werkform*, 1/2 (1947/1949), p. 29. It is worth quoting the appeal in full:

> The collapse has destroyed the visible world in which we live and work. With a feeling of liberation we believed at the time we could go back to work again. Today, 2 years later, we recognize how much the visible collapse is only an expression of the spiritual breakdown, and we could persist in desperation. We have been referred back to the heart of matters, from there the tasks must be newly grasped. All the people on earth are confronted with this task, for our people, however, it will be decided whether it is to be or not to be. But we, the creative, have been entrusted in conscience with building the new visible world of our life and our work. In this responsibility we call for the following:
>
> 1 When they are built, the large towns must become a structured assemblage of intrinsically viable, easy-to-grasp localities; the old centre of town must gain new life as the cultural and political heart.
>
> 2 The destroyed heritage must not be historically constructed, it can only arise in new form for new tasks.
>
> 3 In our country towns with their old buildings and streets – the last visible heralds of German history – it is necessary to find a living unity of the old structure and modern residential and industrial buildings.
>
> 4 The complete upheaval also requires planned construction of Germany's villages.

5 For residential buildings and our public buildings, for furniture and appliances we are looking for the simple and valid instead of over-specialisation or the stunted form of necessity. For only the simple and valid can be used in many ways.

Only with collective effort, only by working in shops and shop communities can the building succeed. From the spirit of the victims we call all people of good will.

3 Hans Scharoun, for the exhibition 'Berlin Plans', in *Neue Bauwelt*, 10, (1946), p. 3.

4 All three quotes according to Max Guther, Rudolf Hillebrecht, Heinz Schmeissner, Walter Schmidt in conversation with Werner Durth. 'I cannot conceive of myself as being outside the course of history to which I am bound.' 'Memories of the reconstruction of the Federal Republic: backgrounds, models, plans', Stadtbauwelt, 72, 72 (No. 8 of *Bauwelt*) (25 December 1981), pp. 346–80 (2128–2162), quotation on pp. 369, 370 (2151, 2152).

5 *Bauwelt*, Berlin (1957), p. 972.

6 Hans Scharoun, lecture on the occasion of the bestowal of the Erasmus Prize in 1970. Quoted from Edgar Wisniewski, 'Hans Scharoun's Last Work for Berlin.

A report on the Finished Building', *Bauwelt*, 70, 1 (5 January 1979), p. 15.

7 Reinhard Gieselmann, Oswald Mathias Ungers, 'On a new architecture', In Ulrich Conrads, *Programme und Manifeste zur Architektur des 20. Jahrhunderts*, Gütersloh, Berlin, Munich, 1964, pp. 158–9.

BIBLIOGRAPHY

Wolfang Herrmann, *Deutsche Baukunst des 19. und 20. Jahrhunderts*, Part 1: Breslau, 1932, Parts 1 and 2: Basle and Stuttgart, 1977. *Neue deutsche Architektur*, Stuttgart, 1956. *Planen und Bauen im neuen Deutschland*, Cologne, 1960.

Ulrich Conrads and Werner Marschall, *Neue deutsche Architektur 2*, Stuttgart, 1962.

Alfred Simon, *Architecture in Germany/Bauen in Deutschland*, Essen, 1969. Wolfgang Pehnt, *Neue deutsche Architektur 3*, Stuttgart, 1970.

Paolo Nestler, Peter M. Bode, *Deutsche Kunst seit 1960, Architektur*, Munich, 1976.

Joachim Petsch, *Baukunst und Stadtplanung im Dritten Reich*, Munich, 1976. Heinrich Klotz, *Architektur in der Bundesrepublik*, Frankfurt and Berlin, 1977.

Wolfgang Pehnt, *Architektur*, in Erich Steingräber, *Deutsche Kunst der 20er und 30er Jahre*, Munich, 1979.

Helge Bofinger, Margret Bofinger, 'Architektur in Deutschland', *Das Kunstwerk*, 32, 2–3, 1979.

Hartmut Frank, Trümmer, 'Traditionelle und moderne Architekturen im Nachkriegsdeutschland', Bernhard Schulz, *Grauzonen, Farbwelten, Kunst und Zeitbilder 1945–1955*, exhibition catalogue, Berlin 1983.

17 REPRESENTING BERLIN: URBAN IDEOLOGY AND AESTHETIC PRACTICE

1 Christos M. Joachimides, 'A Gash of Fire Across the World', in Joachimides, Rosenthal, Schmied, eds., *German Art in the 20th Century: Painting and Sculpture 1905–1985*, cat. London, 1985, p. 11.

2 The suggestion that 'neoexpressionism' is a misnomer and that it be replaced

by 'pseudoexpressionism' was made by several critics in the early 1980s. Craig Owens, for example, wrote: 'In "Neo-Expressionism," however – but this is why this designation must be rejected – Expressionism is reduced to convention, to a standard repertoire of abstract, strictly codified signs for expression. Everything is bracketed in quotation marks; as a result, what was (supposedly) spontaneous congeals into a signifier: "spontaneity"',' "immediacy" . . . The pseudo-Expressionists retreat to the pre-Expressionist simulation of passion; they create illusions of spontaneity and immediacy sought by the Expressionists as illusions, as a construct of preexisting forms.' Craig Owens, 'Honor, Power and the Love of Women', *Art in America*, 71 (January 1983), 9–10.

3 The emblematic status of Rainer Fetting's numerous versions of *Van Gogh and the Wall* has become a cliché in articles on Berlin's 'violent painters'. See, for example, Ernst Busche, 'Van Gogh an der Mauer: Die neue Malerei in Berlin – Tradition und Gegenwart', *Kunstforum* (December 1981/January 1982), pp. 108–16.

4 Quoted from an interview with Helke Sander by Ulla Ziemann in *Berlin: A Critical View. Ugly Realism 20s–70s*, London, Institute of Contemporary Arts (November 1978–January 1979), 174.

5 When this essay was written, the Museum of Modern Art in New York City was still preparing its exhibition, '*Berlinart*' which subsequently opened in 1987. Predictably, this exhibition's emphasis on the relation between Expressionism and Berlin, its exclusion of artists such as Hans Haacke (despite its inclusion of the work of non-residents working in Berlin) and its concomitant mythologisation of the urban reality of West Berlin confirm the conclusions of this essay. '*Berlinart*' complements the Royal Academy's exhibition (and the entire series of exhibitions I am discussing here). In particular, it highlighted the work of younger neoexpressionists who were omitted from the London show because their work to date did not permit what Christos Joachimides termed a 'comprehensive assessment'.

6 Nicholas Serota, 'Culture is not made by the Ministries of Culture', in *13°E: Eleven Artists Working in Berlin*, London, 5.

7 *ibid.*

8 *ibid.*

9 *ibid.*

10 Christos M. Joachimides, 'Achilles and Hector before the Walls of Troy', in *Zeitgeist*, New York, 1983, p. 10.

11 *ibid.*

12 'Zeitgeist-Fragen: Ein Interview mit Christos M. Joachimides', von Wolfgang Max Faust, *Kunstforum*, 56 (December 1982), 25.

13 Benjamin H. D. Buchloh, 'Formalism and historicity – changing concepts in American and European art since 1945, in *Europe in the Seventies: Aspects of Recent Art*, The Art Institute of Chicago, October-November 1977.

14 *ibid.*

15 Busche, 'Van Gogh an der Mauer', p. 109.

16 Erika Billeter, 'Kreuzberg – das Soho von Berlin', *DU*, 1, (1983), 23.

17 Theda Shapiro, 'The Metropolis in the Visual Arts, 1890–1940', in Anthony Sutcliffe, ed., *Metropolis 1890–1940*, Chicago, 1984, p. 95.

18 Manuel Castells, *The Urban Question*, Cambridge MA, 1977, p. 72.

19 Manfredo Tafuri, *Architecture and Utopia: Design and Capitalist Development*, Cambridge MA, 1976, p. 86.

20 *ibid.*, p. 89.

21 Eberhard Roters, *Berlin, 1910–1933*, New York, 1982, p. 56.

22 *ibid.*

23 Georg Simmel, 'The Metropolis and Mental Life', in *On Individuality and Social Forms*, Chicago, 1971, pp. 324–39.

24 For a discussion of the urban problem that elevates this essentialist presupposition to the status of fact, see Donald B. Kuspit, 'Individual and Mass Identity in Urban Art: The New York Case', *Art in America*, 65 (September–October 1977), 66–77.

25 Louis Wirth, 'A Bibliography of the Urban Community', in Robert E. Park and Ernest W. Burgess, *The City*, Chicago, 1925, p. 219.

26 Louis Wirth, 'Urbanism as a Way of Life', in Richard Sennett, ed., *Classic Essays on the Culture of Cities*, Englewood Cliffs NJ, 1969, p. 148.

27 Helmut Middendorf, 'Interview with Wolfgang Max Faust', *Flash Art* (Summer 1984), p. 36.

28 Donald B. Kuspit, 'Flak from the "Radicals": The American Case against Current German Painting', in Jack Cowart, ed., *Expressions: New Art from Germany*, St. Louis and Munich, 1983, p. 38; reprinted in Brian Wallis, ed., *Art After Modernism: Rethinking Representation*, New York, 1984, p. 141.

29 Gertrud Koch, 'Torments of the Flesh, Coldness of the Spirit: Jewish Figures in the Films of Rainer Werner Fassbinder', *New German Critique*, 38 (Spring–Summer 1986), 30–1.

30 Erika Billeter, 'Kreuzberg – das Soho von Berlin', p. 23.

31 Other articles that describe Kreuzberg in similar terms include: Ursula Prinza, 'Einführung', in *Gefühl & Härte: Neue Kunst aus Berlin*, Kunstverein München, October–November 1982; Harry Zellweger, '"Im Westen nichts Neues,"' *Kunstwerk*, 35, 1, (1982), pp. 27–8; Armin Wildermuth, 'City of the Red Nights: Helmut Middendorf's nächtliche Grosstadtbilder', *DU*, 3 (1983), pp. 84–5; Johannes Halder, 'Helmut Middendorf "Die Umarmung der Nacht,"' *Kunstwerk*, 36 (September 1983), pp. 169–70; John Russell, 'The New European Painters', *The New York Times Magazine*, (April 24 1983), p. 42.

32 Wolfgang Max Faust, '"Du hast keine Chance. Nuze sie!" With It and Against It: Tendencies in Recent German Art', *Artforum*, 20 (September 1981), 36.

33 For a thorough and precise history of the European guest-worker system see Stephen Castles with Heather Booth and Tina Wallace, *Here for Good: Western Europe's new ethnic minorities*, London and Sydney, 1984.

34 Cleve Gray, 'Report from Berlin: Wall Painters', *Art in America*, 73 (October 1985), 39–43.

35 Robert Storr, '"Tilted Arc": Enemy of the People?' *Art in America*, 73 (September 1985), p. 97. Clara Weyergraf-Serra later refuted Storr's contentions about the political effectivity of Borofsky's work, citing in particular Borofsky's painting on the Berlin Wall. See 'Letters', *Art in America*, 73 (November 1985), 5.

36 Gray, 'Wall Painters', p. 43.

37 A typically specious statement that the new public sculpture is both democratic and useful is contained in Douglas C. McGill, 'Sculpture Goes Public', *The New York Times Magazine*, (27 April 1986). 'What is the new public art?' McGill asks. 'Definitions differ from artist to artist, but they are held together by a single thread: It is art plus function, whether the function is to provide water drainage, to mark an important historical date, or to enhance and direct a viewer's perceptions.'

38 Douglas Crimp, 'Serra's Public Sculpture: Redefining Site Specificity', in *Richard Serra/Sculpture*, New York, The Museum of Modern Art, (February–May 1986), pp. 40–55.

39 *ibid.*, p. 43.

40 It is not my purpose in this chapter to identify Haacke's intricate and precise

iconography or to explore its full ramifications. For further information see Walter Grasskamp, 'An Unpublished Text for an Unpainted Picture', *October*, 30 (Fall 1984), 19. *October*, 30 is devoted largely to Haacke's work. It contains a full documentation of *The Broadness and Diversity of the Ludwig Brigade*, essays on the work by Haacke and Grasskamp, and a conversation with Haacke by Yve-Alain Bois, Douglas Crimp and Rosalind Krauss. *The Ludwig Brigade* is updated in Brian Wallis, ed., *Hans Haacke: Unfinished Business*, New York and Cambridge, MA, 1986, pp. 266–71.

41 In 1986, after this essay was written, the Leonard Monheim AG was sold to a Swiss corporation. Ludwig retains his interests in the Trumpf and other labels. See *Hans Haacke: Unfinished Business*, p. 226.

42 Grasskamp, 'An Unpublished Text', p. 19.

43 Yve-Alain Bois, Douglas Crimp, and Rosalind Krauss, 'A Conversation with Hans Haacke', *October*, 30 (Fall 1984), 23.

44 For analyses of the East Village art scene see Craig Owens, 'Commentary: The Problem with Puerilism', *Art in America*, 72 (Summer 1984), 162–162 and Rosalyn Deutsche and Cara Gendel Ryan, 'The Fine Art of Gentrification', *October*, 31 (Winter 1984), 91–111.

45 The literature on gentrification is largely descriptive. For analyses of gentrification in a framework of the broader development of today's cities see Deutsche and Ryan, 'The Fine Art of Gentrification'; Neil Smith and Michele LeFaivre, 'A Class Analysis of Gentrification', in *Gentrification, Displacement and Neighborhood Revitalization*, ed. J. John Palen and Bruce London, Albany NY, 1984, 43–63; Rosalyn Deutsche, 'Krzysztof Wodiczko's *Homeless Projection* and the Site of Urban "Revitalization",' *October*, 38 (Fall 1986), 63–98.

46 Andrea Fraser, 'In and Out of Place', *Art in America*, 73 (June 1985), 125.

Index

Index

Index

Index

Index

Index

Index

Index